WILLIAM BLAKE *His Art and Times*

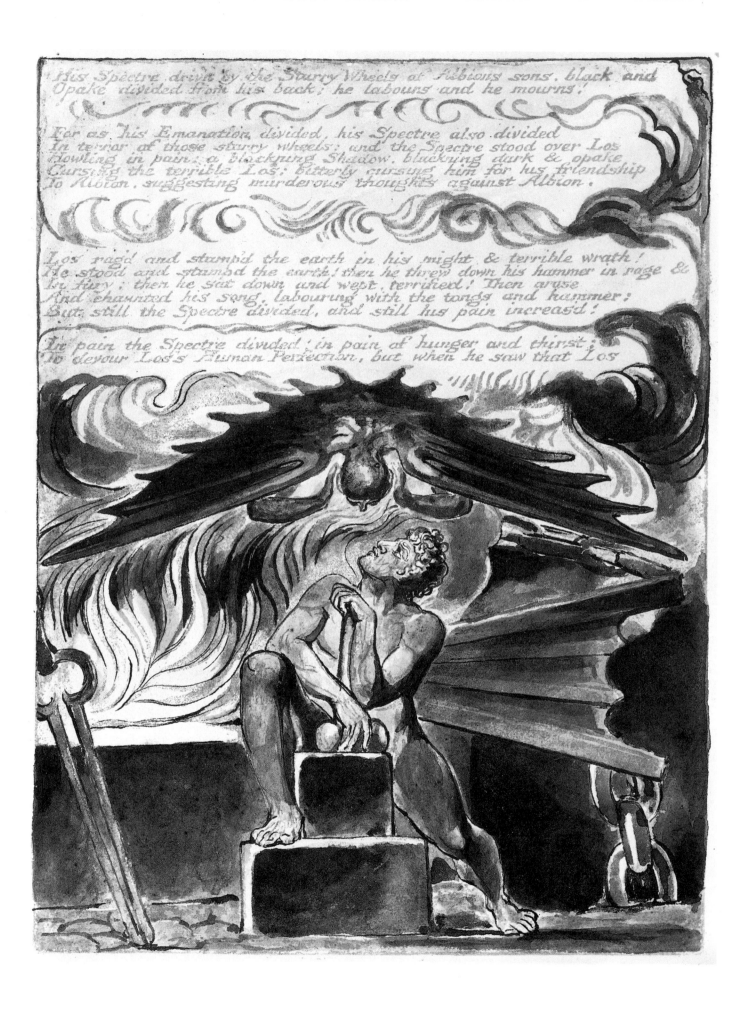

His Spectre driven by the Starry Wheels of Albions sons, black and
Opake divided from his back; he labours and he mourns!

For as his Emanation divided, his Spectre also divided
In terror of those starry wheels: and the Spectre stood over Los
Howling in pain: a blackning Shadow, blackning dark & opake
Cursing the terrible Los: bitterly cursing him for his friendship
To Albion, suggesting murderous thoughts against Albion.

Los rag'd and stamp'd the earth in his might & terrible wrath!
He stood and stamp'd the earth! then he threw down his hammer in rage &
in fury: then he sat down and wept, terrified! Then arose
And chaunted his song, labouring with the tongs and hammer:
But still the Spectre divided, and still his pain increas'd!

In pain the Spectre divided: in pain of hunger and thirst:
To devour Los's Human Perfection, but when he saw that Los

DAVID BINDMAN

WILLIAM BLAKE

His Art and Times

THE YALE CENTER FOR BRITISH ART

THE ART GALLERY OF ONTARIO

Dates of the Exhibition:
Yale Center for British Art, New Haven
15 September–14 November 1982
Art Gallery of Ontario, Toronto
3 December 1982–6 February 1983

Note
The following exhibits will only be shown at the Yale Center for British Art:
Nos. 45c, 74, 91a, 91c, 91d, 92b
The following will only be shown at the Art Gallery of Ontario:
Nos. 78, 91b, 92a

DESIGNED AND PRODUCED BY THAMES AND HUDSON LTD, LONDON

© 1982 the Yale Center for British Art and Art Gallery of Ontario

Library of Congress Catalog Card Number: 82-50073
ISBN 0-930606-38-8 (USA paper)
ISBN 0-919876-89-7 (Canada paper)
Printed and bound in Great Britain by Balding + Mansell Ltd, Wisbech

FRONTISPIECE: *Los at his furnaces*, plate 6 of *Jerusalem* (copy E), relief etching with pen, watercolour and gold. Mr and Mrs Paul Mellon, Upperville, Va. (No. 99c) [actual size]

COVER ILLUSTRATION: detail of *Los entering the grave*, frontispiece of *Jerusalem* (copy E), relief etching with pen, watercolour and gold. Mr and Mrs Paul Mellon, Upperville, Va. (No. 99a)

Contents

Lenders

Beinecke Rare Book and Manuscript Library, Yale University
Professor G. E. Bentley, Jr.
David Bindman
The Trustees of the British Museum, London
The Brooklyn Museum
Museum of Art, Carnegie Institute, Pittsburgh, Pennsylvania
Robert N. Essick
The Syndics of the Fitzwilliam Museum, Cambridge
The Houghton Library, Harvard University
The Lewis Walpole Library, Farmington, Connecticut
The Library of Congress, Washington, Rosenwald Collection
Lutheran Church in America, Glen Foerd, Pennsylvania
Mr and Mrs Paul Mellon, Upperville, Virginia
Metropolitan Museum of Art, New York
The Pierpont Morgan Library, New York
Museum of Fine Arts, Boston
National Gallery of Art, Washington, Rosenwald Collection
Print Collection, Art, Prints and Photographs Division, The New York
 Public Library, Astor, Lenox and Tilden Foundations
Philadelphia Museum of Art
The Art Museum, Princeton University
The Library, Princeton University
Private Collection, Chicago
Museum of Art, Rhode Island School of Design
Rosenbach Museum and Library, Philadelphia, Pennsylvania
Mrs Charles J. Rosenbloom
Mr Charles Ryskamp
The Trustees of the Tate Gallery, London
Trinity College Library, Hartford, Connecticut
Victoria and Albert Museum, London
Mrs John Hay Whitney
Yale Center for British Art
Yale University Art Gallery

Preface

The organization of this exhibition was not undertaken lightly. The art of William Blake has never been more widely appreciated than it is today, yet ironically many of his originals are, for sound reasons of conservation, inaccessible to all but a few highly accredited scholars also blessed with travel funds adequate to support their researches. For the remainder of their natural lives, and in order to prolong their existence, many of Blake's manuscripts, printed books and drawings are destined to see no light of day and very little light of any sort, however carefully filtered and controlled. Under the circumstances, to make a comprehensive selection of work for the purposes of temporary exhibition is an awesome responsibility. It was undertaken with resounding success five years ago in London by the staff of the Tate Gallery; we believe that a similar opportunity is due to the North American public. It was in this spirit that we approached potential lenders, both private and institutional, a very high proportion of them located on this side of the Atlantic. To their generosity, and to the trust they have placed in our two museums, the checklist of the exhibition attests.

In David Bindman we found the ideal collaborator, a leading authority on Blake who was willing to select the exhibition and to write the catalogue. It is no exaggeration to describe him as the chief architect: his was the plan to set Blake's achievement historically, within the appropriate artistic and intellectual context. In the exhibition this is provided by means of supporting material. For example, a group of early watercolours and drawings is accompanied by displays relating to the circumstances of Blake's youth and apprenticeship. Explanations of his new techniques in printing accompany the exhibition of the Illuminated Books of the 1790s, together with material illustrative of the political background of the period. While no area of Blake's activity is neglected, the exhibition concentrates upon the Illuminated Books. They are, undoubtedly, the best known of his works, although they are familiar to most of their admirers from reproduction only. What we are able to do here is to show the originals and, moreover, to compare individual and subtly different plates from multiple copies of the same books. Thus, three copies from different dates of the *Songs of Innocence* are placed next to each other so that the development of Blake's coloring can be traced. Five of the seven known copies of *The Book of Urizen* are likewise assembled, to give an idea of the expressive range of Blake's experimental color printing. These are the temporary privileges of the exhibition; they are outlived by Dr Bindman's catalogue, which speaks for itself. With him, we rejoice that through our publishers it will enjoy distribution independent of the show, as the important contribution to Blake studies that it is.

Foremost among the lenders, we acknowledge our debt to Mr Paul Mellon. The exhibition is, in many respects, a testimony to his long-standing interest in Blake. To Beverly Carter and Mary Ann Thompson, his assistants, we offer our sincere thanks for their unfailing help since the inception of the project. We record here our gratitude to each one of our lenders, both private and public, who have also granted permission to reproduce works in the catalogue. They are listed separately.

Dr Bindman joins us in offering especial thanks to Brian Allen, Jacob Bean, Jean Sutherland Boggs, Suzanne Bolan, Michael Botwinick, Alan Bowness, Martin Butlin, Morris Eaves, Judy Egerton, Sarah Faunce, Stephen Ferguson, Ruth Fine, Eleanor M. Garvey, John Gere, Richard Godfrey, Joseph Holland, Warren Howell, Colta Ives, Ellen S. Jacobowitz, Michael Jaffé, Deborah Johnson, C. M. Kauffmann, Jenijoy LaBelle, Tom Lange, Richard M. Ludwig, William Matheson, Frank Muhly, Morton Paley, Ann Percy, Robert Rainwater, Susan Reed, Kathryn A. Ritchie, Franklin W. Robinson, Andrew Robison, Oswaldo Rodriguez, Allen Rosenbaum, Mrs Charles J. Rosenbloom, Barbara Ross, Dale Roylance, Charles Ryskamp, Margaret Sax, Eleanor Sayre, David Scrase, Arline Segal, Peter Van-Wingen, the late John Hay Whitney and Mrs Whitney, Reginald Williams, Christopher White and Walter J. Zervas.

At Yale, we would like to name Marjorie Wynne and Patricia Howell of the Beinecke Rare Book and Manuscript Library, Alan Shestack and Richard Field of the Yale University Art Gallery, and Joan Sussler of the Lewis Walpole Library. At the Yale Center for British Art, Patrick Noon has had especial responsibility for the exhibition. He has been ably assisted by the members of his staff: Angela Tau Bailey, Ann Schombert and Randi Joseph. Constance Clement, Malcolm Cormack, Joan Friedman, Timothy Goodhue, Mary Kosinski and Laura Prete have each made valuable contributions. Michael Marsland and Joe Szaszfai photographed the Center's holdings, together with Mr Mellon's loans, and Rob Meyers prepared them for installation. The former Director of the Yale Center, Edmund Pillsbury, together with the former Acting Director, Louis Martz, deserve special mention for their support in the initial stages, as does Andrew Wilton, the former Curator of Prints and Drawings.

At the Art Gallery of Ontario, we would like to thank Katherine A. Lochnan, Curator of Prints and Drawings, who originally conceived the exhibition with David Bindman. In addition, we would like to thank Dr Roald Nasgaard, Chief Curator, and his predecessor, Dr Richard Wattenmaker, for their support of the project from its inception. A number of staff members were involved with different aspects of organization, including Alex MacDonald, who conducted discussions with Thames and Hudson, Marie DunSeith, Peter Gale, Barry Simpson, Brenda Rix and Ches Taylor. The exhibition and symposium which will accompany it in Toronto have received the enthusiastic support of the University of Toronto, in particular from Northrop Frye and G. E. Bentley, Jr.

For their help in the preparation of the catalogue, Dr Bindman would like to record particular thanks to Frances Carey, Andrew Lincoln and Andrew Wilton, and especially to Robert Essick, who made available the text of his forthcoming book on Blake's separate plates and also made valuable comments on the present text. He is grateful to his colleagues at Westfield College: Diana Dethloff, Jackie Hoogendyk and Joyce Jayes, without whose kindness the last stages of the catalogue would have been impossible. Finally, it was a great pleasure for him, as it was for us, to work with his old friends at Thames and Hudson; they were tested to the limit but nevertheless managed to handle this publication with the greatest of efficiency and care.

DUNCAN ROBINSON
Director, Yale Center for British Art

W. J. WITHROW
Director, Art Gallery of Ontario

Blake receiving poetic inspiration through the star of Milton: plate 32 of
Milton a Poem (copy D), *c.* 1814–15, relief etching with watercolour, pen and
gold. The Library of Congress, Washington, Rosenwald Collection (No. 90)
[actual size]

INTRODUCTION

The notion that Blake was a naïf either as a poet or as a painter – a 'semi-taught Dreamer', 'delivering the burning messages of prophecy by the stammering lips of infancy'[1] – has long since been abandoned. Thanks to modern scholarship the sophisticated nature of his genius and his profound debt to writers and artists of the past are now obvious. Yet the fact remains that professional writers and artists in general did not see Blake as one of themselves, and although many acknowledged his imaginative qualities there is almost always an element of condescension in their remarks about him. To most of his contemporaries he was an unusual but recognizable phenomenon, the engraver with a highly developed imaginative life. Some recent historians writing on the dissenting religion of Blake's time have revived the implied connection between his profession and his vision of the world, and it seems worth exploring the implications for Blake's art.[2] The first two chapters will consider Blake's career as an engraver and, very briefly, the nature of his visionary ambitions, leading into a discussion of his art within the context of his times. The idea is to move from general considerations to an examination of his practice as an artist.

I 'Mr Blake the Engraver'

Flaxman is . . . a profound mystic. This last is a characteristic common to many other artists in our days – Loutherbourg, Cosway, Blake, Sharp, Varley, &c. – who seem to relieve the literalness of their professional studies by voluntary excursions into the regions of the preternatural, pass their time between sleeping and waking, and whose ideas are like a stormy night, with the clouds driven rapidly across, and the blue sky and stars gleaming between!

<div align="right">William Hazlitt, The Plain Speaker, London, 1826, vol. I, pp. 223–24</div>

As a boy William Blake served a full seven-year apprenticeship to the engraver James Basire (1730–1802), in the years 1772–79. It was intended that he should learn the mundane but respectable trade of reproductive engraving from the designs of other artists. This might involve copying anything from paintings by Royal Academicians to humble book and periodical illustrations, and his master's speciality was antiquarian engraving. As the son of a London hosier it was natural for Blake to enter the world of art at a relatively modest level and not aspire initially to the more elevated profession of portrait or subject painter. Because of this early choice his hopes in later life of being accepted as a painter of serious subjects were persistently thwarted, for he was almost universally regarded as primarily a copy engraver with ambitions beyond his station in life. His career as an engraver was moderately successful, and he was able to make a steady living from it, though he was never regarded as being in the first rank with men like William Woollett and William Sharp (*Fig. 2*), whose phenomenal technical expertise was not affected by any artistic ambitions of their own.

After leaving the apprenticeship to Basire in 1779 Blake entered the Royal Academy, where he attempted to establish himself as a painter of History, supporting himself by engraving book illustrations mainly after the designs of his friend Thomas Stothard (1755–1834). He then progressed to the engraving, again after other artists, of fashionable sentimental genre and literary scenes, which were published as separate plates, sometimes by such enterprising publishers as Thomas Macklin (No. 25). In 1784 he began publishing such plates himself in partnership with his fellow apprentice James Parker (No. 26). His aim was probably to ensure a steady income by this means, and to allow himself time for his private work in poetry and painting. He was not alone in thinking that there were real profits to be made out of the popularity of such trivial plates. The great caricaturist James Gillray (1757–1815), for example, who was born a year earlier than Blake and started at the Royal Academy the year before him, entered the same field in the mid-1780s, though more as a designer than as an executant *(Fig. 1)*.[1]

Blake, then, from the outset was in a position to separate the creation of imaginative art from his means of making a living. He could expect to survive, even live quite comfortably, on the proceeds of his profession and bide his time until public taste began to appreciate his original designs. This material dependence upon his craft was well understood by his contemporaries, who usually referred to him as 'Mr Blake the Engraver'; and even his friends tended to help him not by commissioning imaginative work but by finding him mundane engraving jobs. He could, however, be patient and wait for the few patrons who were interested in his ideas or his innovations in printing, or he could dismiss with devastating rudeness such men as

Fig. 2 William Sharp after G. F. Joseph: *William Sharp*, 1817, engraving. Yale Center for British Art, Paul Mellon Collection

the ineffable Dr Trusler (see No. 74). Behind his appeals to the 'fit audience tho' few', or 'the Young Men of the New Age'[2] was the serene confidence – unjustified as it turned out – that the indifference of his contemporaries could not drive him to poverty.

Reproductive engraving was a monotonous job, requiring many hours of pains-taking work, eyes close to the copper plate. While a certain licence could be exercised by the engraver a high premium was inevitably put on exactness and finish. In a letter of 1799 Blake wrote, 'To engrave after another Painter is infinitely more laborious than to Engrave one's own inventions'; and yet he added that he had 'no objection to Engraving after another Artist. Engraving is the profession I was apprenticed to, & I should never have attempted to live by any thing else, If orders had not come in for my Designs & Paintings.'[3] The mechanical work which occupied his hands throughout the long day would not have fully occupied his mind, and it was a common assumption, frequently applied to Blake, that such routine work could allow the mind to wander into strange reaches. An anonymous reviewer wrote of the distinguished but notoriously eccentric engraver William Sharp (1749–1824) in 1832:[4]

> In engraving and its operation the process of thought may be carried on with that of the work, and neither be retarded in its progress, by one who is master of his subject in either way. Hence the wild and fanciful theories that emanate from a well stored and imaginative mind; – and such was that of Sharp: Not a shape that crossed his thoughts, or was generated from those of others, in the speculative points of his favourite fantasies, but he would embody and invest it with qualities of the most wild and visionary nature, leading or following any object that led out of the beaten path of reason and experience. Nor was he singly the follower of wild theories among the professors of Art: Loutherbourg, Cosway, and Blake, were no less the dupes of visionary fancies.

Blake's contemporaries, then, could place him within a familiar context, as belonging with artists like Sharp, the miniaturist Richard Cosway (1742–1821), and the landscape painter P. J. de Loutherbourg (1740–1812), whose concern for mysticism or the occult was not reflected in their professional work. Blake, as it happens, would have known all of them personally: he was possibly taught by Cosway at the Pars Academy before he was apprenticed to Basire, he often worked for the same publishers as Sharp, and he shared an interest in Swedenborgianism with de Loutherbourg. Henry Fuseli (1741–1825), despite obvious parallels, was not of this company, nor was he sympathetic to the visionary side of Blake's art, claiming that 'the whole of his aim is to produce singular shapes & odd combinations'.[5]

Blake's mental life was in some respects closer to that of Sharp, whose notorious 'Enthusiasm' did not affect his reputation as the best copy engraver of his time. Though he did not produce imaginative designs of his own, Sharp had a vigorously speculative mind which led him not only into political radicalism but into a passionate belief in the claims of such prophets as Richard Brothers (1757–1824) and Joanna Southcott (1750–1814).[6] But where Blake sought to build the New Jerusalem with words and images, in the 1790s Sharp was prepared to follow Brothers, the self-styled Prince of the Hebrews, on an expedition to lead the Jews back to the real Jerusalem where they would rebuild the Holy City brick by brick (see *Fig. 3* and No. 101). He had hopes of persuading Blake to join him, and he attempted to lure the sculptor John Flaxman (1755–1826) by offering him the job of chief architect of the New Jerusalem.[7]

The nature of Blake's millenarianism[8] will be discussed in the next chapter; for the moment it is necessary to observe that his Illuminated Books appeared to his

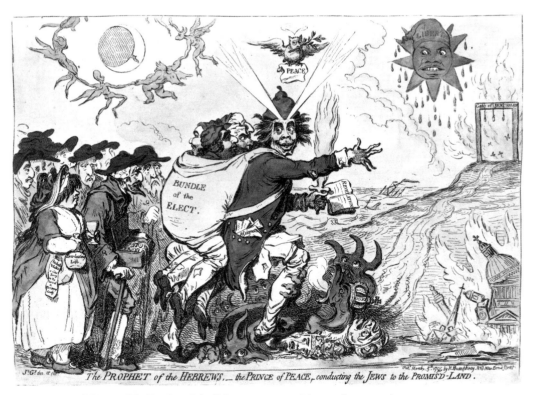

Fig. 3 James Gillray: *The Prophet of the Hebrews*, 1795, etching and watercolour.
Yale Center for British Art, Paul Mellon Collection

more educated contemporaries to be characteristic in their extremism and anti-rationality of the petty craftsman rather than the man of conventional intellect. It is true that a kind of millenarian thinking was not uncommon in the universities, but this looked more to a gradual change in the hearts of men to bring about the Kingdom of God than to the vengeful destruction of the corrupt world. Coleridge put his finger on the difference between the social meaning of his own metaphysics and those of Blake, on his first reading of *Songs of Innocence*: 'he is a man of Genius – and I apprehend a Swedenborgian – certainly a mystic *emphatically*. You perhaps smile at *my* calling another poet a *Mystic*; but verily I am in the very mire of common-place common-sense compared with Mr. Blake, apo- or rather anacalyptic poet, and painter.'[9]

The apocalyptic and revolutionary nature of Blake's beliefs, as he well knew, rendered normal publication of his Prophetic works virtually impossible, for their denunciation of the social order was unlikely to be encouraged by its beneficiaries and upholders. In the 1780s he seems to have attempted to put across millenarian ideas in covert fashion by sending paintings with apocalyptic subjects to the Royal Academy (see Nos. 12 and 13), but this appears to have passed unnoticed. His own abortive experience as a print publisher may have given him the idea to publish his own work himself, and his invention in the years 1787–88 of a process which combined text and design by means of a relief-etched copper plate (pp. 37, 90) was not only an act of personal liberation which enabled him to unify his ideas and his craft as a printmaker: it was also an act of liberation on behalf of artists as a whole, to free them from the tyranny of the marketplace. According to a prospectus that Blake issued in 1793, because 'it produces works at less than one fourth of the expense' the new method could liberate 'The Labours of the Artist, the Poet, the Musician [which] have been proverbially attended by poverty and obscurity'.[10] Through Blake's invention the artist could by-pass the publishers, who invariably exploited artists and prevented the publication of anything critical of the nation's godless rulers. Even so, he never lost the hope of finding publishers for his designs, if not his writings; and it took a whole series of setbacks, beginning with Young's *Night Thoughts* in 1797 (No. 62) and ending with the disastrous relationship with Robert Cromek over designs to Blair's *Grave* in 1805–08 (No. 64), before he fell back entirely upon his own resources. In the *Public Address* of 1810,[11] which is a series of fragmentary paragraphs from an unfinished prospectus to go with the *Canterbury Pilgrims* engraving (No. 97), he began to formulate his own version of what had caused engravers to be degraded into journeymen whose efforts to create original compositions were regarded with scorn and ridicule. At first Blake had accepted the division of his life into copy engraver and creative artist, but that was because his prospects as the former seemed firm and lasting; by 1810 he realized that he had neither enough engraving commissions to keep him going nor enough clients for his imaginative work. The division of labour which had once been a blessing now became a curse, and the *Public Address* presents a forceful historical analysis of how he and the other serious artists of the time were forced into a corner by the publishers and above all by the 'trading' artists, who were only interested in making a fortune.

Blake explains the engraver's alienation as a kind of Fall into a world in which all the functions become fragmented. Perhaps he had in mind by contrast an Eden in which the medieval illuminator wrote and designed each book as a single entity. In Blake's world the author is separated from the artist, one writing for letterpress, the

other making copper plates for the illustrations. The artist then became separated from the engraver, so that a print after a painter's design belonged to neither one nor the other. In the hands of such virtuoso engravers as his master Basire's rival William Woollett, the reproduction in some cases acquired more prestige than the original painting. The process of engraving in turn became so fragmented that one engraver might etch the outline, another be responsible for the final engraving,[12] and yet another actually print off the plates. Hence the prominence in Blake's demonology of the 'arch fiends' Rubens and Joshua Reynolds, for Rubens was thought to have been the first painter to use engravers to disseminate his paintings in a systematic way, while Reynolds had a stable of mezzotinters who devoted themselves to the slavish reproduction of his paintings. Mezzotint, and other recent processes, such as aquatint and stipple engraving, had for Blake two essential drawbacks. In that they were essentially imitative of another medium – painting, wash or chalk drawing – they tended to make the engraver subordinate, forcing him to become a specialist in one particular process. And in that they were more concerned with texture and surface they were opposed to linear methods of engraving.

Despite the tendentiousness of this view and the obvious historical distortions, Blake was unerringly perceptive in noting the economic consequences of the division of labour, and the way in which the early stirrings of the Industrial Revolution were already precipitating a crisis for the artist who cared about the artistic value of his prints. Many artists saw the danger of transferring their designs into a mechanical system which would destroy their individuality. George Stubbs (1724–1806), for example, engraved and etched his own designs, which allowed for individual and sensitive handling, and published them himself in the hope that they might appeal to those bored with the uniform finish of Woollett and others.[13] Thomas Bewick (1753–1828), the great wood engraver, claimed to have seen the way things were going as early as 1777. He came that year from Newcastle to London to work in the print trade, and he later described with some irony his reasons for returning home:[14]

> In London one man does one branch of business & another another of the same kind of work & it is by this division of labour they thus accomplish so much & so well – I however soon tired of thus working alone, and as I had plenty of work to do on my own account . . . I turned my back upon the Masters who took in all kinds of work – & stuck to working for myself.

Without such a possibility of withdrawal, in a way, as Hazlitt suggested, Blake took 'voluntary excursions into the regions of the preternatural', for his prophetic calling could be entered into at any time, whether at his worktable laboriously engraving someone else's design, or at night. In that sense his Prophecies are, like Young's *Night Thoughts* which he had illustrated four to five years before the following passage in a letter, ostensibly the wakeful thoughts of a mind freed from other business, dwelling on life, death and immortality: 'I labour incessantly & accomplish not one half of what I intend, because my Abstract folly hurries me often away while I am at work, carrying me over Mountains and Valleys, which are not real, in a land of Abstraction where Spectres of the Dead wander.'[15] Because he had no specific audience in mind, there was no natural limit to his mental exploration nor to the scope of the work to which he could aspire. With a worktable, a printing press and a complete method for publishing his Prophecies there was no obstacle but his own weakness to the realization of his vision of Redemption.

2 *The Great Task*

I rest not from my great task!
To open the Eternal Worlds, to open the immortal Eyes
of Man inwards into the Worlds of Thought, into Eternity
Ever expanding in the Bosom of God, the Human Imagination.

<div align="right">

Jerusalem, Chapter 1, plate 5

</div>

Blake was undeniably a man in earnest in the Carlylean sense, conceiving of a God-given mission to communicate the higher truth to his fellow men. While he had a dislike of any form of institutional religion, his metaphysical beliefs were not fundamentally different from those of other dissenters in the 17th and 18th centuries who took literally the Christian premise that the world is in a Fallen state until its Redemption through Jesus Christ, and who believed that the Book of Revelation gave a true account of the end of the world. It follows from these beliefs that all man's material ambitions are irremediably corrupt. Any church that created a priesthood, gave divine authority to kingship, or compromised with materialist philosophy or science in its doctrine was necessarily inimical to the Spirit, which offered the only salvation through Jesus. Self-evidently rulers and churches would have to pervert the true message of the Gospel to justify their claims to Christianity, erecting idols and persecuting those who exposed them.

Latter-day prophets like Blake who furiously denounced such idolatry consciously modelled themselves on the prophets of the Old Testament, and he was not alone in predicting the destruction of the modern Babylon and Nineveh with the full conviction of speaking the word of God. For English prophets there was also the necessary assumption that the role of the Chosen People had now passed to the English Nation, who had been vouchsafed warnings of the coming Apocalypse in the terrible events of the present era: Civil War, the Plague and Fire of London, and the American and French Revolutions.

Within this framework of belief there was much scope for differences, particularly over the time of the Apocalypse, whether it had already begun, and by whose agency: there were many claimants like Richard Brothers and Joanna Southcott who persuaded some people that they had a decisive role to play in it.[1] The millennium for Blake, however, was not so much a literal or imminent possibility (though there were times when he may really have thought it was about to happen) as a dream of Redemption which could give consolation and the hope of eternal life to the Christian. It was a state of being which could be entered into at any time: 'Whenever any Individual Rejects Error & Embraces Truth, a Last Judgement passes upon that Individual.'[2] Blake seems not to have belonged to any millenarian group except for a momentary attachment to the Swedenborgian New Church, but he was certainly profoundly familiar with the writings of such influential authorities as the German mystic Jacob Böhme (1575–1624: see No. 4) and Emanuel Swedenborg (1688–1772) himself.

Blake's first Illuminated Books, dating from towards the end of the 1780s, *There is no Natural Religion* (No. 38) and *All Religions are One*, are direct philosophical assaults on Deism or Natural Religion, insofar as it sought to incorporate the discoveries of empirical thought into the doctrine of the Church of England. To

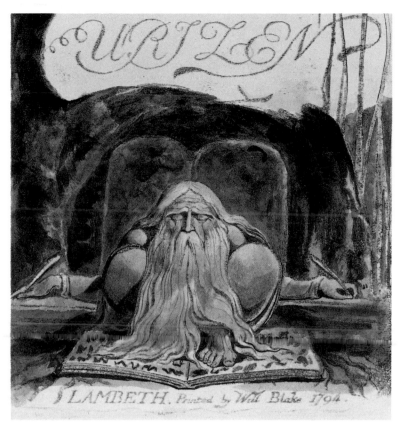

Fig. 4 Blake: Urizen, from the titlepage of *The Book of Urizen* (copy B), 1794, relief etching, colour-printed, with pen and watercolour. The Pierpont Morgan Library, New York (No. 45b)

Blake Deism was the religion of the rulers of England, nothing less than 'the Religion of the Pharisees who murder'd Jesus';[3] he was tireless in his condemnation of philosophical empiricism in all its forms, naming Bacon, Locke and Newton as preachers of doubt and despair. In this Deistical world hypocrisy reigned; materialism triumphed as the divine was relegated to the realm of Mystery, men were divided from each other, politics became synonymous with corruption, and the arts were forced to be merely ornamental and imitative. In the aftermath of the French Revolution, in the early 1790s, using his method of relief etching Blake sought to create in a series of books a 'Sublime Allegory' which would reveal how the forces of materialism had grown to dominate human history until the advent of revolution.

This allegory is worked out in terms of a cosmic conflict between quasi-Biblical personifications, of whom the most important are Urizen, Orc, Los and Enitharmon (*Figs. 4, 5*). Rationalism and the values of Blake's time are embodied in the figure of Urizen, whose tyrannical personality and resemblance to traditional depictions of Jehovah imply that 18th-century Deism is nothing more than the legalism of the Old Testament in new garments – the Letter of the Law rather than the Spirit, which is Christ. Urizen's response to the threat of revolution is that of an aged tyrant, propping up a discredited social order of which he is both creator and creation (see p. 26). He is not, however, a force external to humanity: he is also the reasoning faculty, which in man's Fallen state becomes separated from his imagination.

Blake's Prophecies of the 1790s are marked by a sense of urgency, for they attempt to interpret the course of the French Revolution as it actually unfolds. As a concept revolution appears both creative and destructive: it creates a new world but it could end by usurping the tyranny it destroys. These ambiguities are embodied in the Promethean figure of Orc (ill. p. 103), whose fiery ambition reflects that of Milton's Satan. At one extreme he is Christ-like in that he represents the hope that revolution will be a prelude to the Second Coming; at the other he is a pretender to the throne of Urizen, whose place he will take as the upholder of Moral Law.

Los, the third major character in the drama, encompasses both Orc and Urizen in his role as the spirit of prophetic poetry. As an artist he is able to see beyond the material world into eternity, and as the author of the Bible and all literature and art he dictates the way in which the forces of good and evil are perceived by mankind. But it is due to him that Urizen is visualized as a benevolent patriarch, for the human weakness of artists throughout the ages has led them to be enslaved by temporal power in order to create the very idols which support the hegemony of false religion. The ambiguity of the artist's position – divinely inspired yet with the weaknesses of ordinary men – is represented by Los's relationship with Orc, whom he imbues with creative force, but keeps captive through his jealousy.

Orc is the child of Los by Enitharmon, who as the female principle provides comfort, but also leads Los to abandon the stern duties of the artist; 'the night of Enitharmon's joy' in *Europe* is the era when the institutional Church was able to pervert the meaning of the first Incarnation, because art under her influence abandoned its prophetic role to become a mere adornment to life.

The first cycle of Prophecies ends inconclusively by 1796 with the completion of *The Book of Ahania* (No. 47) and *The Book of Los*. Blake seems to have begun almost immediately to reconstruct the myth within a single volume, which he initially called *Vala* and later *The Four Zoas* (British Library, London), abandoning it some time after 1804. In the course of the revision there emerges, as an archetype of mankind, Albion the Ancient Man, who draws together the history of man's Fall and Redemption with the fate of the island of Britain. This new archetype expresses the shift in Blake's focus from the Fallen world to the restoration of man's primal state before his Fall into mental fragmentation. This change in Blake's thought was partly brought about by a reconsideration of Milton, with whose equivocal legacy Blake wrestled during his period in Felpham in Sussex as assistant to the poet William Hayley (1745–1820) in the years 1800–1803. Blake's great struggle to purge Milton, and thereby himself, of error, is recorded in *Milton a Poem* (No. 90), an Illuminated Book which can be seen as a prelude to the final epic, *Jerusalem* (No. 99).

Jerusalem is, in a nutshell, an account of the spiritual history of man in the context of an emerging and ecstatic vision in which all contraries are finally reconciled and man is returned to his primal unity. Albion's journey to Redemption or the state of Jerusalem parallels man's spiritual progress from the monotheism of the Jews (identified by Blake as the Druids who inhabited Ancient Britain), through the spiritual captivity of Deism to the longed-for Christian Triumph, which is achieved at the moment of Albion's recognition of the true meaning of Christ's sacrifice on the Cross. As the presiding deity of This World, Urizen is no longer a central actor in *Jerusalem* and Orc is relegated to a phase in the history of man. Urizen remains the representative of Reason. He, Los or Urthona (Imagination), Luvah (Love) and Tharmas (Senses) make up the Four Zoas, the 'living creatures' of Ezekiel (see No.

Fig. 5 Blake: Orc chained, with Enitharmon and Los, shown on the first Preludium plate of *America*, 1793, relief etching with pen and watercolour. Mr and Mrs Paul Mellon, Upperville, Va. (See catalogue No. 43)

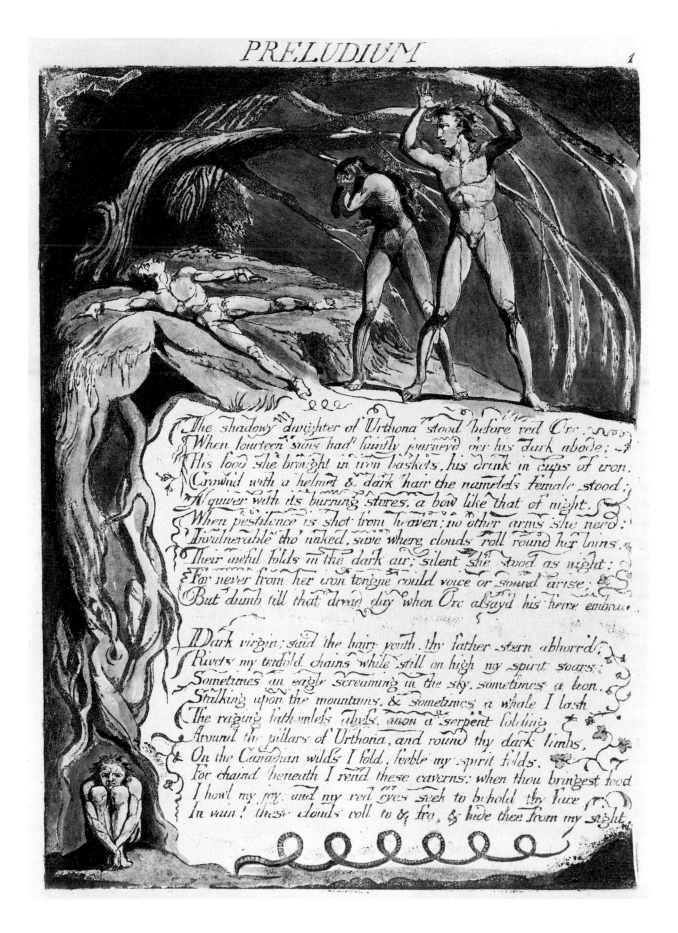

The shadowy daughter of Urthona stood before red Orc
When fourteen suns had faintly journeyd oer his dark abode;
His food she brought in iron baskets, his drink in cups of iron;
Crownd with a helmet & dark hair the nameless female stood;
A quiver with its burning stores, a bow like that of night.
When pestilence is shot from heaven; no other arms she need:
Invulnerable tho' naked, save where clouds roll round her loins,
Their awful folds in the dark air; silent she stood as night;
For never from her iron tongue could voice or sound arise;
But dumb till that dread day when Orc assayd his fierce embrace.

Dark virgin; said the hairy youth, thy father stern abhorr'd;
Rivets my tenfold chains while still on high my spirit soars;
Sometimes an eagle screaming in the sky, sometimes a lion,
Stalking upon the mountains, & sometimes a whale I lash
The raging fathomless abyss, anon a serpent folding
Around the pillars of Urthona, and round thy dark limbs,
On the Canadian wilds I fold, feeble my spirit folds.
For chaind beneath I rend these caverns; when thou bringest food
I howl my joy; and my red eyes seek to behold thy face
In vain! these clouds roll to & fro, & hide thee from my sight.

78) and the four fundamental elements of the mind of man. Los, however, strengthens his dramatic role in *Jerusalem*, and his struggle to build Golgonooza, the City of Art, is an analogue with Blake's own in writing *Jerusalem* itself, for Los has to fight off the temptations of his Spectre who urges him nightly to abandon his 'Great Task', 'by tears, by arguments of science & by terrors, / Terrors in every Nerve'.[4] Just as Blake remains devoted to completing his Prophecy out of patriotic duty, so Los rises above the threats of the Spectre for the sake of Albion, fighting off the torments of neglect and hostility he must endure from the sons of Albion, the ruling powers of the English Nation.

Los in *Jerusalem* is thus a link between Blake as visionary artist and the actual practice of art; however he is not an engraver, painter or poet but a blacksmith-sculptor who casts gigantic figures in a furnace, and also a primitive architect, builder of Golgonooza. Los is an 'artificer in brass and iron',[5] like Tubalcain and like Hephaestus, the artist to the gods on Olympus; and like Hephaestus he is jealous, being subject to the emotions of worldly artists, who, Blake was convinced, are especially prone to be envious of true genius.

Los is also to be presumed to have been the sculptor of the archetypal works of art on the Temple of Solomon, 'the wonderful originals called in the Sacred Scriptures the Cherubim, which were sculptured and painted on walls of Temples, Towers, Cities, Palaces, and erected in the highly cultivated states of Egypt, Moab, Edom, Aram, among the Rivers of Paradise'.[6] These originals 'executed in a very superior style' may also correspond with 'the bright Sculptures of Los's Halls' described in *Jerusalem*, which have for their subject-matter 'All that can happen to Man in his pilgrimage of seventy years'[7] and from which 'every Age renews its powers'. In Blake's view, stated in the *Descriptive Catalogue* of 1809 (No. 95), all true art, whether it is inspired like his own, or merely imitative like the Greek sculptures, must reflect in some way these archetypes; even the canonical works of classical antiquity like the Farnese Hercules, the Medici Venus and the Apollo Belvedere are but 'copies from some stupendous originals now lost or perhaps buried till some happier age'.[8] Hence it is not accidental that Blake's figures sometimes appear to resemble familiar antique sculptures: of himself he wrote, 'He had resolved to emulate those precious remains of antiquity; he has done so and the result you behold; his ideas of strength and beauty have not been greatly different.'[9]

Blake never attempted to make sculptures nor, with the possible exception of Flaxman, was he impressed by contemporary sculptors who had 'continual & superabundant employment' at the expense of painters. But in a sense his relief-etched plates were themselves a form of sculpture, and he seems to have regarded his creative activity as represented by them rather than the final books. In *The Marriage of Heaven and Hell* he describes relief etching in ironical terms as an 'Infernal method', a form of printing by 'corrosives which in Hell are salutary and medicinal melting apparent surfaces away, and displaying the infinite which was hid'.[10] Only a single piece of a relief-etched copper plate by Blake has survived (No. 34); and though it is shallowly bitten by the acid it can be seen as a kind of bas-relief in reverse. The association between sculpture and printing is indeed an ancient one: Blake would have known of the tradition that engraving began as a form of stone-carving and was only later used to give impressions on paper, and that tablets served for recording hieroglyphic texts in ancient Egypt.[11] The majestic image of Los at his furnaces casting sculptures for the buildings of the remotest antiquity (ill. p. 2) was,

therefore, the visionary form of Blake's own activity in his workroom, labouring on a minute scale with burin, etching fluid and printing press. All activities on earth, however humble, have their correspondences in the world of vision.

Blake's attempt to create a unified form of art out of painting and poetry was 'an Endeavour to Restore what the Ancients call'd the Golden Age'.[12] In the historical sense this could mean, as we saw in the previous chapter, a return to a lost medieval unity of the arts. His method of relief etching could also be seen as a reflection of a higher spiritual unity, an art which might transcend all the separate genres. Blake hints at the nature of this Platonic condition in *Jerusalem*, where it appears as the discourse of Heaven:[13] men converse in

> Visionary forms dramatic which bright
> Redounded from their Tongues in thunderous majesty, in Visions
> In new Expanses, creating exemplars of Memory and of Intellect
> Creating Space, Creating Time according to the wonders Divine
> Of Human Imagination, throughout all the Three Regions immense
> Of Childhood, Manhood & Old Age . . .

Although this visionary art will transcend the individual arts it will not eliminate the senses; the individual arts will retain their identity and continue to appeal to the senses, but in combination they will create a Heavenly form of conversation. In Heaven 'all God's children are Prophets', and just as Jesus and the apostles were artists so all those who are in a state of Redemption will converse naturally in all the forms of art, whether it be painting, poetry, music or architecture, moving freely from one to another.[14]

These ideas are most fully expressed in the designs to the *Book of Job* of 1805–25 (No. 115). In the first one Job's adoption of the Letter of the Law rather than the Spirit is symbolized by the musical instruments which the family have hung in the tree (a reference to the Babylonian Captivity which is representative of their moral state at that point), and their Redemption is expressed in the final design where they praise the Lord with the same instruments. Their realization of the meaning of art precisely parallels Blake's remark on the *Laocoön* engraving (No. 110): 'Praise is the Practice of Art. The outward Ceremony is Antichrist.'[15] A contrast can also be observed between the first and second half of the *Job* series, for before Job is Redeemed men converse in accusation and recrimination, embodied in physical gesture and ordinary speech; but after his realization of error, in plates 11–13, a new form of discourse emerges. In plate 14, *When the Morning Stars sang together*, God presents the Creation of the World as a series of tableaux which Job and his companions observe with wonder, accompanied by the singing and joyful shouts of the angels; and in the penultimate plate, no. 20, Job recounts his experiences to his daughters through images of his mental pilgrimage on the walls behind him. The engraving does not make it clear whether these images are painted or are relief sculptures, but in any case they are clearly part of a depiction of 'all that can happen to Man in his pilgrimage of seventy years'.

If 'Visionary forms dramatic' provide an ideal for the forms and relationships of art, then the concept of an art which encompasses the whole spiritual experience of man lies behind the range of Blake's subjects. If the Old and New Testaments contain 'All that Exists', then the artist must aspire to bring all the spiritual states of man together in one mighty work. Blake's greatest single painting, now lost, would have

been the tempera of the *Last Judgment*, containing, according to someone who saw it in his lifetime, 'upward of one thousand figures'.[16] He worked on it for the last twenty years of his life, and it is known from a detailed description and a number of watercolours and drawings (No. 98). Although seemingly conventional in structure and recognizable in terms of traditional iconography, as an attempt to encompass the history of the human spirit from Fall to Redemption it is an equivalent in pictorial terms of *Jerusalem*, which itself was the culmination of Blake's efforts, beginning with the Prophecies of the 1790s, to create a Bible of his own.

In 1799 Blake was commissioned by the Rev. John Trusler to paint a watercolour on the theme of 'Malevolence', in the expectation that he would illustrate it by an incident from real life, in the manner of Hogarth and Rowlandson. The clergyman was completely baffled by the allegory in the watercolour that was offered to him (No. 74, *Pl.X*) and he complained that Blake wanted somebody to 'Elucidate [his] Ideas'.[17] Blake replied with a conventional appeal to the classical idea of *difficultas*, according to which the reader experiences a higher satisfaction by having to work to achieve understanding: 'The wisest of the Ancients consider'd what is not too Explicit as the fittest for Instruction, because it rouzes the faculties to act'. For Blake, however, there was obviously more to it than that, for his ambition (one he might be wary of admitting to a worldly cleric) was Biblical in scope, and his real justification was that of the Church Fathers, who argued that the history of the Jews contained a hidden spiritual meaning which could only be revealed to those with special claims to understanding. While theologians would have argued that it could only be reached by the accumulated wisdom invested in a church, Blake and other millenarians saw the true meaning of the Bible as being within the reach of those few privileged individuals throughout the ages who were guided by an inner light.

Blake was perfectly aware that his Prophetic and personal works were incomprehensible to most of his contemporaries, and he was also aware of the protection this gave him, especially in the period of anti-radical reaction in England in the 1790s. Such considerations would have been well understood by those who shared his millenarian culture; but, of course, they were never more than a minority in artistic circles at the time.

3 Satire and Vision: Blake and his Contemporaries

In my Brain are studies & Chambers filled with books & pictures of old which I
wrote & painted in ages of Eternity before my mortal life . . .

> Letter to John Flaxman, 21 September 1800

Blake's long hours of lone endeavour never precluded the close study of other art or an awareness of what was available in London. He knew most of the Royal Academicians personally and he spent time studying the Orléans Collection when it was on view in London in 1798–99,[1] and the Truchsessian Gallery in 1804 see No. 68). His experience was thus comparable to that of any other artist or connoisseur living in London, so it is not surprising that his own art often makes allusions which presuppose such experience on the part of its audience.

Fig. 6 Blake: *Famine*, plate 6 of *Europe*, 1793, relief etching with colour printing and watercolour. British Museum, London

Educated observers of art in the 18th century – those who had, in Reynolds's words, 'cultivated their taste' – could be expected to have a ready grasp of allusions in painting to classical antiquity and the High Renaissance. It can be assumed, for example, that they would have found it easier than we do to observe a connection between the restraint with which Job bears his afflictions in the early separate engraving of *Job* (No. 15) and that shown by the Trojan High Priest in the famous Hellenistic *Laocoön* group in the Vatican (see No. 110).[2] By allowing for such analogies Blake would only be conforming to the standards of an age which saw 'the judicious adoption of figures in art'[3] as the mark of a serious and cultivated artist, who could thereby increase the expressive value of his work. In the early *Great Plague of London* (No. 12), the mourning group on the right evokes a Crucifixion group in an early Italian painting, elevating a subject from recent English history to a higher level of authority: the Plague of 1665 becomes a divine Judgment rather than a random occurrence or a purely historical event.

Such references should warn us that the interpretation of Blake's designs is more than a matter of reading them like a text. In plate 6 of *Europe* (*Fig. 6*), the *idea* of famine is expressed so strongly that it is of secondary importance to consider whether the women are only lamenting the death of the child or proposing to cook him in the large pot behind. The headpiece to *The Ecchoing Green* in *Songs of Innocence* (*Fig. 7*) has

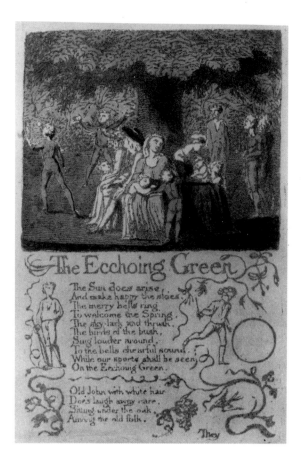

often been the subject of readings in which the physiognomy and gestures of each figure have been closely analysed. A contemporary of Blake's would have recognized the scene, where a spreading tree shelters the old folk watching the children at play, as an image of rural content, familiar not only from the many editions of Goldsmith's *Deserted Village*, illustrated by such artists as Bewick, Gillray (*Fig. 1*) and J. K. Sherwin, but also from crude illustrations in children's books. He might also have been sensitive to the elegiac implications, for Goldsmith's poem is a lament for a village razed in the name of improvement. The little boy chasing a hoop, next to the text below, is a commonplace emblem of the transience of youthful delight, for he is as oblivious of his fate as the boy in a vignette by Bewick, playing behind an old man contemplating a gravestone (*Fig. 8*).

The use of such familiar images by Blake suggests a greater respect for the genre of the children's book than he is usually given credit for.[4] The titlepage of *Songs of Innocence* (No. 39) shows the ideal circumstances under which the book is to be read: by a devoted nurse to attentive children under the shade of a tree. It is a convention of 18th-century books for children – and sometimes of those for adults as well – that on the titlepage the book itself is depicted actually being used, in the family circle with the mother or father reading it, or the child reading it alone. As a professional engraver Blake had particular experience of such popular forms of art: he worked with Stothard on the illustration of novels and magazines, and on one occasion designed the illustrations for a children's book (No. 58).

Another form of popular art available to anyone living in London in the 1790s would have been political caricatures, whose profusion in the streets and printshops

of London was noted by Goya's friend Moratin on his visit in 1792.[5] Blake must have been acquainted with Gillray, the greatest caricaturist of the day, and despite later political differences they share a sense of the unremitting corruption of the world, which in Gillray's case may have derived from his Dissenting background: his father was the sexton of the Moravian Church in Chelsea.[6]

While Blake accused the hapless Dr Trusler of having his 'Eye . . . perverted by Caricature Prints, which ought not to abound as much as they do', it is arguable that he learnt much from them, especially in the 1790s.[7] A satirical print pretends to conceal its intentions: the real point is disguised, however transparently, by humorous and ironical inscriptions. Gillray's *Presages of the Millenium* (No. 61), of 1795, for example, purports to be about Richard Brothers's prophecies of universal destruction, but the satirical point is the identification of Pitt as Death on a Pale Horse riding over Burke's 'swinish multitude'.[8] The prints of Gillray often employ a process of unmasking, in which true motives are revealed behind the public façade. The improbable imputation that Charles James Fox was a Jacobin was expressed in countless ways. The most familiar strategy is revealed in Gillray's witty print *Doublûres of Characters* (Fig. 9), of 1798. Here, in a reference to Lavater's book on physiognomy, Fox and his Whig friends are represented by their 'real' countenances and by their 'doubles', which reveal their underlying nature;[9] Fox appears as 'The Patron of Liberty' but behind him is the ghastly 'Doublûre' of himself as 'The Arch-Fiend'. Another common motif in Gillray and his fellow caricaturists is the scene of worship in which the true nature of the worshipper is revealed in his prostration before a grotesque and comic idol. Fox was often enough presented as the worshipper, and on one occasion so was the great print publisher Alderman Boydell. In

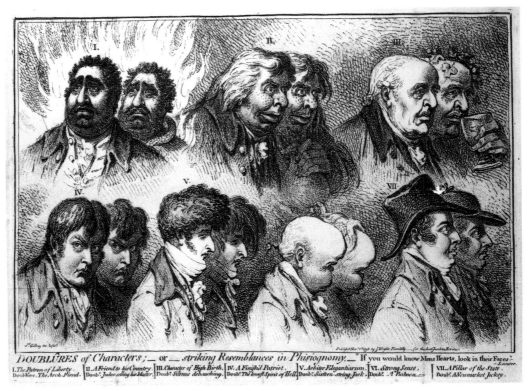

Fig. 9 James Gillray: *Doublûres of Characters*, 1798, etching and engraving. Private Collection

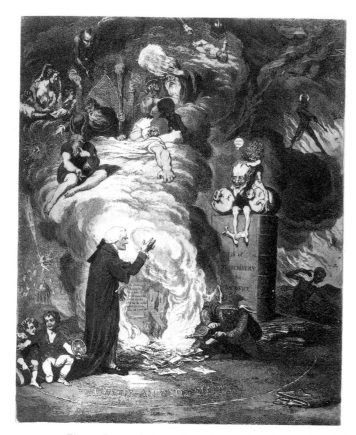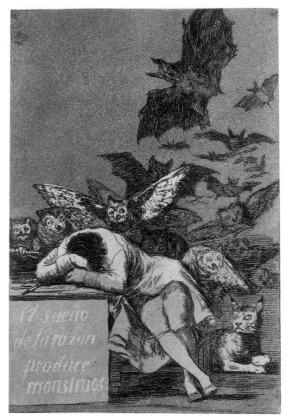

Fig. 10 James Gillray: *Shakespeare – Sacrificed; or The Offering to Avarice*, 1789, etching, aquatint and watercolour. British Museum, London.

Fig. 11 Francisco Goya: *El sueño de la razon produce monstruos*, plate 43 of *Los Caprichos*, 1799, etching and aquatint. British Museum, London

Shakespeare – Sacrificed (Fig. 10), of 1789, Boydell's scheme to employ painters of high reputation to paint Shakespearean subjects to be engraved in an elaborate edition is travestied by showing him sacrificing the plays of Shakespeare before an altar, upon which sits a gnome in the manner of Fuseli holding bags of money denoting Avarice.

Such satirical procedures may well have left a direct mark on Blake's work, particularly in the Prophetic Books of the 1790s which are essentially an exploration of the Fallen world. Blake rarely makes a clear allusion to a real person, but there is a strong caricatural element in, for example, the frontispiece to *The Song of Los* (No. 46a). This shows a high priest making obeisance to a murky sun that stands for Nature, which is 'indefinite' and therefore lacks the clarity of Vision. In plate 10 of *Europe (Fig. 12)* the grotesque figure of a bat-winged pope, accompanied by two angels with sceptres, makes clear the hidden truth that behind the gorgeous vestments of the Catholic – and Established – Church lie cynicism and lust for power; institutional religion helps to pervert men's minds to accept war and domination. The most striking contribution of satirical method in Blake's art lies in the depiction of Urizen himself, whose true nature is revealed behind the benevolent Renaissance image of God the Father created by Michelangelo and Raphael. In the titlepage to *The Book of Urizen* (No. 45; *Pl. III* and *Fig. 4*) he appears as an essentially ridiculous figure, squatting awkwardly over a murky book, his beard overflowing on either side: a bewildered and legalistic tyrant rather than the benign Creator of all things.

Fig. 12 Blake: plate 10 of *Europe*, 1794, relief etching, colour-printed, with wash and watercolour. Mr and Mrs Paul Mellon, Upperville, Va. (See catalogue No. 44)

Fig. 13 Francisco Goya: *Devota profesion*, plate 70 of *Los Caprichos*, 1799, etching. British Museum, London

It has been observed that in general the satirical prints of the 1790s foreshadow the most imaginative imagery of the Romantic painters in their frequent use of grotesque fantasy.[10] The idea that satire required an imagination capable of going beyond empirical observation was expressed in the 1799 advertisement for his *Caprichos* by Francisco Goya (1746–1828): the artist 'has to put before the viewer forms and poses which hitherto have existed only in the darkness and confusion of an irrational mind or one beset with uncontrolled passions'.[11] Only grotesquery, therefore, can do justice to 'the follies and blunders to be found in any civilized society'. While Goya attacked the follies of his age in the name of Reason and Blake saw them as a consequence of its triumph, the essential universality of the two artists on occasions draws them together, though there is little possibility that they could have seen each other's work. The plate in *Europe* of the bat-winged pope (*Fig. 12*) is akin to *Devota profesion* in the *Caprichos* series (*Fig. 13*), which is a satire on the clergy and their encouragement of popular superstition. Both Goya and Blake are opposed to the superstition and mystery which can surround established religion; these are represented in monstrous guise in Blake's Colour Print of *Hecate* (No. 55) and in the famous plate 43 of the *Caprichos* (*Fig. 11*), where phantoms are released by the mind bereft of reason. A comparison could also be made between the immense and grotesque figure of an ecclesiastic writing in a book in plate 71 of Goya's *Desastres de la Guerra*, entitled *Contra el bien general*, and the merciless presence of Blake's Urizen presiding over the horrors of the Fallen world. One might even go so far as to compare

the horrific sequence of images of the Fallen world in *Europe* with the *Desastres* as a whole, for they both present a vision of human life as a Dantesque gallery of misery and degradation;[12] but where Blake sees man's captivity ending in Apocalypse, Goya looks forward to the eventual triumph of constitutionalism and Truth.

The imaginative freedom in Blake's Prophecies of the 1790s also parallels the growing desire, even in Royal Academy circles, for a more imaginative art than Joshua Reynolds as President was prepared to encourage. The key figure was Henry Fuseli, who was elected a full member of the Royal Academy in 1790 and in 1799 Professor of Painting. Blake knew him well, and was certainly influenced by the expressive extremism of his art, though he chose to ignore Fuseli's denial of the moral value of art. Fuseli's view of Blake was characteristically double-edged, but he was prepared to allow that he possessed 'fancy' if not 'imagination' in the full sense, and to support Blake's efforts to get his designs published.[13] To some contemporaries Blake seemed to have been led away from the study of nature by Fuseli, and John Hoppner, the portrait painter, who complained of the absurdity of Blake's imagination, was just as uneasy about Fuseli and Flaxman. Thus Blake could feel himself in the 1790s to be in mortal danger through the radical sentiments expressed in his Prophecies, and yet remain hopeful of attracting a public for his designs by the agency of such publishers as Richard Edwards, who commissioned him to illustrate a magnificent edition of Young's *Night Thoughts* (No. 62) for an audience that would not have been sympathetic to his millenarianism.

Blake occasionally adopted a satiric mode in his later work, most notably in plate 51 of *Jerusalem* (No. 99k), but it appears less often after 1800. The turning point came with the commission he received in 1799 from Thomas Butts (d. 1845) for a series of approximately fifty tempera paintings to form a Biblical cycle covering the Old and New Testaments. This commission came at a significant time: there were many examples of Biblical paintings of the highest quality to be seen in London from disbanded French collections, and Blake's friend Flaxman was in the process of creating a new type of small monument notable for its medieval sense of piety and simplicity.[14] Such examples led him to evolve a more reflective manner in which naturalistic conventions gradually give way to the hieratic and devotional. Blake characteristically claimed that this transformation, the result of years of experiment and observation, had come as a moment of revelation after his visit to the Truchsessian Gallery in 1804 (see No. 68). It was associated in his mind with a return to the confident days of his youth and his immersion in Gothic sculpture as an apprentice. The most extreme example of his new devotional manner is the watercolour of *Christ in the Sepulchre, guarded by Angels* (No. 95), painted about 1803–05, which is notable for its symmetry of composition and solemnity of feeling. Even so its Gothicism is of an early 19th-century kind and the draperies still fall in folds and cling to the body in an essentially classical way.

This compromise between Gothic and classical modes recalls some of the early work of German Nazarenes like Friedrich Overbeck and Franz Pforr who, in the same and the following decade, were seeking to create a devotional style based on the supposed polarities of Raphael and Dürer (*Fig. 14*).[15] It is striking that like Blake they proclaimed the value of art as a form of prayer, and looked for new artistic forms in medieval art – of which they saw the High Renaissance as the heir. There is no likelihood that Blake and the Nazarenes knew each other's work, but there is a common source in Flaxman, whose line-engraved illustrations to Homer

Fig. 14 Friedrich Overbeck:
The Death of St Joseph, 1833,
oil on canvas. Öffentliche
Kunstsammlung, Basel

and Dante were well known in all European countries by the end of the first decade
of the 19th century. For Blake, however, an 'Early Christian style' did not imply a
rejection of Greek art, and in letters around 1800 he fervently claimed that 'the
purpose for which alone I live . . . is . . . to renew the lost Art of the Greeks'.[16] Only
at the end of the decade are the Greek muses reduced to 'daughters of memory', and
even then, as we have seen, Blake can still accept classical sculpture as reflecting
distantly the inspired art of the primeval age.

Blake's continuing loyalty to classical antiquity and his equivocal view of nature
tend to set him apart from those artists of comparable visionary ambitions who came
to maturity after 1800, and he himself showed signs of alarm that the pantheism of
poets like Wordsworth might lead them back to Natural Religion.[17] Younger artists
like Philipp Otto Runge (1777–1810) and later Samuel Palmer (1805–81) felt no
inhibition to their love of nature, and sought to be both Christian artists and land-
scape painters. Perhaps only Caspar David Friedrich (1774–1840) shares to a degree
Blake's sense of Original Sin, particularly in his paintings of winter scenes, which
convey the contrast between the bleakness of earthly existence and the radiant hope
of Redemption. Friedrich almost always expresses this in terms of landscape, but one
notable exception, which brings him closer to Blake, is *A Vision of the Christian Church*,
of 1812 (Schäfer Collection, Schweinfurt),[18] in which two pagans, perhaps Druidic,
look up in astonishment at the vision of a cathedral which symbolizes the advent of
Christianity and their own destruction.

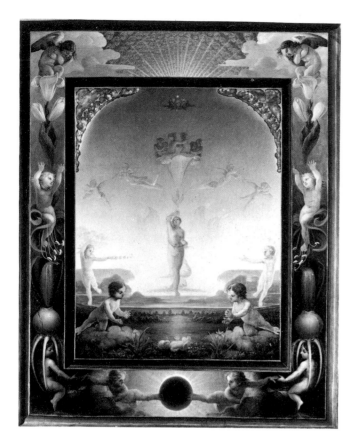

Fig. 15 Philipp Otto Runge:
Morning I, oil on canvas.
Kunsthalle, Hamburg

Though Runge professed to be a landscape painter his work is still largely conceived in terms of the human figure. Like Blake his early training had been classical, at the Copenhagen Academy, and also like Blake he conceived an enthusiasm for Böhme (see No. 4), which played a major part in forming his spiritual aspirations.[19] Runge's engravings of *The Four Times of Day* (1803) and his later painted versions of *Morning* (*Fig. 15*) were conceived as part of an immense scheme to create a universal religion through the fusion of all mythologies. The four paintings to be developed from the engravings were intended to be enlarged to an enormous size as part of a chapel of 'the Living Spirit' in which choral music would accompany their contemplation.[20] His aim was a *Gesamtkunstwerk* which would transcend the separate arts, and although it could never have been realized it was conceived in more worldly terms than Blake's union of the arts which could only exist in the realm of the Spirit. Despite the breadth of visionary feeling which draws the two artists together there are profound differences in their conceptions of nature. For Runge the Creation was the 'Anfang aller Dinge', the beginning of all things, and not, as it was for Blake, an aspect of the Fall of man which alienated him from eternity.[21] Runge's world is illuminated by a benevolent Creator whose works may show the path to Redemption. Yet in practice his designs can be remarkably close in spirit to Blake, whose positive response to nature often belied his theoretical mistrust of it. Blake's watercolour of *The Repose of the Holy Family in Egypt* (No. 79) is notable for its lyrical and tender atmosphere – but a reading of Blake makes it clear that the landscape could not be benign, for it is the materialistic realm of 'those Fiends, the Egyptian Gods'. In Runge's marvellous oil painting of the same subject (*Fig. 16*), on the other hand, the

natural forms inhabited by angels, who reflect the Christ Child's exultation in the dawning day, are treated unaffectedly as part of the mystic realm of Paradise.[22]

A more scientific vision lies behind the theories of the strange Dutch artist Pierre David Humbert de Superville (1770–1869), whose ideas and personality also bear some comparison with Blake (*Fig. 17*). His studies in early Italian art and his academic position at the University of Leiden concealed a revolutionary past and a belief in the literal truth of Genesis.[23] His quest for an archetypal language of art led him to seek the earliest of man's artefacts, which he believed were to be found in the sculptures of Easter Island. He claimed that they were derived from Atlantis, and reflected in their scale the giants who ruled the earth between the age of Adam and the Flood, the central event in man's history. Despite his placing of theological above literal truth, for Humbert 'the psychic history of man is rooted in the physiognomy of the earth',[24] and this marks him as of a later generation than Blake.

Other artists, and groups like Les Méditateurs[25] in France, shared Blake's spiritual concerns, but the apocalyptic element in Blake's thought is more often to be found in England. English artists of the generation following Blake tended to express millenarian attitudes through landscape – or rather cityscape, in the case of John Martin (1789–1854). In Blake's *Last Judgment* (see No. 98) Jerusalem is depicted as a woman and Babylon as a 'King crowned, Grasping his Sword & his Sceptre';[26] in allegorical terms Jerusalem is also the Redeemed city of London, which in the Fallen world is Babylon. For millenarians growing up at the beginning of the 19th century, who saw the growing urbanization of London, the notion of rebuilding it as the Holy City tended to be taken more literally, and there is a clear

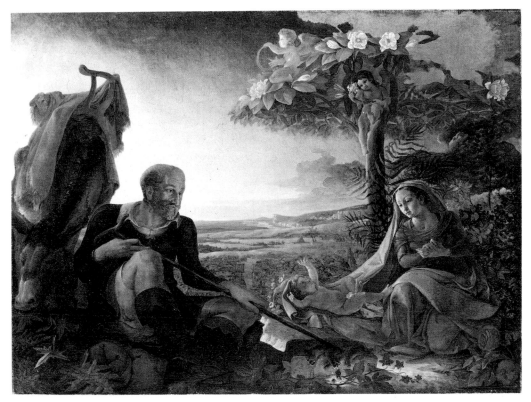

Fig. 16 Philipp Otto Runge: *The Rest on the Flight into Egypt*, oil on canvas. Kunsthalle, Hamburg

Fig. 17 Pierre David Humbert de
Superville: *The Giving of the Laws to Moses*,
drawing. Printroom of the University,
Leiden

Fig. 18 John Martin: *The Last Judgment*,
1853, oil on canvas. The Tate Gallery,
London

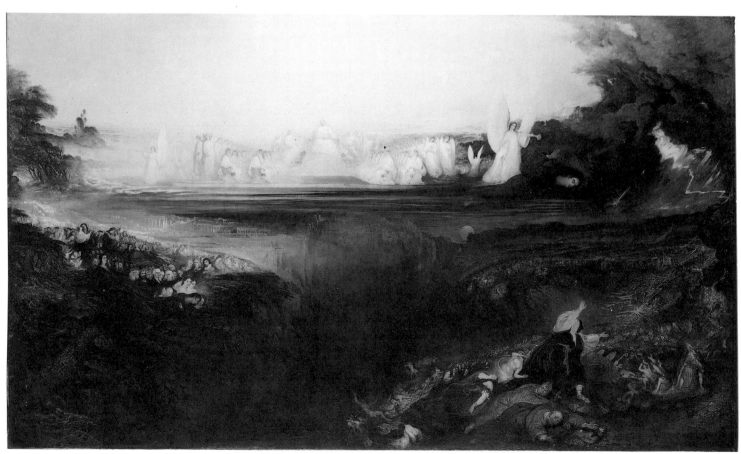

connection between John Martin's ambitious schemes for the metropolitan improvement of London and the apocalyptic imagery of his paintings of Biblical cities in the process of destruction.[27] For Martin, in his three large paintings of the End of the World (Tate Gallery, London), painted late in his life, apocalypse is a geological cataclysm. In *The Last Judgment* (*Fig. 18*) the earth opens up to swallow humanity and all its works (including two trains falling into the abyss), while the Whore of Babylon flees in vain. The theme is one that might have appealed to Blake, but the way of expressing it belongs to a completely different artistic context.

4 *The Language of Prophetic Art*

I intreat, then, that the Spectator will attend to the Hands & Feet, to the
Lineaments of the Countenances; they are all descriptive of Character, & not a line
is drawn without intention, & that the most discriminate & particular.

A Vision of the Last Judgment, K.611

From History Painting to Prophecy

Blake, like other artists, began from a basis in current practice, and the development of his art involved the reinforcement of some received conventions and the rejection of others. To an unusual degree he kept his earliest work in mind throughout his life, using it as a touchstone for his mature achievement. His starting point as an independent artist was the practice of the painters of History at the Royal Academy, like James Barry (1741–1806) and Benjamin West (1738–1820), and a work like *The Witch of Endor raising the Spirit of Samuel* (No. 11), dated 1783, has little to distinguish it from other Biblical paintings exhibited at the Academy in the 1780s except that it is in watercolour and not in oil.

The subject was fashionable with History painters at the time (see No. 22), under the influence of Burke's theory of the Sublime. The spirit of Samuel, conjured up by the Witch of Endor, prophesies the defeat of Saul. In his watercolour Blake depicts the sequence of actions simultaneously: the Witch calls up the vision, the attendants react to it with astonishment, Saul falls upon his knees, and Samuel delivers his gloomy prophecy. This method of telling a story derives from conventions established by Raphael in the Vatican Logge and used by History painters in Blake's day, and the facial expressions are governed by standard manuals like Charles Le Brun's treatise on physiognomy often published in England as *Heads representing the various Passions of the Soul*. The bystander at the far left, for example, with his mouth open, expresses emotions which appear to fall between Le Brun's categories of Horror and Attention. The abjectness of Saul's feelings, on the other hand, is expressed not by his physiognomy but by his whole body, which sinks to the earth, his head almost touching the ground. The setting contributes relatively little to the atmosphere, which is notably less eerie than in West's version of the subject (No. 22), where Samuel is more ghostly in his insubstantiality. The figures in Blake's watercolours are strongly linear, and the colour is kept within the contours, except in the background here where it is modulated to give emphasis to the ghost.

A later version of the same subject, made for Thomas Butts after 1800 (No. 77), shows the elements integrated into a scene of powerful and instantaneous drama, the sense of horror intensified by the central position of the spirit of Samuel and the extreme reactions of the participants. Gesture is unrestrained, and the light, seeming to emanate from the ghost itself, suggests a sudden advent from another world. A comparison with the earlier version of the subject shows Blake's mature mastery but also his continued dependence on the expressive use of physiognomy and gesture.

Despite the general restraint of Blake's figures in the 1780s he is still working to a principle of variety rather than simplicity. Even in the tiny and ineptly drawn early watercolour, The Keys of Calais (No. 9), each group is differentiated from the other, and there are significant contrasts between the united group of burghers on the left and the astonished courtly bystanders on the right. By drawing together such disparate elements into a whole, Blake was following a method associated in his time with Raphael, in whose work Thomas Stothard noted 'The graceful union that pervades the whole, whilst every part is varied according to the character, or circumstances that mark every individual scene'.[1]

In his mature art, on the other hand, Blake achieved a greater directness of expression usually by eliminating bystanders and background figures except where specifically called for by the subject. In doing so, however, he tends to bring to the fore the strong facial expressions normally associated in History paintings with bystanders rather than the main actors in a scene. In his early works it is the bystanders who usually exhibit Horror, Terror, Ecstasy and Wonder, categories derived from Le Brun, but in the most powerful images of the Prophetic Books of the 1790s the main actors show such emotions towards things the spectator cannot see. In plate 7 of Europe (No. 44) an old man wards off some fearful sight outside the image; in plate 8 of The Book of Urizen (Pl. IV), we cannot see the object of Los's horror-stricken gaze but we know from the text that it is the unformed Urizen. The powerful image of Plague in plate 11 of Europe (No. 44) is essentially a distillation to three figures of the early composition of The Great Plague of London (No. 12), with the bellringer brought from the background to play a prophetic role, his words now written on the wall behind him: 'Lord have Mercy on Us.'

Blake's work in the 1790s tends to exploit more fully the expressive possibilities of the human body through physiognomy and bodily gestures. Blake still had recourse, probably unconsciously, to Le Brun's categories of facial expression, and in The Book of Urizen on occasions appears to follow them quite closely. Los's reaction to the unformed Urizen in plate 8 corresponds partially to Le Brun's illustration and description of 'Terrour or Fright' (Fig. 19):

> The violence of this Passion alters all the parts of the face; the eye-brow rises in the middle; . . . the eyes are very open; . . . the eye-ball fixed toward the lower part of the eye; . . . the mouth is very open, & its corners very apparent; . . . the hair stands on end . . . to conclude all ought to be strongly marked.

It is perhaps more surprising that Blake should also appear still to have Le Brun in mind when depicting Albion's sublime rapture before the crucified Christ in plate 76 of Jerusalem (No. 99n, Pl. XV): in the state of Rapture

> the head inclines to the left side; the eye-balls and eye-brows rise directly up; the mouth half opens, and the two corners are also a little turned up. The other parts remain in their natural state.

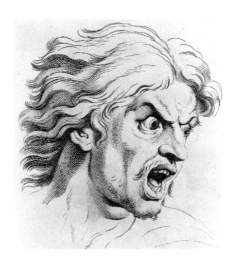

Fig. 19 After Charles Le Brun: *Terrour or Fright*, plate 18 of *Heads representing the various Passions of the Soul*, n.d., engraving. British Museum, London

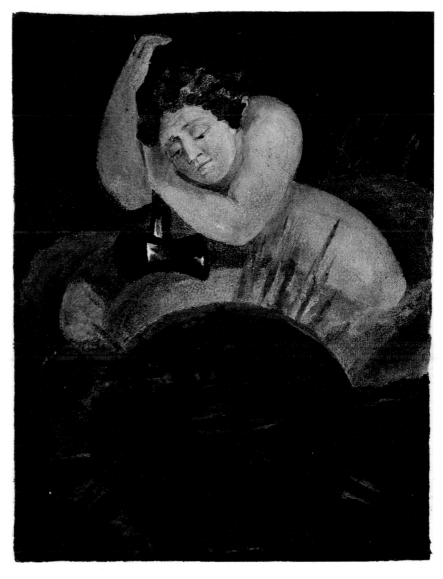

Fig. 20 Blake: plate 8 of *The Song of Los*, 1795, relief etching, colour-printed, with pen and watercolour. The Pierpont Morgan Library, New York

One needs to exercise a certain caution, for Blake's notation is rarely detailed enough to allow for fine distinctions; besides, as was realized in the 18th century, many expressions involved mixed or complex emotions. But in certain cases a knowledge of Le Brun can bring an unexpected precision to an interpretation, especially in the more Sublime images of the Prophetic Books and the Colour Prints of the 1790s. In the final plate of *The Song of Los* (Fig. 20), where Los rests his hammer after forging the sun, it has been suggested that his expression is one of 'anxious compassion',[2] but the emphatic eyebrows and down-drawn eyelids and corners of the mouth suggest rather Le Brun's characterization of Sadness. The face of Elohim in *Elohim creating Adam* (Tate Gallery, London) seems on the other hand to reflect conflicting emotions: the steady gaze and calmly open eyes Compassion, and the knitted brows Hatred or Jealousy.

One of Blake's greatest achievements was to have developed a coherent vocabulary of bodily gesture to express emotions of despair and religious ecstasy.[3] This vocabulary presupposes the complete malleability of the human body; despair is expressed as the closing-in of the body and a downward direction to the gaze, often bringing

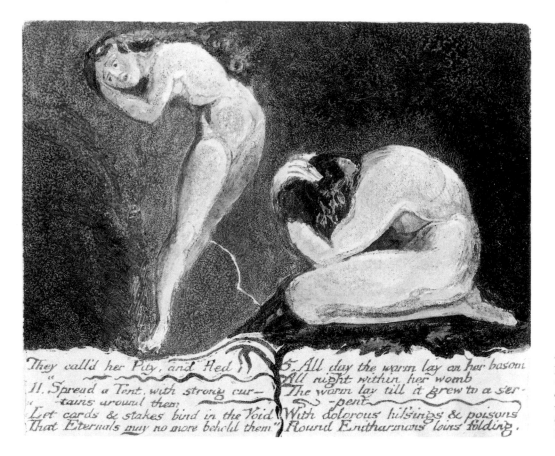

They call'd her Pity, and fled

"11. Spread a Tent, with strong cur-
" -tains around them
"Let cards & stakes bind in the Void
"That Eternals may no more behold them"

5 All day the worm lay on her bosom
All night within her womb
The worm lay till it grew to a ser-
 -pent
With dolorous hissings & poisons
Round Enitharmons loins folding.

Fig. 21 Blake: detail of plate 18 of *The Book of Urizen*, 1794, relief etching, colour-printed, with watercolour. Yale Center for British Art, Paul Mellon Collection

the head below the level of the shoulders. In the Colour Print of *Newton* (*Pl. VI*) the scientist's posture represents the despair of a man whose perceptions of the world are limited by his senses. A more extreme case is the figure of Theotormon in the frontispiece to *Visions of the Daughters of Albion* (No. 42): he is closed up almost into a ball, his face hidden in his arms. An immediate precedent for such imagery can be found in the work of Fuseli, but the real archetype for such metaphysical despair is the late Michelangelo of the *Last Judgment*, and to a lesser degree the buried face of Adam in Raphael's *Expulsion* in the Vatican Logge. The highest form of ecstasy is expressed by the arms extended fully with the palms open, accompanied by a strong upward movement of the whole body. The source can be divined from *Jerusalem*, plate 76, for Albion's arms mirror those of Christ crucified upon the tree: his affirmation is a recognition of the meaning of Christ's sacrifice. This gesture, which is meant to be one of prayer, is also in *The Dance of Albion* (No. 49) associated with Christ's sacrifice, for in Albion's awakening, 'Giving himself for the Nations he danc'd the dance of Eternal Death'. The cruciform gesture is also adopted by the malevolent Hand, a son of Albion, in *Jerusalem*, plate 26 (No. 99f), but his usurpation of the role of Christ is made evident by other signs – the serpent enfolding his arms, his expression and the flames which surround him. Furthermore small changes can alter the meaning entirely: if the palms are turned down it can then signify arbitrary power. Blake's gestures, however, should not be seen as part of a rigid code. A knowledge of the context is required, and we need also to see gestures as antitypes of others: a gesture of affirmation may be contrasted not only with despair but with conventional prayer, where the hands are pressed together in supplication.

Such bodily language can work in a less specific symbolic way. In plate 18 of *The Book of Urizen* (*Fig. 21*) Enitharmon's simultaneous feelings of repulsion and attraction towards Los are expressed by the emphatic forward movement of her legs and the contrary movement of her torso, and elongation of the body is frequently used to suggest speed and urgency. The titlepage of Night III of the *Night Thoughts* (No. 62) shows Narcissa rushing towards the light, but her ardour for Redemption is thwarted at the moment of triumph; thus her legs are extremely elongated while her torso is contracted as if it had met an immovable force.

The process of relief etching which Blake developed from 1788 onwards contributed to the dramatic effect of the Illuminated Books of the 1790s, but also imposed restraints. In that technique the design is printed from the surface of the copper, white areas being etched away: this makes it difficult to achieve very fine lines in printing, because the acid in producing the line on the plate slightly erodes its edges (see Nos. 33, 34). Blake accordingly tended to work with broad contrasts of tone and relatively large areas of white. The problem from the beginning was legibility; and the need for careful etching and printing, and often for additional work on the actual print, prevented the process from becoming commercially viable. Though Blake in the *Descriptive Catalogue* of 1809 insisted on the necessity for a 'hard wiry line', there is no reason to suppose that in the previous decade he felt the 'Indefiniteness' of relief etching to be a matter for regret. On the contrary the suggestive possibilities of the medium were admirably suited to the depiction of war and terror. In the frontispiece to *America* (No. 43) the dense working of the surface in relief etching and white-line engraving creates a mood of desolation and defeat, in which broken weapons can be dimly made out through the deliberate roughness of the surface printing. An apt comparison can be made here with Goya's evocative use of aquatint in *Los Caprichos*.

Colour printing further extended the expressive range of the Prophetic Books. Significantly some may have been conceived from the start with colour printing in mind, while others were not.[4] All but a few copies of *America* (No. 43) are printed in monochrome, usually in black with additions in grey wash; the contrast of light and dark is presumably intended to reflect the fitful emergence of a New Order from the gloom of the Old. *Europe* (No. 44), on the other hand, is usually colour-printed, and the dense grainy surface evokes the misery of the state of Europe before the French Revolution. Colour printing comes most fully into its own, however, with those Prophecies which relate the emergence of the material world from primeval chaos. All copies but one late printing of *The Book of Urizen* (No. 45) and all known copies of *The Song of Los* (No. 46) are colour-printed over relief etching. The unique copies of *The Book of Ahania* (No. 47) and *The Book of Los* are colour-printed in conjunction with intaglio etching. Here colour printing unforgettably suggests a sense of chaotic immensity and primeval horror, and these images represent a complete expression of Burke's theory of the Sublime. Some densely colour-printed designs were taken from the Illuminated Books and gathered together in the *Small* and *Large Book of Designs* (Nos. 48–50), and nothing in Blake's art is more astonishing than the infinite scale suggested by these tiny images (*Pl. V*). The depth and richness is also remarkable on a larger surface in the great Colour Prints of *c.* 1795 (Nos. 51–56, *Pls. VI, VII*), yet Blake is only known to have taken up the process of colour printing on one occasion after the 1790s (see No. 56b).

In the years after 1800 Blake looked back on the period from his first attempts in the mid-1780s to be an independent artist until the beginning of the new century as one of mental captivity, and he frequently claimed that as a consequence of his three years in Felpham he had regained the true road of art he had known in his youth: in January 1802 he wrote to Thomas Butts,

> One thing of real consequence I have accomplish'd by coming into the country, which is to me consolation enough: namely, I have recollected all my scatter'd thoughts on Art & resumed my primitive & original ways of Execution in both painting & engraving, which in the confusion of London I had very much lost & obliterated from my mind.[5]

He claimed also that he had finally liberated himself from the 'spirit of Titian' and from that 'most outrageous demon' Rubens, who had led him to destroy 'the original conception [which] was all fire and animation', and settle for a 'hellish brownness'.[6] Though he is here referring to a version of *Satan calling up his Legions* (Victoria and Albert Museum, London), these remarks can be taken as a reflection on his technique of the previous decade.

The shift towards an 'Early Christian' style in the Biblical paintings for Butts, as we have seen, led Blake to rely more on compositional symmetry and the representation of light. In the tempera painting of *The Last Supper* (*Fig. 22*), for example, Christ occupies the central axis of the composition, his centrality emphasized by the way in which the apostles group symmetrically around him. The effect is one of extreme formality (probably reflecting the influence of Poussin), and a sense of spiritual moment is affirmed by the radiance which emanates from Christ. This formality can also be seen in the watercolour of *St Paul preaching at Athens* of 1803 (No. 75), in which Paul faces the viewer directly, the perfect symmetry of his body broken only by an assertive left foot. His head and body are the source of divine light, and the audience is reduced to representatives of the generations of man – the young and old responding directly, those in mid-life equivocally. In the *Mary Magdalen at the Sepulchre* (No. 76) the angels act as supporters for the composition, and Christ is framed by a simple Romanesque-type arch, his light illuminating the Magdalen's face with great delicacy and fading to a glimmer in the darkness. In such works we can see the benefit of Blake's two years of 'intense study of those parts of the art which relate to light & shade & colour'.[7]

The task set for him by Butts, after he had completed the tempera series from the Bible in 1800, to make watercolour illustrations probably for a massive extra-illustrated Bible, encouraged him to a high degree of adventurousness in his methods of composition. The Book of Revelation, for instance, presented the problem of the cosmic scale of the events described; in Blake's watercolours the immense forms of the Angels and the Beasts of Revelation and the Whore of Babylon can become vengeful idols exacting submission from the massed ranks of humanity beneath (Nos. 80–83). In the *Vision of Ezekiel* (No. 78) Blake, unusually for a post-medieval artist, depicts the vision described in the Bible in all its complexity: the prophet is a tiny figure gazing in awe at the fourfold man in the whirlwind, the four living creatures and the rings of eyes.

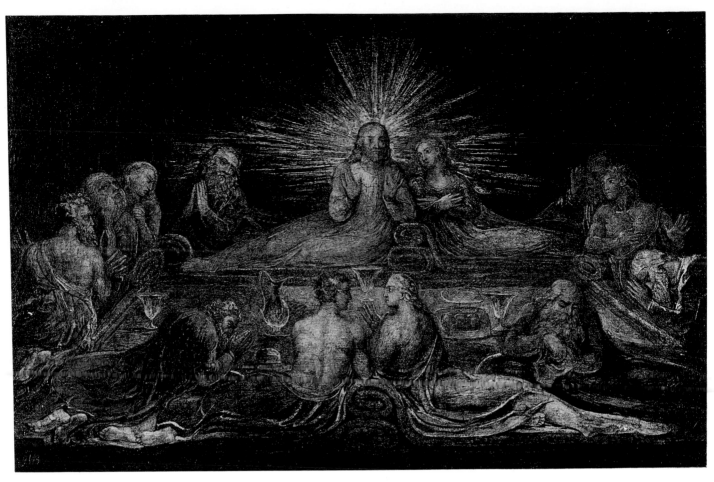

Fig. 22 Blake: *The Last Supper*, 1799, tempera. National Gallery of Art, Washington

In the *Descriptive Catalogue* of 1809, Blake's fullest discussion of his own art, he insists upon the absolute value of outline in depicting vision with complete clarity, and avoiding the indefinite: 'A Spirit and a Vision are not, as the modern philosopher supposes, a cloudy vapour, or a nothing: they are organised and minutely articulated beyond all that the mortal and perishing nature can produce.'[8] Colour is to be subordinated and the 'great and heavy shadows' of the Moderns are to be avoided. A renewed concern with outline had been evident in his work since the *Night Thoughts* watercolours of 1795–97 and the Butts temperas; the *Paradise Lost* watercolours of 1808 (No. 91 and *Fig. 23*), however, take the process a stage further, for their precision of contour and monumental form seem to refer back to the Neoclassical ideals of the 1780s. This severity and nostalgia for an earlier phase in his art are reflected in the *Canterbury Pilgrims* engraving (No. 97c), which, he claimed in the *Public Address*, followed the engraving technique of his master Basire;[9] it is also a large scale print of the Historical kind which had tended to go out of fashion after 1800. Some watercolours from the 1808 *Paradise Lost* series, like *The Creation of Eve* (*Fig. 23*), are models of solemnity and lucid simplicity, but others in the series show an almost Gothic richness and elaboration in the vegetation of the Garden of Eden.

The monumental forms of the 1808 *Paradise Lost* watercolours may be partly a response to the epic nature of Milton's poem, for the illustrations to *L'Allegro* and *Il Penseroso* (No. 93) of the next decade show a great sensitivity to the pastoral genre

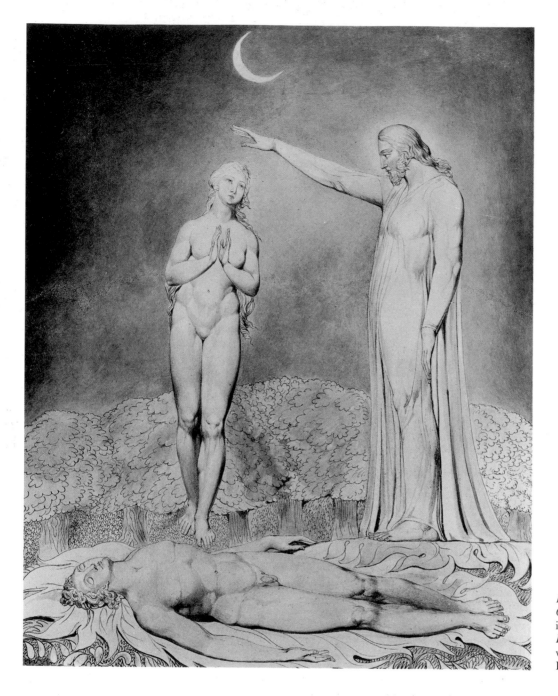

Fig. 23 Blake: *The Creation of Eve,* illustration to Milton's *Paradise Lost,* 1808, watercolour. Museum of Fine Arts, Boston

of the two poems. By contrast with the *Paradise Lost* series the lyrical mood is engendered by a richness of treatment which gives full value to Milton's metaphors. In *The Spirit of Plato* (No. 93e) Milton reflects upon Plato in his study while the Platonic theory of the elements is enacted in tiny scenes which surround him. In the most lyrical of the series, *The Youthful Poet's Dream* (*Pl. XI*), the profusion of Miltonic imagery is made to reflect Blake's own view on youthful inspiration by contrasting 'the more bright Sun of Imagination' with the empirical sun, placing 'Hymen at a Marriage & the Antique Pageantry attending it'[10] within the former, so that, supported by Ben Jonson and Shakespeare, it represents the innocence of the young poet's imagination.

The *L'Allegro* and *Il Penseroso* watercolours represent an inspired renewal of the pastoral style of the *Songs of Innocence*, which Blake might have looked back on as products of his own youth before he embarked on the ocean of business. The exquisite sensitivity to landscape suggests such a strong response to nature that the prominence of Vala as a temptress in *Jerusalem* may have reflected his own fear of being seduced by it. Vala, from *The Four Zoas* onwards (she does not yet appear in the Prophecies of the 1790s), is associated with the state of Beulah, the earthly paradise which is a place of rest from the true Eden, which requires perpetual mental struggle. Beulah, like Tennyson's Lotos-land, tempts man to linger and avoid the difficulties of the quest for Jerusalem. In Blake's later years his work reveals a growing sensuousness; from the time of his meeting with John Linnell (1792–1882) in 1818 he was continually in the company of landscape painters, who may have cultivated his love of nature while he encouraged their visionary leanings.

A delight in nature and in the sensual effects of printing and watercolour can also be observed in the final Prophecies, *Milton a Poem* (No. 90) and *Jerusalem* (No. 99). He probably did not begin to etch the former until as late as 1807–09 and did not complete *Jerusalem* until after 1820. In the 1790s Blake had used white-line engraving to increase the richness of texture, but in *Milton* and *Jerusalem* it is used extensively to achieve precision of line and subtle effects of light. In the frontispiece to *Jerusalem* in uncoloured copies (*Fig. 25*) the forms emerge from the darkness as in a mezzotint, the range of tone extending from pitch blackness to the radiance of the lamp in Los's hand. Equally mysterious and beautiful is the effect of white-line engraving in plate 33 of *Jerusalem* (*Fig. 24*), where Christ, as he raises up Albion, gently illuminates the trees behind. The effect is comparable to that in the wood engravings for Thornton's *Virgil* of 1821 (No. 106a), where Samuel Palmer observed 'such a mystic and dreamy

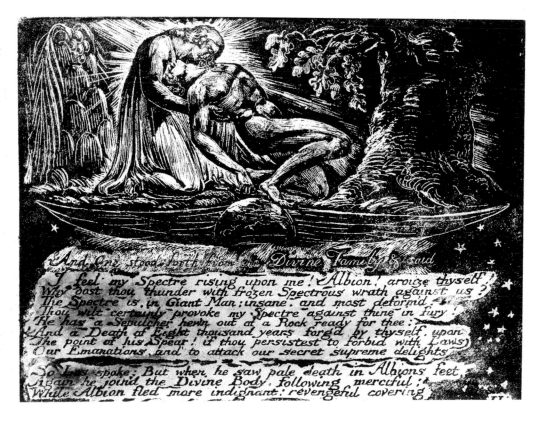

Fig. 24 Blake: detail of proof of plate 33 of *Jerusalem*, relief etching and white-line engraving. Private Collection

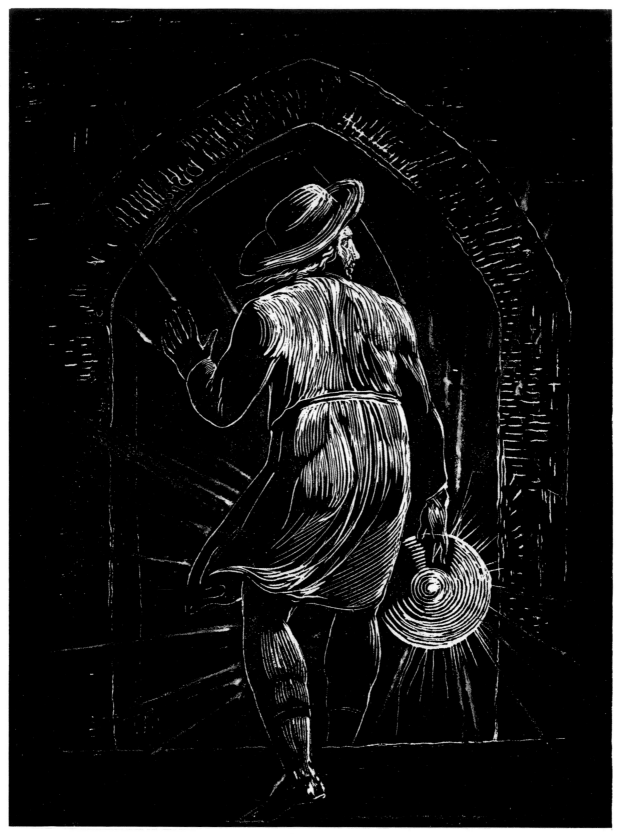

Fig. 25 Blake: *Los entering the grave*, frontispiece to an uncoloured copy of *Jerusalem*, relief etching and white-line engraving, with additions in wash and white paint. The Pierpont Morgan Library, New York

glimmer as penetrates and kindles the inmost soul'.[11] Not all the plates in the un-coloured copies of *Jerusalem* were printed carefully, however; many of them, particularly towards the conclusion of the book, were printed a little messily, endowing the final vision with an even greater sense of urgency.

Like *America*, *Jerusalem* was normally printed in monochrome; only one copy was coloured in full, the spectacular version in the collection of Mr and Mrs Paul Mellon (No. 99). Blake worked on it in the last years of his life, and wrote a few months before he died: 'it is not likely that I shall get a Customer for it'.[12] The text and design, with one exception, are printed in orange, and in the frontispiece and many other plates dark tones are added in wash with the highlights picked out in gold paint, the orange printing acting as an intermediate tone (*Pls. XII–XVIII*). The sumptuousness of the book is so overwhelming that the dark side of Blake's vision is in danger of being lost. By the 1820s he would have become more familiar with medieval illuminated manuscripts[13] and they may have led him to such opulence, which is also displayed in late printings of other Illuminated Books, like the Rosenwald copy of *The Book of Urizen* (No. 45d) and the Princeton *Songs of Innocence and of Experience* (No. 39c). Blake might have wanted to bring them into harmony with the more optimistic vision of his later years.

Some late watercolours also reveal the advance in the rendering of light and atmosphere which Blake made in the last decade of his life, and a recognition of this may have led Linnell to commission one hundred watercolour designs for Dante's *Divine Comedy* (No. 116). For Linnell the challenge might have seemed to lie in the atmospheric and emotional extremes of Dante's work, but for Blake it also lay in his dislike of Dante's positive attitudes towards nature and the Catholic Church.[14] Although the watercolours were left incomplete on his death in 1827, enough were finished to reveal his imagination at the height of its powers. It seems fitting therefore to end a brief survey of his art by looking closely at one of the finest watercolours in the series, *Beatrice on the Car, Dante and Matilda* (No. 116l, *Pls. XX, XXI*).

There could hardly be two more difficult cantos to illustrate than Cantos 28 and 29 of the *Purgatorio*, for they contain some of the richest imagery in the *Divine Comedy*, when Dante, still in Purgatory, first glimpses Paradise across the river Lethe and encounters the procession escorting Beatrice on her triumphal car. Blake conflates the action of the two cantos, depicting first Dante's address to Matilda, who is picking flowers on the far bank, then her reply, and finally, after they have walked along on opposite sides of the river, the advent of the procession which Matilda has warned Dante to expect. In Blake's design we see Matilda when, at the sight of Dante, she drops the flowers she has picked from 'the tender may-bloom flush'd through many a hue, / In prodigal variety',[15] while walking through the Garden of Eden. Behind her, fully delineated but mainly still in pencil, is the procession with almost every detail as described by Dante. It appears first as a 'sudden lustre', and then reveals itself to be led by a glorious candelabrum of 'seven trees of gold', the flames of which leave a trail of the colours of the rainbow. Behind the candelabrum walk the elders in front of Beatrice's car drawn by a gryphon with wings uplifted; the car itself, in accordance with Dante's description, is enfolded by Ezekiel's vision of the whirlwind, containing the four animals (symbols of the Evangelists) with six wings, their plumage filled with eyes (see *Fig. 26*). Three nymphs dance before the car, which is followed by Luke and Peter, four other elders, and an old man who could be Moses or John the Evangelist.

Fig. 26 Blake: *Beatrice addressing Dante from the Car*, illustration to the Dante's *Divine Comedy* (*Purgatorio*, Cantos 29–30), 1824–27, watercolour, pen and pencil. The Tate Gallery, London

Such a description shows the virtuosity with which Blake keeps faithful to Dante's text. The real achievement, however, is the convincing image of Paradise expressed largely through the use of watercolour washes. The keynote is set by the spectrum radiating from the candelabrum, the colours flowing out in unmodulated washes or touches of pure colour. The tree trunks in the foreground are illuminated by the reflection of the spectral colours, while the flowers on the far bank of the Lethe are suggested by a carpet of separately applied dots. The river's cool colour separates the two banks, but they are drawn together by the trees arching over to mingle with each other from opposite sides. The sight of Paradise and Beatrice's procession is in the watercolour as it would have been to Dante, unequivocally seductive; but by considering this, and the following design of *Beatrice addressing Dante from the Car* (*Fig. 26*), in the light of Blake's ideas we can see that such seductiveness is an illusion: Beatrice is nothing more than the Goddess of Nature whose beauty deludes the Natural Man in Dante and leads him back to the Catholic Church.[16] The ravishing vision of the flowery field beyond the Lethe is not the true Eden but only 'the Flowers of Beulah' – a passive, not an active paradise.

Beatrice on the Car, Dante and Matilda thus expresses Blake's equivocation over Dante, who was undeniably a great poet yet in Blake's eyes committed to false religion. It is clear that he agonized over this problem as he worked on the illustrations; on one unfinished watercolour he wrote, 'Every thing in Dante's Comedia shews That for Tyrannical Purposes he has made This World the Foundation of All, & the Goddess Nature Memory is his Inspirer & not Imagination the Holy Ghost';[17] and there may well have been similar comments under the exquisite surface of the present watercolour. In contemplating such a work we begin by admiring its visionary beauty, and if we look up the passage in Dante we will be impressed by its subtlety and accuracy as an illustration. But with Blake we cannot stop there, for he intends us always to go further and find that our certainties have evaporated.

Notes to the Introduction

1. Ruskin's words on Cimabue and Giotto applied to Blake by his Victorian biographer Alexander Gilchrist, in *The Life of William Blake*, 1863, p. 3.
2. I am thinking here in particular of E. P. Thompson, *The Making of the English Working Class*, 1965, J. F. C. Harrison, *The Second Coming: Popular Millenarianism, 1780–1850*, 1979, and also Morton Paley, 'William Blake, The Prince of the Hebrews, and the Woman Clothed with the Sun', in M. D. Paley and M. Phillips, eds., *William Blake: Essays in honour of Sir Geoffrey Keynes*, 1973, pp. 260–93.

1 'Mr Blake the Engraver'

1. Draper Hill, *Mr. Gillray The Caricaturist*, 1965, pp. 26f.
2. *Milton a Poem*, K.480.
3. To Trusler, 23 August 1799, K.794.
4. *Library of the Fine Arts*, IV, July 1832, p. 4.
5. *Farington Diary*, 24 June 1796 (quoted in G. E. Bentley, Jr., *Blake Records*, p. 52).
6. For Sharp see J. F. C. Harrison, *op. cit.*, pp. 74–76.
7. Flaxman often dined out on the story. See *Diary, Reminiscences and Correspondence of Henry Crabb Robinson*, 2nd ed., 1869, I, pp. 53–54.
8. A millenarian, according to J. F. C. Harrison (*op. cit.*, p. 4), believes that the world is to be 'transformed by the second coming of Christ and the establishment of the kingdom of God on earth. This state would last for a thousand years, after which would come the Last Judgment. During the period of the millenium the saints would reign with Christ.'
9. To H. F. Cary, 6 February 1818 (*Blake Records, op. cit.*, p. 251).
10. K.207.
11. K.591.
12. Blake attacks Woollett for employing J. Brown as an etcher (*op. cit.*, p. 594), but Woollett was at least honest about it and added Brown's signature on some plates.
13. D. Alexander and R. T. Godfrey, *Painters and Engraving*, Yale Center for British Art, 1980, p. 46.
14. Thomas Bewick, *A Memoir*, ed. Iain Bain, 1979, p. 71.
15. To Butts, 11 September 1801, K.809.

2 The Great Task

1. For Brothers and Southcott see J. F. C. Harrison, *op. cit.*
2. *A Vision of the Last Judgment*, K.613.
3. *Jerusalem*, plate 52, K.682.
4. *Jerusalem*, plate 7, K.625.
5. Genesis 4:22.
6. *Descriptive Catalogue*, K. 565.
7. *Jerusalem*, plate 16, K.638.
8. *Descriptive Catalogue*, K.565.
9. *Descriptive Catalogue*, K.579.
10. K.154.
11. D. Bindman, *The Complete Graphic Works of William Blake*, 1978, Introduction, pp. 13–14.
12. *A Vision of the Last Judgment*, K.605.
13. Plate 98, K.746.
14. *Laocoön*, K.775–76.
15. K.776.
16. J. T. Smith (quoted in *Blake Records, op. cit.*, p. 467).
17. K.793.

3 Satire and Vision: Blake and his Contemporaries

1. D. Bindman, *Blake as an Artist*, 1977, p. 127.
2. *Ibid.*, p. 37.
3. H. Fuseli, 3rd Royal Academy lecture, 1800. Quoted and discussed in D. Bindman, 'Blake's Theory and Practice of Imitation', in R. N. Essick and D. Pearce, eds., *Blake in his Time*, 1978, p. 93.
4. See R. N. Essick, *William Blake, Printmaker*, 1980, pp. 137–40.
5. Juliet Wilson Bareau, *Goya's Prints*, British Museum, London, 1981, p. 25.
6. Draper Hill, *op. cit.*, p. 9. According to Draper Hill the Moravians 'grounded their faith on the essential depravity of man'.
7. See D. V. Erdman, *Blake: Prophet against Empire*, 1977, p. 38, *passim*, and the same author's article, 'Blake's Debt to Gillray', in *Art Quarterly XII*, 1949, pp. 165–70.
8. Draper Hill, *op. cit.*, p. 55.
9. *Ibid.*, p. 84.
10. E. Gombrich, 'Imagery and Art in the Romantic Period', in *Meditations on a Hobby Horse*, 1963, pp. 120–27.
11. *Diario de Madrid*, February 1799.
12. For the fascinating suggestion that Flaxman's illustrations to the Divine Comedy might have had a seminal influence on Goya's *Desastres* see Sarah Symmons, 'Flaxman and the Continent', in *John Flaxman*, exh. cat., Royal Academy, London, 1979, pp. 167–68.
13. *Farington Diary*, 24 June 1796 (*Blake Records, op. cit.*, p. 52).
14. See Mary Webster, 'Flaxman as sculptor', in *John Flaxman, op. cit.*, pp. 100–111.
15. For a symbolic representation of this union, see the engraving after a lost drawing by Franz Pforr of *Dürer and Raphael before the throne of Art*, reproduced in *Die Nazarener*, exh. cat., Städel Inst., Frankfurt, 1977, no. A1.

16. Letter to Trusler, 16 August 1799, K.792.
17. 'I see in Wordsworth the Natural Man rising up against the Spiritual Man Continually, & then he is No Poet but a Heathen Philosopher at Enmity against all true Poetry or Inspiration.' *Annotations to Wordsworth's Poems*, K.782.
18. Reproduced in Jens Christian Jensen, *Caspar David Friedrich*, 1981, plate 47.
19. See Jörg Traeger, *Philipp Otto Runge und sein Werk*, 1977.
20. Hanna Hohl, 'Das Universum der Zeiten', in *Runge in seiner Zeit*, exh. cat., Hamburger Kunsthalle, 1977, p. 190.
21. See D. Bindman, 'Blake and Runge', in *Runge: Fragen und Antworten*, Hamburger Kunsthalle, 1979, p. 86.
22. *Runge in seiner Zeit, op. cit.*, p. 174.
23. For Humbert de Superville see the catalogue of an exhibition of his work at the Stedelijk Museum 'Het Prinsenhof', Delft, 1975, and especially Barbara Stafford's article in the *Journal of the Warburg and Courtauld Institutes*, XXXV, 1972, pp. 308–38.
24. Stafford, *op. cit.*, p. 338.
25. See J. H. Rubin, 'New Documents on the Méditateurs', *Burlington Magazine*, CXVII, 1975, p. 785.
26. *A Vision of the Last Judgment*, K.608.
27. See W. Feaver, *The Art of John Martin*, 1975.

4 The Language of Prophetic Art

1. Mrs Bray, *Life of Thomas Stothard*, 1851, p. 112.
2. D. V. Erdman, *The Illuminated Blake*, 1974, p. 181.
3. See Janet Warner, 'Blake's Use of Gesture', in D. V. Erdman and J. E. Grant, eds., *Blake's Visionary Forms Dramatic*, 1970, pp. 174–95.
4. See *Graphic Works, op. cit.*, Introduction.
5. K.812.
6. *Descriptive Catalogue*, K.582–83.
7. Letter to Butts, 22 November 1802, K.814.
8. K.576.
9. 'In this Plate Mr B. has resumed the style with which he set out in life . . .'. K.592.
10. Descriptions of the illustrations, K.617.
11. *Blake Records, op. cit.*, pp. 271–72.
12. Letter to Cumberland, 12 April 1827, K. 878.
13. For the growing taste for medieval manuscripts in the early 19th century see A. N. L. Munby, *Connoisseurs and Medieval Miniatures, 1750–1850*, 1972.
14. A. S. Roe, *Blake's Illustrations to the Divine Comedy*, 1953, pp. 30–34.
15. From Carey's translation, the one used by Blake.
16. Roe, *op. cit.*, pp. 167–70.
17. K.785.

Chronology

1757
28 November: William Blake born at 28 Broad [Broadwick] Street, Golden Square, Soho, London.
11 December: baptised in St James's Church, Piccadilly.

1767/68
Probably enters Henry Pars's drawing school in the Strand.

1769–70
Begins as apprentice to the engraver James Basire (1730–1802), at 31 Great Queen Street, Lincoln's Inn Fields.

1773
First state of engraving after Michelangelo, *Joseph of Arimathea among the Rocks of Albion*.

1779
8 October: admitted to Royal Academy Schools as an engraver. Meets there John Flaxman (1756–1826), Thomas Stothard (1755–1834) and George Cumberland (1754–1848). Probably drops out in the first year.
Begins making a living as a commercial engraver.

1780
Exhibits at the Royal Academy *The Death of Earl Goodwin*.
First engraving for the radical publisher Joseph Johnson.

1782
2 April: Robert Blake (probably born 1767), Blake's young brother, enters the Royal Academy Schools as an engraver.
18 August: marries Catherine Butcher (or Boucher, born 25 April 1762).

1783
Publication of *Poetical Sketches*, financed by Flaxman and the Rev. and Mrs A. S. Matthew.

1784
J. T. Smith records Blake at the Matthews' house.
26 April: Flaxman sends William Hayley Blake's *Poetical Sketches*, and also claims that a Mr Hawkins 'is so convinced of his [Blake's] uncommon talents that he is now endeavouring to raise a subscription to send him to finish his studies in Rome'.
Exhibits at the Royal Academy *A Breach in a City, the Morning after a Battle* and *War unchained by an Angel, Fire Pestilence and Famine Following*.

4 July: burial of Blake's father, James.
Sets up a print shop with James Parker (1750–1805) (see No. 26).
Possibly begins manuscript of *An Island in the Moon*.

1785
May: exhibits at the Royal Academy four works – three of the *Story of Joseph* (Fitzwilliam Museum, Cambridge) and *The Bard, from Gray*.

c. **1786–89**
Tiriel manuscript and drawings.

1787–88
11 February 1787: burial of Blake's brother, Robert.
First experiments with Illuminated printing.

1789
13 April: Blake and his wife sign a declaration of belief in the doctrines of Swedenborg at first session of the New Church, but they appear not to have joined.
Songs of Innocence and *The Book of Thel*.

1790
Moves to Hercules Building, Lambeth.
Begins *The Marriage of Heaven and Hell*.

1791
The French Revolution set up in page proofs by Joseph Johnson.

1792
Death of Blake's mother, Catherine.

1793
Visions of the Daughters of Albion, *America*, and *For Children: The Gates of Paradise* (first version).

1794
Songs of Experience, *Europe* and *The (First) Book of Urizen*.

1795
The Song of Los, *The Book of Ahania* and *The Book of Los*.
Commissioned by Richard Edwards to illustrate Young's *Night Thoughts*, partly published in 1797.

1796
Publication of George Cumberland's *Thoughts on Outline*, with 8 plates engraved by Blake.
Probably begins work on manuscript of *Vala or the Four Zoas* (unfinished).

1797
Commissioned by Flaxman to illustrate Gray's *Poems* for his wife Ann (Nancy).

1799
Exhibits at the Royal Academy the tempera painting of *The Last Supper* (National Gallery of Art, Washington).

Beginning of patronage of Thomas Butts.

1800
Exhibits at the Royal Academy the tempera painting of *The Loaves and the Fishes* (Collection of Robert N. Essick).
18 September: moves to Felpham, near Chichester, to work for Hayley.

1801
Commissioned by the Rev. J. Thomas to illustrate Milton's *Comus* and Shakespeare.

1802
First series of *Ballads* by Hayley with illustrations by Blake.

1803
Publication of the first two volumes of Hayley's *Life of William Cowper*, with 4 plates engraved by Blake; also Hayley's *Triumphs of Temper*, with 6 plates engraved by Blake after Maria Flaxman.
12 August: ejects a soldier called John Scolfield from his garden; Blake later charged with sedition.
19 September: returns to London.

1804
11 January: acquitted on charge of sedition at Chichester.
Date on titlepages of *Milton a Poem* and *Jerusalem*.

1805
Reissue of Hayley's *Ballads* with illustrations by Blake.
Commissioned by Robert Hartley Cromek to illustrate Blair's *Grave*.

1806
Publication of Benjamin Heath Malkin's *A Father's Memoirs of his Child*, with biographical account of Blake (see No. 7).

1807
Portrait of Blake by Thomas Phillips (National Portrait Gallery, London) exhibited at the Royal Academy.

1808
Exhibits at the Royal Academy *Jacob's Dream* (British Museum) and *Christ in the Sepulchre, guarded by Angels*.
Publication of Blair's *Grave* with Blake's designs engraved by Luigi Schiavonetti.
Robert Hunt attacks Blake's designs in *The Examiner* for 7 August and the *Antijacobin Review* for November.

1809
May: opening of Blake's exhibition of his own work, with *Descriptive Catalogue*, at his brother's house, 28 Broad Street.
17 September: Robert Hunt attacks the exhibition in *The Examiner*.

1810
Begins work on engraving after his

painting, *Chaucer's Canterbury Pilgrims.* Stothard's rival picture of the same subject exhibited.
28 April: Henry Crabb Robinson visits Blake's exhibition.

1811
January: publication of Henry Crabb Robinson's essay, 'William Blake, Künstler, Dichter und Religiöser Schwärmer', in *Vaterländisches Museum,* Hamburg.

1812
Exhibits at the Associated Painters in Water Colour four works: *The Canterbury Pilgrims, The Spiritual Form of Pitt guiding Behemoth, The Spiritual Form of Nelson guiding Leviathan,* and *Detached Specimens of an original illuminated Poem, entitled 'Jerusalem. The Emanation of the Giant Albion'.*

1813
11 April: George Cumberland, now living in Bristol, visits Blake.

1814
3 June: Cumberland remarks on Blake, 'still poor still Dirty'.

1815
20 April: Cumberland's two sons found Blake and his wife 'drinking Tea, durtyer than ever . . .' Blake showed them 'his large drawing in Water Colors of the last Judgement; he has been labouring at it till it is nearly as black as your Hat. His time is now intirely taken up with Etching & Engraving.'
Engraved outlines of Wedgwood ware for pattern-books.

1816
Probably meets Charles Augustus Tulk, a noted Swedenborgian and friend of Flaxman and Coleridge.

1818
6 February: Coleridge, given a copy of *Songs of Innocence and of Experience* by Tulk, replies, putting the Songs in order of excellence.
John Linnell (1792–1882) introduced to Blake by Cumberland's son George.
12 September: Linnell introduces John Varley (1778–1842) and John Constable (1776–1837) to Blake.

1819
14 October: first dated 'Visionary Head' for Varley.

1821
Publication of Thornton's *Virgil* with Blake's wood engravings.
Moves to the first floor of 3 Fountain Court, off the Strand.
Sells his collection of prints to Colnaghi's about this time.

1822
28 June: the Royal Academy Council agree to pay Blake, 'an able Designer & Engraver laboring under great distress', the sum of twenty-five pounds.
The Ghost of Abel.

1823
1 August: Blake's life-mask taken by James S. Deville (Fitzwilliam Museum). Linnell formally commissions engravings after the *Book of Job.*

1824
6 March: Linnell moves to Hampstead, where Blake visits him.
May: visits the Royal Academy with Samuel Palmer (1805–81).

1825
George Richmond (1809–96) first meets Blake at C. H. Tatham's.
Blake meets other members of his late circle at this time: Edward Calvert (1799–1883), Francis Oliver Finch (1802–62), John Giles and Henry Walter.
Goes with Palmer and Calvert to Palmer's grandfather's home at Shoreham, Kent.
10 December: account by Crabb Robinson of Blake's conversation at a party at the Aders'.
Robinson makes a number of visits to Blake.

1827
2 February: Robinson takes to see Blake a young German painter, Jacob Götzenberger, who is greatly impressed.
12 August: Blake dies at 3 Fountain Court.
11 September: Catherine Blake goes to live with Linnell at Cirencester Place, as his housekeeper.

1828
March/June: Catherine Blake moves to 20 Lisson Grove as Frederick Tatham's housekeeper.

1830
Publication of Allan Cunningham's *Lives of the Most Eminent British Painters, Sculptors and Architects,* with a long section on Blake.

1831
18 October: Catherine Blake dies.

1863
Publication of the first edition of Alexander Gilchrist's *Life of William Blake, 'Pictor Ignotus'.* Gilchrist had died in 1861; Dante Gabriel Rossetti and his brother William Michael added sections and finished the book off.

Abbreviations and Bibliography

The Blake bibliography is notoriously large; an attempt to mention every reference to the works exhibited would overwhelm the catalogue completely. I have, therefore, in each catalogue entry normally given one reference, to books which themselves contain extensive bibliographies. For original paintings and drawings by Blake, for example, the reader is referred to Martin Butlin's extremely comprehensive *Paintings and Drawings of William Blake,* which contains a full bibliography and provenance for each item. I have occasionally added a more recent source, if it postdates the latest edition of the appropriate reference book.

Abbreviations used in the catalogue

Bentley, *Records*
 G. E. Bentley, Jr., *Blake Records,* 1969
Bentley, *Blake Books*
 G. E. Bentley, Jr., *Blake Books,* 1977
Bindman, *Artist*
 David Bindman, *Blake as an Artist,* 1977
Bindman, *Graphic Works*
 David Bindman, *The Complete Graphic Works of William Blake,* 1978
Blake in his Time
 Robert N. Essick and Donald Pearce, eds., *Blake in his Time,* 1978
Butlin, *Paintings*
 Martin Butlin, *The Paintings and Drawings of William Blake,* 2 vol., 1981
Easson and Essick, *Book Illustrator*
 Roger Easson and Robert N. Essick, *William Blake: Book Illustrator,* 1972
Erdman, *Prophet*
 David V. Erdman, *Blake: Prophet against Empire,* 1954, rev. 1969 and 1977; 1969 edn referred to
Erdman, *Illuminated Blake*
 David V. Erdman, *The Illuminated Blake,* 1974/75
Essays for Keynes
 M. D. Paley and M. Phillips, eds, *William Blake: Essays in Honour of Sir Geoffrey Keynes,* 1973
Essick, *Printmaker*
 Robert N. Essick, *William Blake, Printmaker,* 1980
Essick, *Separate Plates*
 Robert N. Essick, *The Separate Plates of William Blake: A Catalogue* (forthcoming)
Flaxman
 John Flaxman, exh. cat., Royal Academy, London, 1979

Fuseli Circle
 Nancy L. Pressly, *Fuseli Circle in Rome*, exh. cat., Yale Center for British Art, 1979
K.
 Geoffrey Keynes, *Complete Writings of William Blake*, 1957 and subsequent edns
Keynes and Wolf
 Geoffrey Keynes and Edwin Wolf 2nd, *William Blake's Illuminated Books: A Census*, 1953
Keynes, *Letters*
 Geoffrey Keynes, *The Letters of William Blake*, 3rd edn, 1980
Lindberg, *Job*
 Bo Lindberg, *William Blake's Illustrations to the Book of Job*, 1973
Manhattanville, 1974
 H. Stahl and B. D. Barone, *William Blake: The Apocalyptic Vision*, Manhattanville College, 1974
Romantic Art in Britain
 F. Cummings and A. Staley, *Romantic Art in Britain, 1760–1860*, exh. cat., Detroit and Philadelphia, 1968
Schiff
 G. Schiff, *Johann Heinrich Füssli, Oeuvrekatalog*, 1973

The works mentioned above all carry the study of individual works in this catalogue a stage further; other books which might be found useful are listed below. The selection is directed towards Blake's visual rather than literary achievements and is, of course, the merest fraction of what is available.

General

G. E. Bentley, Jr., ed., *William Blake's Writings*, 2 vol., 1978
Anthony Blunt, *The Art of William Blake*, 1959
S. Foster Damon, *William Blake, his Philosophy and Symbols*, 1924
– *A Blake Dictionary*, 1965 and 1973
David V. Erdman, *The Poetry and Prose of William Blake*, 1965
– and John E. Grant, eds., *Blake's Visionary Forms Dramatic*, 1970

Robert N. Essick, ed., *The Visionary Hand, Essays for the Study of William Blake's Art and Aesthetics*, 1973
Northrop Frye, *Fearful Symmetry, a Study of William Blake*, 1947
Alexander Gilchrist, *Life of William Blake*, 1863; later edns 1880, 1907, and, with notes by Ruthven Todd, 1942 and 1945
Jean Hagstrum, *William Blake, Poet and Painter*, 1964
M. L. Johnson and J. E. Grant, *Blake's Poetry and Designs*, 1979
Geoffrey Keynes, *Blake Studies*, 1949, 2nd enlarged edn 1971
– *Engravings by William Blake: The Separate Plates*, 1956
Anne Kostelanetz Mellor, *Blake's Human Form Divine*, 1974
Morton D. Paley, *William Blake*, 1978
Arthur H. Rosenfeld, ed., *William Blake: Essays for S. Foster Damon*, 1969
William Blake in the Art of his Time, exh. cat., University of California, Santa Barbara, 1976
Blake, an Illustrated Quarterly (formerly *Blake Newsletter*), ed. Morris Eaves and Morton D. Paley, contains current articles, recent bibliography and other valuable information
The Burlington Magazine and *Journal of the Warburg and Courtauld Institutes* contain a number of articles on Blake

On the Illuminated Books

Colour facsimiles of examples of every Illuminated Book have been published by the Trianon Press for the William Blake Trust in limited editions
G. E. Bentley, Jr., *William Blake: Vala or the Four Zoas*, 1963
David V. Erdman, *The Notebook of William Blake*, 1973, rev. edn 1977
Morton D. Paley, *Energy and the Imagination*, 1970
W. J. T. Mitchell, *Blake's Composite Art*, 1978

On the watercolour and engraving series

G. E. Bentley, Jr., *William Blake: Tiriel*, 1967

Stuart Curran and Joseph Anthony Wittreich, Jr., eds., *Blake's Sublime Allegory: Essays on the Four Zoas, Milton and Jerusalem*, 1973
Pamela Dunbar, *William Blake's Illustrations to the Poetry of Milton*, 1980
William Blake's Designs for Edward Young's Night Thoughts, ed. David V. Erdman, John E. Grant, Edward J. Rose and Michael J. Tolley, 1980
Geoffrey Keynes, *William Blake's Laocoön, a Last Testament, with Related Works*, 1976
Albert S. Roe, *Blake's Illustrations to the Divine Comedy*, 1953
Irene Tayler, *Blake's Illustrations to the Poems of Gray*, 1971
Joseph Wicksteed, *Blake's Vision of the Book of Job*, 1910, rev. and enlarged edn 1924

Museum catalogues

Helen D. Willard, *William Blake, Water-Color Drawings*, Museum of Fine Arts, Boston, 1957
Richard Morgan and G. E. Bentley, Jr., list of the Blake collection of the British Museum, London, in *Blake Newsletter*, V, 20, Spring 1972, pp. 22–58
David Bindman, *William Blake: Catalogue of the Collection in the Fitzwilliam Museum*, Cambridge, 1970
C. H. Collins Baker and R. R. Wark, *Catalogue of William Blake's Drawings and Paintings in the Huntington Library*, San Marino, 1957
G. E. Bentley, Jr., *The Blake Collection of Mrs. Landon K. Thorne* (now in the Pierpont Morgan Library, New York), 1971
Martin Butlin, 'The Blake Collection of Mrs. William T. Tonner' (now in the Philadelphia Museum), in *Bulletin, Philadelphia Museum of Art*, LXVII, 307, July–September 1972, pp. 5–31
Ruth Fine Lehrer, list of the Blake collection of Lessing J. Rosenwald (now split between the Library of Congress and the National Gallery of Art, Washington), in *Blake Newsletter*, IX, 35, Winter 1975–76, pp. 58–85
Martin Butlin, *William Blake: A Complete Catalogue of Works in the Tate Gallery*, London, 1971

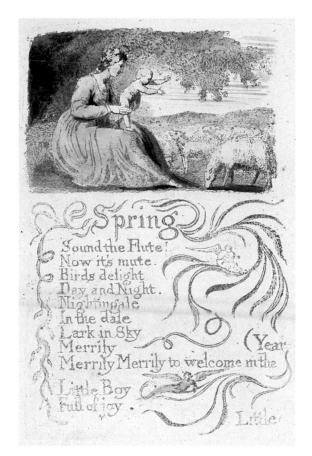 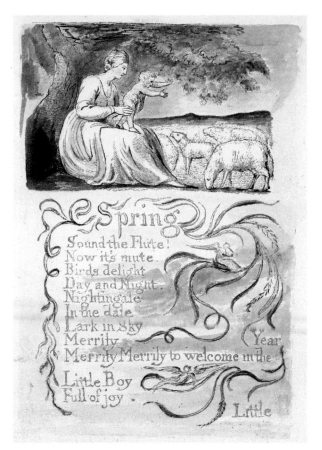

I *Spring*, from *Songs of Innocence and of Experience*, copy F, *c.* 1789–90, relief etching with watercolour (No. 39a) [actual size]

II *Spring*, from *Songs of Innocence*, copy P, 1802–05, relief etching with pen and watercolour (No. 39b) [actual size]

III Titlepage of *The Book of Urizen*, copy A, *c.* 1794–96, relief etching, colour-printed,
with pen and watercolour (No. 45a) [actual size]

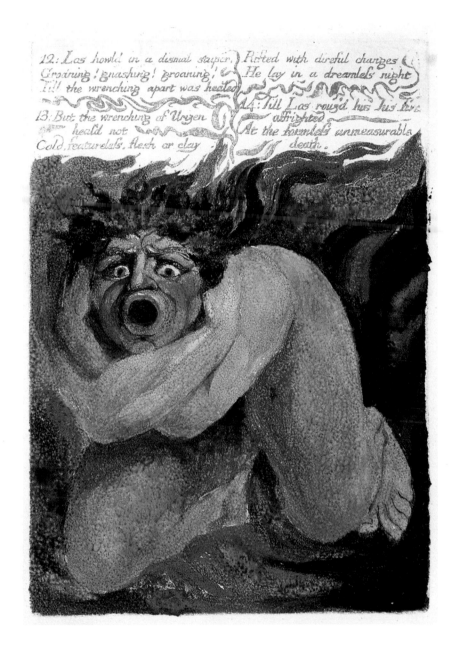

IV *Los howld in a dismal stupor*, plate 8 of *The Book of Urizen*, copy A, *c*. 1794–96, relief etching, colour-printed, with pen and watercolour (No. 45a) [actual size]

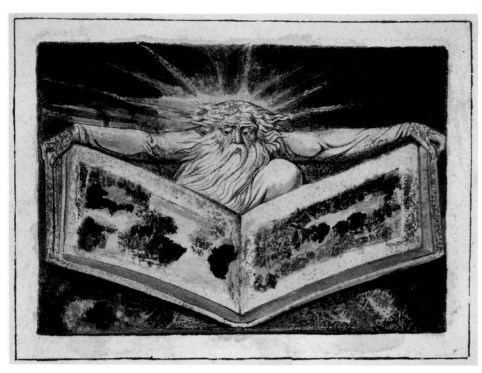

V *"The Book of my Remembrance"*, from the *Small Book of Designs*, c. 1796, relief etching, colour-printed, with pen and watercolour (No. 48b) [actual size]

VI *Newton*, c. 1804–05, colour print with pen and watercolour (No. 56b) [reduced]

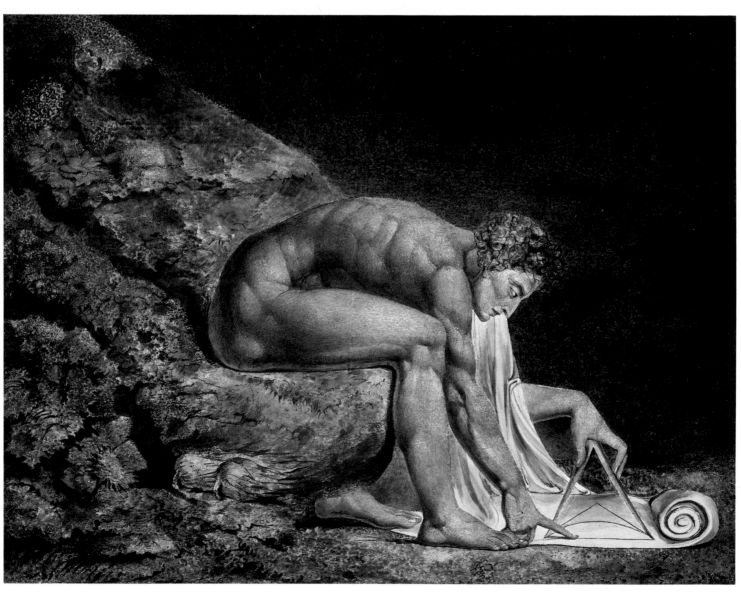

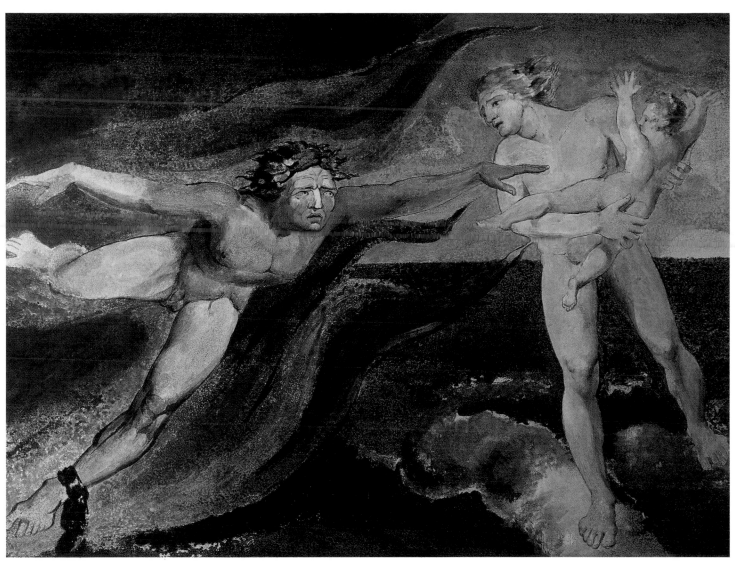

VII *The Good and Evil Angels struggling for Possession of a Child, c.* 1795, colour print with pen and watercolour (No. 53) [reduced]

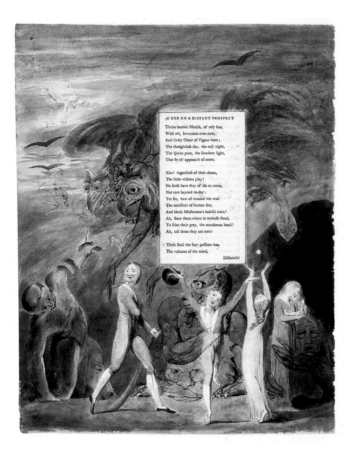

VIII *Ode on a Distant Prospect of Eton College*, 6th page,
illustration to Thomas Gray's *Poems*, 1797–98,
watercolour (No. 63c) [reduced]

X *(opposite) Malevolence*, 1799, watercolour with pen (No. 74) [reduced]

IX *The Virgin hushing the young John the Baptist*, 1799,
tempera with pen on paper (No. 70) [reduced]

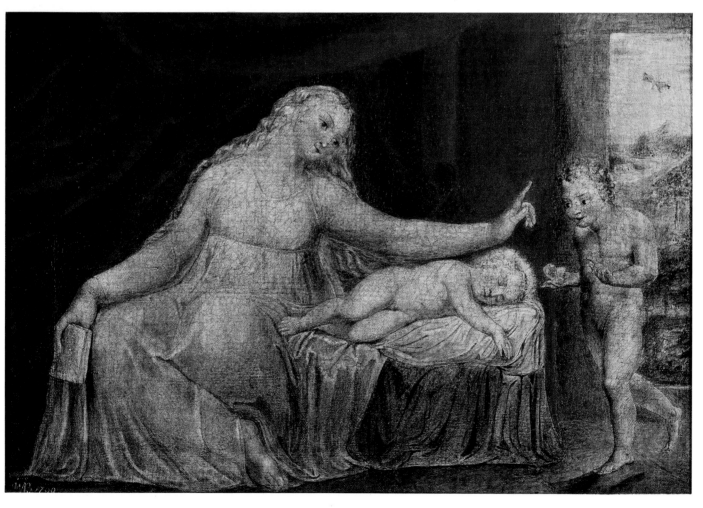

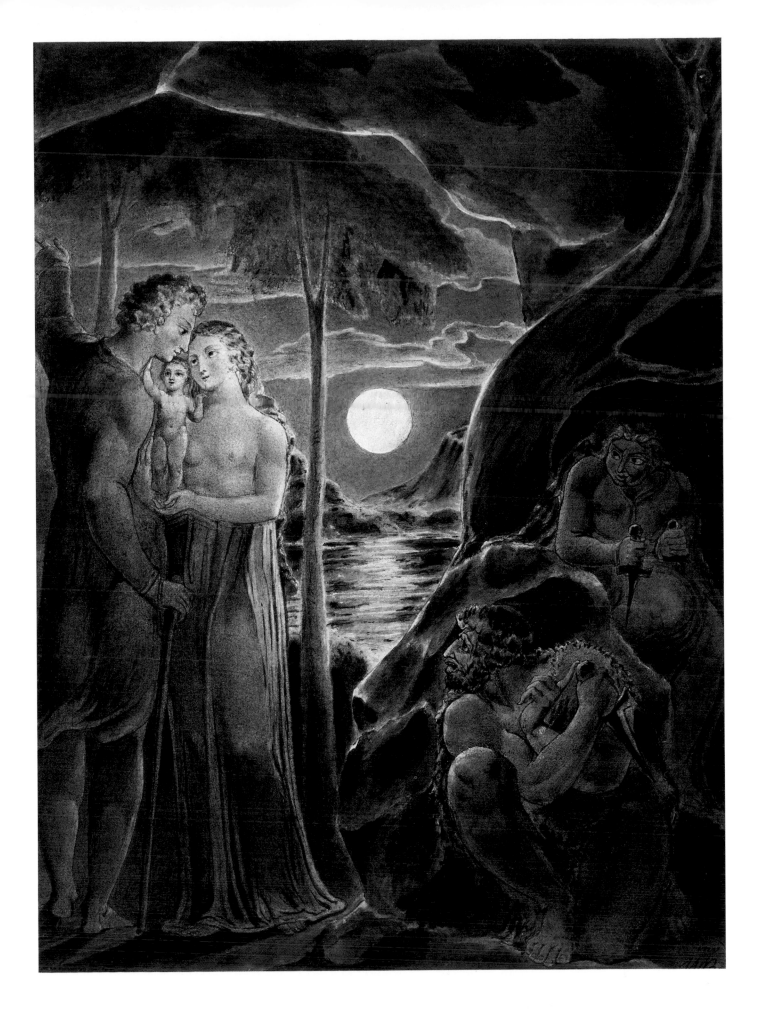

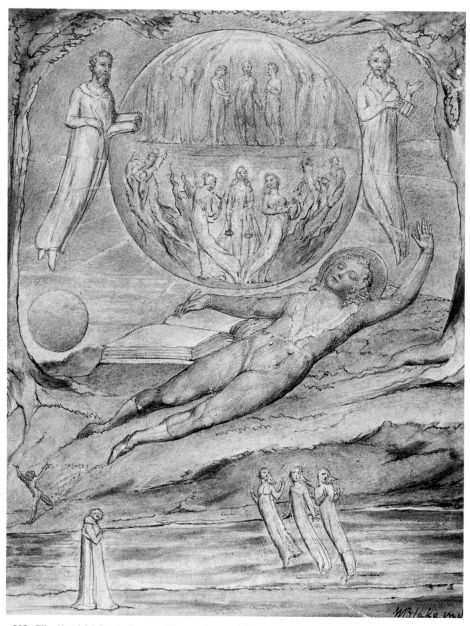

XI *The Youthful Poet's Dream*, illustration to Milton's *L'Allegro*, *c.* 1816–20, watercolour
with pen (No. 93c) [actual size]

XII *Los entering the grave*, frontispiece to *Jerusalem*, copy E, relief etching with pen,
watercolour and gold (No. 99a) [actual size]

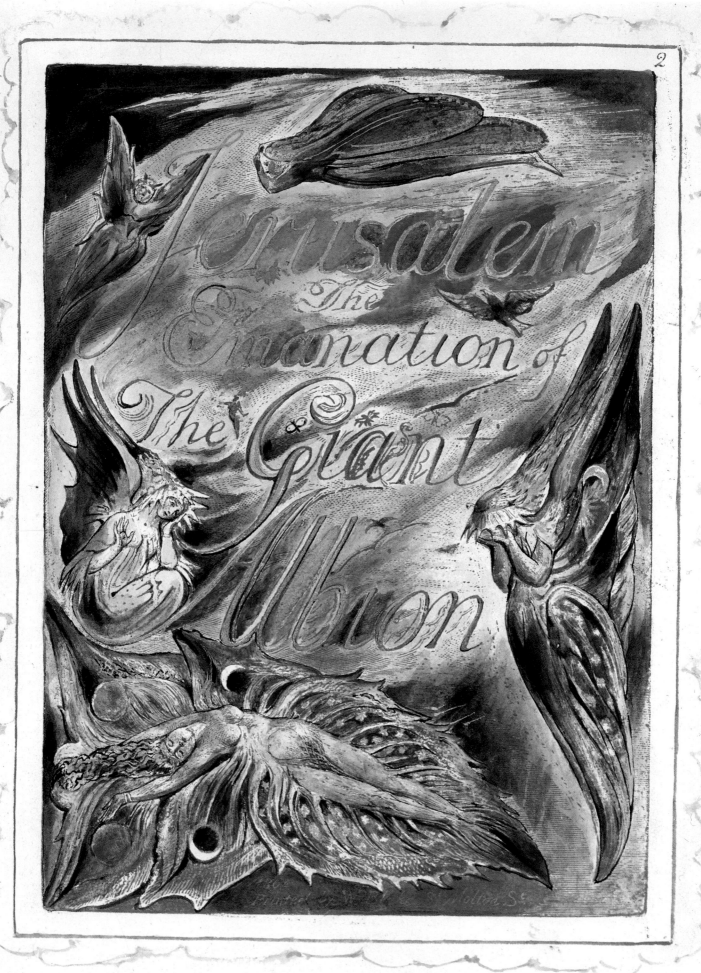

Jerusalem The Emanation of The Giant Albion

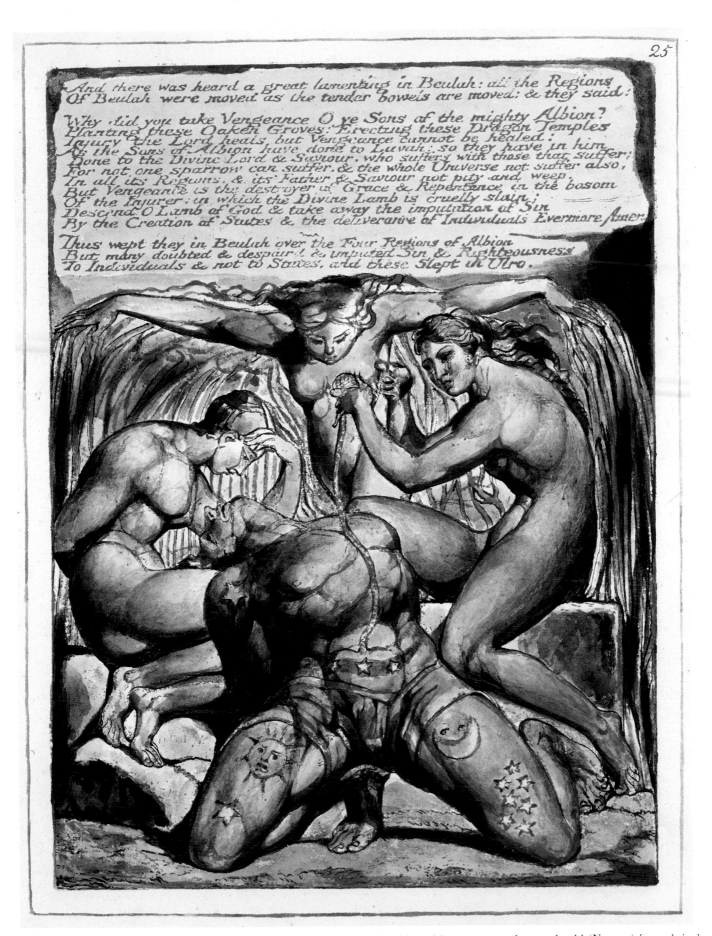

XIV *Albion in the agony of self-division*, plate 25 of *Jerusalem*, copy E, relief etching with pen, watercolour and gold (No. 99e) [actual size]

◄XIII *Jerusalem in her desolation*, titlepage to *Jerusalem*, copy E, relief etching with pen, watercolour and gold (No. 99b) [actual size]

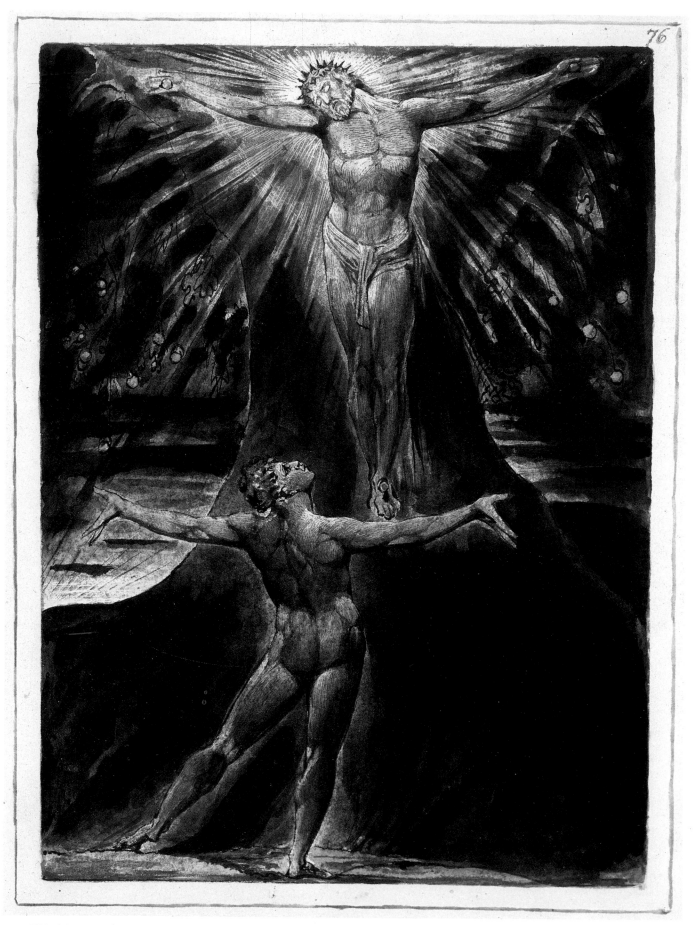

XV *Albion adoring Christ*, plate 76 of *Jerusalem*, copy E, relief etching with pen, watercolour and gold (No. 99n) [actual size]

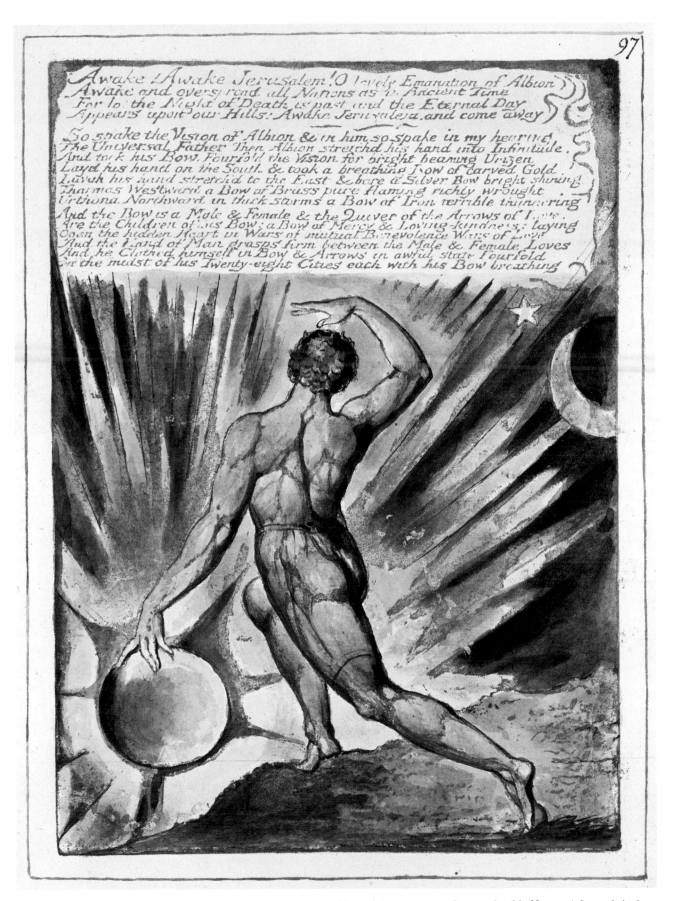

Awake! Awake Jerusalem! O lovely Emanation of Albion
Awake and overspread all Nations as in Ancient Time
For lo! the Night of Death is past and the Eternal Day
Appears upon our Hills: Awake Jerusalem, and come away

So spake the Vision of Albion & in him so spake in my hearing
The Universal Father Then Albion stretchd his hand into Infinitude.
And took his Bow. Fourfold the Vision for bright beaming Urizen
Layd his hand on the South & took a breathing Bow of carved Gold
Luvah his hand stretchd to the East & bore a Silver Bow bright shining
Tharmas Westward a Bow of Brass pure flaming richly wrought
Urthona. Northward in thick storms a Bow of Iron terrible thundering

And the Bow is a Male & Female & the Quiver of the Arrows of Love.
Are the Children of this Bow: a Bow of Mercy & Loving-kindness: laying
Open the hidden Heart in Wars of mutual Benevolence Wars of Love
And the Hand of Man grasps firm between the Male & Female Loves
And he Clothed himself in Bow & Arrows in awful state Fourfold
In the midst of his Twenty-eight Cities each with his Bow breathing

XVI *Los with the sun*, plate 97 of *Jerusalem*, copy E, relief etching with pen, watercolour and gold (No. 99p) [actual size]

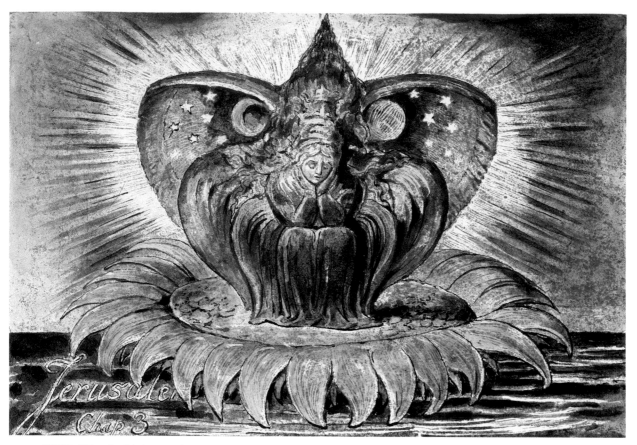

XVII *Winged spirit in a sunflower*, detail of plate 53 of *Jerusalem*, copy E, relief etching with pen, watercolour and gold [No. 99l] [actual size]

XVIII Detail of *Jerusalem in her desolation*: see pl. XIII [enlarged]

HELL
Canto 19

XIX *The Simoniac Pope*, illustration to Dante's *Divine Comedy* (*Inferno*), 1824–27, watercolour with pen and pencil (No. 116e) [reduced]

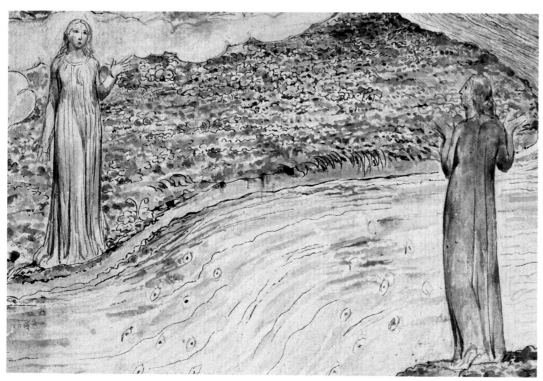

XX *Beatrice on the Car, Dante and Matilda*, illustration to Dante's *Divine Comedy (Purgatorio)*, 1824–27, watercolour, pen and pencil (No. 116l) [reduced]

XXI Detail of *Beatrice on the Car, Dante and Matilda*: see pl. XX [slightly reduced]

CATALOGUE

Plate numbers of Illuminated Books The order of pages within the Illuminated Books can vary from copy to copy, and because of the preliminary matter in each book there are different ways of arriving at the plate numbers. To avoid confusion the plate numbers here follow those in Bindman, *Graphic Works*.

Media Blake almost invariably used a pencil underdrawing in his pen and watercolour drawings. As this is a standard practice it is not mentioned in the description of the media. Similarly, engravings in Blake's time were almost always made on an etched under-design which can sometimes be seen. Where an object is described as an engraving this can be taken for granted, except in Blake's last works in intaglio where he did not use etching. Engraved lines can be added to a plate which has already been relief-etched, in which case these lines appear in white. Blake often used both techniques on the same plate. Unless it is dominant in the plate, white-line engraving is not mentioned in the description.

Illuminated Books may be taken to include all those that combine text and design by Blake's method of relief etching. Prophetic Books are those Illuminated Books which are called 'A Prophecy' on the titlepage, like *America*, or which are obviously part of the same cycle, like *The Song of Los*; they also include *Milton* and *Jerusalem*.

All works are on white paper unless otherwise stated.

Inscriptions are by Blake unless otherwise stated.

Dimensions are in inches followed by millimetres; height precedes width. Normally the image size is given, not the area of the paper.

Blake's works are illustrated actual size as often as possible; they are never, except in the case of a detail, enlarged.

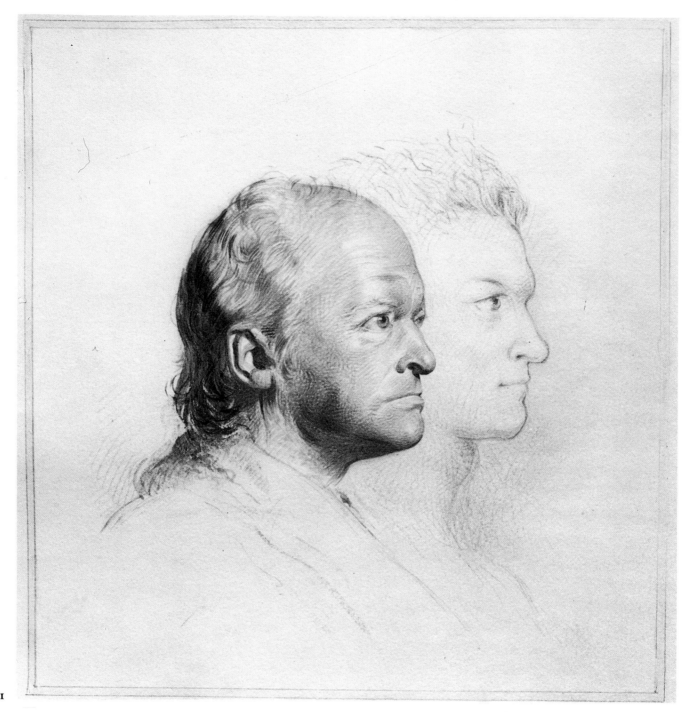

1

GEORGE RICHMOND after FREDERICK TATHAM?

1 William Blake in Youth and Age

Pencil with brush and brown ink, $6\frac{3}{16} \times 5\frac{13}{16}$
 (157×147)
Inscr: (by Tatham?) 'Portraits of Willm Blake at
 the Ages of 28 & 69 years'
Lit: Keynes, *The Complete Portraiture of William
 Blake*, 1978, no. 41; Patrick Noon, *English
 Portrait Drawings and Miniatures*, exh. cat., Yale
 Center for British Art, 1979, no. 108
Mr and Mrs Paul Mellon, Upperville, Va.

This portrait was bound in with the Mellon copy of
Jerusalem (No. 99), and thus belonged to Tatham, who has
always been presumed to have been the author. In fact the
fine quality and the presence of George Richmond's
signature on a companion drawing of Mrs Blake suggest
that this study is by him, perhaps copying a cruder version
in Tatham's hand, formerly in the T. E. Hanley Collec-
tion. The profile of Blake as a young man is derived from
a drawing made by Mrs Blake (Fitzwilliam Museum,
Cambridge), probably between Blake's death in 1827 and
her own in 1831.

For Richmond see No. 123.

The Engraver's Apprentice, 1772–79

The young Blake's engraving work for his master James Basire appears to have been competent and conventional, but there are hints of a desire, unusual for an engraver's apprentice, to learn as much as possible about the great artists of the past. His fellow apprentices 'who were accustomed to laugh at what they called his mechanical taste' probably did not know that he was writing poetry in his spare time, or have any inkling of his avid reading in mystical and alchemical writers like Paracelsus and

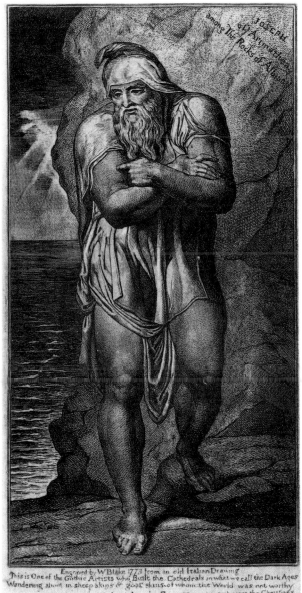

2

Fig. 27 Blake: *Joseph of Arimathea among the Rocks of Albion*, 1st state, *c.* 1773, line engraving. Keynes Collection

Jacob Böhme. He apparently established from the beginning a pattern of working at the drudgery of engraving during the daytime, while enjoying a rich mental life in private. The *Poetical Sketches* show wide reading in the work of his predecessors, and even as an engraver's apprentice he prepared himself for a career as a History painter, on the model proposed by Joshua Reynolds in his *Discourses* to the Royal Academy.

2 **Joseph of Arimathea among the Rocks of Albion** 2nd state, c. 1805–20

Line engraving, with wash additions by Blake, $8\frac{3}{4} \times 4\frac{5}{8}$ (223 × 120)
Inscr: top right, 'JOSEPH of Arimathea among The Rocks of Albion'; beneath image, 'Engraved by

W Blake 1773 from an old Italian Drawing /
This is One of the Gothic Artists who Built the
Cathedrals in what we call the Dark Ages /
Wandering about in sheep skins & goat skins of
whom the World was not worthy / such were the
Christians / in all Ages / Michael Angelo Pinxit'
Lit: Essick, *Printmaker*, pp. 29–32, 185–87; Essick,
Separate Plates, no. I, 2I
Trinity College Library, Hartford, Connecticut

One of the best impressions of the second state, with
delicate tinting almost certainly applied by Blake himself.
The second state is a virtuoso reworking in Blake's
maturity of a youthful engraving made in Basire's work-
shop, according to Blake in 1773 (unique impression in
the Keynes Collection: see *Fig. 27*). It derives, by means
of an engraving or perhaps a drawing, from an unidenti-
fied figure on the right of Michelangelo's *Crucifixion of St
Peter* in the Pauline Chapel; Blake has added the back-
ground.

In revising the work on the original plate Blake has not
only infused life into a pedestrian student exercise, but has
also given it an allegorical meaning as a depiction of
Joseph of Arimathea, the disciple who, according to
legend, brought Christianity to England, the inhospitable
shores of Albion. His rocky isolation and the grimness of
his mission, as the inscription makes clear, are also
emblematic of the fate in all ages of the artist, who brings
the divine message to an unworthy world, yet is sustained
by the light of Eternity, hinted at in the background.

Blake's artistic experience as a boy would have come
largely from copying engravings by Renaissance masters,
of which he had a large collection. He had from the
beginning, it seems, a decided taste, preferring engravings
after Raphael and Michelangelo and by the German
masters, and abhorring the Baroque models placed in
front of him.

3 Poetical Sketches, by William Blake 1783

Printed book, letterpress
Lit: Bentley, *Blake Books*, copy N
*Beinecke Rare Book and Manuscript Library, Yale
University. Bequeathed by Chauncey B. Tinker, 1963*

Poetical Sketches was privately printed, with the help of
John Flaxman and his friends the Rev. and Mrs A. S.
Matthew, in an edition of about 50, and given to Blake to
distribute. Flaxman tried to put copies in the hands of
influential literary figures like his friend William Hayley,
but with little success; hence Blake had copies left on his
hands over forty years later.

The anonymous introduction claims the poems as 'the
production of untutored youth, commenced in his
twelfth, and occasionally resumed by the author till his
twentieth year' (i.e. 1777); they are uncorrected, because

since then 'his talents having been wholly directed to the
attainment of excellence in his profession, he has been
deprived of the leisure requisite to such a revival of these
sheets, as might have rendered them less unfit to meet the
public eye'.

This confirms that Blake in 1783 was intent on proving
himself as a painter of Historical subjects (see Nos. 9–13),
and not yet thinking of combining poetry and painting.
Even so some of the imagery of the poems does prefigure
his later visual work, and parallels can be drawn between
the dramatic fragments like *King Edward the Third* and the
subjects of his early Historical watercolours. One may
also note the pervasive example of Thomas Chatterton,
whose poetic works and premature death were illustrated
by Flaxman about the time of the publication of the
Poetical Sketches. (See Sarah Symmons in *Flaxman*, nos. 7,
9, 10.)

According to a note by A. H. Palmer the copy exhibited
belonged to his father, Samuel Palmer, who seems to have
inherited Blake's library. Blake left at least five copies in
sheets; unlike those which he gave away, they have no
corrections in his hand.

4 The Works of Jacob Behmen, the Teutonic Theosopher vol. 3, 1772

Printed book, letterpress, with engraved
illustrations after J. C. Leuchter, open at 'The
Third Table'
Lit: D. Bindman, 'Blake and Runge' in *Runge:
Fragen und Antworten*, Hamburger Kunsthalle
Symposion, 1979
*Beinecke Rare Book and Manuscript Library, Yale
University*

In 1825 Blake spoke to Henry Crabb Robinson of the
German Renaissance mystic Jacob Böhme or Behmen 'as
a divinely inspired man', and praised the illustrations in
this edition, claiming that 'Michelangelo could not have
done better'. Böhme was one of the key influences on
Blake's youth, and there is every reason to suppose a life-
long acquaintance with the extraordinary illustrations in
this book, published in 1764–81, especially the 'Three
Tables of Divine Revelation' in vol. 3, engraved by an
unknown London engraver after drawings by the early
18th-century German artist J. C. Leuchter. Leuchter in
turn had adapted them from diagrams by the compiler,
the German Behmenist Dionysius Andreas Freyer, who
lived in England in the 1730s.

Each of the Tables allows the spectator to pick up a
series of flaps or 'Vails' to unfold the development of man's
spirit from the Creation to his Redemption. The First
Table begins with the World, and passes through the
Unfallen man to the Creator, the Mysterium Magnum.
The Second Table reveals man in his Fallen state, in
spiritual darkness, bereft of the light of Redemption. The

Third Table (shown here) charts man's Redemption, which begins with the dove of the Holy Spirit supplanting the peacock (man's vanity) in his heart. His Redemption is achieved with great struggle, and the 'Vails' reveal his gradual transformation into female form and his unity of body, soul and spirit.

The engravings of the Three Tables are good London work (see the view of St Paul's presumably from Islington in the Third Table), and they were published in the first year of Blake's apprenticeship. There is no reason to attribute them to Basire, but the production of such unusual works must have been known to the young Blake, either through Basire or through Richard Cosway (see No. 19). Many scholars have pointed to the seminal influence of Böhme's ideas on Blake's later work, and the use of the ideal human body as a vehicle for the expression of spiritual ideas. Furthermore the idea of the 'Vail', although not used in this way by Blake, pervades his later thought and designs.

4

JAMES BASIRE after BENJAMIN WEST

5 Pylades and Orestes 1771

> Line engraving, $17\frac{7}{8} \times 22\frac{1}{4}$ (456 × 565)
> Lit: Essick, *Printmaker*, p. 44
> *Yale Center for British Art, Paul Mellon Collection*

This engraving was made by Basire (1730–1802) before Blake began his apprenticeship with him, and it belongs to the most prestigious form of engraving, the copying of serious History paintings. It represented a high point for Basire, who was rarely able to compete with the great specialists in this genre like William Woollett; by the time Blake arrived in his workshop he was well established as an antiquarian engraver in direct succession to George Vertue. Blake continued to resent the overshadowing of his master by rivals: his *Public Address* of *c.* 1810 makes constant reference back to the workshop rivalries of his youth, presented in terms of the martyrdom of Basire by unscrupulous enemies.

Basire's careful use of engraved outline and cross-hatching, though competent, does not justify Blake's claim that his master remained faithful to 'Old English engraving' while others indulged in foreign and imitative techniques. Basire does seem, however, to have been a notably kind and generous master to his young apprentices, one of whom at least cannot have been an easy pupil.

5

BLAKE AND JAMES BASIRE?

6 Tomb of Aveline of Lancaster 1780, from *Vetusta Monumenta*, vol. 2, 1789

> Line engraving, $19 \times 12\frac{3}{16}$ (482 × 310)
> Inscr: 'J. Basire del. et sc.', and dated 1780

6

as portraits; and all the ornaments appeared as miracles of art to his Gothicised imagination.' The attribution to Blake of the engraving cannot be certain, because it is likely that the work of engraving would have been shared out in Basire's shop. From this project Blake became familiar with major works of English Gothic sculpture, an enthusiasm for which he shared with John Flaxman.

7 A Father's Memoirs of his Child, by Benjamin Heath Malkin 1806

Printed book, letterpress, with frontispiece by
 R. Cromek after Blake
Lit: Bindman, *Artist*, p. 141
Yale Center for British Art, Paul Mellon Collection

Benjamin Heath Malkin (1769–1842) was a schoolmaster and eventually a professor of history at London University. His book, about a talented son who died very young, includes comments by Blake, who gave drawing lessons to the young Malkin, on the boy's work, and also a long account of Blake's own youth.

Malkin's book, with a selection of poems from *Songs of Innocence and of Experience* (for Malkin's copy of *Innocence* see No. 39b) and the *Poetical Sketches*, provided one of the very few accessible accounts of Blake's work in his lifetime. It clearly came from friendly conversations with Blake himself; though perhaps a little coloured by Blake's later appreciation of the Gothic, it gives a convincing picture of his youthful enthusiasm for medieval sculpture (see No. 6), and of the way he absorbed knowledge of earlier art through attending auctions and collecting prints.

8 Drawing of a male figure from life *c.* 1779–80

Pencil, $18\frac{7}{8} \times 14\frac{9}{16}$ (479 × 370)
Lit: Butlin, *Paintings*, no. 71
The Trustees of the British Museum, London

This drawing probably dates from Blake's brief period of study at the Royal Academy after completing his apprenticeship to Basire in 1779. It suggests that, though unwilling, he entered fully into the routine of a Royal Academy student. According to Malkin (see No. 7), 'Here he drew with great care, perhaps all, or certainly nearly all the noble antique figures in various views. But now his peculiar notions began to intercept him in his career. He professes drawing from life always to have been hateful to him; and speaks of it as looking more like death, or smelling of mortality. Yet he drew a good deal from life, both at the academy and at home.'

The intimacy of the drawing and the direct gaze suggest the home, and it may, as Keynes suggests, be of his younger brother Robert. On the other hand the awkward drawing of the fingers of the model's left hand might indicate a self-portrait done in a mirror, since the 'left' hand would then really be the pencil-holding right hand.

Lit: Butlin, *Paintings*, no. 4; Easson and Essick,
 Book Illustrator, II, no. XIV
Yale Center for British Art, Paul Mellon Collection

This engraving and others of the tomb of Countess Aveline were first published in Joseph Ayloffe's *Some Ancient Monuments in Westminster Abbey*, 1780. Though they are signed by Basire it is usual to attribute to Blake as an apprentice both the drawings for the book (Society of Antiquaries, London) and the engravings after them. The evidence derives from the account of Blake's youth given by Malkin (see No. 7), which describes Blake's enthusiasm for the monuments in Westminster Abbey that Basire had sent him to draw: 'All these he drew in every point he could catch, frequently standing on the monument, and viewing the figures from the top. The heads he considered

8

Radical History Painter: the 1780s

The works in this section chart Blake's attempt to paint, in watercolour rather than oil, subjects from the Bible and English history. He conscientiously learned the style associated with the higher aspirations of the Royal Academy, choosing where possible subjects with apocalyptic implications. He had some success in exhibiting his watercolours, but he must have sensed that there was little apparently to distinguish them from the bland conformity of Benjamin West; so he turned increasingly towards printmaking, making books with his own text and designs, avoiding the limitations imposed by the Royal Academy.

9 The Keys of Calais *c.* 1779–80

Pencil, pen and watercolour, $5 \times 7\frac{1}{8}$ (127 × 182)
Lit: Butlin, *Paintings*, no. 64; Bindman, 'Blake's Gothicised Imagination and the History of England' in *Essays for Keynes*, pp. 29–49
Beinecke Rare Book and Manuscript Library, Yale University

This is one of a series of small watercolour illustrations made about the time Blake left his apprenticeship in 1779. Nine of them can now be identified, covering English

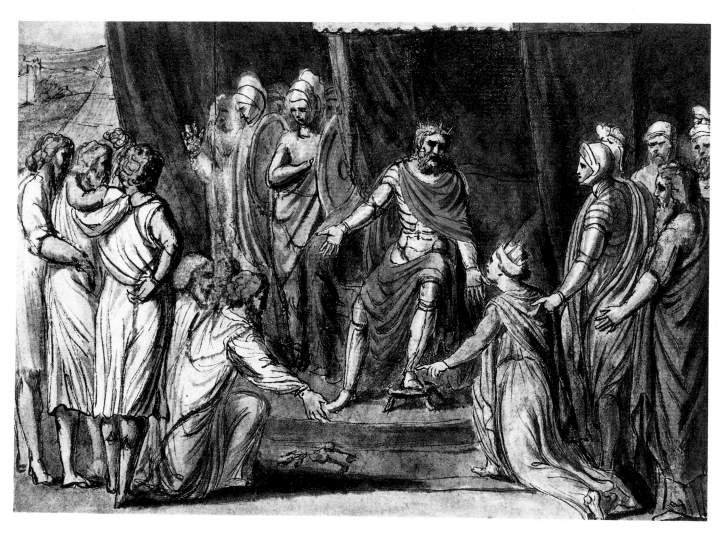

9

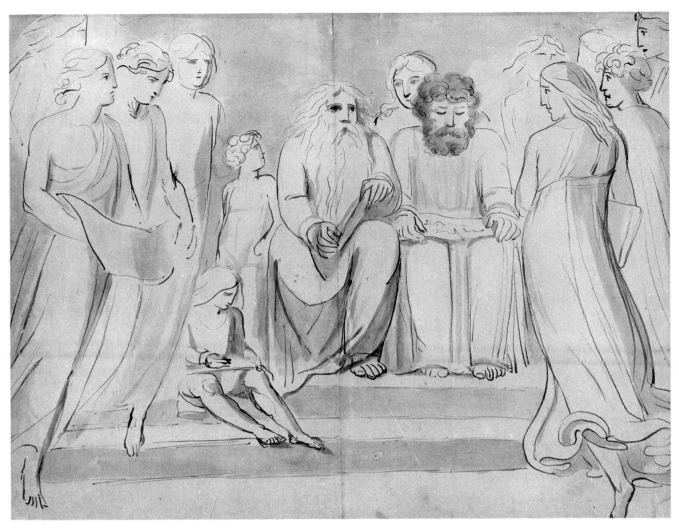

10

history from the legendary arrival of Brutus of Troy, the great-grandson of Aeneas, to the Great Plague of London. One of the watercolours, *The Death of Earl Goodwin* (British Museum, London, or a larger version), was exhibited at the Royal Academy in 1780. Blake has followed a 'poetical' account of English history, giving a role to myth and the intervention of God in human affairs. The series is thus seminal for the later Prophetic works.

The story of *The Keys of Calais* could be taken in two ways – as favourable to kings (as it was by Benjamin West in one of a set of large paintings made for George III at Windsor Castle), or as unfavourable, revealing Edward III as a bloodthirsty tyrant. Edward had laid siege to Calais and offered to be lenient if the burghers of the town surrendered the keys and offered themselves as hostages. He proposed to execute them, but relented on the intervention of his wife, Queen Philippa. The action could be interpreted as a sign of the King's mercy, or, as Blake saw it, of the power of Innocence over the stony heart of a tyrant.

10 Moses and Aaron flanked by Angels?
c. 1780–85

Pen and wash, $18 \times 23\frac{1}{2}$ (455 × 595)
Lit: Butlin, *Paintings*, no. 112
The Library, Princeton University

The subject of this impressive drawing has not been satisfactorily established, though it is clearly from the Old Testament. It used to be connected with the Book of Job, but recent opinion identifies the two central figures as Moses and Aaron. Lindberg (*Job*, 1973) suggests, not quite convincingly, 'Moses speaking, his Face shining' (Exodus 34: 29–35). The drawing is a characteristic example of Blake's bold and somewhat inaccurate pen-work of the early 1780s. The strong linearity and the use of wash closely parallel Flaxman's drawings of this period (see No. 18), but with more energy and less anatomical knowledge. There are many other drawings in the same vein of Old Testament subjects dating from the early 1780s; it is not possible to form them into a coherent series.

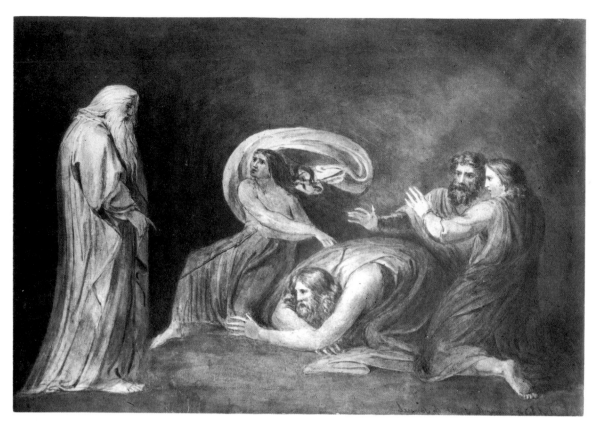

11

11 The Witch of Endor raising the Spirit of Samuel 1783

Pen and watercolour, $11\frac{1}{8} \times 16\frac{5}{8}$ (283 × 423)
Inscr: '1783 WBlake inv' and 'The witch of Endor
 raising the Spirit of Samuel'
Lit: Butlin, *Paintings*, no. 144; *Fuseli Circle*,
 no. 136
*Print Collection, Art, Prints and Photographs Division,
 The New York Public Library, Astor, Lenox and
 Tilden Foundations*

This watercolour is unusual in being precisely dated.
Despite the horrific nature of the subject it is relatively
measured in gesture and expression, particularly if com-
pared to Blake's later version (No. 77). The composition
draws much from engravings after the 'Raphael Bible' in
the Vatican Logge. It can also be compared, on a small
scale, with some of the Biblical paintings Benjamin West
was exhibiting at the Royal Academy at the time. Blake
might therefore have submitted the watercolour for
exhibition unsuccessfully.

 The subject was a fashionably horrific one, best known
through Benjamin West's painting of 1777, engraved by
William Sharp (No. 22). It illustrates Saul's attempt, the
day before a battle with the Philistines, to conjure up the
spirit of the dead King Samuel to predict the outcome.
Samuel is duly raised by the Witch of Endor and foretells

disaster for Saul, who is shown prostrate at the spirit's
feet. There might perhaps be a political implication in
depicting a king whose impending defeat is prophesied.

 For a further discussion of this watercolour see the
Introduction, p. 33.

12 Pestilence or The Great Plague of London
 c. 1783–84

Pen and watercolour, $7\frac{1}{4} \times 10\frac{3}{4}$ (185 × 275)
Lit: Butlin, *Paintings*, no. 185
Collection of Robert N. Essick

A key work providing a link between Blake's early
History painting and the imagery of the Prophetic Books.
It is related to two lost watercolours exhibited at the
Royal Academy in 1784 which are known in other ver-
sions, *War unchained by an Angel, Fire, Pestilence, and Famine
following* (see Butlin, *Paintings*, no. 187) and *A Breach in a
City, the Morning after a Battle* (No. 13). In subject it may
be associated with the former, which refers to the Book of
Revelation; it also goes back to the *Great Plague of London*
in the History of England watercolour series (see No. 9).

 We are, therefore, intended to see the 17th century
plague as a fulfilment of the prophecy of Revelation, a
manifestation of God's wrath upon the English Nation.
The miseries of modern times are a sign that the apoca-
lypse is at hand. The chiliastic note is sustained in the

12

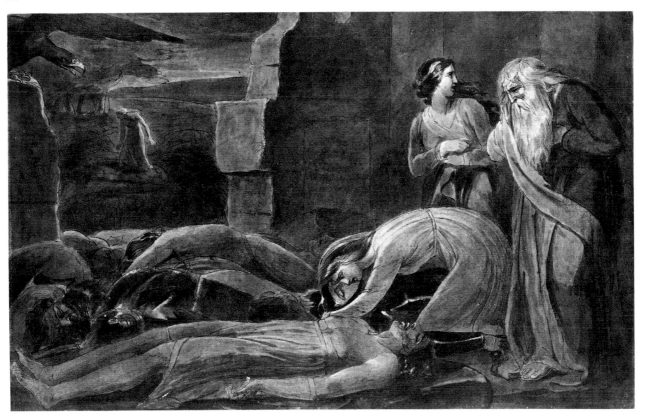

13

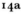

haunting figure of the bellringer in the background. He becomes the central figure in the reworking of this design in plate 11 of *Europe* (No. 44), which also depicts plague, and perhaps reappears as Los entering the grave, in the frontispiece to *Jerusalem* (No. 99a).

Despite the apocalyptic undertones, the Renaissance *pathosformulae* and restrained gestures keep the drawing firmly within the classicizing mode of Benjamin West and James Barry.

13 A Breach in a City, the Morning after a Battle *c.* 1790–93

Pen and watercolour, $11\frac{11}{16} \times 18\frac{1}{4}$ (297 × 463)
Lit: Butlin, *Paintings*, No. 189
Museum of Art, Carnegie Institute, Pittsburgh. Bequest of Charles J. Rosenbloom, 1974

Despite Cummings's attempt (*Romantic Art in Britain*, no. 93) to identify this watercolour as the one of the same title exhibited by Blake at the Royal Academy in 1784, it can be dated on stylistic grounds to a more mature phase of Blake's art, after 1790. If, as seems likely, the design is based on a prototype of 1784 or earlier, like the previous watercolour, it provides a link between the History of England series and the apocalyptic imagery of the Prophetic Books of the 1790s.

No precise historical incident has been identified. The scene of misery and desolation emphasizes the destructiveness and cruelty of war rather than its heroism, by contrast with the historical paintings of Benjamin West. It also invokes a connection between human destruction and the wrath of God – war as an evil released upon man by the Angel of Revelation.

The woman mourning the dead knight and the breach in the wall recur in the titlepage and frontispiece of *America* (No. 43, ill. pp. 100–101).

14 Ezekiel

a Drawing, *c.* 1785–90
Pen and indian ink, $13\frac{5}{8} \times 18\frac{7}{8}$ (345 × 480)
Lit: Butlin, *Paintings*, no. 166
Philadelphia Museum of Art

b Engraving, 1800–1825
Engraving on India paper, $13\frac{7}{8} \times 19\frac{7}{8}$ (353 × 480)
Inscr: 'Painted & Engraved by W Blake /
EZEKIEL / I take away from thee the Desire of

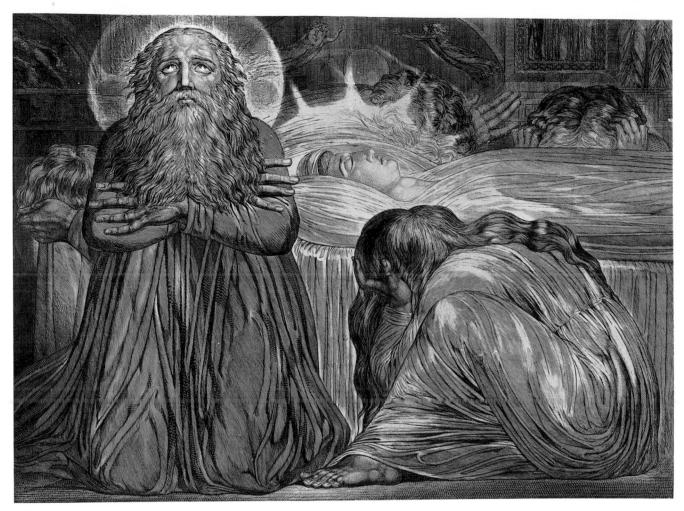

14b

thine Eyes, Ezekiel xxiv / Published October 27 1794 by W Blake No. 13 Hercules Buildings Lambeth'

Lit: Essick, *Printmaker*, p. 64, *passim*; Essick, *Separate Plates*, no. VI, 2A

The Trustees of the British Museum, London

Ezekiel, having preached to the people that they may not mourn, finds that his wife has died that day: 'So I spake unto the people in the morning: and at even my wife died; and I did in the morning as I was commanded.' The theme is partly a parable of the prophetic artist who obeys the command of his imagination in the face of incomprehension. The intensity of feeling and the psychological isolation of Ezekiel point to Blake's increasingly solipsistic view of his art from the mid-1780s onwards. There is conceivably also a reference to the death in 1784 of his father, who had always encouraged his artistic ambitions.

The monumental drawing (**a**), which can be dated on stylistic grounds to the mid-1780s or a little later, corresponds in size and finish to one of *Job* (see No. 15). Together they represent Blake's most ambitious youthful compositions, conceived not as Royal Academy exhibits but as large-scale privately published engravings, though

the latter may not have been completed at the time. The relationship of the *Ezekiel* drawing to the surviving engraving of the same subject (**b**), which bears the date 1794, is not completely straightforward, because of uncertainties in dating the latter.

The *Ezekiel* engraving (**b**) was made as a companion to the *Job* (No. 15). Three impressions are known, all of the same state, whereas two states of the *Job* exist, one of which is clearly earlier than the existing state of the *Ezekiel*. Keynes assumed the earlier state of the *Job* to be about 1786, but Essick dates it 1793. Essick points out the use of burnishing in the known impressions of *Ezekiel* and in the final state of *Job*, and argues strongly for a dating in the 1820s for both.

Essick also argues that the two plates together present different 'reactions to physical and spiritual vicissitude' – *Job* that of a man still in spiritual darkness, and *Ezekiel* that of a prophet who has heard the voice of God. The contrast is more evident in the engravings than in the early finished drawings, and may support the argument that Blake revised the designs after 1805, when he began to reconsider the story of Job for his watercolour series and later his engravings. Certainly the haloes around Ezekiel and his wife appear only in the engraving.

15 Job designed *c.* 1785–90, this state 1800–1825

Engraving on India paper, $13\frac{11}{16} \times 19\frac{7}{16}$
(348 × 494)
Inscr: 'Painted & Engraved by William Blake /
JOB / What is Man That thou shouldest Try him
Every Moment? Job VII C17 & 18v / Published
18 August 1793 by W Blake N? 13 Hercules
Buildings Lambeth'
Lit: Essick, *Separate Plates*, no. V, 2B
The Trustees of the British Museum, London

The subject of Job and his comforters has a long history in
art, particularly that of the Northern Renaissance. The
most immediate source for Blake must be James Barry's
print (No. 21), to which Blake's composition is indebted
in scale, broad handling and sense of personal suffering. It
is perhaps also indebted to Reynolds's then famous
painting of *Ugolino and his Sons*. An early drawing of the
composition, a companion to that of *Ezekiel* (No. 14a), is
in the Achenbach Foundation, San Francisco.

The engraving is also known in a unique impression of
the first state in the Keynes Collection, dated *c.* 1786 by
Keynes and 1793 by Essick. By comparison with the
drawing and the first state, Blake has brought to the
present plate a dramatic and eerie light, partly achieved
by burnishing, which has led Essick to date it as late as the
1820s.

**16 Oberon, Titania and Puck with Fairies
dancing** *c.* 1785–87

Watercolour with pen and pencil, $18\frac{3}{4} \times 26\frac{1}{2}$
(475 × 625)
Lit: Butlin, *Paintings*, no. 161
The Trustees of the Tate Gallery, London

An illustration to the final scene of Shakespeare's *A Mid-
summer Night's Dream*, close in style to works exhibited by
Blake at the Royal Academy. It is, therefore, near in date
to Fuseli's paintings from the same play made for Boydell's
Shakspeare Gallery, first mooted in 1786 (represented here
by an engraving, No. 23). Blake's rendering is very much
less fantastic, lacking the dramatic disorder and contrasts
of scale of the Fuseli design. The dance of the fairies is,
relatively speaking, classical and measured, showing that

Blake in the 1780s could still be allied with the more con-
sciously monumental History painters like Benjamin West
and James Barry, and was as yet no rival in extravagance
to Fuseli. Fuseli also tended to select from the play subjects
of an erotic and nightmarish character, while Blake has
chosen a moment in which Puck ironically proclaims the
unreality of material vision:

> If we shadows have offended,
> Think but this, and all is mended,
> That you have but slumbered here
> While these visions did appear.

The watercolour is important for the early appearance
in Blake's works of the fairy mode, for fairies were to play
an important part in the Illuminated Books as vegetative
spirits who enact in nature the great drama of human
Redemption; see for example the titlepage to *Jerusalem*
(No. 99b).

**17 Tiriel supporting the dying Myratana and
cursing his Sons** *c.* 1786–89

Pen and grey wash, $7\frac{5}{16} \times 10\frac{11}{16}$ (186 × 272)
Lit: Butlin, *Paintings*, no. 198; Bentley, *William
Blake: Tiriel*, 1967
Yale Center for British Art, Paul Mellon Collection

This is the first of a now dispersed series of twelve drawings
illustrating a manuscript by Blake (British Library,
London), which is his earliest surviving attempt to create
a personal mythology with characters of his own inven-
tion. Blake was apparently proposing to have it printed
in normal letterpress, possibly with engraved illustrations
on the opposite page.

Tiriel is a Lear-like king who embarks on a journey of
self-discovery. William Michael Rossetti described the
tale as 'a piece of erratic Ossianism', but this does not do
justice to the echoes of the Bible and Greek and Northern
myths which can be found in it. In this illustration Tiriel
supports his dying wife while cursing his sons, who are
intent on expelling him from his palace. The pyramids
suggest Blake's later imagery of Egyptian materialism.
Tiriel's epic journey eventually forces him to see the
limitations of his material vision.

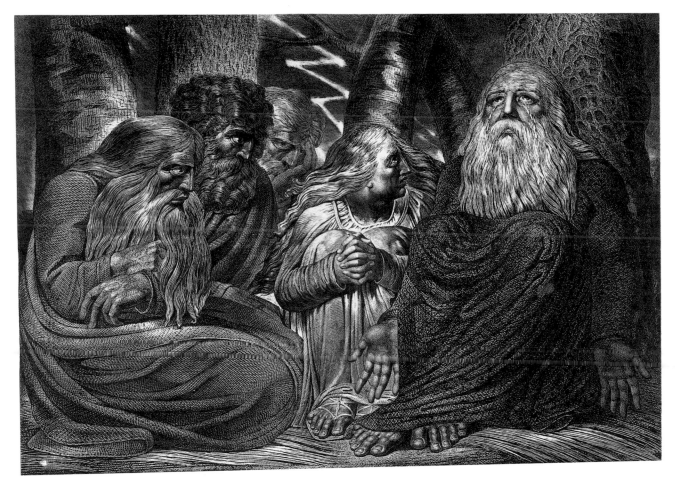

15

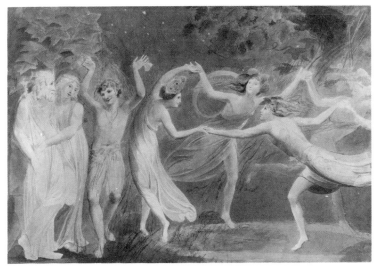

16

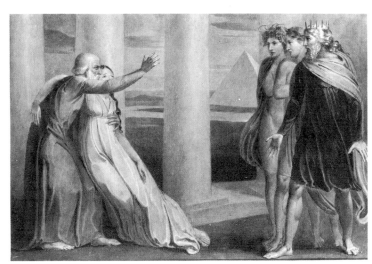

17

The Elevated Style in the 1780s

The works by Blake's contemporaries in this section briefly define the scope of subject painting in the 1780s, and give an indication of Blake's relationship to the Royal Academy in that decade.

The Academy from its founding in 1768 had been rent with disputes, and Blake seems to have allied himself firmly with artists like James Barry who were in general hostile to the ascendency of the President, Joshua Reynolds, and the King's painter, Benjamin West, who was eventually to succeed Reynolds. These disputes were more on political than on artistic grounds, and Blake's style owes something to the example of both Barry and West, who had, unlike him, spent long periods in Rome. Blake's religious intensity and radicalism did not isolate him from other artists: Flaxman and Cosway shared some of the former, while Barry and George Romney were sympathetic to the idea of revolution. Furthermore his opposi-

tion to Reynolds may not have been as strong as it became later, and there is some evidence that he got on well with West despite the latter's royal office. Political differences only became important with the advent of the French Revolution and the threat that it might spread to England.

JOHN FLAXMAN

18 Get thee behind me, Satan *c.* 1783–87

Pencil, pen and grey wash, $16 \times 21\frac{7}{8}$ (405×555)
Lit: *Flaxman*, p. 44
Yale Center for British Art, Paul Mellon Collection

This drawing by Flaxman (1755–1826) belongs to a group of the mid-1780s (examples in the Huntington Library, San Marino (Flaxman catalogue, no. 27), and the Fogg Museum, Cambridge) in which Christ is the

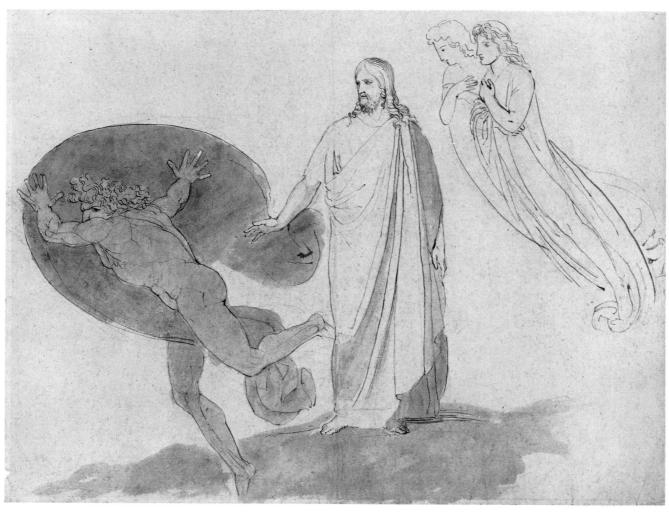

18

central figure, but the iconography is unusual. The presence of the watching angels suggests a Swedenborgian source, perhaps influenced by the fact that Flaxman in 1784 joined the Theosophical Society to propagate the writings of Emanuel Swedenborg. Blake and Flaxman were closest in this period, both artistically and in their concern with spiritual religion. Flaxman remained a Swedenborgian all his life, while Blake only associated himself with the movement briefly around 1789. Flaxman may have directed Blake towards Swedenborgian ideas, especially that of the centrality of Jesus, expressed in the *Songs of Innocence*. There is a similarity between the angels here and those in the decorative background of *Ezekiel* (No. 14).

RICHARD COSWAY

19 The Deposition

> Pencil, pen, red chalk and grey wash, 9 × 7
> (227 × 178)
> *Yale Center for British Art, Gift of Mr and Mrs
> Stuart P. Feld*

Chiefly known as a miniaturist and fashionable portraitist, Richard Cosway (1742–1821) had also a passionate interest in religion and the occult. He owned a collection of manuscripts of Böhme translations (see No. 4) and he knew Blake as a boy when he taught at the Pars Academy. He remained in touch with Blake, and he was reported by Farington as speaking warmly of Blake's designs (Bentley, *Records*, p. 50). A group of drawings of religious subjects in the Yale Center is evidence of Cosway's 'Enthusiasm',

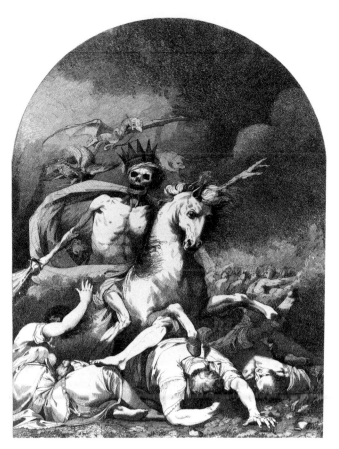

20

though their over-ripe Correggesque sentiment is far removed from Blake's style.

JOHN HAMILTON MORTIMER engr. by J. HAYNES

20 Death on a Pale Horse published 1784

> Etching, $27\frac{1}{8} \times 18\frac{3}{4}$ (689 × 477)
> Lit: J. Sunderland in *La Peinture romantique anglaise
> et les préraphaélites*, Paris, 1972, no. 198; *John
> Hamilton Mortimer*, exh. cat., Eastbourne, 1968,
> no. 44
> *Yale Center for British Art, Paul Mellon Collection*

The original design was exhibited at the Society of Artists in 1775, this etching being made some four years after the death of Mortimer (1741–79). This work is of importance in heralding a new sensibility in which horrific motifs can again play a part in religious imagery; the influence of Dürer and other German engravers can be seen in the motif of Death and the fiends accompanying him. A comparison with Blake's designs in the mid-1780s of apocalyptic and war themes (Nos. 12 and 13) and also with Benjamin West's *Death on a Pale Horse* of 1783 (ill. Bindman, *Artist*, pl. 25) defines Blake's place in relation to painters who attempted the Sublime mode. Blake later saw Mortimer along with Barry and Fuseli as a heroic figure who had stood out against Reynolds's attempt to suppress imaginative art in England.

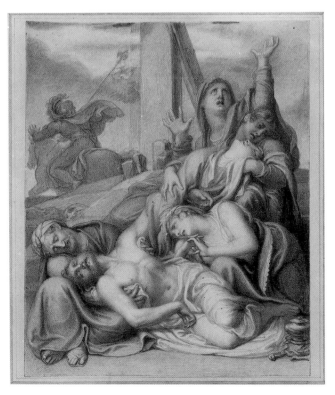

19

21 Job reproved by his Friends 1777

Etching and aquatint, $22\frac{3}{8} \times 29\frac{13}{16}$ (568 × 757)
Lit: William Pressly, *The Life and Art of James Barry*, 1981, pp. 78–81 and print cat. no. 10
Yale Center for British Art, Paul Mellon Collection

For the influence of this plate on Blake see No. 15. Pressly pairs this powerful print with Barry's *The Conversion of Polemon* (1778), arguing that Job represents the English Nation reproved by Edmund Burke, the dedicatee. On the other hand it might be argued that Job represents Barry (1741–1806) himself, at the moment of beginning work on the wall-paintings at the Adelphi against the advice of friends, perhaps including Burke. Certainly such an explanation could be expected in view of Barry's extreme touchiness towards Burke. This and other prints by Barry are important for Blake as works of creative printmaking which could conceal ideas beneath acceptable academic subject-matter.

The example of Barry as a major artist, forced into isolation supposedly by Reynolds and the artistic establishment, was also important for Blake: the extremism of Blake's statements on art in the *Annotations to Reynolds* and the *Descriptive Catalogue* must owe a lot to Barry's lectures to the Royal Academy (from which he was expelled in 1799), and perhaps to his conversation as an extremely embittered old man. Blake certainly met him before he died in 1806, and even contemplated writing a poem on his sad fate at the hands of Sir Joshua. (For Blake's references to Barry see K.445, and for a proposed extract from *Barry, a Poem*, see K.553.)

BENJAMIN WEST engr. by WILLIAM SHARP

22 The Witch of En-dor 1788

Engraving, $19\frac{3}{8} \times 25\frac{1}{2}$ (492 × 624)
Yale Center for British Art, Paul Mellon Collection

The original painting dates from 1777 (Wadsworth Athenaeum, Hartford, Conn.). West (1738–1820) tends to emphasize the horrific and supernatural elements of the scene, under the influence of Salvator Rosa and perhaps also Mortimer and Fuseli. In general West chose to adopt a Sublime mode for Old Testament subjects, and a Raphaelesque one for the New Testament. Blake's treat-

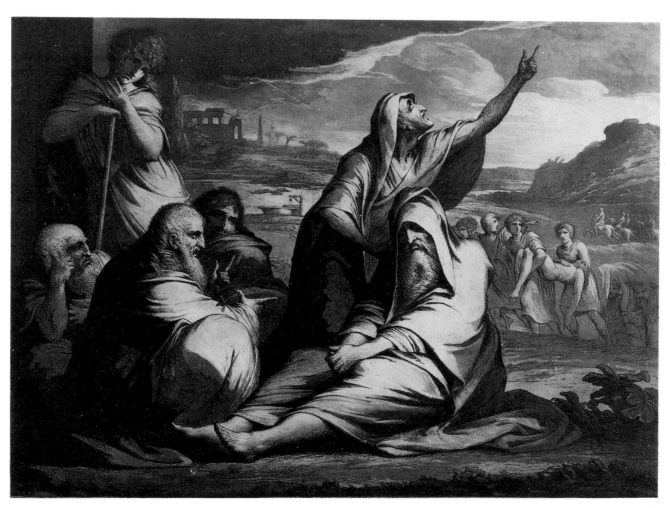

21

ment of the same subject (No. 11) is Raphaelesque and less dramatic than West's. It is interesting that a subject which might appear unfavourable to a king should have been painted by the 'Historical Painter to his Majesty'.

The engraver William Sharp, one of the most notorious 'Enthusiasts' of his day, is discussed in the Introduction, pp. 12–13.

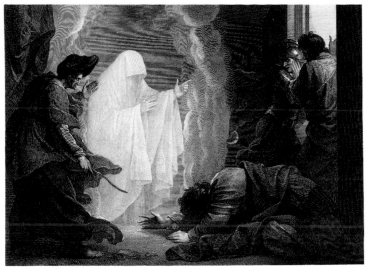

22

HENRY FUSELI engr. by P. SIMON

23 A Midsummer Night's Dream, Act IV, Scene 1 1796

Stipple engraving, $19\frac{1}{4} \times 24\frac{3}{4}$ (489×629)
Lit: Schiff, no. 753
Yale Center for British Art, Paul Mellon Collection

Engraved from a painting for Boydell's *Shakspeare Gallery* (see No. 16), now in the Tate Gallery, London. It is probable that Blake in this period was not especially impressed by Fuseli (1741–1825): the distinctive elements of Fuseli's style, fantasy and disjunction of scale, only make an impact on Blake's work in, for example, the frontispiece to *America* (No. 43). Blake's 'fairy' vocabulary

23

may owe something to the hobgoblins of Fuseli's Germanic imagination (see the watercolour of *Oberon and Titania*, No. 16), but whereas in Fuseli these tiny creatures parody man's baser desires, in Blake's art they are nature spirits who enact within all the orders of creation the drama of Fall and Redemption.

GEORGE ROMNEY

24 Study for John Howard Visiting a Lazaretto
c. 1790

Pencil, pen and wash, $11\frac{1}{4} \times 18\frac{5}{16}$ (285 × 466)
Lit: Patricia Jaffé, *Drawings by George Romney from the Fitzwilliam Museum*, 1977, nos. 94–100;
J. Hagstrum, 'Romney and Blake' in *Blake in his Time*, p. 201
Yale Center for British Art, Yale University Art Gallery Collection, Gift of Mr and Mrs J. Richardson Dilworth

Flaxman had shown Blake's drawings to Romney (1734–1802) in the early 1780s, and the latter had, with some exaggeration, claimed that 'his historical drawings rank with those of M Angelo' (Bentley, *Records*, p. 27). It is possible that Blake saw Romney's early large charcoal drawings of classical subjects (Walker Art Gallery, Liverpool), for their extremism of gesture does seem to affect his art of the 1780s.

Though better known as a portrait painter, Romney thought of himself as a History painter in the grand style, but failed to bring any of his immense conceptions to fruition. A series of paintings on Sublime and Miltonic subjects exists only in numerous rapid and unrestrained sketches of groups in action, indicating an energy that could find no outlet in oil painting. This drawing is one of many commemorating the great prison reformer John Howard, who had made 'perilous visits to the Lazarettos and prisons abroad'. Romney, like Blake, was initially sympathetic to the French Revolution, and this subject, as Mrs Jaffé points out, was a product of a phase of high enthusiasm for the prospect of liberty in Europe.

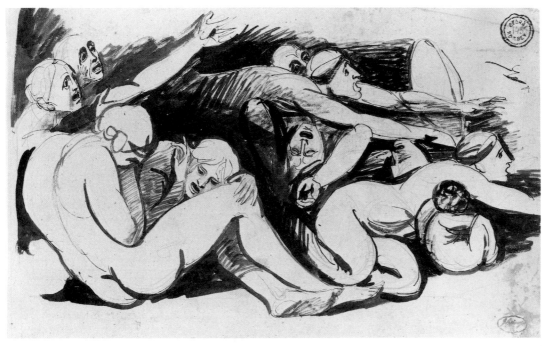

24

Making a Living: Reproductive Engraving

Blake served a full apprenticeship as a reproductive engraver, and it remained the basis of his livelihood. Most of the hundreds of engravings he made after other artists' designs are barely distinguishable from those of others working at the time, but occasionally his relationship to the designer was more than merely subservient. His range of techniques was greater than he admitted later; his vigorous defence, in the *Public Address*, of 'Old English engraving' did not stop him from practising some of the techniques he condemned. His professional experience as a publisher of reproductive prints formed the background to his own self-publication.

In this section a range of his different types of reproductive work is exhibited, but they are only a few examples of a very large output.

BLAKE after JEAN ANTOINE WATTEAU

25 Evening Amusement 2nd state, 1782

> Stipple engraving, $13 \times 14\frac{1}{8}$ (330 × 360)
> Inscr: 'Pub.d as the Act directs August 21 1782 by
> T. Macklin, No 39 Fleet Street', etc.
> Lit: Essick, *Separate Plates*, No. XXIII, 2B
> *Collection of Robert N. Essick*

One of a pair of plates, with *Morning Amusement*, engraved from two paintings by Watteau (probably copies of those in the Wallace Collection), and one of 5 known copies of the second state. The first separate plates engraved by Blake after his apprenticeship, the pair were made for Thomas Macklin, one of the best known publishers of the day (see Nos. 66, 67). Blake did some other prints for Macklin but the relationship did not flourish – because of Flaxman's malice, Blake claimed.

Stipple engraving was generally associated with purely decorative prints of the kind Blake later professed to despise; he became critical of the 'blurring' properties of a technique imitative of chalk drawings, comparing it unfavourably with the linear rectitude of Basire's line engraving (see No. 5).

BLAKE after THOMAS STOTHARD

26 Zephyrus and Flora 1784

> Stipple engraving, $9\frac{15}{16} \times 9\frac{15}{16}$ (252 × 252)
> Inscr: 'Published as the Act directs Decr 17. 1784
> by Parker & Blake No 27 Broad St Golden
> Square', etc.
> Lit: Essick, *Separate Plates*, no. XXVI, 2C
> *Collection of Robert N. Essick*

This plate is one of the two published by the short-lived

25

26

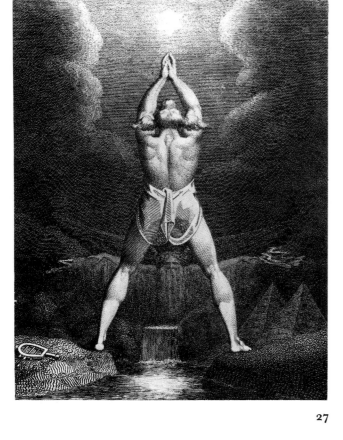

27

firm of Parker and Blake. James Parker (1750–1805) was an apprentice with Blake under Basire, and it is probable that the firm was set up after the death of Blake's father in 1784. It seems to have lasted three years. As Keynes suggests, the business was probably more print-selling than publishing. It was of central importance for Blake, being the first of his lifelong attempts to avoid the network of booksellers and print publishers like Macklin. It is ironical, however, that his first self-published works should be a pair of mildly erotic stipple engravings in the most despised manner of the London booksellers. Blake no doubt hoped to build up capital on the proceeds of a popular success. The attempt was a failure, and the prints are now very rare.

BLAKE after HENRY FUSELI

27 Fertilization of Egypt from Erasmus Darwin, *The Botanic Garden*, 1791

Engraving, $6\frac{1}{16} \times 7\frac{3}{4}$ (154 × 196)
Lit: Bentley, *Blake Books*, no. 450
Beinecke Rare Book and Manuscript Library, Yale University

The subject is an allusion to the annual flooding of the Nile. The jackal-headed god Anubis stands astride the river; above his head is the dog-star, Sirius, to the left a sistrum, to the right the Pyramids. A comparison with Fuseli's drawing in the British Museum makes it clear that Blake could take some liberties with the design he worked from; in this case he has emphasized the Urizen-like rain-god (Jupiter Pluvius) in the background. The book was published by Joseph Johnson, for whom Blake did much engraving in the 1790s.

BLAKE after HENRY FUSELI

28 Head of a Damned Soul 1787–88?

Etching and engraving, $16\frac{7}{8} \times 12\frac{5}{8}$ (430 × 320)
Inscr: in ink 'H. Fuseli R. A. Pinx, *Satan*, W. Blake Sculp.'
Lit: Essick, *Separate Plates*, no. XXXII, 1E;
 Essick, *Printmaker*, p. 61
Collection of Charles Ryskamp, New York

This spectacular print represents, in its most fully realized form, the 'dot and lozenge' technique that Blake would have learned from Basire. It exists only in proof impressions with pen or pencil attributions to Blake after Fuseli. It may be connected with the publication of J. C. Lavater's *Essays on Physiognomy* (1788–99), for the head appears there, described as a tortured sinner in Dante's *Inferno*, engraved by another artist. Blake's engraving is larger than any of the plates in that book, which might account for its rejection.

This foreshortened head became absorbed into Blake's vocabulary and appears again in the *Book of Job* (No. 115b.2) and Dante illustrations (No. 116h).

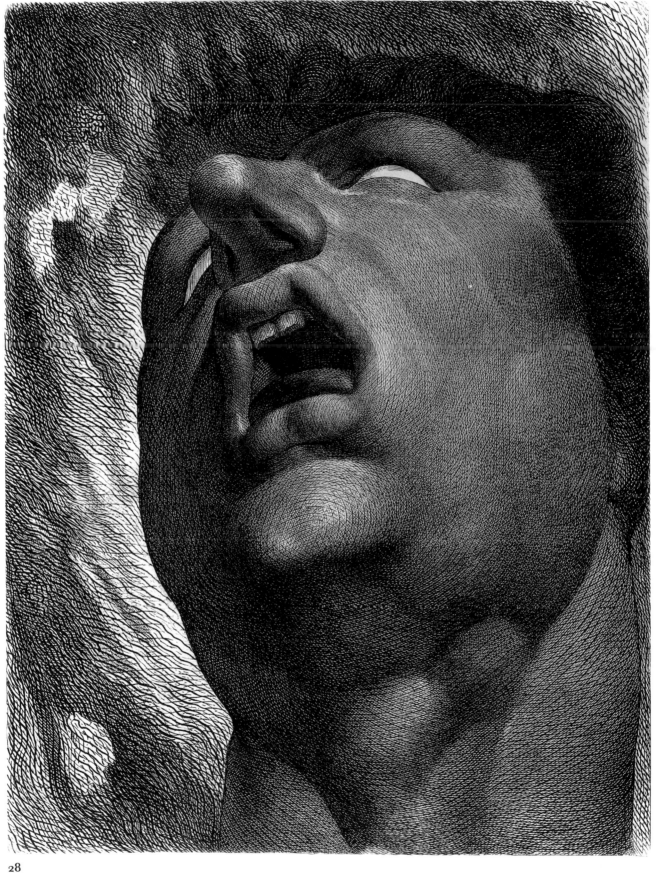

28

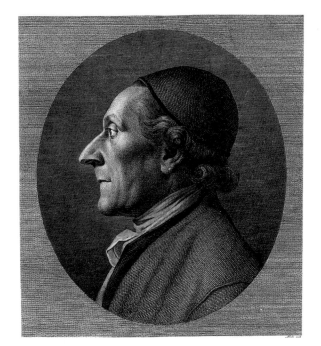

29

BLAKE after an unknown artist

29 Portrait of John Caspar Lavater 1787–1801

Etching and engraving, $14\frac{1}{2} \times 11\frac{5}{8}$ (368 × 295)
Inscr: 'Pub.^d May 1, 1800, by J. Johnson, in
Saint Paul's Church Yard, London, from a
Drawing in his Possession, taken in 1787' etc.
Lit: Essick, *Separate Plates*, no. XXIX; Essick,
Printmaker, p. 61
Yale Center for British Art, Paul Mellon Collection

This fine dot and lozenge print may, like No. 28, have
been made in connection with the 1788–99 edition of
Lavater's *Essays on Physiognomy*. The possibility that it was
a rejected frontispiece is strengthened by the recent
appearance, in Leo Steinberg's collection, of an early
state dated 1787. Like the *Head of a Damned Soul*, it is too
large to fit comfortably in Johnson's book as published.
The drawing Blake probably worked from is in the
Princeton University Library.

Johnson held onto the plate, and the present impression
is from a memorial edition printed after Lavater's death
in 1801.

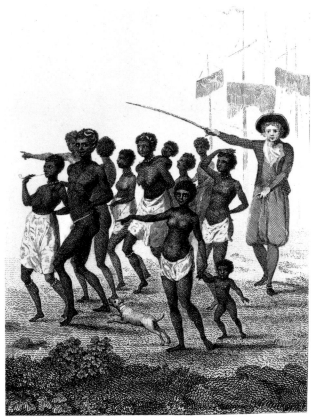

30

BLAKE after J. G. STEDMAN

**30 Group of Negros, as imported to be sold for
Slaves** from Stedman's *A Narrative of a five years
expedition against the Revolted Negroes of Surinam*, 1796

Engraving, $5\frac{1}{4} \times 7\frac{1}{8}$ (133 × 182)
Lit: Bentley, *Blake Books*, no. 499
*Beinecke Rare Book and Manuscript Library, Yale
University*

Blake's profession as an engraver and his work for Joseph
Johnson, the radical publisher, brought him into contact
with some congenial spirits, among them Captain Stedman, a soldier who had turned against the cruelties of
slavery and wrote a passionate book denouncing its
abuses. Blake was sympathetic to the cause and he and
Stedman became close friends for a time. Erdman
(*Prophet*, pp. 230–33) has argued strongly for the influence
of Stedman's book on *Visions of the Daughters of Albion*
(No. 42).

31 **Michelangelo** for Fuseli's *Lectures on Painting*, 1801

Pen drawing with pencil, $8\frac{1}{16} \times 6\frac{7}{16}$ (205 × 163)
Mounted with a proof of Blake's engraving,
$4\frac{5}{8} \times 2\frac{7}{8}$ (117 × 73)
Inscr: (by John Linnell) ' Mich:Angelo / by
 Fuseli / original Drawing had from Wm Blake'
Lit: Essick, *Printmaker*, pp. 51–53
Collection of Robert N. Essick

This, like No. 27, is an example of the freedom with which
Blake sometimes adapted Fuseli's designs when engraving
them: it seems probable that Blake added the legs in
pencil on the drawing and the Colosseum in the engraving
(*Fig. 28*). More profoundly, Blake has altered the whole
spirit of the drawing, making Michelangelo another
archetype of the inspired artist, the turbulence of his mind
expressed in the intense gaze and broken light around his
head. Michelangelo as a 'Gothic' artist is now a descen-
dant of Joseph of Arimathea in Blake's engraving (No. 2),
a true inheritor of the artists of 'the Dark Ages . . . of whom
the World was not worthy'.

The drawing may have been one of two by Fuseli bought
from Mrs Blake by Linnell in January 1829 (see Bentley,
Records, p. 596).

Fig. 28 Blake after Fuseli: *Michelangelo*, for Fuseli's *Lectures on Painting*, 1801, line engraving. Collection of David Bindman

31

Relief Etching and Experimental Printing, 1788–96

The aim of this section is to give an idea, as far as possible in visual terms, of the methods of relief etching and colour printing developed by Blake in the years 1788–96. All the copper plates used for Illuminated printing have been lost, with the single exception of a small battered fragment of a rejected plate (No. 34), and some electrotypes cast from plates for the *Songs of Innocence* (No. 33).

Relief etching involves printing from the raised surface, like letterpress, after the rest of the copper plate has been etched away; it is the opposite of intaglio engraving or etching, where the design is cut or bitten into the plate, and the ink is squeezed onto the paper. Used by Blake for both text and design, relief etching allowed the two to intermingle on the same plate, giving the artist as much freedom as if he were making an illuminated manuscript – an analogy that was not lost on Blake.

Colour printing occupied Blake intensively for only a short period, mainly in the years 1794–96. His method was essentially a monotype process, that is to say the colour was applied to a surface – according to Frederick Tatham, a piece of millboard, but perhaps in some cases a piece of copper (see No. 51) – and then printed onto the paper while the pigment remained wet. By this technique only three or four impressions at most could have been taken without recolouring the plate, and each of these impressions would require a different degree of strengthening with pen and watercolour. The amount of labour saved by the method was thus minimal, and Blake must have been drawn to it more for its expressive potential. In particular, density of colour could be achieved by exploiting the reticulation or web-like structure of the surface left by the printing plate, which allowed for strange and accidental effects, like the anemone-like forms in the background of *Newton* (No. 56b). The fact that he used the process most consistently in such 'dark' Prophecies as *Europe* and *The Book of Urizen* suggests that he associated it with the Fallen world. He seems to have regarded it as a kind of 'fresco' painting in the manner of early Italian art (see No. 51, which is inscribed 'Fresco'), and it looks forward to the development of his tempera painting technique which emerged in 1799.

The invention of relief etching and colour printing was inseparable from Blake's spiritual concerns, for it facilitated the production of Illuminated Books in which his profoundest thoughts could be expressed without fear of compromise or censorship. On the mundane level it is a further venture in self-publishing; on the spiritual level it marked his coming of age as a prophetic visionary. It is to be expected then that Blake should see his discovery of the method in visionary terms, as a divine gift through the agency of his beloved younger brother Robert, who had died after a long illness in 1787. According to J. T. Smith (Bentley, *Records*, p. 460),

> Blake, after deeply perplexing himself as to the mode of accomplishing the publication of his illustrated songs, without their being subject to the expense of letterpress, his brother Robert stood before him in one of his visionary imaginations, and so decidedly directed him in the way in which he ought to proceed, that he immediately followed his advice.

This section contains a number of trial proofs and cancelled plates which show the appearance of Blake's prints before he added watercolour and penwork to them, as he almost always did in finished works.

32 A Select Collection of English Songs, edited by Joseph Ritson 1783

Printed book, letterpress, with engravings after
 Thomas Stothard, including 8 by Blake
Engravings approx. 3 × 4 (76 × 100)
Lit: Bentley, *Blake Books*, no. 491
Yale Center for British Art, Paul Mellon Collection

Ritson's *Songs* is typical of much of the work Blake did after Stothard – small book illustrations for popular publications in a rococo style. This example shows what was normally required to combine text and design before Blake developed his method of relief etching. The printing of the design and the text are completely separate operations: the text is printed in ordinary letterpress, leaving a space at the top for the copper plate to be printed later on a different type of press. Text and illustration had to be conceived separately, with the design normally acting as head- or tailpiece. Blake's new method allowed the design to interweave through the text at will.

33 Electrotype of Songs of Innocence copper plate

Lit: Essick, *Printmaker*, pp. 94–97; Bentley, *Blake Books*, p. 381
Prof. G. E. Bentley, Jr., Toronto

This is a modern electrotype, cast from one of those made from 16 original copper plates in the mid-19th century for Gilchrist's *Life of Blake* (1863). The original plates are

VI

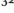

32

now lost. The text and design are printed from the surface of the copper, which is protected from the etching acid by a stopping-out solution, allowing the acid to eat away the parts which do not print. It is a laborious business to control the acid; the plate requires successive immersions and constant correction. Blake often used a burin to engrave the surface as well, and the final image was usually strengthened with pen and watercolour. For a detailed account of the process see Essick, *Printmaker*.

34 Fragment of cancelled plate for America

Copper plate (with impression from it), $3\frac{1}{4} \times 2\frac{1}{4}$ (82×58)
Lit: Bindman, *Graphic Works*, no. 164a(i); Essick, *Printmaker*, pp. 86–87, *passim*
National Gallery of Art, Washington, Rosenwald Collection, 1943

This is the only surviving piece of a relief-etched plate by Blake; all the others, with the exception of some *Songs of Innocence* plates (see No. 33), disappeared when in the possession of Mrs Blake's executor Frederick Tatham shortly after 1832, after he had printed from many of them. This fragment, which is much damaged, was cut by Blake for scrap and was given to his pupil Tommy Butts who engraved a design on the other side. It is shallowly bitten and

was abandoned early in the development of *America*. See the following entry for the plate before it was cut.

35 A Prophecy, one of three cancelled impressions for America

Relief etchings (bound in volume), approx. $9\frac{1}{4} \times 6\frac{9}{16}$ (233×165)
Lit: Bindman, *Graphic Works*, nos. 164a, 166c; Essick, *Printmaker*, pp. 93–94
The Library of Congress, Washington, Rosenwald Collection

The first cancelled impression, the one exhibited, is of particular interest because it was taken from the copper plate of which a fragment survives (No. 34), before it was cut. Essick, in drawing attention to the shallow biting of the copper fragment, notes that Blake could nevertheless print a reasonably clear impression from it. From this and other evidence he argues that the relief-etched plates were in general quite shallowly bitten.

Keynes has proposed that the three cancelled impressions are continuous, representing an earlier beginning to the book. The substantial changes between these three plates and the final printing of *America* suggest that Blake allowed the shape of the book to evolve as he printed it.

36 Proof for Europe, plate 10 c. 1794

Relief etching, $9\frac{1}{16} \times 6\frac{1}{2}$ (231×166)
Lit: Bindman, *Graphic Works*, no. 178
Philadelphia Museum of Art: Print Club Permanent Collection

A trial proof of the plate printed before additions in pen and watercolour, or colour printing. For a finished impression, see *Fig. 12*.

37 Titlepage, one of three proofs for The Book of Urizen 1794

Relief etchings, colour-printed (bound in volume), $5\frac{3}{4} \times 4\frac{1}{16}$ (147×103)
Lit: Bentley, *Blake Books*, copy H; Essick in *Blake Quarterly*, XV, no. 1, pp. 11–12
Beinecke Rare Book and Manuscript Library, Yale University, Gift of Charles J. Rosenbloom, 1970

The title page to *The Book of Urizen* is a rare example of a half-finished colour-printed plate. Blake has printed the relief etching and added the colour printing, but not the final touches. He has left white areas, especially in the eyes, to be finished in pen and watercolour, and he would have given greater definition to the figure with pen.

The reticulation caused by the colour-printing is particularly striking in this plate. See No. 45 for a range of different colour printings of this book.

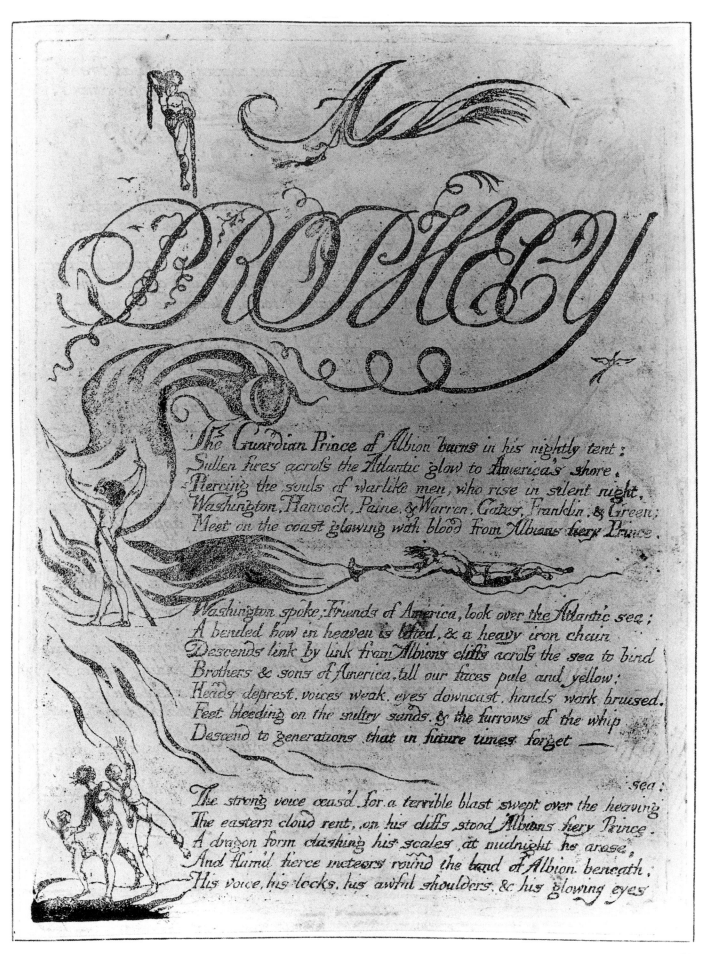

A PROPHECY

The Guardian Prince of Albion burns in his nightly tent:
Sullen fires across the Atlantic glow to America's shore,
Piercing the souls of warlike men, who rise in silent night,
Washington, Hancock, Paine, & Warren, Gates, Franklin, & Green;
Meet on the coast glowing with blood from Albions fiery Prince.

Washington spoke; Friends of America, look over the Atlantic sea;
A bended bow is lifted in heaven, & a heavy iron chain
Descends link by link from Albions cliffs across the sea to bind
Brothers & sons of America, till our faces pale and yellow;
Heads deprest, voices weak, eyes downcast, hands work bruised,
Feet bleeding on the sultry sands, & the furrows of the whip
Descend to generations that in future times forget. ——

 sea:
The strong voice ceas'd; for a terrible blast swept over the heaving
The eastern cloud rent; on his cliffs stood Albions fiery Prince
A dragon form clashing his scales at midnight he arose,
And flam'd fierce meteors round the land of Albion beneath;
His voice, his locks, his awful shoulders, & his glowing eyes

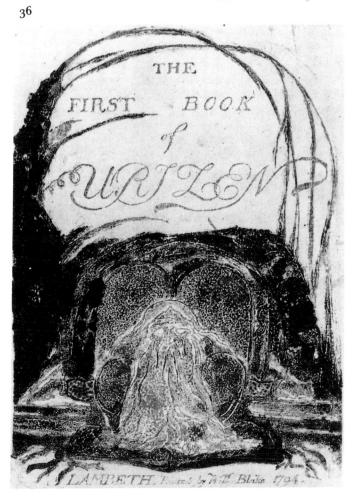

Albions Angel rose upon the Stone of Night.
He saw Urizen on the Atlantic;
And his brazen Book.
That Kings & Priests had copied on Earth
Expanded from North to South.

36

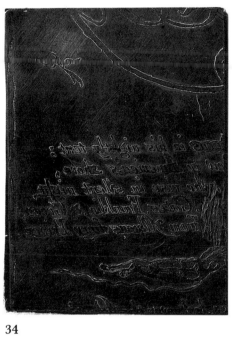

34

THE
FIRST BOOK
of
URIZEN

LAMBETH. Printed by Will Blake 1794.

37

Illuminated Books and Prophecies, 1788–95

Blake used Illuminated printing to produce philosophical, poetic and Prophetic books. The first ones, the incomplete tracts *There is no Natural Religion* and *All Religions are One*, the *Songs of Innocence* and *The Book of Thel*, were probably completed before 1790. They are less urgent in tone than those of 1790 onwards, beginning with *The Marriage of Heaven and Hell* and ending probably with *The Book of Los* and *The Book of Ahania*. The division reflects the growing awareness in England of the convulsive nature of the French Revolution, the dawn of a new age characterized by Fuseli as early as December 1789 as one 'pregnant with the most gigantic efforts of character, shaken with the convulsions of old, and the emergence of new empires: while an unexampled vigour seemed to vibrate from pole to pole through the human mind, and to challenge the general sympathy' (quoted in *Henry Fuseli*, exh. cat., Tate Gallery, London, 1975, p. 47).

There is no Natural Religion is represented by an incomplete copy of one of the two series of plates grouped under this title, and a unique plate from the Morgan Library. *Songs of Innocence* is represented by three copies – the first almost certainly coloured and issued soon after the first printing, the second dating from after 1800, and a combined *Songs of Innocence and of Experience* from Blake's later years. *The Book of Thel*, *The Marriage of Heaven and Hell*, and *Visions of the Daughters of Albion* are all represented by copies printed by Blake at the time of their conception and delicately finished in watercolour by him. The splendid copy of *America*, displayed in full, is unusual for this work in being coloured, probably some seven years after its first printing in 1793. All the other Prophetic Books in this section, with the exception of one copy of *The Book of Urizen*, are colour-printed. Five copies of *The Book of Urizen* are displayed to show the extraordinary range of expression that Blake could achieve with his newly-invented medium. The rarer Prophetic Books, *The Song of Los* and *The Book of Ahania*, the latter etched in intaglio not relief, are represented by detached plates.

The first cycle of Prophecies comes to an end about 1796. Beginning with *America*, they could be seen to make up what Blake called his 'Bible of Hell', presenting in fragmentary form a complete myth of human history, the implications of which are discussed briefly on pp. 17ff.

38 There is no Natural Religion *c.* 1788

Relief etchings with additions in pen and wash, approx. $2\frac{1}{8} \times 1\frac{9}{13}$ (55 × 40)

Though incomplete, the two tracts grouped under the title of *There is no Natural Religion* (series A and B) and *All Religions are One* (unique copy in the Huntington Library, San Marino) are a direct assault on Deism, in the form of a series of propositions demonstrating the existence of the world beyond the senses, and associating the Poetic Genius with the Spirit of Prophecy. The tracts seem not to have been issued at the time of their etching: all known copies appear to have been printed later, and left as loose sheets by Blake. They are usually taken to be Blake's first attempts to unite text and design through relief etching, and to predate the *Songs of Innocence*.

a 11 plates on 11 leaves: 8 from series A, 3 from series B
Lit: Keynes and Wolf, copy B; Bentley, *Blake Books*, no. 443
Mr and Mrs Paul Mellon, Upperville, Va.

A characteristic mixed copy, combining a near complete set of series A with three additional plates from series B. According to Keynes it, like some others, was made up from a bundle of 50 plates 'for a very small work', sold anonymously at Sotheby's on 29 April 1862, and bought by R. Monckton Milnes, whose crest adorns the cover. This copy contains relatively little colour except in the frontispiece, but all plates have some pen or wash. The watermark is certainly later than 1788; the printing may even have been done after 1811, the date of the watermark on some other copies.

38a

b Series B: *Application* plate
 Lit: Keynes and Wolf, copy G, but this plate added
 to it from copy L; Bentley, *Blake Books*, pp. 445–46
 The Pierpont Morgan Library, New York

This plate is unique. It was given by Sir Geoffrey Keynes
to the Morgan Library to complete their copy, to which
it originally belonged. The motif of the man of reason,
whose vision is circumscribed by science and who thus
'sees himself only', is an important foreshadowing of the
great *Newton* Colour Print of 1795 and later (No. 56).

39 Songs of Innocence and of Experience
 1789–94

Songs of Innocence is a collection of pastoral poems, some of
which probably date from very early in Blake's career.
They can be read as children's poems, but they subsume
profound meditations upon the state of childhood and the
presence of Christ. The influence of Swedenborg has often
been noted. *Songs of Experience* was added to it in 1794,
many of the poems being counterparts from the Fallen
world of poems in *Innocence*.

 The order, colouring and medium of the combined
Songs of Innocence and of Experience underwent great varia-
tion in the many copies Blake produced into his final years.
Only in the 1820s do they settle into a fixed order; until
then at least three of the plates alternate between *Inno-
cence* and *Experience*. It was the one Illuminated Book to
sell fairly steadily throughout Blake's life, and he seems to
have been prepared to print copies to order.

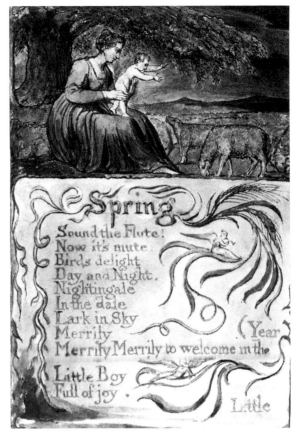

39c

a *Songs of Innocence*, c. 1789–90 (bound with separate Pl. I
 copy of *Songs of Experience*, c. 1794)
 48 plates on 34 leaves
 Relief etchings with watercolour, approx. $4\frac{1}{2} \times 3$
 (115×77)
 Lit: Keynes and Wolf, *Songs of Innocence and of
 Experience*, copy F; Bentley, *Blake Books*,
 pp. 414–15
 Yale Center for British Art, Paul Mellon Collection

Though catalogued by Keynes and Wolf and by Bentley
among the combined copies of *Songs of Innocence and of
Experience*, this consists of a separately issued copy of
Songs of Innocence, almost certainly printed and coloured
before 1794, to which has been added a colour-printed
and incomplete copy of *Songs of Experience*. The two books
were probably bound together in the 1830s at the earliest,
for George Cumberland's signature, on the reverse of the
frontispiece to *Experience*, has been cut through in binding
the volumes together.

 The *Songs of Innocence* is a characteristic and exception-
ally fine early copy, printed in green with delicate water-
colour washes. In early coloured copies the watercolour
is normally used as a tint to the main image and the text
area is untouched. Such tinting gives a certain austerity
to the images, emphasizing the classicism of the figures.

38b

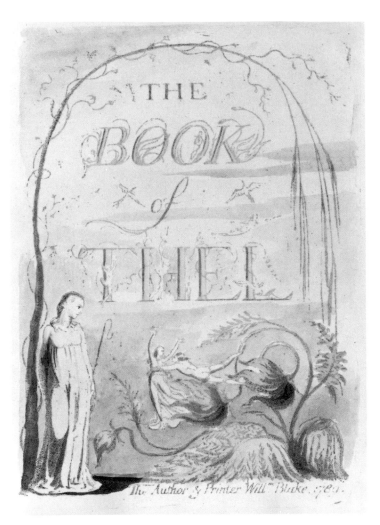

40 (titlepage)

outlined the forms in pen, and the colour is much fuller and more atmospheric. The cool luminosity which pervades the design and the text areas is quite unusual; it is carried out with great care and sensitivity, perhaps in response to Malkin's sympathetic interest in Blake's work.

> **c** *Songs of Innocence and of Experience, c.* 1815–25
> 54 plates on 54 leaves
> Relief etchings with pen, watercolour and gold,
> approx. $4\frac{1}{2} \times 3$ (115 × 77)
> Lit: Keynes and Wolf, copy U; Bentley, *Blake
> Books,* pp. 421–22
> *The Library, Princeton University*

A magnificent example of late printing of the combined edition, dating from at least 1815, and perhaps later. Like others of Blake's later years it is printed in orange (see *Jerusalem,* No. 99). The colour is built up with the utmost richness, with heightening in gold. The relatively large number of copies coloured in this elaborate way suggests that the book had something of a revival after 1815. This copy may have been bought originally by James Boswell, the son of the biographer, and it later belonged to William Beckford, to whose medieval taste it might have appealed.

The effect is more like a tinted drawing or aquatint of the late 18th century, compared with the opulence of the two following copies. The simplicity of these early copies is arguably more in sympathy with the poems.

> II **b** *Songs of Innocence,* 1802–05
> 26 plates on 26 leaves
> Relief etchings with pen and watercolour, approx.
> $4\frac{1}{2} \times 3$ (115 × 77)
> Lit: Keynes and Wolf, copy P; Bentley, *Blake
> Books,* p. 409
> *Beinecke Rare Book and Manuscript Library, Yale
> University*

The printing and colouring of this copy can be dated with fair precision because some pages have a watermark of 1802, and it was given in 1805 by Benjamin Heath Malkin (see No. 7) to Thomas Johnes of Hafod. The changes brought about by the use of pen and watercolour are striking if it is compared to an early copy of the book: in harmony with his renewed concern with outline in this period (see the Introduction, p. 39), Blake has carefully

40 The Book of Thel 1789

> 8 plates on 8 leaves
> Relief etchings with pen and watercolour, approx.
> $6 \times 4\frac{1}{8}$ (152 × 104)
> Lit: Keynes and Wolf, copy B; Bentley, *Blake
> Books,* pp. 125–26
> *Mr and Mrs Paul Mellon, Upperville, Va.*

The Book of Thel is a pastoral poem telling of the maiden Thel's journey of self-discovery through the Vales of Har; there she questions the Lily-of-the-Valley, the Cloud, the Worm, and the Clod of Clay, who lead her towards Experience, which she rejects, seeking refuge back in the valley. The theme is analogous in some respects to *Tiriel* (No. 17).

With its sparse and delicate colouring, this is a characteristic early printing of the book, probably dating from shortly after 1789, the same time as the early *Songs of Innocence* (No. 39a). The original owner is not known but it was acquired later by Richard Monckton Milnes. Yale is particularly rich in copies of *The Book of Thel*: there are two in the Beinecke Library, including one owned and apparently extensively used by Thomas Stothard (copy E), and another in the Center for British Art. Some fifteen copies altogether are known, most of which were printed about 1789–90, suggesting that it was initially as popular as *Songs of Innocence.*

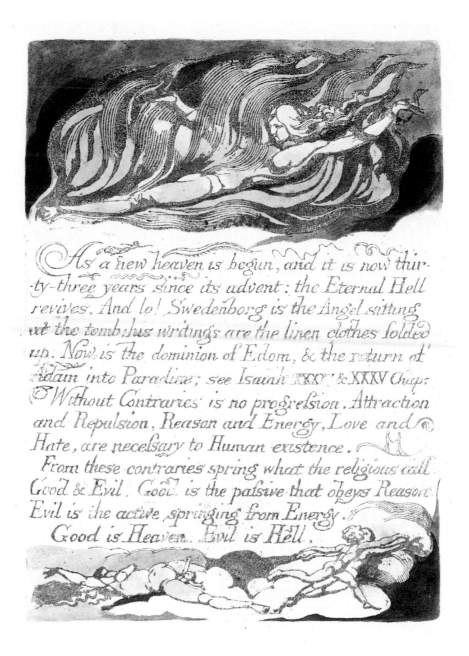

41 (plate 3)

41 The Marriage of Heaven and Hell *c.* 1790–93

27 plates on 15 leaves
Relief etchings with watercolour, approx. 6 × 4
 (153 × 102)
Lit: Keynes and Wolf, copy C; Bentley, *Blake
 Books*, p. 298
The Pierpont Morgan Library, New York

The Marriage of Heaven and Hell is, in the form of journey of
discovery, a satire upon Swedenborg's *Heaven and Hell*, and
a renunciation of Blake's own commitment to Sweden-
borgianism. The prophetic Song of Liberty, with the
promise of 'The Bible of Hell: which the world shall have
whether they will or no', looks forward to the Prophecies
of 1793 and later.

This is one of the earliest copies of the book, giving a
quite different impression from the more familiar and
flamboyant late coloured versions. The sparsity of the
colouring suggests a date near to 1790, like the early *Songs
of Innocence* (No. 39a) and *The Book of Thel* (No. 40). Only
nine complete copies of the book are recorded. The early
owners of this one are not known.

42 Visions of the Daughters of Albion 1793

11 plates on 6 leaves
Relief etchings with watercolour, approx. $6\frac{1}{2} \times 4\frac{5}{8}$
 (165 × 118)
Lit: Keynes and Wolf, copy I; Bentley, *Blake
 Books*, p. 475
Yale Center for British Art, Paul Mellon Collection

Visions of the Daughters of Albion tells of the sexual alienation of the Fallen world through the tragic and inconclusive story of Oothoon, the freedom-seeking heroine, and her triangular relationship with Theotormon and Bromion, who represent respectively emotion and reason. Their interdependence and the slavery of the children of Albion are represented in the powerful frontispiece, which is sometimes also bound in at the end. See No. 58 for the possible influence of Mary Wollstonecraft on the ideas expressed in the book.

 This seems to be an early printing; the colouring appears to be autograph though it is a little crude. Seventeen copies are known, most of them issued before 1800. The original owners of this copy are not known; it is likely that it is the one sold by Sir William Tite in 1874.

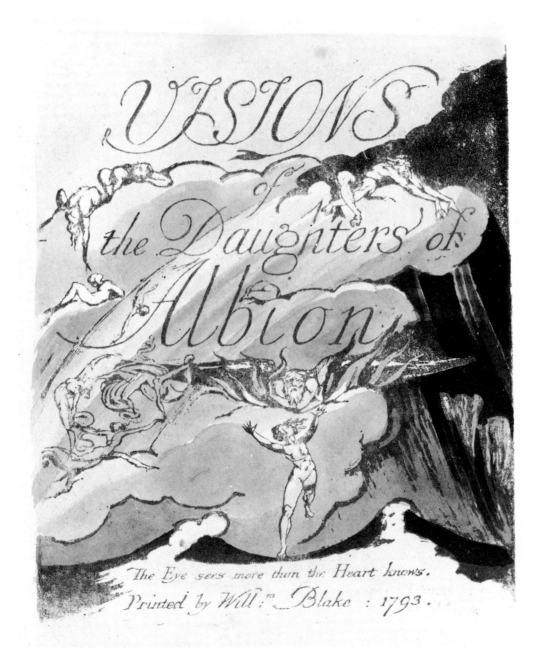

42 (titlepage)

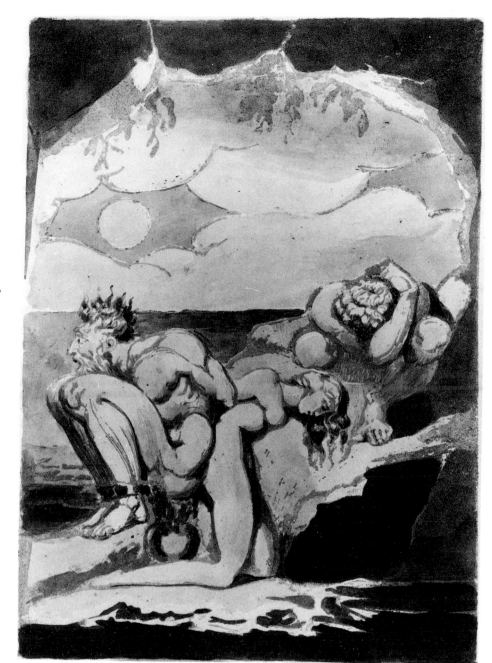

Fig. 29 Blake: frontispiece to *Visions of the Daughters of Albion* (showing Bromion, Oothoon and Theotormon), copy A, *c.* 1793, relief etching with watercolour. British Museum, London

43 **America a Prophecy** 1793

18 plates on 18 leaves, mounted separately
Relief etchings with pen and watercolour, approx.
9 × 6⅝ (229 × 168)
Lit: Keynes and Wolf, copy M; Bentley, *Blake Books*, p. 104
Mr and Mrs Paul Mellon, Upperville, Va.

America is the first of the full-scale Prophecies of the 1790s. It tells the story of the cosmic outbreak of Energy, in the form of the American Revolution, personified by Orc, who confronts the reactionary powers of the Fallen world in the guise of 'Albion's Angel', otherwise Urizen. It was often issued together with *Europe a Prophecy* (No. 44).

This is a magnificent copy, coloured in a strong yet restrained manner, probably shortly after 1799, the date of some of the watermarks. Most versions of *America*, and especially the early printings, were issued in monochrome and printed darkly. The essential coolness of the colours may be compared with the Malkin *Songs of Innocence* II (No. 39b), which may not be distant in date. The first recorded owner of this copy was Richard Monckton Milnes.

The Beinecke Library also has an interesting copy of *America* (copy K), which has a tantalizingly unsubstantiated tradition attached to it that it belonged to Benjamin West. It is perfectly possible that Blake would have presented a copy to the President of the Royal Academy, who certainly knew of his Prophetic work, but it cannot be proved that he did so.

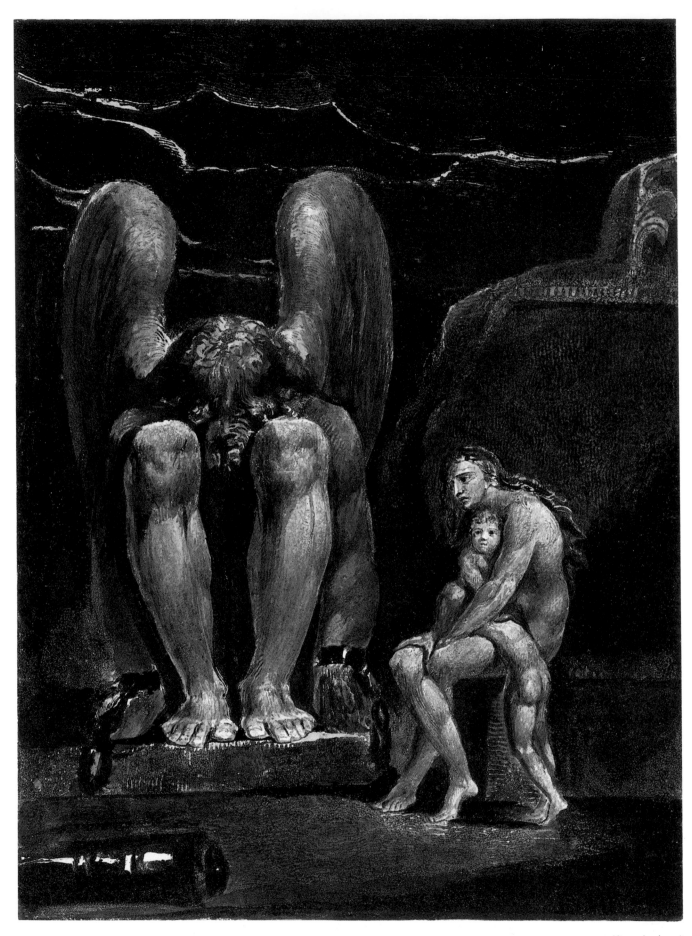

43 (frontispiece)

AMERICA

PROPHECY

LAMBETH
Printed by William Blake in the year 1793

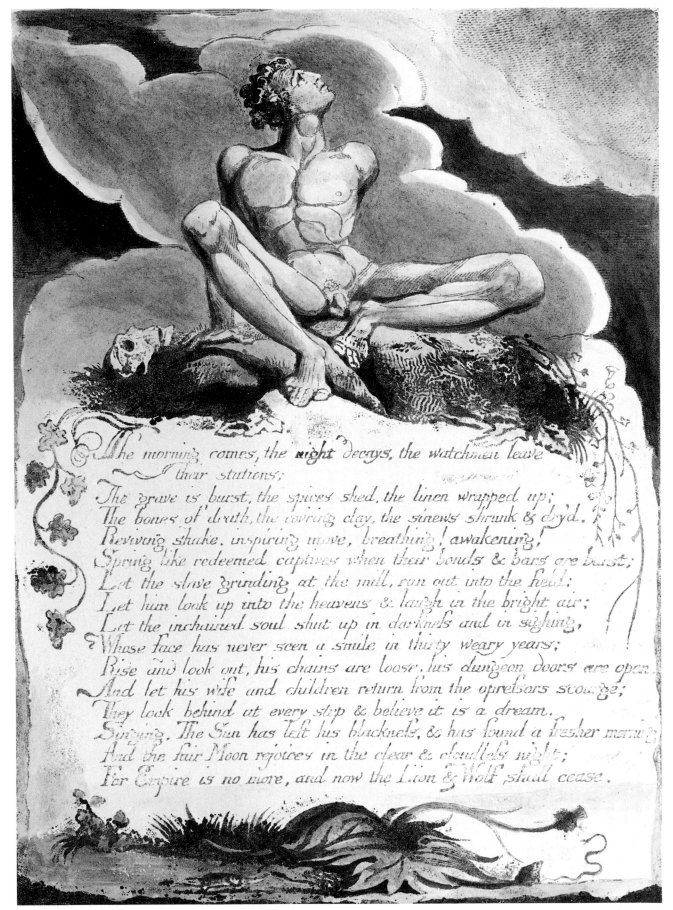

The morning comes, the night decays, the watchmen leave
 their stations;
The grave is burst, the spices shed, the linen wrapped up;
The bones of death, the cov'ring clay, the sinews shrunk & dry'd.
Reviving shake, inspiring move, breathing! awakening!
Spring like redeemed captives when their bonds & bars are burst;
Let the slave grinding at the mill, run out into the field:
Let him look up into the heavens & laugh in the bright air;
Let the inchained soul shut up in darkness and in sighing,
Whose face has never seen a smile in thirty weary years;
Rise and look out, his chains are loose, his dungeon doors are open.
And let his wife and children return from the opressors scourge;
They look behind at every step & believe it is a dream.
Singing, The Sun has left his blackness, & has found a fresher morning
And the fair Moon rejoices in the clear & cloudless night;
For Empire is no more, and now the Lion & Wolf shall cease.

Thus wept the Angel voice & as he wept the terrible blasts
Of trumpets, blew a loud alarm across the Atlantic deep.
No trumpets answer; no reply of clarions or of fifes,
Silent the Colonies remain and refuse the loud alarm.

On those vast shady hills between America & Albions shore;
Now barrd out by the Atlantic sea: calld Atlantean hills:
Because from their bright summits you may pass to the Golden world
An ancient palace, archetype of mighty Emperies.
Rears its immortal pinnacles, built in the forest of God
By Ariston the king of beauty for his stolen bride.

Here on their magic seats the thirteen Angels sat perturbd
For clouds from the Atlantic hover o'er the solemn roof.

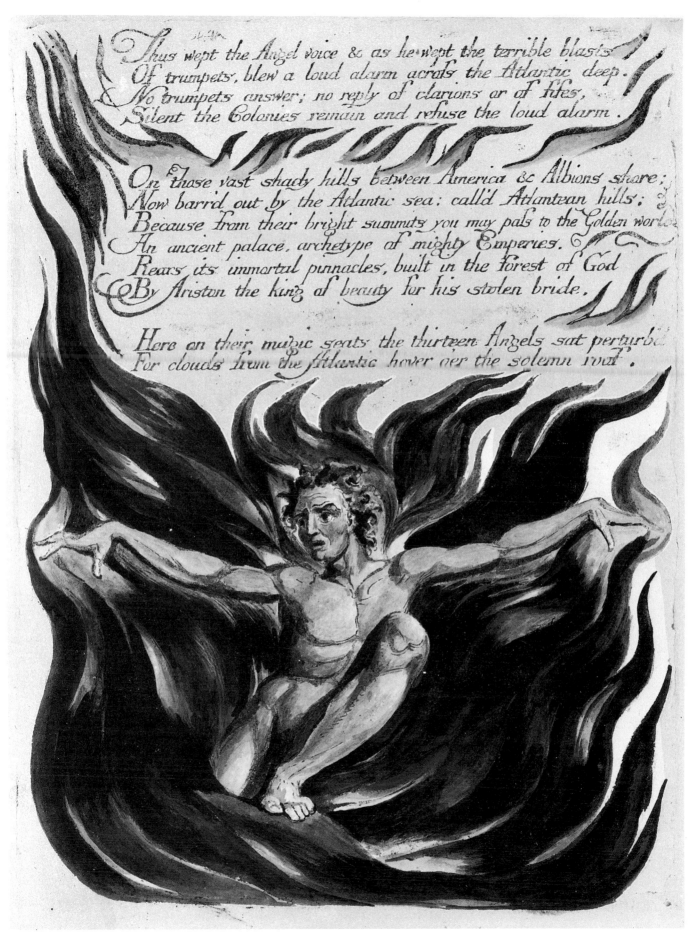

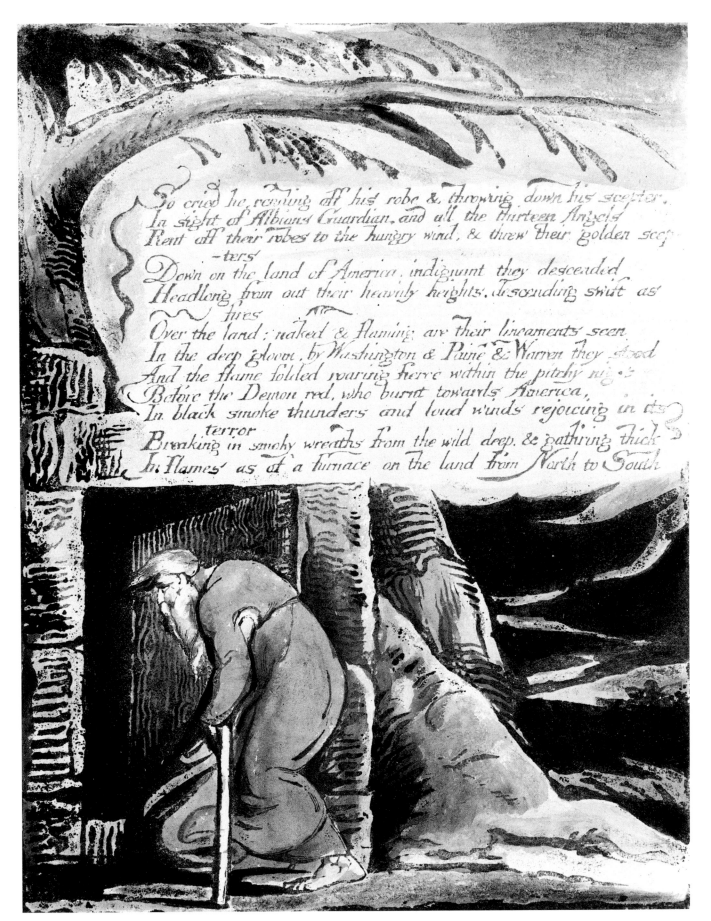

So cried he, rending off his robe & throwing down his scepter.
In sight of Albions Guardian, and all the thirteen Angels
Rent off their robes to the hungry wind, & threw their golden scep
 -ters
Down on the land of America, indignant they descended
Headlong from out their heavnly heights, descending swift as
 fires
Over the land; naked & flaming are their lineaments seen
In the deep gloom, by Washington & Paine & Warren they stood
And the flame folded roaring fierce within the pitchy night
Before the Demon red, who burnt towards America,
In black smoke thunders and loud winds rejoicing in its
 terror
Breaking in smoky wreaths from the wild deep, & gathring thick
In flames as of a furnace on the land from North to South

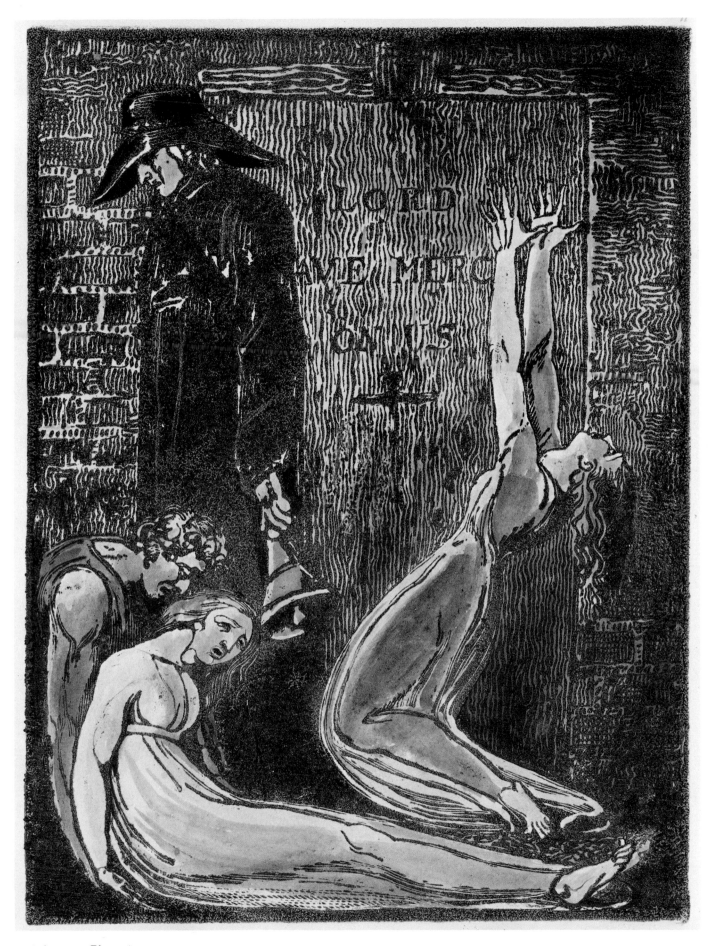

44 (plate 11: Plague)

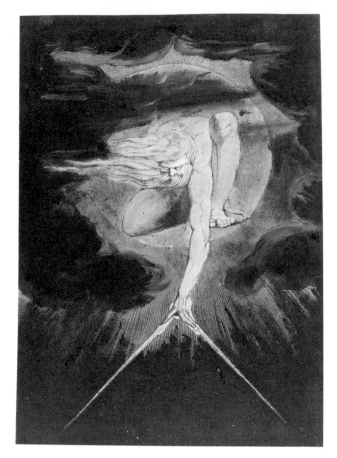

44 (frontispiece: Urizen)

44 Europe a Prophecy 1793

17 plates on 17 leaves
Relief etchings, colour-printed, with wash and
 watercolour, approx. $9 \times 6\frac{1}{2}$ (230 × 165)
Lit: Keynes and Wolf, copy A; Bentley, *Blake
 Books*, pp. 156–57
Mr and Mrs Paul Mellon, Upperville, Va.

Europe follows *America* and was often bound with it by
Blake. The main action concerns the period in Europe's
history before the revolutions of Blake's time, 'the 1,800
year sleep of Enitharmon' since Christ's Incarnation, the
message of which was suppressed by the Church. It is
grave in tone, and the illustrations, many of which occupy
the whole plate, present a litany of the miseries of the
Fallen world and, in historical terms, of the Ancien
Régime: Plague, Famine, Terror, Blight, and Imprison-
ment. These powerful images do not refer to the text
directly, but provide a commentary on the consequences
of the allegorical action of the book. Some of the imagery
may have been influenced by Northcote's painting of
The Entry into the Bastille, engraved by Gillray in 1790.
Plague (plate 11), with the memorable figure of the bell-
man, goes back to an early design by Blake (No. 12).
 The present copy was probably bought directly from
Blake by Isaac D'Israeli, and inherited by his son Ben-
jamin, later Earl of Beaconsfield. It is partially colour-

printed, with bold additions in opaque watercolour that
may have been touched up by another hand. Bentley
(p. 147) claims the style of the colouring to be 'about
1805', but in fact it seems to belong to the mid-1790s.
There are watermarks of 1794. Only twelve complete
copies of the book are known, dating mostly from the
1790s.
 For plate 10 see No. 36 and *Fig. 12*. For *Famine* (plate 6)
see *Fig. 6*.

45 The [First] Book of Urizen 1794

Relief etchings, colour-printed, with pen and
 watercolour, except **d**, which is not colour-printed
 but is finished with pen, watercolour and gold,
 approx. 6×4 (153 × 102)

The Book of Urizen is the Genesis in Blake's 'Bible of Hell',
describing the initial division of man, with consequences
that are explored in the later books. Reason in the form of
Urizen separates from the other elements of the human
mind, and Los the eternal artist takes on the task of giving
him form, so that his nature may be recognized by
humanity. Los's struggle to give form to Urizen is the

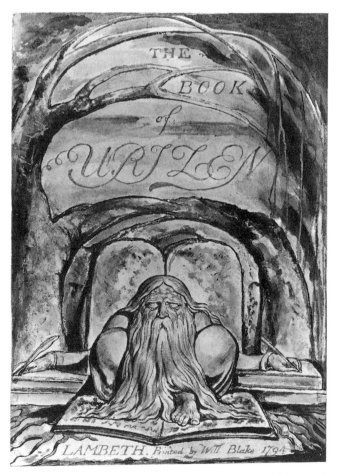

45d (titlepage)

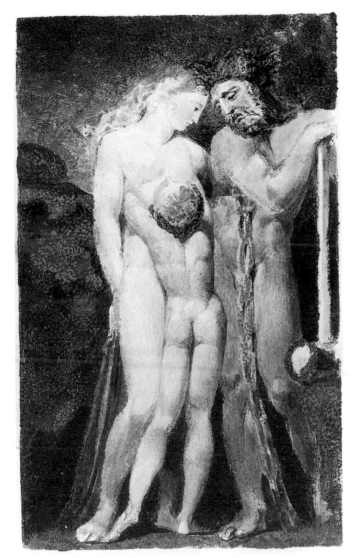

45c (plate 23: Los at the forge with Enitharmon and Orc)

d 27 plates on 27 leaves
Lit: Keynes and Wolf, copy G; Bentley, *Blake Books*, p. 182
The Library of Congress, Washington, Rosenwald Collection
e 25 plates on 25 leaves
Lit: Keynes and Wolf, copy C; Bentley, *Blake Books*, p. 181
Yale Center for British Art, Paul Mellon Collection

Five of the seven known copies of *The Book of Urizen* are represented in the exhibition, giving an unparalleled opportunity to observe the different effects of Blake's colour printing, and also to compare the colour-printed copies with the only known fully watercoloured version (**d**). An unfinished proof plate from *Urizen* is also exhibited (No. 37).

The Mellon (**a**) and Morgan Library (**b**) copies alone have the full complement of 28 plates: the Rosenwald copy (**d**) has 27, the Houghton (**c**) 26, the British Art Center (**e**) 25. The order of every known copy is also different (see the table in Bentley, *Blake Books*, pp. 168–

central action of the book; in feeling pity for his creation, Los himself divides, becoming enslaved to his own creation. In this book revolutionary energy in the form of Orc is born and chained to the rock; meanwhile Urizen, now fully formed, imprisons the spirit of man in 'a Net of Religion'.

III, IV **a** 28 plates on 28 leaves
Lit: Keynes and Wolf, copy A; Bentley, *Blake Books*, p. 180
Mr and Mrs Paul Mellon, Upperville, Va.
b 28 plates on 28 leaves; titlepage only exhibited
Lit: Keynes and Wolf, copy B; Bentley, *Blake Books*, pp. 180–81
The Pierpont Morgan Library, New York
c 26 plates on 26 leaves; 10 plates exhibited at Yale only
Lit: Keynes and Wolf, copy F; Bentley, *Blake Books*, pp. 181–82
The Houghton Library, Harvard University

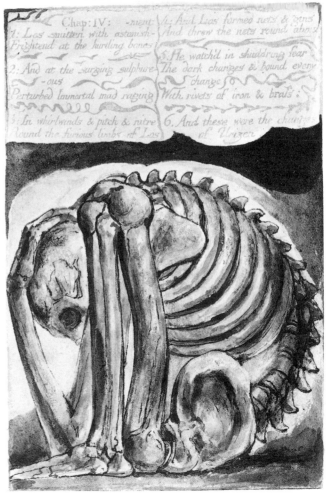

45c (plate 11: the skeletal form of Urizen)

69). The Mellon copy seems to have been reshuffled by a late owner so its order should not be taken as canonical.

The colour-printed copies were probably finished in the years 1795–96, but the magnificent watercolour version (**d**; the titlepage now worded just *The Book of Urizen*) must be after 1815 (watermark) and in all probability was not completed until the early 1820s, for it is close in finish to the coloured *Jerusalem* (No. 99). The Morgan copy (**b**) is only lightly colour-printed with much use of watercolour, allowing the relief-etched lines to carry the expressive weight of the design. The Mellon and Houghton copies (**a, c**) by contrast use the colour printing to the full, and are remarkable for the sombre and mysterious effects created by the reticulation of the colour. The Rosenwald copy (**d**), on the other hand, is more linear, and its seductive colour and atmosphere present, perhaps against the grain of the text, an inescapably optimistic vision.

The original owner of the Mellon copy (**a**) may have been the first Baron Dimsdale; the Morgan copy (**b**) seems to have been bought from Blake himself by Isaac D'Israeli (see No. 44); the Houghton copy (**c**) belonged to Blake's friend George Cumberland; and the owners of the Rosenwald copy (**d**) are not traceable before it was acquired by Richard Monckton Milnes in 1852.

For a detail of the titlepage of the Morgan copy (**b**) see *Fig. 4*, and for a detail of plate 18 see *Fig. 21*.

46 The Song of Los 1795

8 plates on 8 leaves; 2 exhibited: frontispiece, and plate 5, *A King and Queen on a Lily*
Relief etchings, colour-printed, with pen and watercolour, approx. $9 \times 6\frac{5}{8}$ (230 × 174)
Lit: Keynes and Wolf, copy C; Bentley, *Blake Books*, pp. 362, 474–75
The Pierpont Morgan Library, New York

The Song of Los tells of the events which follow Urizen's imposition of his order upon the world, as described at the end of *The Book of Urizen*: the bringing of religion to Africa in the first part, and the rise of Orc in Asia in the second part, to which plate 6 acts as frontispiece. *The Song of Los* also completes in a summary fashion the continental cycle beginning with *America* and *Europe*. Though the text shows signs of the crisis that was to lead to the abandonment of the 1790s cycle of Prophecies, the imagery and the free use of colour printing place the full-page designs among the greatest of Blake's achievements as an artist.

The richness and density of the colour printing in the frontispiece is incomparably effective in evoking the early existence of man, his primitive submission to false religion in the form of the murky 'indefinite' sun worshipped by a submissive priest. The *King and Queen on a Lily* is also transformed by the colour printing into a sinister and

46 (frontispiece) 46 (plate 5)

infinitely remote image, which can be compared with more benign versions of the same motif by Blake's brother Robert in the *Notebook* (Butlin, *Paintings*, no. 201 5(13)), and a slightly earlier watercolour by Blake himself (Butlin, no. 245).

Like the other four copies of *The Song of Los*, the Morgan version is densely colour-printed; presumably all were issued soon after the date on the titlepage. The book was not advertised and no original owners are known. The fact that no late copies were made suggests that Blake either became disillusioned with it or re-used the copper plates.

For plate 8 see *Fig. 20*.

47 The Book of Ahania 1795

> 6 plates on 6 leaves
> Intaglio etchings with colour-printed designs,
> approx. $5\frac{5}{16} \times 3\frac{3}{4}$ (135 × 95)

a Frontispiece
> Lit: Keynes and Wolf, copy A; Bentley, *Blake Books*, pp. 114–15
> *The Library of Congress, Washington, Rosenwald Collection*

b 3 proof plates: 2 of titlepage and 1 of plate 4
> Lit: Keynes and Wolf, copy Bb; Bentley, *Blake Books*, p. 114–15
> *Beinecke Rare Book and Manuscript Library, Yale University*

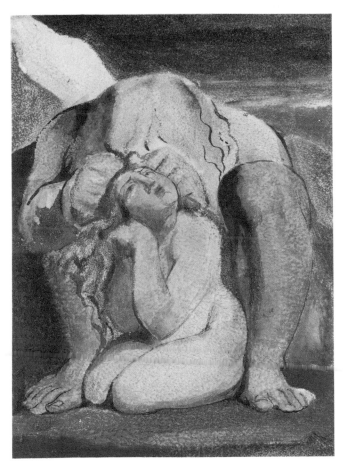

47a

As in *The Book of Los* (British Museum, London), the intensity of the visual imagery is combined with a text of great complexity and terseness. It may have been intended as a further *Book of Urizen*; it tells the story of the Children of Israel led by Moses in the form of Fuzon. Ahania, Urizen's emanation, begins as Pleasure, but under the moral law of Urizen becomes Sin, and her tragic plaint ends the book.

Also like *The Book of Los*, *The Book of Ahania* exists in only one complete copy and a few scattered proofs. As it stands the Rosenwald book is complete, but its frontispiece appears not to have originally belonged to it; and it seems probable that the correct frontispiece for the Rosenwald book is the other known copy of this plate, now in the Keynes Collection (Keynes and Wolf Ba). The problem is not serious, however, for they were clearly printed at about the same time, and are very similar.

Ahania is etched in intaglio (again like *The Book of Los*), with dense colour printing on the frontispiece, titlepage and final plate. The frontispiece may or may not have an underlying etched outline.

Separate Colour Prints, c. 1794–1805

Blake's separate colour prints can be divided into two groups: the smaller ones, which were at one time gathered in volumes, now classed under the headings of *Small* and *Large Book of Designs*; and twelve much larger monotypes, each known in from one to three impressions.

Complete copies of both *Books of Designs* are in the British Museum, made up probably in 1794 for the miniature painter Ozias Humphry: 'Those I printed for Mr Humphry are a selection from the different Books of such as could be printed without the writing, tho' to the Loss of some of the best things. For they when Printed perfect accompany Poetical Personifications & Acts, without which Poems they never could have been Executed' (Letter to Dawson Turner, 9 June 1818, K.867). The colour print of *The Dance of Albion* (No. 49a) comes from one of these. Others exhibited here are from copies broken up and scattered quite early in the 19th century. The so-called copy B of the *Small Book of Designs*, now dispersed, is of particular interest because Blake numbered each picture, adding brief poetic inscriptions. The surviving pages from this copy indicate that it was a kind of emblem book, made up from a selection of his own designs in 1796, the date on a colour print of the titlepage of *The Book of Urizen* which he apparently used as a frontispiece. (See Bindman, *Graphic Works*, no. 289a, and pp. 475–76 for a full list of the inscriptions.)

The quality of colour printing in the *Small* and *Large Book of Designs* was recognized by J. T. Smith, who in 1828 (*Nollekens and his Times*, II, p. 480) published an account of copy A, then belonging to William Upcott, Ozias Humphry's natural son: they 'are coloured . . . with a degree of splendour and force, as almost to resemble sketches in oil colours'. He singled out among the finest in the group, as 'peculiarly remarkable for their strength and splendour of colouring', 'a figure of an angel standing in the sun'; this must be the impression of *The Dance of Albion* (No. 49a) in the present exhibition.

The great Colour Prints (Nos. 51–56) were conceived as being more like paintings to be framed and hung on the wall. They are larger in size and form what may have been a coherent group, though on what principles is still not clear. Attempts to order them have been made (Bindman, *Graphic Works*, p. 477, and Ann Kostelanetz in A. M. Rosenfeld, ed., *William Blake: Essays for S. Foster Damon*, 1969, pp. 117–30); but perhaps, as Butlin suggests, 'Blake is drawing indiscriminately on a number of sources to find images to express various aspects of his own universal philosophy'.

Many of the Colour Prints are dated 1795, and it has been assumed by recent scholars (Bindman, *Artist*, pp. 98–99; Butlin, *Paintings*, p. 156; and Essick, *Printmaker*,

p. 132) that all the colour printing was done at the same time, probably in 1795, but that Blake may, for those bought by Thomas Butts in 1805–06, have added line and watercolour at a later date. This would seem to be confirmed by comparing the two versions of the *Newton* in the present exhibition (No. 56a and b), for the higher definition of the Tate version (No. 56b) does seem more characteristic of Blake's linear style around 1805. However, in the process of preparing No. 56b for the present exhibition the Tate Gallery discovered a previously unrecorded 1804 watermark (for a full discussion see Butlin, 'A newly discovered watermark and a visionary's way with his dates', *Blake Quarterly*, 1981, XV, no. 2, p. 101). This means that the Tate *Newton* must have been made completely *de novo* in 1804–05, disproving the universally held assumption that Blake abandoned colour printing about 1796.

The inscribed date of 1795 on the Tate *Newton* is therefore an 'ideal' date, and the question of the dating of the large Colour Prints is now open pending closer examination for any other watermarks that might be concealed. It may be true in some cases that Blake did pull three successive impressions from one colouring of his 'plate' (see Butlin in *Burlington Magazine*, 1958, p. 42), but it is now certain that he did not do so in every case.

The recent discovery of what might be an embossed mark, caused by a platemaker's stamp on the back of a copper plate, on an impression of *God judging Adam* (No. 51) has also cast doubt on Tatham's account of Blake's colour printing method (quoted Butlin, *Paintings*, p. 156), in which he claims that Blake 'took a common thick millboard, and drew in some strong ink or colour his design upon it strong and thick'. The embossed mark would suggest that he made use of the back of a copper plate. Tatham himself was not born until 1805, and his first account of the method dates from 1862.

48 Small Book of Designs, copy B *c.* 1796

Relief etchings, colour-printed, with pen and watercolour
Beinecke Rare Book and Manuscript Library, Yale University

a *"Does the Soul labour thus"*: fragment of *The Book of Urizen*, plate 10, separately printed
$2\frac{1}{2} \times 3\frac{13}{16}$ (63 × 97)
Inscr: '"Does the Soul labour thus" / "In Caverns of the Grave"'
Lit: Keynes and Wolf, p. 86; Bindman, *Graphic Works*, no. 303a; Butlin, *Paintings*, no. 261 6

An impressive colour print bearing an inscription in

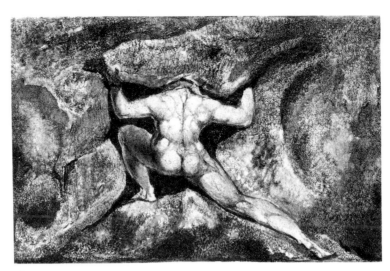

48a

Blake's hand. The design is taken from the headpiece of plate 10 of *The Book of Urizen*, where it may represent Los's agonies in the creation of Urizen. The new inscription seems to give it quite a different meaning, one closer in spirit to Blake's designs for Blair's *Grave* (No. 64), though this print is certainly much earlier.

V **b** *"The Book of my Remembrance"*: fragment of *The Book of Urizen*, plate 5, separately printed
3 × 4$\frac{1}{8}$ (76 × 107)
Inscr: '"The Book of my Remembrance"'
Lit: Keynes and Wolf, p. 86; Bindman, *Graphic Works*, no. 309a; Butlin, *Paintings*, no. 261 8

Like the previous entry this colour print carries an inscription in Blake's hand. In *The Book of Urizen* the design refers to Urizen's first separation from the other Immortals, when he proclaims the eternal laws of humanity to be found in his 'Book of eternal brass'. The murkiness of the image there, which looks like a landscape, proclaims the book's derivation from Nature and not the Spirit.

49 The Dance of Albion ('Glad Day')

 a Colour print, 1794–96
Colour print, with pen and watercolour, over line engraving, 10$\frac{5}{8}$ × 7$\frac{7}{8}$ (271 × 201)
Lit: Essick, *Separate Plates*, no. VII, 1A; Bindman, *Graphic Works*, no. 315(1); Butlin, *Paintings*, no. 262 1
The Trustees of the British Museum, London

 b Line engraving, after 1800
Line engraving, 10$\frac{3}{8}$ × 7$\frac{3}{8}$ (265 × 188)

Inscr: 'WB inv 1780 / Albion rose from where he labourd at the Mill with Slaves / Giving himself for the Nations he danc'd the dance of Eternal Death'
Lit: Essick, *Separate Plates*, no. VII, 2D; Bindman, *Graphic Works*, no. 400
National Gallery of Art, Washington, Rosenwald Collection, 1943

The Dance of Albion is one of Blake's most convincingly affirmative images (see the Introduction, p. 36). Essick also stresses the element of personal regeneration, connecting it with the letter to Hayley of 23 October 1804, in which Blake claims to have been 'a slave bound in a mill among beasts and devils', but is now 'again enlightened with the light enjoyed in youth' (K.852).

The version exhibited as **a** is one of only two colour-printed impressions, the other being in the Huntington Library, San Marino; **b** is one of two known uncoloured impressions, and is unique in having the inscription (a trimmed impression is in the British Museum, London). From the inscribed date of 1780 on the engraving, the design would seem to go back to a lost print or watercolour from Blake's youth. The colour print dates from the mid-1790s, like the others in the *Large Book of Designs*, while the engraving appears by its technique to date from after 1800.

If 1780 is the date of the original idea then it can be connected with passages in *King Edward the Third* in *Poetical Sketches* (No. 3) which look forward to national regeneration. In the context of the 1790s it is closer in spirit to images of the awakening of humanity from slavery, which can be seen in *The Marriage of Heaven and Hell*, plate 21, and *America*, plate 6 (ill. p. 102).

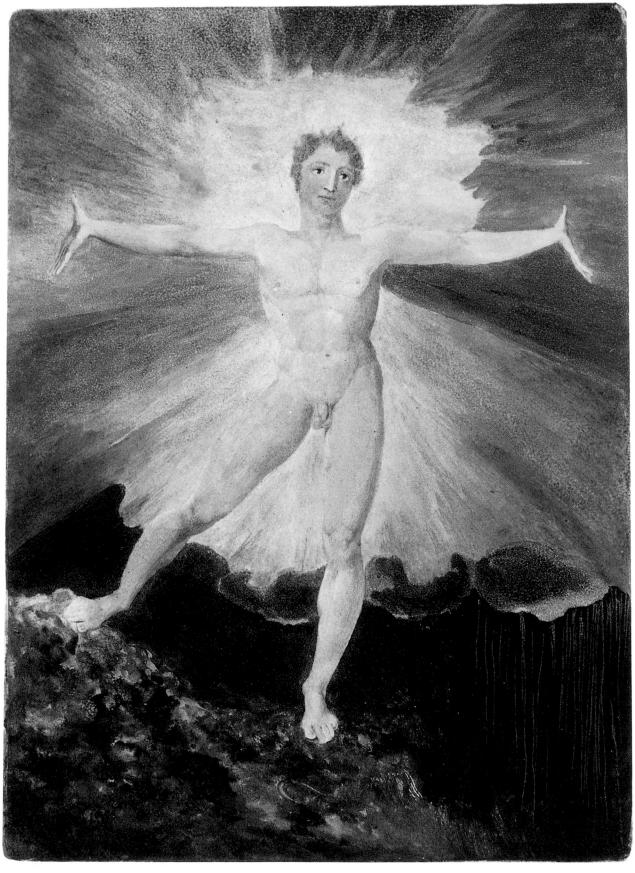

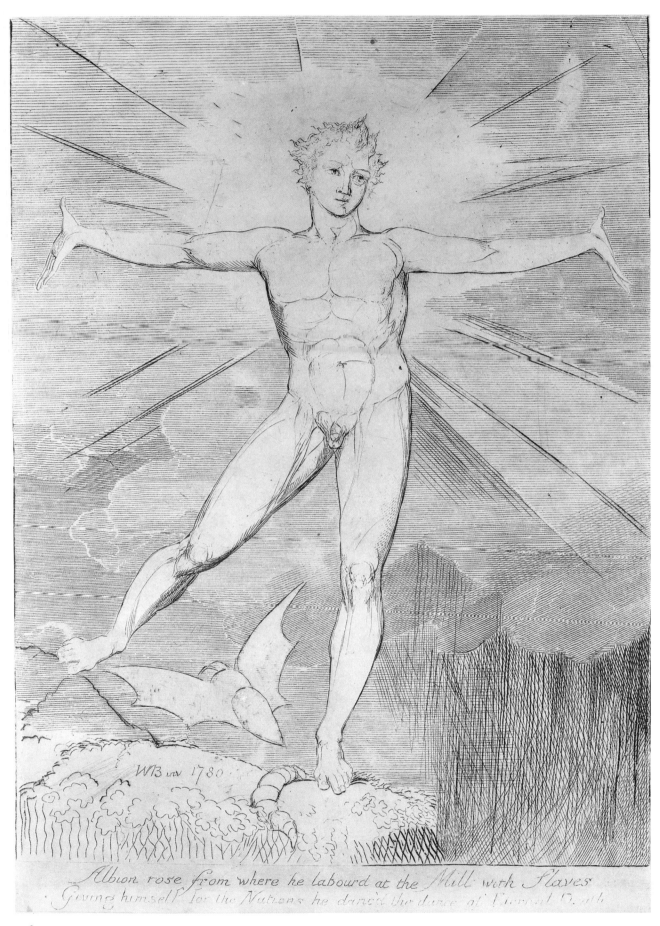

Albion rose from where he laboured at the Mill with Slaves
Giving himself for the Nations he danc'd the dance of Eternal Death

49b

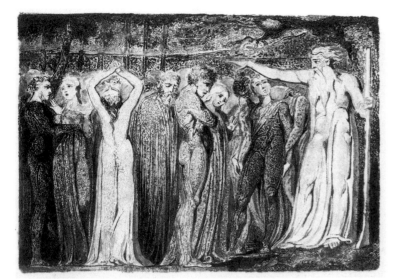

50

50 Joseph of Arimathea preaching to the Inhabitants of Britain 1794–96

Relief etching, colour-printed, with pen and
watercolour, $3\frac{1}{16} \times 4\frac{1}{4}$ (77 × 106)
Lit: Essick, *Separate Plates*, no. XI, 1B; Bindman,
Graphic Works, p. 476; Butlin, *Paintings*, no. 286
*National Gallery of Art, Washington, Rosenwald
Collection, 1943*

One of two known impressions, the other being in the
Large Book of Designs in the British Museum, London.
Apart from two drawings the design is not known in any
other form, though its subject suggests it may have
belonged originally to a series of English historical sub-
jects. It depicts one of the central events of the legendary
history of England, the supposed founding of Christianity
in Britain by Joseph of Arimathea (see No. 2), and the
building of the first church at Glastonbury. Joseph is
apparently performing the miracle of making his staff
take root and blossom.

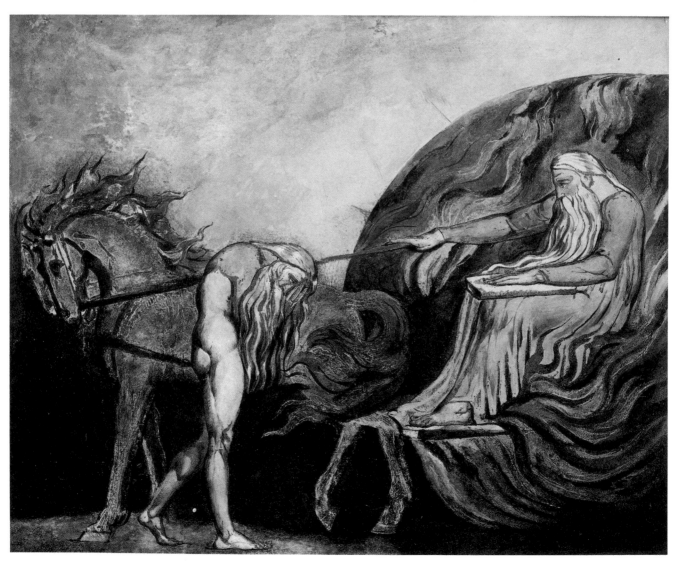

51

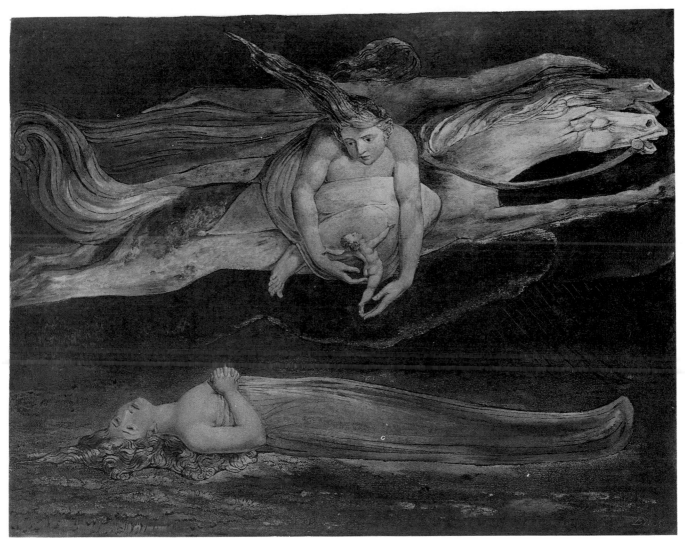

52

51 **God judging Adam** c. 1795

Colour print with pen and watercolour, $17 \times 21\frac{1}{8}$ (432 × 535)
Inscr: 'Fresco. WBlake inv.'
Lit: Bindman, *Graphic Works*, no. 329 (5); Butlin, *Paintings*, no. 295; *The Monotype*, exh. cat., Boston, 1980
The Metropolitan Museum of Art, New York, Rogers Fund, 1916

The subject, which has no precise source in the Bible, shows the Jehovah of the Old Testament exacting submission from Adam, who has in his Fallen state grown like him. The resemblance of the aged figures to each other looks forward to Job's resemblance to Jehovah and Christ in the *Book of Job* designs (No. 115); man creates God in his own image and Urizen himself is merely a creation of the Fallen perceptions of man.

According to Butlin this is the first pull of the design, which exists in two other versions (Philadelphia Museum of Art, and Tate Gallery, London). Until 1965 it was always known as *Elijah in the Fiery Chariot*, but the correct title was discovered by Butlin (see *Burlington Magazine*, 1965, pp. 86–89). This impression is perhaps the strongest in colour printing of the three; the extensive use of yellow also distinguishes it from the others.

In the lower right-hand corner there appears to be, embossed, a trace of an address of the type incised on the back of a copper engraving plate. If this is so then it casts doubt on Tatham's suggestion that Blake used a millboard: he might in fact have used a copper plate to transfer the colour to the paper.

52 **Pity** c. 1795–1805

Colour print with pen and watercolour, $16\frac{3}{4} \times 21\frac{5}{16}$ (425 × 539)
Inscr: 'Blake' (incised)
Lit: Bindman, *Graphic Works*, no. 326(3); Butlin, *Paintings*, no. 310
The Trustees of the Tate Gallery, London

The design has always been assumed to illustrate lines from Macbeth (Act I, sc. vii):

> And pity, like a naked new-born babe,
> Striding the blast, or heaven's cherubim, hors'd
> Upon the sightless couriers of the air
> Shall blow the horrid deed in every eye,
> That tears shall drown the wind

If pity is indeed the theme then the design can also be related to ideas in *The Book of Urizen*, where pity appears as a negative emotion, felt by Los for his creation Urizen. It causes Los's division into the two sexes, and the consequent separation from him of Enitharmon. She eventually gives birth to Orc, which may be the subject of this print.

The Butts copy exhibited here is one of three known impressions, the others being in the Metropolitan Museum of Art, New York, and (in poor condition) in the Yale Center for British Art. There is also a smaller trial impression in the British Museum, London.

53 **The Good and Evil Angels struggling for** VII
possession of a Child *c.* 1795

Colour print with pen and watercolour, approx.
$17\frac{1}{2} \times 23$ (445 × 585)
Lit: Bindman, *Graphic Works*, no. 328(4); Butlin, *Paintings*, no. 324
Collection of Mrs John Hay Whitney

There seems to be no source for this subject outside Blake's own mythology, and the motif appears in other contexts. In *The Marriage of Heaven and Hell* (page 4) the 'Devil' denies the separation of Body and Soul, proclaiming Energy as the life-giving force; the design there would seem to represent an image of alienated man, his body separated from his soul. This, however, does not explain the action in the Colour Print: Butlin has suggested that the fettered angel may represent Orc and the other angel Los; but who then is the child? In the context of the twelve large Colour Prints the design seems to belong to those which describe the Creation – in which case it is

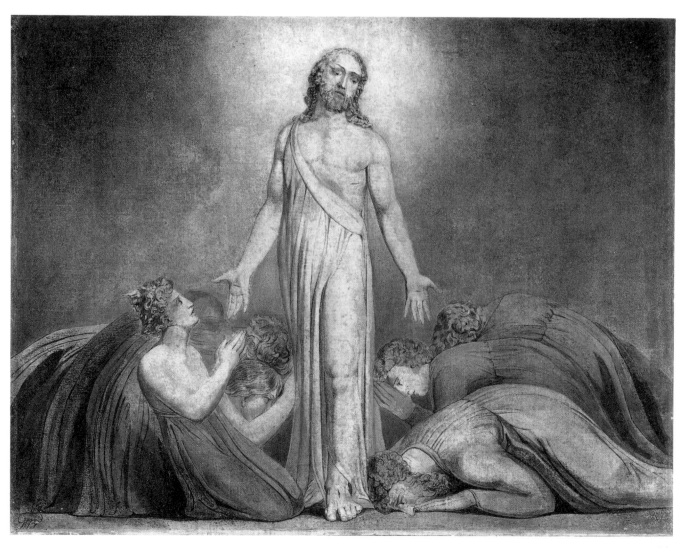

54

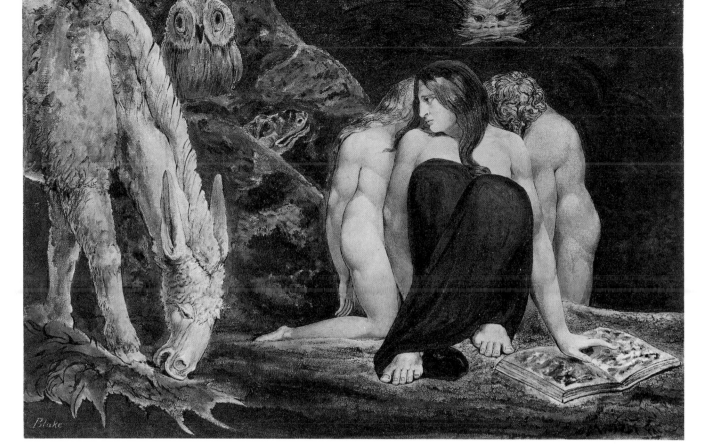

55

more likely that the child itself is Orc, before he becomes a victim to Los's jealousy.

This is one of two known impressions, of which the other, the Butts copy, is in the Tate Gallery, London. This version is slightly less finished, but the dense pigment of the colour printing suggests it is the first pull; the other has been more intensively worked up in pen and watercolour.

54 **Christ appearing to the Apostles after the Resurrection** *c.* 1795–1805

Colour print with pen and watercolour, varnished, 17 × 22½ (430 × 573)
Inscr: 'WB inv' (monogram)
Lit: Bindman, *Graphic Works*, no. 333(9); Butlin, *Paintings*, no. 325
Yale Center for British Art, Yale University Art Gallery Collection

This print appears to illustrate Luke 24: 36–40, where Jesus attempts to persuade the 'terrified and affrighted'

apostles that it is indeed he: 'Behold my hands and my feet, that it is I myself: handle me, and see; for a spirit hath not flesh and bones, as ye see me have.' The contrast between the affirmation of Christ and the troubled reactions of all but one of the apostles recalls an early composition from the *Story of Joseph* (Butlin, *Paintings*, no. 157) in which Joseph reveals himself to his bewildered brethren, who are more disturbed than glad to recognize him. This analogy suggests that Blake is here depicting the failure of man to recognize the true nature of Jesus; if so it would represent in the context of the twelve Colour Prints the moment of the first Incarnation, the significance of which remains hidden from man for the next 1,800 years (see *Europe a Prophecy*, No. 44).

The version exhibited is from the Butts collection, delivered and probably finished, as the clear outlines suggest, about 1805, though possibly colour-printed about 1795. There are two other versions (National Gallery of Art, Washington, and Tate Gallery, London); Butlin suggests that this is the second pull from the millboard or colour-printing plate.

55 Hecate *c.* 1795–1805

Colour print with pen and watercolour, $17 \times 22\frac{7}{8}$
(439 × 581)
Inscr: 'Blake' (incised)
Lit: Bindman, *Graphic Works*, no. 334(10); Butlin,
 Paintings, no. 316; Essick, *Printmaker*, p. 181
The Trustees of the Tate Gallery, London

The scene, probably from Shakespeare, is of the realm of
'triple Hecate'. All the associations are, in Blakean terms,
negative, implying the Female Will (Hecate herself),
Mystery (the 'landscape' book), vegetative existence (the
donkey), and the desires of divided humanity (the sinister
creatures). The creepy atmosphere of this moony place is
marvellously suggested by the colour printing. There is
something Fuselian in the humorous grotesquery of the
imagery (Butlin cites Fuseli's *The Witch and the Mandrake*,
in the Yale Center for British Art, as a possible compari-
son); the creatures in the background suggest also early
German prints, which were beginning to be studied by
artists in Blake's time (see No. 20).

The print is signed by Blake in the same way as *Pity* (No.
52), and Butlin has suggested that the two might have
been designed as companions. This version (there are two
others, in the National Gallery of Scotland, Edinburgh,
and the Huntington Library, San Marino) belonged to
Thomas Butts; it may have been colour-printed in 1795
and finished for Butts in 1805, though the new dating of
Newton (No. 56b) must make this uncertain.

56 Newton *c.* 1795–1805

Colour print with pen and watercolour, $18\frac{1}{8} \times 23\frac{5}{8}$
(460 × 600)
Lit: Bindman, *Graphic Works*, no. 336(12); Butlin,
 Paintings, nos. 307(**a**), 306(**b**); Essick,
 Printmaker, pp. 132, 148, 181; Butlin in *Blake
 Quarterly*, 1981, no. 2, p. 101

a Inscr: 'NEWTON' and 'Fresco WBlake inv.'
 *Lutheran Church in America, Glen Foerd at Torresdale,
 Philadelphia*

b Inscr: '1795 WB inv.' (monogram) VI
 The Trustees of the Tate Gallery, London

The germ of this design is to be found in the *Application*
plate of *There is no Natural Religion* (No. 38b), which
depicts a man led into solipsism by the evidence of his
senses, an apt image of a Blakean scientist. Newton and
Locke are the keepers of 'the Philosophy of the Five
Senses' entrusted to them by Urizen, and they exist in a
state of 'single vision or Newton's sleep', synonymous with
the despair of men cut off from their own spirit. Newton,
however, has for Blake a positive role as well: because his
material view of the universe is undisguised, he reveals the
true attitude of those Deists who cloak their materialism
in piety. Hence in *Europe* he is the Angel who blows the
Trump announcing the doom of the Old Order. In the
context of the twelve Colour Prints *Newton* seems to belong
with the final group of four, which approximately parallel
the action of the Prophetic Book *Europe*, covering the
period of the perversion of the meaning of Christ's first
Incarnation by the governors of Europe.

The exhibits are the only known impressions of this
print. The Tate version (**b**) is extremely well known,
but the other one (**a**) has rarely been seen in recent years.
The confrontation is made more interesting by the recent
discovery of an 1804 watermark on the Tate *Newton* (see
p. 110). Butlin formerly argued that the Glen Foerd ver-
sion was pulled after the Tate version from the same
board; if so, then it would be late as well. The inscription
on it, however, corresponds exactly in form to that on the
Metropolitan *God judging Adam* (No. 51), which Butlin
suggests is a first pull from the colour printing plate. If
that does indeed date from 1795 – and one cannot preclude
later additions – then we are left with the bizarre possi-
bility that those impressions of the Colour Prints which
are *not* dated by Blake belong to 1795, while those that
Blake dates 1795 in fact date from 1804–05!

The present hypothesis must be that Blake made the
Glen Foerd version at the same time as most of the other
Colour Prints, i.e. *c.* 1795, but that when preparing a
group for Butts in 1805 he made a completely new version
of the *Newton* to add to the group. It is to be hoped that a
comparison between these and the other Colour Prints in
the exhibition will shed further light on this unexpected
and difficult problem.

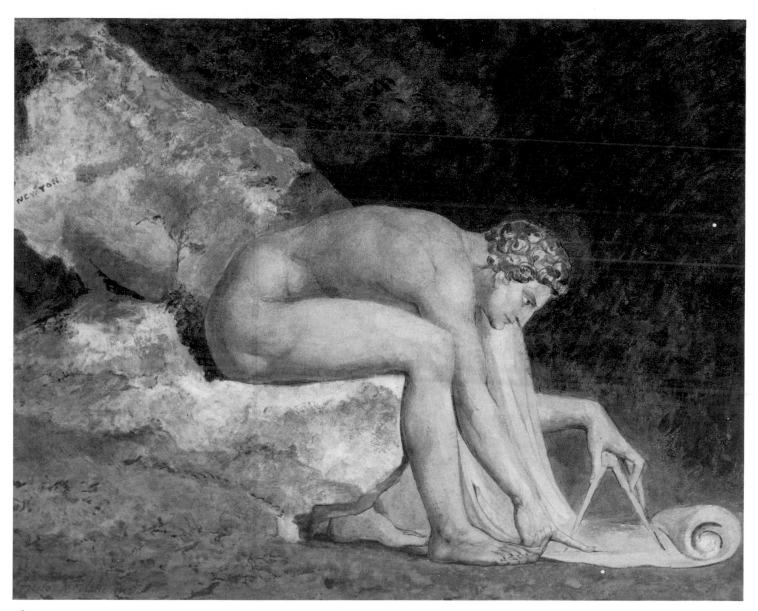

56a

The Revolutionary Background: Blake's Circles in the 1790s

In 1791 Blake nearly had some poetry published by the radical publisher Joseph Johnson, for whom he had already worked as an engraver; Johnson got as far as setting up his *French Revolution* in type (unique copy in the Huntington Library, San Marino). Blake's relationship with the Johnson circle, which included such luminaries as Tom Paine, Joel Barlow, Mary Wollstonecraft, William Godwin and Henry Fuseli, was seen as an active one by Victorian biographers; in fact it is doubtful whether he was taken very seriously by them, though Blake entertained hopes of their friendship. Blake shared with them a passionate belief in the French Revolution and the hope that it would lead to moral improvement and liberty, but the apocalyptic strain in his beliefs meant that the divergence between his views and theirs increased as the 1790s progressed. Blake had no sympathy with a society based on Reason; in general he shared their dislike of current mores, but not their idea of the new society which would arise from the ashes of Old Corruption. For a brief period Blake, like William Sharp, was able to span the 'respectable' and popular extremes of British radicalism, but, even with all his misgivings about its literalism, the millenarian vision of Richard Brothers would have been more sympathetic to his own metaphysical views.

In this section Blake's connections with revolutionary sympathisers are briefly indicated. Joel Barlow, an American, wrote revolutionary prophecies which might have influenced Blake. Blake's work as illustrator for Johnson is represented by designs for a book by Mary Wollstonecraft and his own *The Gates of Paradise* which he may have hoped to persuade Johnson to publish. Blake also admired James Barry, whose early support for the American colonies was paralleled by his later hatred for the ruling powers of the Royal Academy. The chiliastic side of Blake's revolutionary sympathy is represented by a Gillray caricature, which contains a satirical reference to Richard Brothers.

57 The Vision of Columbus, by Joel Barlow 1787

Printed book, letterpress (Hudson and Goodwin, for the Author, Hartford, Conn.)
Lit: D. V. Erdman, 'William Blake's Debt to Joel Barlow', *American Literature*, 1954; Erdman, *Prophet*, pp. 23, 26, 154, 158, 399
Beinecke Rare Book and Manuscript Library, Yale University

Erdman has argued convincingly for the influence of Joel Barlow (1754–1812) on Blake, especially of *The Vision of*

Columbus on *America* (No. 43). Barlow was an active member of the Johnson circle in the years 1791–92, and it is probable that he met Blake there.

Barlow entered Yale College in 1774, graduating in 1778. In 1787 he published his epic *Vision of Columbus*, which deals in allegorical form with the discovery, settlement and visionary future of America. On his English visit he was particularly friendly with Tom Paine, and produced radical pamphlets which gained him honorary French citizenship. In 1804 he finished a revised version of his epic, now called the *Columbiad*; it is comparable in scale and ambition to Blake's myth, but almost wholly without inspiration.

58 Illustrations from Original Stories from Real Life, by Mary Wollstonecraft 1791

2 line engravings out of 6:
a Frontispiece, $4\frac{3}{16} \times 2\frac{9}{16}$ (116 × 66)
b p. 94, *Be calm, my child*, $4\frac{1}{2} \times 2\frac{9}{16}$ (114 × 66)
Lit: Bentley, *Blake Books*, no. 514; Easson and Essick, *Book Illustrator*, I, no. III
The Library of Congress, Washington, Rosenwald Collection

Mary Wollstonecraft (1759–97) was a prominent feminist and member of the Johnson circle, and she was rumoured to have had an affair with Fuseli. Blake probably got the commission for the six engravings in her book for children on the strength of the *Songs of Innocence*; there is no reason to suppose he was particularly close to the author, though *Visions of the Daughters of Albion* (No. 42) shows the influence of her thinking on sexual matters (see D. V. Erdman, 'Blake's Vision of Slavery', *Journal of the Warburg and Courtauld Inst.*, 1952, pp. 242–52, and *Prophet*, pp. 156–57).

The engravings were designed as well as engraved by Blake; they stand, therefore, midway between the commercial illustrations made after Stothard, like Ritson's *Songs* (No. 32), and self-produced works like the *Songs of Innocence* (No. 39).

59 For Children: The Gates of Paradise 1793

18 etchings with some line engraving, approx. $2\frac{11}{16} \times 2\frac{1}{2}$ (68 × 64)
Lit: Bentley, *Blake Books*, copy E, p. 193; Essick, *Printmaker*, pp. 68–70
Yale Center for British Art, Paul Mellon Collection

The Gates of Paradise is a series of emblems distilled from a large group of designs in Blake's *Notebook* (British Library),

Look what a fine morning it is.—Insects,
Birds, & Animals, are all enjoying existence.

Published by J. Johnson, Sept.^r 1.st 1791.

58a

(Be calm, my child, remember that you
must do all the good you can the present day.

Published by J. Johnson, Sept.^r 1.1791.

58b

where they are gathered together under the title of 'Ideas
of Good and Evil'. In ordering them for publication Blake
has made them follow the life of man from birth to death.
As Essick points out (p. 69) these emblems are closer to the
spirit of children's books of the time than is usually
thought; they are however still extremely complex in
thought and allusion.

This copy, one of only five known, according to an
inscription on the fly-leaf was given by Henry Fuseli to
Harriet Jane Moore on 22 November 1806. She was the
daughter of the doctor to the Lockes of Norbury Park. It
appears in its first state; it was re-engraved later in Blake's
career as *For the Sexes: The Gates of Paradise* (reproduced in
full in Bindman, *Graphic Works*, nos. 580–600).

According to the etched titlepage Blake published this
collection jointly with Joseph Johnson, but the inscription
must represent wishful thinking on Blake's part: after
1791, when he set *The French Revolution* in type and printed
the Wollstonecraft book (No. 58), Johnson did nothing to
recognize Blake as anything more than one of his team of
reproductive engravers.

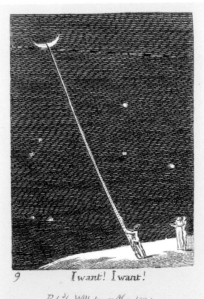

9 *I want! I want!*

Pub ^d by WBlake 17 May 1793

59

60 The Phoenix or the Resurrection of Freedom
1776

Etching and aquatint, $17 \times 24\frac{1}{8}$ (432 × 613),
 2nd state
Lit: William Pressly, *The Life and Art of James
 Barry*, 1981, pp. 77–79 and print cat. no. 8;
 Sarah Symmons, 'James Barry's *Phoenix*: An
 Irishman's American Dream', *Studies in
 Romanticism*, XV, 1976, pp. 531–48
Yale Center for British Art, Paul Mellon Collection

Barry's *The Phoenix* is a testimony to his political radicalism
and sympathy for the American Revolution, fuelled by
his consciousness as an Irishman that he too was a
Colonial. The complex theme of the print concerns the
flight of Liberty from an England grown 'Corrupt &
Worthless', given over 'to chains & despondency', to 'a
new people of manners simple & untainted'. In the fore-
ground a company of English libertarians, including
Milton, mourn over the bier of Britannia, some gesturing
longingly towards America, with its temple of liberty and
scenes of pastoral contentment.

Barry was a very strong personal influence on Blake, who
believed him to have been a martyr for his art (see No. 21).
The imagery of this print foreshadows the vision of the
American Republic found two decades later in *America*
(No. 43) and *Visions of the Daughters of Albion* (No. 42), as
a place of freedom from Old Corruption. Barry reissued
the plate about 1790.

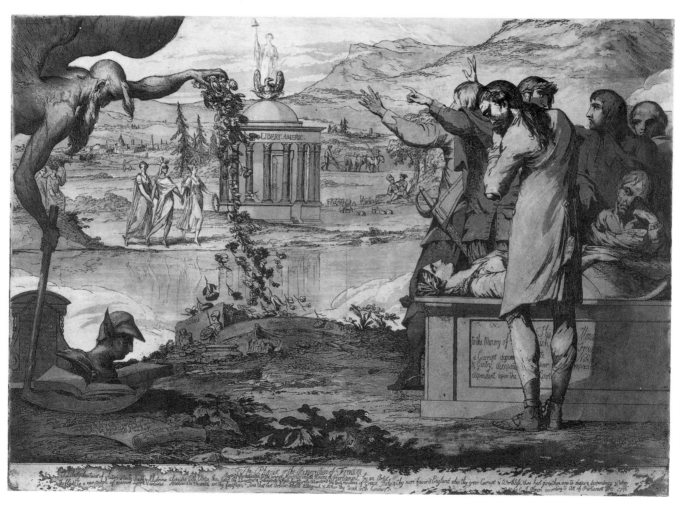

60

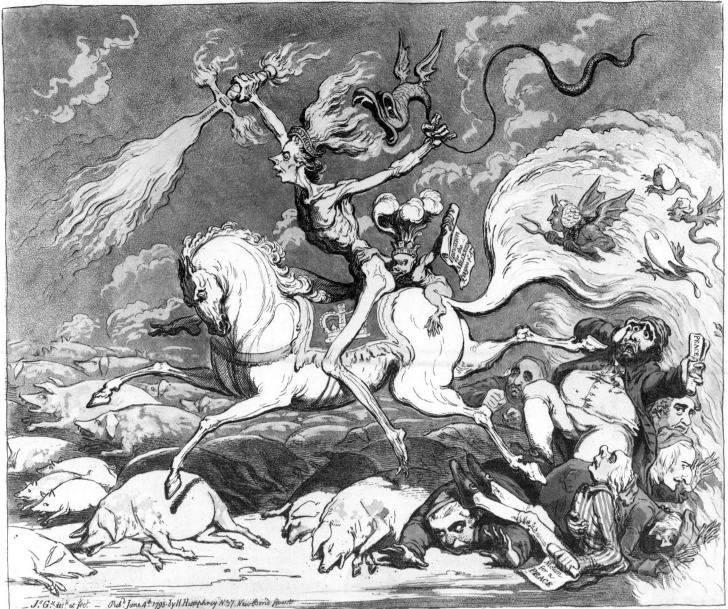

Presages of the MILLENIUM; — with — The Destruction of the Faithful, — as Revealed to R:Brothers, the Prophet, & attested by M.B.Hallhead Esq.
"And eer the Last Days began, I looked, & behold, a White Horse, & his Name who sat upon it was Death; & Hell followed after him; & Power was given unto him, to kill with the
Sword, & with Famine, & with Death: — And I saw under him the Souls of the Multitude, those who were destroy'd for maintaining the word of Truth, & for the Testimony

61

JAMES GILLRAY

61 Presages of the Millenium 1795

Etching, aquatint and watercolour, $12\frac{13}{16} \times 14\frac{5}{8}$
(326×377)
Lit: Draper Hill, *Mr Gillray the Caricaturist*, 1965,
p. 55
Yale Center for British Art, Paul Mellon Collection

An attack on Pitt as Death on the Pale Horse of Hanover,
trampling over 'the swinish multitude', while Fox and his

friends are kicked towards the fiery abyss. The imagery,
as in many of Gillray's caricatures, is borrowed from the
History painting of the time, in this case almost certainly
Mortimer's *Death on a Pale Horse* (No. 20). The inscription
makes reference to Richard Brothers and his proclama-
tion that the prophecy of Revelation was in the process of
being fulfilled by the revolutionary wars. Like Gillray's
print of Richard Brothers (*Fig. 3*), this gives a sense of
the widespread interest in the activities of millenarians in
the mid-1790s (see the Introduction, pp. 13 and 16).

After the Prophecies: Illustrated Books

In the early 1790s, through the activities of such publishers as Josiah Boydell (see *Fig. 10*) and Thomas Macklin, the hope of serious patronage for artists seemed to lie in the production of grand illustrated books, containing engravings after the work of contemporary masters. The most famous was Boydell's *Shakspeare Gallery*, and Fuseli had hopes of creating a *Milton Gallery* which would enable him to sell both paintings and prints after them. Success was thought to lie in the combination of a famous author and new illustrations. By 1795, when Blake received a commission to provide designs for a grand edition of Young's *Night Thoughts*, the formula must have seemed to promise profits for both artist and publisher. In fact only the first four of the nine Nights were engraved before the scheme was abandoned. It is, however, a measure of Blake's reputation in the mid-1790s that he should have received such a commission in the first place, possibly at the behest of the members of the Royal Academy who had a regard for his imaginative powers. If Blake had little to show for the enormous effort of producing 537 watercolours (British Museum) and 43 engraved plates, it did lead to a commission on a less ambitious scale, for illustrations in a similar format to Gray's *Poems* (No. 63). More surprisingly, it was later to qualify him for a chance to illustrate an edition of Blair's *Grave*, for the notorious Robert Cromek (No. 64).

A number of items have been added to this section for comparison with Blake's illustrations, and also to illuminate the background to the Biblical illustrations which he began to make for Thomas Butts in 1799.

62 **Illustrations to The Complaint and the Consolation: or Night Thoughts, by Edward Young** 1795–97

Lit: D. V. Erdman *et al.*, *William Blake's Designs for Edward Young's Night Thoughts*, 1980. Watercolours: Butlin, *Paintings*, no. 330 78, 87. Engravings: Dover facsimile, ed. Essick and J. LaBelle, 1975; Bindman, *Graphic Works*, nos. 337–79

a Watercolours for Night III: (i) titlepage, (ii) p. 12
Pen and watercolour, surrounding letterpress of 1742, approx. $16\frac{1}{2} \times 12\frac{7}{8}$ (420×325)
The Trustees of the British Museum, London

b Engraved book, 1797
43 line engravings surrounding letterpress, hand-coloured probably by Blake
Inscr: on fly-leaf, 'This copy was coloured for me by Mr Blake W.E.'
Yale Center for British Art, Paul Mellon Collection

The commission from Richard Edwards in 1795 for a magnificent set of large-scale watercolours to Young's *Night Thoughts*, a selection of which were to be engraved, must have occupied Blake fully during the years 1795–97; among other things it turned him away from colour printing towards watercolour and intaglio engraving. The format of the page is unusual; the design was to surround the text, and for the watercolours Blake was given or prepared a copy of the *Night Thoughts*, set into a larger sheet of paper to take the designs.

Making 537 watercolours must have been a monotonous task, so it is a wonder that Blake so often succeeded in responding imaginatively to the text. Despite the inauspicious economic climate quite a few copies of the engraved *Night Thoughts* were sold and it remained into the 19th century, with the illustrations to Blair's *Grave* (No. 64), his best-known work.

A number of copies of the engraved book were hand coloured; the one displayed here has, because of its inscription and the quality of the colouring, a good claim to have been done by Blake himself. 'W.E.' has not been identified; the handwriting appears not to be that of William Esdaile, the noted collector, and no other likely candidates have yet emerged.

NIGHT THE THIRD.

NARCISSA.

Humbly Infcrib'd to her GRACE

The DUTCHESS of *P------.*

Ignofcenda quidem, fcirent fi ignofcere Manes.
VIRG

The SECOND EDITION.

LONDON:
Printed for R. DODSLEY, at *Tully*'s Head in *Pall-Mall*, and
T. COOPER, at the *Globe* in *Pater-Nofter-Row*.

M,DCC,XLII.

62a.i

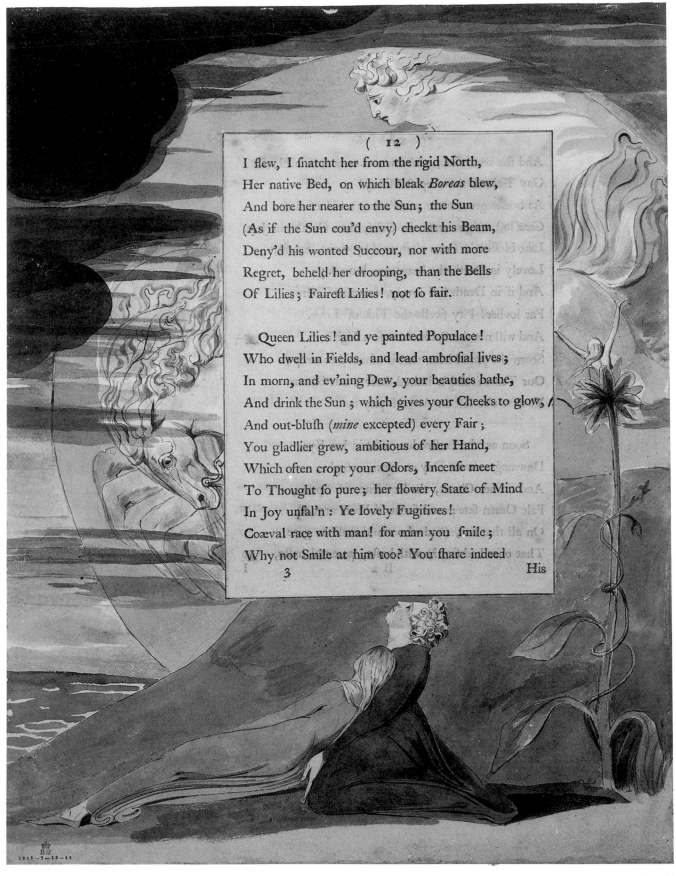

(12)

I flew, I snatcht her from the rigid North,
Her native Bed, on which bleak *Boreas* blew,
And bore her nearer to the Sun; the Sun
(As if the Sun cou'd envy) checkt his Beam,
Deny'd his wonted Succour, nor with more
Regret, beheld her drooping, than the Bells
Of Lilies; Faireſt Lilies! not ſo fair.

Queen Lilies! and ye painted Populace!
Who dwell in Fields, and lead ambroſial lives;
In morn, and ev'ning Dew, your beauties bathe,
And drink the Sun; which gives your Cheeks to glow,
And out-bluſh (*mine* excepted) every Fair;
You gladlier grew, ambitious of her Hand,
Which often cropt your Odors, Incenſe meet
To Thought ſo pure; her flowery State of Mind
In Joy unfal'n: Ye lovely Fugitives!
Coæval race with man! for man you ſmile;
Why not Smile at him too? You ſhare indeed

3

His

62a.ii

63b

63e

63 Illustrations to Thomas Gray's Poems
1797–98

Pen and watercolour, surrounding letterpress,
approx. $16\frac{1}{2} \times 12\frac{7}{8}$ (420 × 325)
Lit: Butlin, *Paintings*, no. 335
Mr and Mrs Paul Mellon, Upperville, Va.

VIII

The volume is constructed in the same way as the *Night Thoughts* (No. 62), which must have prompted the commission from John Flaxman. It was to be presented to Flaxman's wife Nancy; the sculptor was in the habit of giving her illustrated books of a light-hearted nature on her birthdays, usually written and drawn by himself. The illustrations to Gray were therefore not meant to be too serious, and might have been a diversion to Blake after the exertions of the *Night Thoughts*.

The present selection spans the range of illustrations to the book, from Gray's 'innocent' enthusiasm as a young poet to the tragic vision of the final *Elegy*. As all commenta-

tors have pointed out, Blake felt deeply equivocal towards Gray, whose progress through the poems can be interpreted as the gradual fading of his youthful vision into academicism (*The Progress of Poesy*) and finally despair. Even so they are the wittiest of Blake's illustrations. Good humour is in the ascendant, though the tragedy of adolescence is portrayed memorably in **c**, as the vultures of Experience descend on the boys playing carelessly. The handling of watercolour is remarkably free – especially in the scene from the *Ode on the Death of a Favourite Cat* (**b**), in its broad depiction of water and the Turneresque freshness of its landscape. The illustrations to *A Long Story* (**d** and **e**) reveal Blake as a master of the comic horrific.

64 Illustrations to The Grave, by Robert Blair
1805–08

a *Prone on the lowly grave – she drops*, unused design
Watercolour with pen, $6\frac{1}{16} \times 8\frac{3}{16}$ (154 × 208)
Lit: Butlin, *Paintings*, no. 633
Yale Center for British Art, Paul Mellon Collection

b *Death's Door*, unique proof etched by Blake himself
White-line etching with wash, $6\frac{7}{8} \times 4\frac{1}{2}$ (175 × 114)
Lit: Essick, *Separate Plates*, no. XIII
Mrs Charles J. Rosenbloom, Pittsburgh

c Engraving from the printed version, 1808, by
 L. Schiavonetti after Blake
 Line engraving, $9\frac{1}{4} \times 5\frac{7}{16}$ (235 × 138)
 Lit: Bindman, *Graphic Works*, nos. 408, 465–76;
 Essick, *Printmaker*, pp. 159–60, *passim*
 Yale Center for British Art, Paul Mellon Collection

Blair's long poem on the subject of death and mortality
was published in 1743. The history of Blake's designs for
it is long and complicated, involving angry misunder-
standings between him and the publisher Robert Cromek,
who seems to have been quite as villainous as Blake thought
him to be. In 1805 Blake made forty drawings and water-
colours, including *Prone on the lowly grave* (**a**), which was
singled out for commendation by Flaxman. With the
support of senior members of the Royal Academy, Blake

was to engrave twenty of these himself as a demonstration
of his abilities as a designer and engraver.

By the beginning of 1806 Cromek had developed cold
feet about Blake's engraving technique, apparently
because of the vigorous white line displayed in *Death's
Door* (**b**), which is the only known impression of an illus-
tration etched by Blake himself. Behind Blake's back,
Cromek hired the engraver Luigi Schiavonetti, a pupil of
the hated Bartolozzi. Despite Blake's chagrin – which
spilled out into scatological rhymes in his notebook
(Cromek becomes 'Screwmuch' and Schiavonetti 'Assassi-
netti') – Cromek worked hard to sell the publication,
which appeared with Schiavonetti's dry engravings from
Blake's designs.

Three stages are represented here: a watercolour design
which in the end was not one of the twelve to be engraved

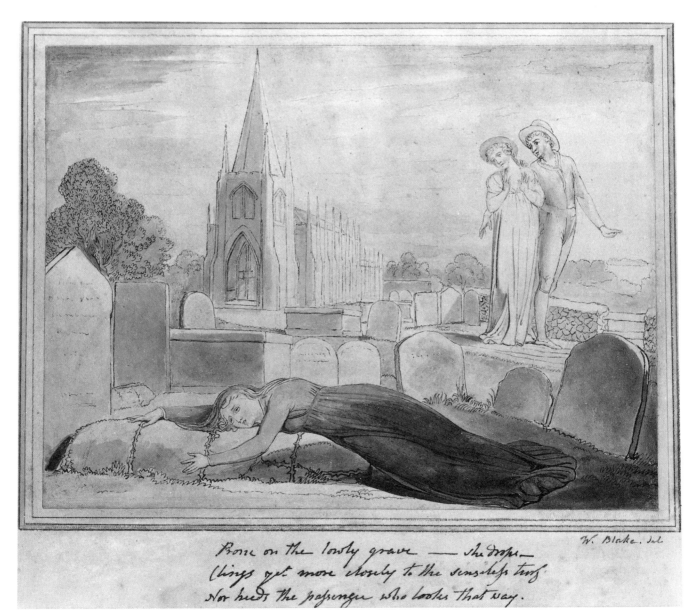

Prone on the lowly grave — she drops—
Clings yet more closely to the senseless turf
Nor heeds the passenger who looks that way.

W. Blake. del

64a

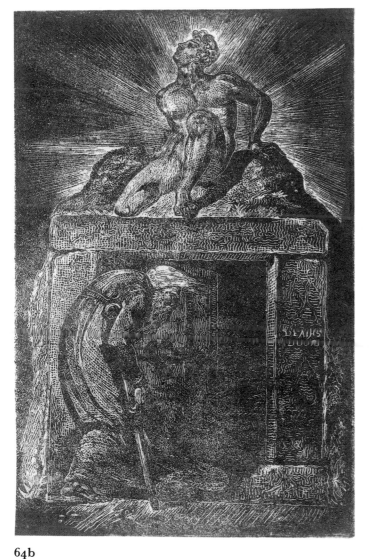

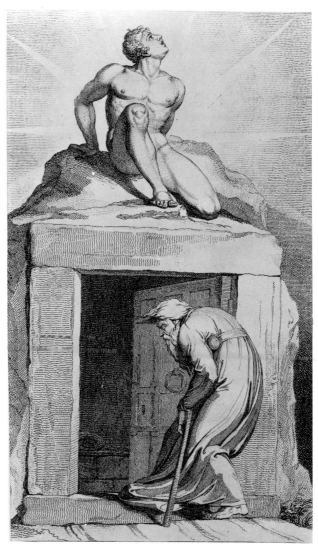

64b

64c

(a); the unique proof of an etched design of *Death's Door* (b); and a plate from the published edition of 1808 (c).

The *Death's Door* etching is a remarkable survival, for it seems to have been the occasion of Cromek's rejection of Blake as the engraver. According to Stothard's son, 'Cromek found, and explained to my father, that he (Blake) had etched one of the subjects, but so indifferently and so carelessly . . . that he employed Schrovenetti to engrave them'. Though it is a magnificent and striking print, one can see Cromek's point in the context of engraved book illustrations of the time. The composition is essentially a combination of two previous Blakean designs, both to be seen separately in *America*: the youth from plate 6 and the old man from plate 12 (ill. pp. 102, 104). It is described in the printed edition as showing 'the Door opening, that seems to make utter darkness visible; age, on crutches, hurried by a tempest into it. Above is the renovated man seated in light and glory.'

65 Designs by Mr. Richard Bentley for Six Poems by Mr. Thomas Gray 1753

Printed book, letterpress, with 6 engravings after
Bentley by J. S. Müller and C. Grignion,
published by R. Dodsley
Lit: H. Hammelmann, *Book-Illustrators in 18th
century England*, 1975, p. 14
Lewis Walpole Library, Farmington, Conn.

Richard Bentley (1708–82), the youngest son of the great
classical scholar of the same name, was a great friend of
Horace Walpole and Thomas Gray, who encouraged his
talent for drawing, though he remained an amateur. He
was closely involved in Walpole's schemes for Strawberry
Hill, and the designs for Gray are a precise equivalent in
sensibility to that extraordinary house, treating the Gothic
in a fanciful Rococo manner. The imaginative freedom of
Bentley's designs makes them an interesting forerunner
of Blake's designs to the same book (No. 63).

HENRY FUSELI engr. by F. BARTOLOZZI

66 Queen Katharine's Dream 1788

Stipple engraving, $17 \times 19\frac{13}{16}$ (432×503)
Lit: Schiff, no. 729
Yale Center for British Art, Paul Mellon Collection

This engraving was made for Thomas Macklin's *British
Poets Gallery*, one of the many schemes, like Boydell's
Shakspeare Gallery, to publish designs on literary themes by
serious artists. Blake was influenced by this design and
attempted the subject a number of times, most notably in
the late version made for Sir Thomas Lawrence (National
Gallery of Art, Washington).

65 (*Ode on a Distant Prospect of Eton College*; cf. Pl. VIII)

Bartolozzi was the most famous stipple engraver of his
day, noted for his ability to convey the texture and
atmosphere of the original painting, rather than achieve
boldness of outline – hence Blake's particular fury at
having his Blair's *Grave* designs engraved by one of
Bartolozzi's Italian pupils (see No. 64). Fuseli complained
about the smooth effect and lack of vigour of this print.

P. J. DE LOUTHERBOURG engr. by J. FITTLER

67 Christ at Emmaus 1798, from the *Macklin Bible*, 1800

Engraving, $12\frac{7}{12} \times 10\frac{1}{12}$ (319×225)
Lit: D. Alexander and R. T. Godfrey, *Painters and
Engraving*, exh. cat., Yale Center for British Art,
1980, pp. 61–62
Collection of David Bindman

Thomas Macklin had more success in completing the
publication of his large *Bible* with 71 engraved plates than
he did with the *British Poets Gallery* (No. 66). The chief
contributor was de Loutherbourg, who provided twenty
plates and numerous vignettes. Though Sharp and other
engravers known to Blake worked on the *Bible*, Blake was

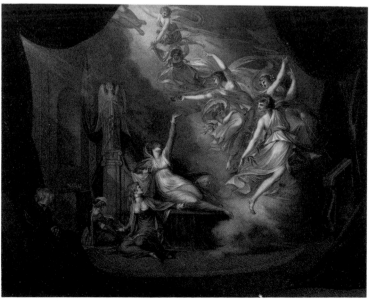

66

excluded even though he had worked for Macklin before.

The scale and comprehensiveness of the *Macklin Bible* may have provided a model for Blake's watercolours for Thomas Butts (Nos. 74–79), which were intended to make up an extra-illustrated Bible.

The apostle's gesture of affirmation and astonishment can be contrasted with Blake's cruciform gesture of recognition in plate 76 of *Jerusalem* (No. 99n).

XV

68 Proposals for the Establishment of a Public Gallery of Pictures in London, by Count Truchsess 1802

Lit: M. D. Paley, 'The Truchsessian Gallery Revisited', *Studies in Romanticism*, XVI, no. 2, Spring 1977, pp. 165–78
Yale Center for British Art, Paul Mellon Collection

The Truchsessian Gallery is of particular importance because of Blake's remark to William Hayley in a letter of 23 October 1804: 'Suddenly on the day after visiting the Truchsessian Gallery of Pictures, I was again enlightened with the light I enjoyed in my youth, and which has for exactly twenty years been closed from me as by a door and by window-shutters.'

The Truchsessian Gallery was, relatively speaking, a late-comer in the series of collections which had been exhibited in London following the break-up of Continental collections. The greatest of these, and one which left an obvious mark on Blake's art around 1800, was the Orléans Collection, exhibited to great excitement in London in 1798–99 (see Bindman, *Artist*, p. 127). The stir was caused not only by the quality of the works, but by the opportunity it gave to set up a national gallery of painting, to provide models for emulation by young painters. This came about with the founding of the National Gallery in 1824; in the meantime a number of candidates like Count Truchsess offered to provide the nucleus of the national collection. Blake was fully in sympathy with this ambition, for he believed that the nation 'must possess Originals as well as France or be Nothing'.

Truchsess, however, seems to have been a charlatan, and as Paley points out, the common opinion was that the collection was mainly made up of copies. On the other hand there do seem to have been many paintings in the 'Gothic' taste, of Italian and Northern schools of the 15th century, though the few that can be identified were by no means in the first rank. Their clear outlines and colours may have suggested to Blake an alternative to the broad handling of artists like Rubens and Rembrandt, so violently condemned in his *Descriptive Catalogue* (see the Introduction, p. 38).

67

An Understanding Patron: Thomas Butts and Paintings from the Bible, 1799–c. 1809

It would be difficult to exaggerate the importance for Blake's art of the advent of Thomas Butts, a clerk in the office of the Muster-Master General. Though Butts could be critical of Blake's art (see Blake's letter to him of 22 November 1802), he bought it extensively, commissioning 'regular conceptions', that is to say subjects with a source in the Bible and great literature (e.g. Milton, No. 92).

The first commission came in 1799 for fifty tempera paintings in a new technique which Blake called 'Fresco'. These are represented in the exhibition by four of the thirty or more which have survived. The tempera series was a Biblical cycle, with typological connections between Old and New Testaments. (See also *Fig. 22.*)

The programme of the Biblical watercolours made for Butts, on the other hand, was conceived much more loosely: it seems that Butts paid Blake the sum of one guinea for any that he delivered over a period of nearly ten years. Butts's idea was evidently to fill up an extra-illustrated Bible, adding Blake's watercolours to it as they arrived; Blake was therefore obliged to range widely within the Bible, often tackling subjects resistant to naturalistic treatment. He painted over a hundred of these watercolours (see also No. 95), which can be difficult to date precisely because he did not distribute them systematically throughout the Bible.

In his tempera paintings Blake used carpenters' glue as a medium, aiming to give them the permanence and density of oil painting, and used pen to avoid the 'indefinite' effect of oil. In damp conditions, the glue causes darkening and lifting from the ground, but where the paintings are in exceptionally good condition it is possible to see the incisive outlines as Blake intended. The later development of his method can be seen in a painting probably of the 1820s, the so-called '*Black Madonna*' (No. 73), which, though damaged, shows a more confident handling of the medium.

The selection of the watercolours, from the great many available in American collections, indicates the stylistic range of the Butts series, from the 'Early Christian' gravity of the *Mary Magdalen at the Sepulchre* (No. 76) to the sublimity of *The Vision of Ezekiel* (No. 78). The magnificent illustrations to the Book of Revelation are singled out for strong representation in this section because of the lifelong importance of that book to Blake's thought.

Tempera paintings

69 Abraham and Isaac 1799–1800

Tempera with pen on canvas, $10\frac{1}{2} \times 15$ (267×380)
Inscr: 'WB inv'
Lit: Butlin, *Paintings*, no. 382
Yale Center for British Art, Paul Mellon Collection

The subject was treated by Blake in his early period (in a watercolour and a drawing, Butlin, *Paintings*, nos. 108 and 109), but here there is a significant difference: instead of kneeling submissively to the knife, Isaac discovers the ram in the thicket – symbolizing the moment when mankind turned from human to animal sacrifice. In terms of Blake's syncretic myth, in which Biblical and British history were fused, it signifies the end of the Druidical age of human sacrifice:

> And the Druids' golden Knife
> Rioted in human gore,
> In Offerings of Human Life

(*Jerusalem*, plate 27, K.650). Abraham, Blake tells us, was himself a Druid; he 'was called to succeed the Druidical age, which began to turn allegoric and mental signification into corporeal command, whereby human sacrifice would have depopulated the earth' (K.578).

A typological connection between this episode and Christ's sacrifice can also be assumed, and this would possibly have been more explicit when the paintings were first hung on the walls of Thomas Butts's house.

69

IX 70 The Virgin hushing the young John the Baptist 1799

Tempera with pen on paper, $10\frac{5}{8} \times 15$ (270 × 382)
Inscr: 'WB inv 1799'
Lit: Butlin, *Paintings*, no. 406
Private Collection, Chicago

This painting is particularly indebted to Italian Renaissance prototypes in design and subject-matter. The intimate quality of the scene and the colour suggest a close study of the Madonnas by and attributed to Raphael displayed in the Orléans Collection in 1798–99, now on loan from the Bridgewater Collection to the National Gallery of Scotland, Edinburgh. The subject is essentially that of 'Il Silenzio', which Blake would have known indirectly from a prototype by Michelangelo. In the Michelangelo design, however, it is St John who raises his finger to silence the Christ Child.

Blake's treatment reveals in a domestic setting intimations of Christ's death: the butterflies, with the *Eros funéraire* position of the Child, signify the return of the soul to the body when the sleep of death has passed. This painting belongs to a group within the New Testament section of the Butts cycle, dealing with the reconciliation of Old Testament prophecy with Christian revelation: the Virgin pointing to the butterfly in the sky refers to the promise of eternal salvation implicit in Christianity. It is closely allied to the tempera painting of *Jesus riding on a Lamb* (Victoria and Albert Museum, London), the lamb also being an intimation of Christ's sacrifice.

The picture is painted on paper rather than the more usual copper or canvas, which is perhaps a factor in its unusually good state of preservation.

71 Faith, Hope and Charity 1799

Tempera with pen on paper, $10\frac{5}{16} \times 14\frac{3}{4}$
(266 × 375)
Inscr: 'WB 1799'
Lit: Butlin, *Paintings*, no. 428
Museum of Art, Carnegie Institute, Pittsburgh, Bequest of Charles J. Rosenbloom, 1974

The subject appears to be from I Corinthians 13:13: 'And now abideth faith, hope, charity, these three; but the greatest of these is charity.' Charity in Blake's image stands over the other two. Her association with prophecy, made by St Paul, is indicated by her role as instructress to the children below. Faith, on the other hand, a priestly figure absorbed in a book, attracts the emulation of a child, perhaps suggesting the limitations of doctrinal understanding. Hope is seen as a sibylline recording angel, wearing sandals while Charity and Faith are barefoot.

This is one of the best preserved and least reproduced of Blake's tempera paintings for Butts. It is also clearly dated. The thin paint surface allows the strong outline in pen to show clearly.

71

72

72 Christ giving Sight to Bartimaeus 1799–1800

Tempera with pen on canvas, $10\frac{5}{8} \times 15\frac{5}{8}$
(270 × 396)
Inscr: 'WB inv'
Lit: Butlin, *Paintings*, no. 420
Yale Center for British Art, Paul Mellon Collection

The subject of the healing of the Blind Man (Mark 10: 46–52) belongs with the group of Christ's Ministry, and the intervention of the Holy Spirit in the affairs of mankind. Bartimaeus is cured of spiritual blindness through his longing for Jesus: 'And Jesus said unto him, Go thy way; thy faith hath made thee whole.'

The surface of the picture is badly flaked in parts as is so often the case with the Butts tempera series.

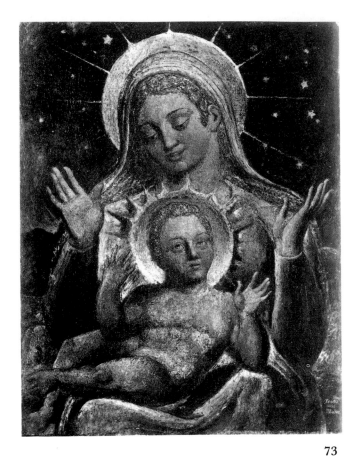

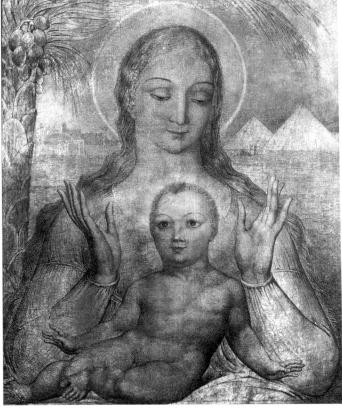

73

Fig. 30 Blake: *The Virgin and Child in Egypt*, 1810, tempera on canvas. Victoria and Albert Museum, London

73 Virgin and Child ('The Black Madonna')

Tempera with pen and gold paint, $12 \times 9\frac{3}{8}$
(305×239)
Inscr: 'Freso [sic] / 1825 / Blake'
Lit: Butlin, *Paintings*, no. 674
Yale Center for British Art, Paul Mellon Collection

An important but problematic work. In the first place there are obvious signs of damage: the right leg of the Christ Child does not join the body convincingly and is obviously repainted, and much of the gold has been reinforced. Furthermore the picture surface has in parts a granular appearance not characteristic of Blake's work, and the signature with its curious misspelling of the word 'fresco' has certainly been repainted relatively recently. On the other hand recent technical examination and a cautious cleaning by Mr John Brealey, as well as a provenance dating back to the 1860s, leave little doubt of its authenticity, and it remains a compelling work through its battered surface. The darkening was already evident in the 19th century and it was described by William Michael Rossetti (Gilchrist, 1880, p. 243) as 'A quaint, mystic, Byzantine-looking little picture'.

Butlin doubts the date 1825 and connects the painting with an earlier phase of Blake's tempera technique, dating the picture *c.* 1810–20. However, some credibility may be attached to the date of 1825, which was evidently visible in the 19th century, and this later date is supported by the style, which is closer to the *Book of Job* engravings (No. 115b). The sunlight which emerges from behind the hill to light up the Virgin's right sleeve with quite broad strokes of paint is close to the luminous effects in the *Job* (e.g. No. 115b.7). Through such bold highlighting the painting is suffused with a mysterious light, quite different in feeling from that of the comparable painting dated 1810, of *The Virgin and Child in Egypt* (Fig. 30), which by contrast is hard and linear. The light in the Yale painting is the true subject of the picture; it is the Light of Salvation about to dispel the stars of night through Christ's sacrifice. The tragedy and promise are expressed in the simultaneity of the Virgin's tears and joy.

Watercolours

X 74 **Malevolence** 1799

Watercolour with pen, $11\frac{7}{8} \times 8\frac{7}{8}$ (300 × 225)
Lit: Butlin, *Paintings*, no. 341
Philadelphia Museum of Art: Given by
 Mrs William T. Tonner

This watercolour was the subject of an acrimonious and hilarious correspondence between Blake and the intended patron, the Rev. Dr Trusler, author of *Hogarth Moralized* and *The Way to be Rich and Respectable*. Trusler was introduced to Blake by George Cumberland and commissioned from him two illustrations of 'Malevolence' and 'Benevolence' to be followed by 'Pride' and 'Humility', expecting pastoral or satirical treatments of those themes. Trusler was bitterly disappointed with *Malevolence* and wrote back a long letter of criticism. He had clearly laid down strict guidelines, for Blake in his letter of 16 August 1799 accompanying the watercolour claimed, 'I attempted every morning for a fortnight together to follow your Dictate', but in the end decided to offer the present composition which he described as 'A Father, taking leave of his Wife & Child, Is watch'd by Two Fiends incarnate, with intention that when his back is turned they will murder the mother & her infant'. Trusler's reply is lost but Blake in writing of the incident to Cumberland (on 26 August; K.794) claims that Trusler said the design 'accords not with his Intentions, which are to Reject all Fancy from his Work'.

Blake's reply of 23 August (K.793), beginning 'Revd Sir, I really am sorry that you are fall'n out with the Spiritual World, Especially if I should have to answer for it', is a classic statement of his artistic creed, proclaiming the primacy of the imagination and the right of a work not to be too explicit. He also takes a high classical stance on the question of 'low' subject-matter in words that might have been spoken by Sir Joshua Reynolds: 'But as I cannot paint Dirty rags & old shoes where I ought to place Naked Beauty or simple ornament, I despair of Ever pleasing one Class of Men'. He asserts that his figures 'are those of Michael Angelo, Rafael & the Antique, & of the best living Models', and accuses the clergyman of having his eye perverted by caricature prints!

The richness of the Blake-Trusler correspondence has tended to draw attention away from the quality of Blake's design, especially the eerie moonlit landscape, suggestive of the paintings of Joseph Wright of Derby. This landscape is close to the background of *Eve Tempted* (Butlin, *Paintings*, no. 379), probably done about the same time.

Blake's conception of Malevolence goes back to the first Preludium plate of *Europe* (Bindman, *Graphic Works*, no. 169), where a fiend lies in wait for the Mental Traveller (see No. 99a), exhibiting the envy of the mediocre for the man of genius: 'Is not Merit in one a Cause of Envy in another, & Serenity & Happiness & beauty a Cause of Malevolence?' (K.793).

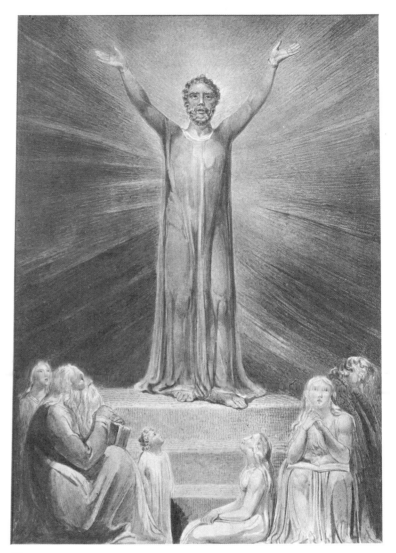

75

75 **St Paul preaching at Athens** 1803

Watercolour and pen, $18\frac{1}{8} \times 12\frac{1}{2}$ (460 × 317)
Inscr: 'WB inv' (monogram), '1803'
Lit: Butlin, *Paintings*, no. 507
Museum of Art, Rhode Island School of Design,
 Providence

An example of the change in Blake's technique as he worked on the Biblical watercolours. It corresponds to others of the same year in the use of stippling to depict light, and a tendency towards hieratic composition, making St Paul address the spectator directly and reducing the audience to the generations of humanity. As such it represents a conscious break from the canonical depiction of the subject in the Raphael Cartoons. In a letter to Butts announcing that he was working on this drawing, among others (K.824), Blake claims that 'They are all in great forwardness, & I am satisfied that I improve very much & shall continue to do so while I live.'

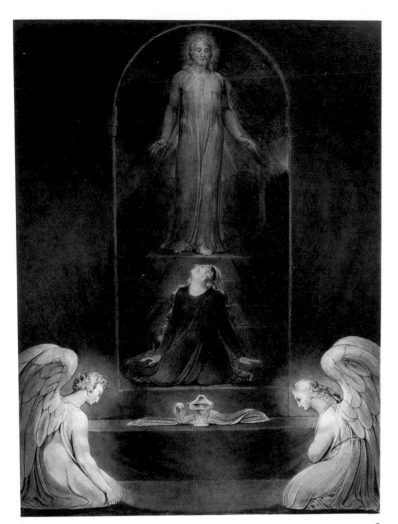

76

76 Mary Magdalen at the Sepulchre *c.* 1805

Watercolour and pen, $16\frac{13}{16} \times 12\frac{1}{4}$ (427×311)
Inscr: 'WB inv' (monogram)
Lit: Butlin, *Paintings*, no. 504
Yale Center for British Art, Paul Mellon Collection

A profoundly spiritual rendering of Mary Magdalen's recognition of Jesus after the Resurrection (John 20: 15). Unusually in European art, Christ does not appear as a gardener. Blake has given the scene a Gothic atmosphere by placing the angels on either side like supporting figures. The light is of a subtlety rarely found in his work up to this date; it is fortunate that the watercolour has not faded substantially. Like No. 95 in the present exhibition, it belongs to a group of Butts watercolours of the Crucifixion, probably done about 1805, as the sharp outlines would suggest.

77 The Ghost of Samuel appearing to Saul *c.* 1800–1805

Watercolour with pen, $12\frac{9}{16} \times 13\frac{9}{16}$ (320×344)
Inscr: 'WB inv' (monogram)
Lit: Butlin, *Paintings*, no. 458
National Gallery of Art, Washington, Rosenwald Collection, 1945

A reworking of an early composition (No. 11). The differences between the two are discussed in the Introduction, pp. 33–34. This watercolour is dated by Butlin *c.* 1800, but it could be a little later.

78 The Vision of Ezekiel *c.* 1805

Watercolour with pen, $15\frac{9}{16} \times 11\frac{5}{8}$ (395×295)
Inscr: 'WB inv' (monogram)
Lit: Butlin, *Paintings*, no. 468; Manhattanville, 1974, no. 26
Museum of Fine Arts, Boston

This watercolour is one of the most successful of Blake's attempts to give pictorial form to the complex visionary imagery of the Bible. Ezekiel's assumption of the mantle of prophecy and the fourfold nature of his vision, with its typological prefiguring of the four Evangelists, were especially important to Blake, as to other prophets.

The fourfold man of Ezekiel's vision is made up of the 'Four Zoas' or living creatures, which act as a kind of chariot for God (in Dante they act as the wheels of Beatrice's chariot: see *Fig. 26*). Ezekiel is seen below, on the bank of the river, looking in astonishment at the vision (Ezekiel 1: 4–28):

And I looked, and, behold, a whirlwind came out of the north . . . out of the midst thereof came the likeness of four living creatures . . . they had the likeness of a man.

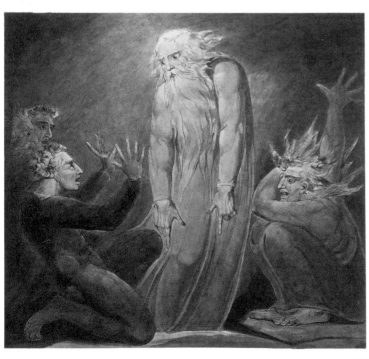

77

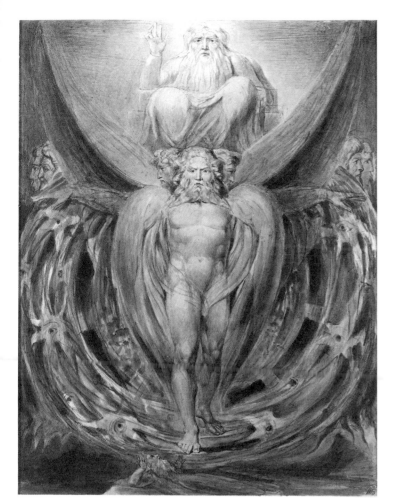

78

79 The Repose of the Holy Family in Egypt 1806

Watercolour with pen, $13\frac{13}{16} \times 14\frac{11}{16}$ (351×373)
Inscr: '1806 WB inv' (monogram)
Lit: Butlin, *Paintings*, no. 472
*The Metropolitan Museum of Art, New York,
Rogers Fund, 1906*

The presence of the date 1806 prevents this drawing from being identified with another of the same subject sent to Butts in July 1803, but Blake's description of that suggests something of the spirit behind the present work: 'It represents the Holy Family in Egypt, Guarded in their Repose from those Fiends, the Egyptian Gods.' He claimed a similarity to Milton's *On the Morning of Christ's Nativity*, the idea of which also informs this design.

It is possible that this watercolour did not in fact belong to Butts; he already had the other version, and it does not appear in any of the Butts sales. For a comparison with Runge's version of the subject see the Introduction, pp. 30–31.

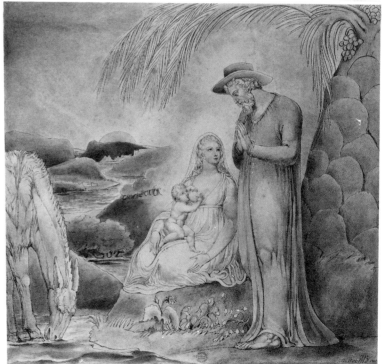

79

And every one had four faces, and every one had four wings. . . . As for the likeness of the living creatures, their appearance was like burning coals of fire . . .

Now as I beheld the living creatures, behold one wheel upon the earth by the living creatures, with his four faces. The appearance of the wheels and their work was like unto the colour of a beryl: and they four had one likeness: and their appearance and their work was as it were a wheel in the middle of a wheel. . . . As for their rings, they were so high that they were dreadful; and their rings were full of eyes round about them four. . . .

And above the firmament that was over their heads was the likeness of a throne . . . and upon the likeness of the throne was the likeness as the appearance of a man above upon it. . . . This was the appearance of the likeness of the glory of the Lord.

The watercolour was delivered to Butts on 12 May 1805 and was listed by Blake as 'Ezekiel's Wheels'.

Illustrations to the Book of Revelation

The four watercolours here displayed do not make up a coherent series. Blake made a number of watercolours from Revelation between *c.* 1800 (*Death on a Pale Horse*: *Fig. 31*) and 1809 (*The Whore of Babylon*, British Museum, London: Butlin, *Paintings*, no. 523). Even so, Nos. 81–83 were certainly done within a short period of time, probably about 1803–05, and their imagery is closely allied.

The Book of Revelation, as a prophecy of the end of the world and the triumph of the Spirit, was the bedrock of all millenarian attempts to link the prophecies of the Bible with the events of the contemporary world. Some of Blake's early watercolours contained veiled references to Revelation (see Nos. 12 and 13), and the arcane imagery of the Illuminated Books is to a degree governed by it. The failure of the French Revolution to spread throughout the world did not diminish for Blake the relevance of the Book of Revelation, and two of his most far-reaching attempts to apply its prophecy to contemporary politics belong to about the same period as these watercolours. They are the damaged tempera paintings of *The Spiritual Form of Nelson guiding Leviathan* and *The Spiritual Form of Pitt guiding Behemoth* (both Tate Gallery, London). In the latter Pitt is to be understood as the Angel of Revelation 'who, pleased to perform the Almighty's orders, rides on the whirlwind, directing the storms of war'.

The association of the Great Dragon with Satan, and the Beast from the Sea with worldly power, contributed to Blake's conception of Urizen, and there are many references to the imagery of Revelation in the later Prophecies. The following passage from *Vala or the Four Zoas* (K.356) is an example of how closely Blake's own myth and that of Revelation are intertwined:

> Rahab triumps over all; she took Jerusalem
> Captive, a Willing Captive, by delusive arts
> impell'd
> To worship Urizen's Dragon form, to offer her
> own Children
> Upon the bloody Altar. John saw these things
> Reveal'd in Heaven
> On Patmos Isle, & heard the souls cry out to
> be deliver'd.

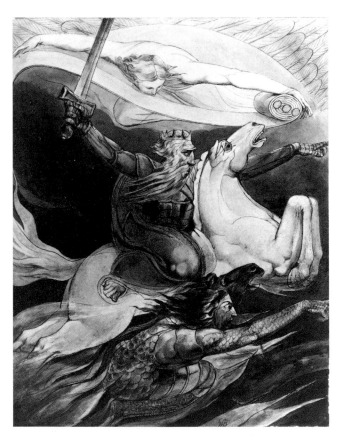

80 The Angel of Revelation (Revelation 10: 1–6), *c.* 1803–05

Watercolour with pen, $15\frac{7}{16} \times 10\frac{5}{16}$ (393×262)
Inscr: 'WB inv' (monogram)
Lit: Butlin, *Paintings*, no. 518; Manhattanville, 1974, no. 21
The Metropolitan Museum of Art, New York, Rogers Fund, 1914

John the Evangelist is vouchsafed a vision of a 'mighty angel' who 'lifted up his hand to Heaven', and is given 'the little book which is open in the hand of the angel'; he then swallows it in order to 'prophesy again before many people, and nations, and tongues, and kings'. (In Dürer's great woodcut from his Apocalypse series St John is seen in the act of swallowing the book.) The colossal angel spanning land and sea is possibly derived from an earlier engraving of the Colossus of Rhodes. The horsemen are probably, as the Manhattanville catalogue suggests, the 'seven thunders' mentioned in the Biblical text.

81 The Great Red Dragon and the Woman clothed with the Sun (Revelation 12: 1–4), *c.* 1803–05

Watercolour with pen, $17\frac{1}{8} \times 13\frac{1}{2}$ (435×345)
Inscr: 'WB inv' (monogram)
Lit: Butlin, *Paintings*, no. 519; Manhattanville, 1974, no. 22
The Brooklyn Museum, Gift of William Augustus White

The beginning of chapter 12 is marked by the appearance

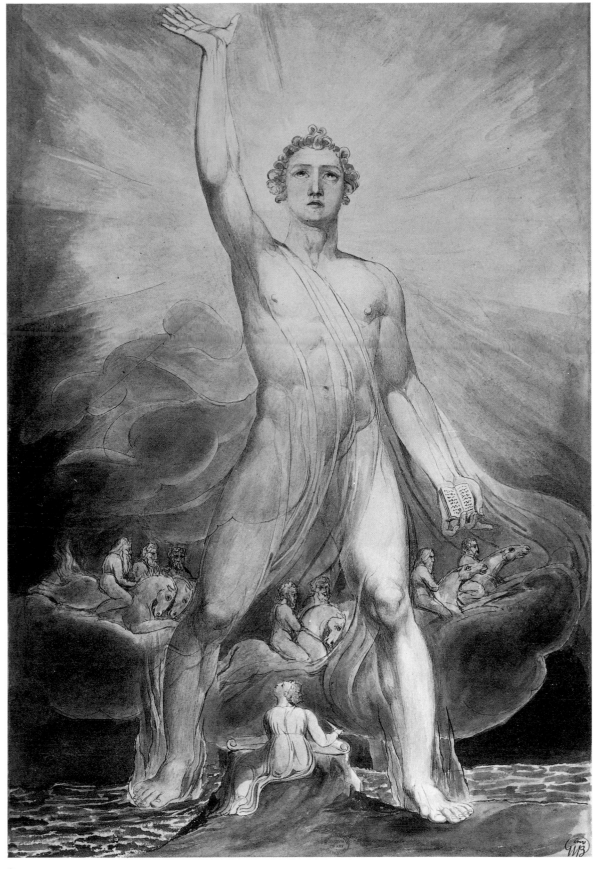

80

of 'a great wonder in heaven, a woman clothed with the sun, and the moon under her feet, and upon her head a crown of twelve stars'. She cries aloud in the pain of childbirth while there appears another wonder, 'A great red dragon, having seven heads and ten horns, and seven crowns upon his heads', whose tail casts the stars to earth. He waits before the Woman 'to devour her child as soon as it is born'. The Dragon is Satan, and the Woman the mother of the Redeemer. In Blake's *Vision of the Last Judgment*, 'the Dragon has Satan's book of Accusations lying on the Rock open before him', while the Woman is 'the Church Universal', the state of 'the innocent civilized Heathen & the Uncivilized Savage, who, having not the Law, do by Nature the things contain'd in the Law'.

Another watercolour, not exhibited (Butlin, no. 520), shows the Dragon's pursuit of the Woman, attempting to drown her by a flood of water, but she is saved by the earth opening up and swallowing the flood.

82 The Great Red Dragon and the Beast from the Sea (Revelation 13: 1–7), *c.* 1803–05

Watercolour with pen, $15\frac{13}{16} \times 14$ (401 × 356)
Inscr: 'WB inv' (monogram)
Lit: Butlin, *Paintings*, no. 521
National Gallery of Art, Washington, Rosenwald Collection, 1945

The next chapter opens with the appearance of the Beast from the Sea, 'having seven heads and ten horns, and upon his horns ten crowns, and upon his heads the name of blasphemy'. The Beast from the Sea is another symbol of temporal power, an enemy to Christianity yet worshipped by humanity; his power is given to him by the Dragon, so Satan is behind this hideous image of war which enthralls humanity. 'And they worshipped the dragon which gave power unto the beast: and they worshipped the beast, saying, Who is like unto the beast? who is able to make war with him?' The precise text depicted by Blake is the one in which the Dragon gives power to the Beast 'to make war with the saints', indicated by the sword and the sceptre.

The grotesque description of the Beast from the Sea in Revelation suggests the bestial face of worldly power lurking behind many other images in Blake, for example the bat-winged pope in plate 10 of *Europe* (*Fig. 12*). The Beast, with heads of a pope, king, judge, etc., and upon whose tail sits the Whore of Babylon, also appears in the *Night Thoughts* watercolours (ill. *William Blake*, exh. cat., Tate Gallery, London, 1978, no. 115).

83 The Number of the Beast is 666 (Revelation 13:11–12), *c.* 1803–05

Watercolour with pen, $16\frac{3}{16} \times 13\frac{3}{16}$ (412 × 335)
Inscr: 'WB inv' (monogram)
Lit: Butlin, *Paintings*, no. 522; Manhattanville, 1974, no. 24
Rosenbach Museum and Library, Philadelphia

The Beast from the Sea, or temporal power, is worshipped through the agency of the Beast from the Earth, a gigantic lamb, which takes on the deceitful role of False Prophecy. The Beasts are seen as a gigantic altar beneath which the ranks of humanity pay obeisance. The Dragon behind is in distress because he has heard 'the voice of a great thunder', the prophecy of his own impending destruction.

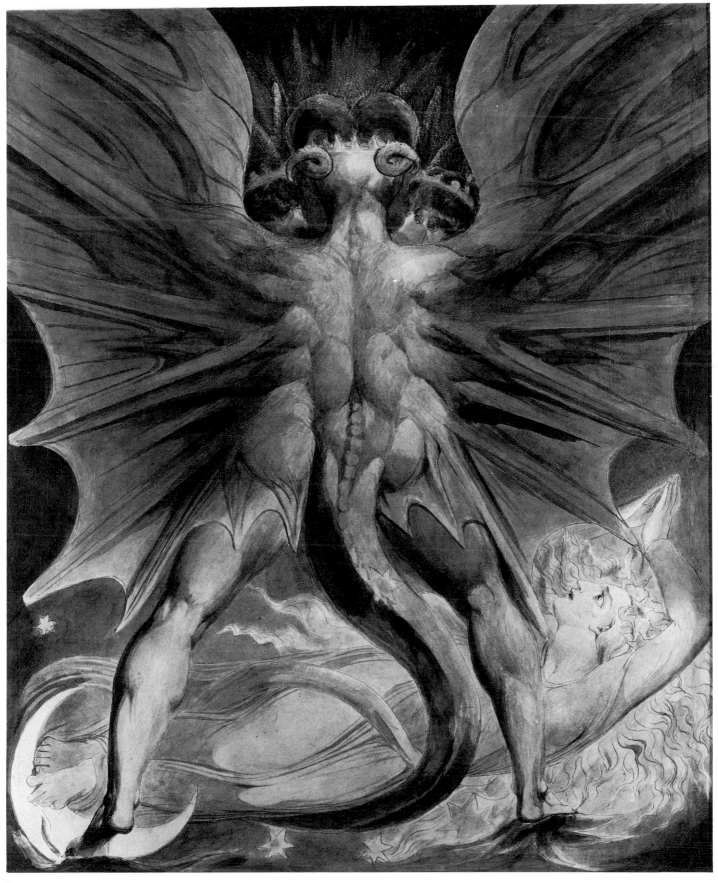

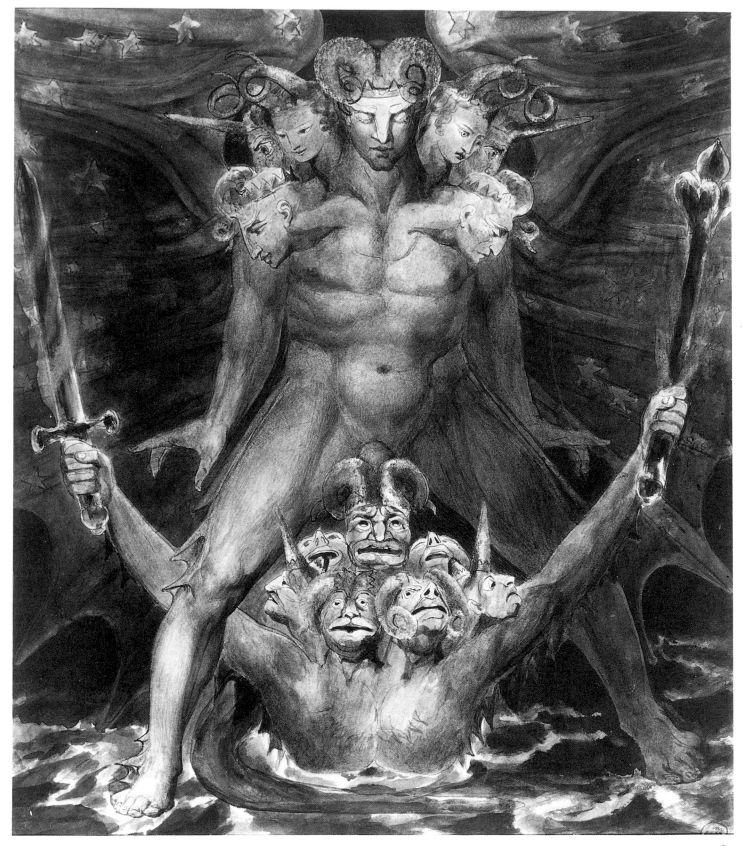

142 · THOMAS BUTTS AND PAINTINGS FROM THE BIBLE

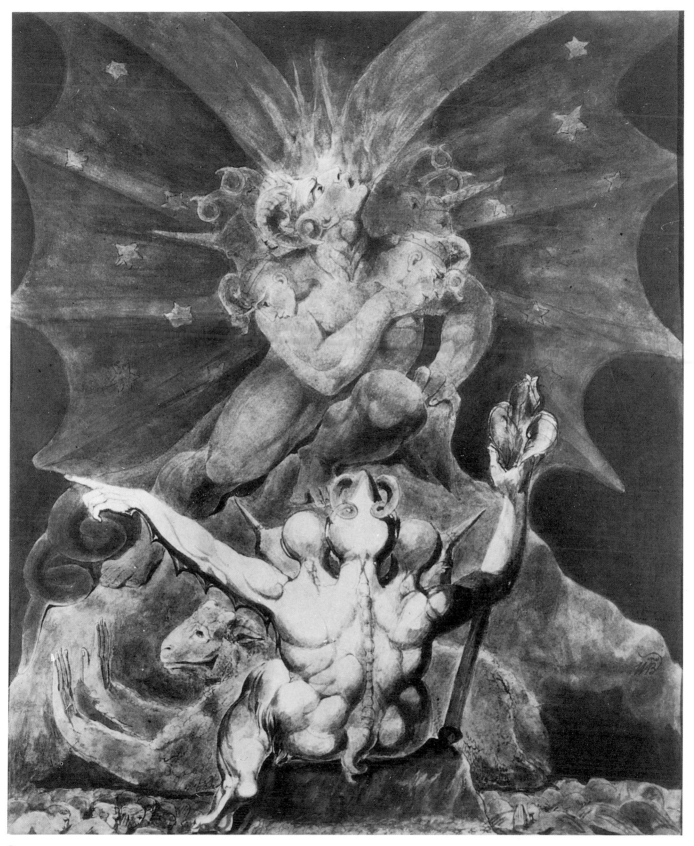

83

Blake in Felpham, 1800–1803

Blake's period at Felpham in Sussex, which he called his 'three years slumber on the banks of the Ocean' (*Jerusalem*, plate 3, K.620), is fully documented in his surviving correspondence with William Hayley (1745–1820), his employer. Hayley was a country gentleman of some literary reputation, who turned out an endless stream of vapid verse. He is mainly of interest for his encouragement of artists: Romney and Flaxman both benefited and suffered from his attentions. He assiduously promoted them, publishing book-length poems in their honour.

Blake came into a different category, however, as an amanuensis to help him with his many literary projects and the decoration of his library. Blake was justified in feeling his patron's 'Genteel Ignorance & Polite Disapprobation' towards his imaginative works, but it should be said that Hayley was only following the path indicated by Flaxman, who had hoped he would reconcile Blake to abandoning his artistic ambitions, writing to Hayley on 19 August 1800 (Bentley, *Records*, p. 72):

I hope that Blake's residence at Felpham will be a Mutual Comfort to you & him, & I see no reason why he should not make as good a livelihood there as in London, if he engraves & teaches drawing, by which he may gain

considerably as also by making neat drawings of different kinds, but if he places any dependence on painting large pictures, for which he is not qualified, either by habit or study, he will be miserably decieved.

Blake was given commissions for heads of poets for the library (Manchester City Art Gallery), and illustrated Hayley's poems and books – activities which he could only find trivial. Even so some of these minor works are not without merit, and, despite Blake's complaints, the period was seminal for the growth of his final myth: both *Milton* and *Jerusalem* emerged from this sojourn by the sea.

84 Letter to John Flaxman 21 September 1800
(with later etching of Blake's cottage)

Double leaf written on 3 sides
Lit: Keynes, *Letters*, no. 22(18)
Beinecke Rare Book and Manuscript Library, Yale University

This touching letter expresses Blake's gratitude to Flaxman for arranging the stay at Felpham, and his delighted first reactions to the cottage.

Dear Sculptor of Eternity

We are safe arrived at our Cottage which is more beautiful than I thought it & more convenient. It is a perfect Model for Cottages & I think for Palaces of Magnificence only Enlarging not altering its proportions & adding ornaments & not principals. Nothing can be more Grand than its Simplicity & Usefulness. Simple without Intricacy it seems to be the spontaneous Effusion of Humanity congenial to the wants of Man. No other formed House can ever please me so well nor shall I ever be persuaded I believe that it can be improved either in Beauty or Use.

Mr. Hayley received us with his usual brotherly affection. I have begun to work Felpham is a sweet place for Study because it is more spiritual than London. Heaven opens here on all sides her golden Gates her windows are not obstructed by vapours voices of Celestial inhabitants are most distinctly heard & their forms more distinctly seen & my Cottage is also a Shadow of their houses. My Wife & Sister are both well courting Neptune for an Embrace.

Our journey was very pleasant & tho we had a great deal of Luggage. No Grumbling all was Cheerfulness & Good Humour on the Road & yet we could not arrive at our Cottage before half past Eleven at night owing to the necessary shifting of our luggage from one Chaise to another for we had Seven Different Chaises & as many

Fig. 32 H. H. Gilchrist: Blake's cottage at Felpham, etching. Beinecke Rare Book and Manuscript Library, Yale University

different drivers. We set out between Six & Seven on the Morning of Thursday with Sixteen heavy boxes & portfolios full of prints. And Now Begins a New Life because another covering of Earth is shaken off. I am more famed in Heaven for my works than I could well conceive In my Brain are studies & Chambers filled with books & pictures of old which I wrote & painted in ages of Eternity before my mortal life & those works are the delight & study of Archangels. Why then should I be anxious about the riches or fame of mortality. The Lord our Father will do for us & with us according to his Divine will for our Good.

You O Dear Flaxman are a Sublime Archangel My Friend & Companion from Eternity in the Divine bosom is our Dwelling place I look back into the regions of Reminiscence & behold our ancient days before this Earth appeared in its vegetated mortality to my mortal vegetated Eyes. I see our houses of Eternity which can never be separated tho our Mortal vehicles should stand at the remotest corners of heaven from each other.
Farewell My Best Friend Remember Me & My Wife in Love & Friendship to our Dear Mrs. Flaxman whom we ardently desire to Entertain beneath our thatched roof of rusted gold & believe me for ever to remain
> Your Grateful & Affectionate
> William Blake

Felpham
Sept.ʳ 21 1800
 Sunday Morning

85 A Series of Ballads, by William Hayley 1802

Printed book, letterpress, with 14 plates designed
 and engraved by Blake
Engraved full-page plates approx. $6\frac{1}{8} \times 5$
 (155×127)
Lit: Bindman, *Graphic Works*, nos. 385–98
The Library, Princeton University

The *Ballads* were issued in separate parts by Blake himself, and this is one of the very few complete copies. The origins of the work are recounted by Hayley in his preface, which sums up his whimsical character and patronizing attitude towards Blake:

To amuse the Artist in his patient labour [on the engravings for the *Life of Cowper*, No. 87] and to furnish his fancy with a few slight subjects for an inventive pencil, that might afford some variety to his incessant application, without too far interrupting his more serious business, I chanced to compose, in hours of exercise and leisure, a few Ballads, upon anecdotes relating to animals, that happened to interest my fancy. They succeeded perfectly as an amusement to my Friend; and led him to execute a few rapid sketches, that several judges of his talent are desirous of converting to his honour and emolument.

Blake as usual had exaggerated hopes of the success of publication; though Hayley tried to sell some to his friends, it seems that Blake had most of the expenses of publication.

86 Letter to James Blake 30 January 1803

Double leaf written on 4 sides
Lit: Keynes, *Letters*, no. 43(31)
*The Library of Congress, Washington, Rosenwald
Collection*

A letter very different in tone from No. 84, expressing with great frankness Blake's disillusionment with Hayley and determination to leave his employ. He characteristically accuses Hayley of envy towards him. The envy of mediocrity for genius is an important element in Blake's mythology, explaining the subservience of artists to false values.

> Felpham,
> Jan.ʸ, 30, 1803.

Dear Brother,
 Your Letter mentioning Mʳ Butts' account of my Ague surprized me because I have no Ague, but have had a Cold this Winter. You know that it is my way to make the best of everything. I never make myself nor my friends uneasy if I can help it. My Wife has had Agues & Rheumatisms almost ever since she has been here, but our time is almost out that we took the Cottage for. I did not mention our Sickness to you & should not to Mʳ Butts but for a determination which we have lately made, namely To leave This Place, because I am now certain of what I have long doubted, Viz that H. is jealous as Stothard was & will be no further My friend than he is compell'd by circumstances. The truth is, As a Poet he is frighten'd at me & as a Painter his views & mine are opposite; he thinks to turn me into a Portrait Painter as he did Poor Romney, but this he nor all the devils in hell will never do. I must own that seeing H. like S., Envious (& that he is I am now certain) made me very uneasy, but it is over & I now defy the worst & fear not while I am true to myself which I will be. This is the uneasiness I spoke of to Mʳ Butts, but I did not tell him so plain & wish you to keep it a secret & to burn this letter because it speaks so plain. I told Mʳ Butts that I did not wish to Explore too much the cause of our determination to leave Felpham because of pecuniary connexions between H. & me—Be not then uneasy on any account & tell my Sister not to be uneasy, for I am fully Employ'd & Well Paid. I have made it so much H's interest to employ me that he can no longer treat me with indifference & now it is in my power to stay or return or remove to any other place that I choose, because I am getting before hand in money matters. The Profits arising from Publications are immense, & I now have it in my power to commence

publication with many very formidable works, which I have finish'd & ready. A Book price half a guinea may be got out at the Expense of Ten pounds & its almost certain profits are 500 G. I am only sorry that I did not know the methods of publishing years ago, & this is one of the numerous benefits I have obtain'd by coming here, for I should never have known the nature of Publication unless I had known H. & his connexions & his method of managing. It now would be folly not to venture publishing. I am now Engraving Six little plates for a little work of Mr H's, for which I am to have 10 Guineas each, & the certain profits of that work are a fortune such as would make me independent, supposing that I could substantiate such a one of my own & I mean to try many. But I again say as I said before, We are very Happy sitting at tea by a wood fire in our Cottage, the wind singing above our roof & the sea roaring at a distance, but if sickness comes all is unpleasant.

But my letter to Mr Butts appears to me not to be so explicit as that to you, for I told you that I should come to London in the Spring to commence Publisher & he has offer'd me every assistance in his power without knowing my intention. But since I wrote yours we had made the resolution of which we inform'd him, viz to leave Felpham entirely. I also told you what I was about & that I was not ignorant of what was doing in London in works of art. But I did not mention illness because I hoped to get better (for I was really very ill when I wrote to him the last time) & was not then perswaded as I am now that the air tho' warm is unhealthy.

However, this I know will set you at Ease. I am now so full of work that I have had no time to go on with the Ballads, & my prospects of more & more work continually are certain. My Heads of Cowper for Mr H's life of Cowper have pleas'd his Relations exceedingly & in Particular Lady Hesketh & Lord Cowper—to please Lady H. was a doubtful chance who almost ador'd her Cousin the poet & thought him all perfection, & she writes that she is quite satisfied with the portraits & charm'd by the great Head in particular, tho' she never could bear the original Picture.

But I ought to mention to you that our present idea is: To take a house in some village further from the Sea, Perhaps Lavant, & in or near the road to London for the sake of convenience. I also ought to inform you that I read your letter to Mr H. & that he is very afraid of losing me & also very afraid that my Friends in London should have a bad opinion of the reception he has given to me. But My Wife has undertaken to Print the whole number of the Plates for Cowper's work, which She does to admiration, & being under my own eye the prints are as fine as the French prints & please every one: in short I have Got every thing so under my thumb that it is more profitable that things should be as they are than any other way, tho' not so agreeable, because we wish naturally for friendship in preference to interest.—The

Publishers are already indebted to My Wife Twenty Guineas for work deliver'd; this is a small specimen of how we go on: then fear nothing & let my Sister fear nothing because it appears to me that I am now too old & have had too much experience to be any longer imposed upon, only illness makes all uncomfortable & this we must prevent by every means in our power.

I send with this 5 Copies of N4 of the Ballads for Mrs Flaxman & Five more, two of which you will be so good as to give to Mrs Chetwynd if she should call or send for them. These Ballads are likely to be Profitable, for we have Sold all that we have had time to print. Evans the Bookseller in Pallmall says they go off very well, & why should we repent of having done them? it is doing Nothing that is to be repented of & not doing such things as these.

Pray remember us both to Mr Hall when you see him.

I write in great haste & with a head full of botheration about various projected works & particularly a work now Proposed to the Public at the End of Cowper's Life, which will very likely be of great consequence; it is Cowper's Milton, the same that Fuseli's Milton Gallery was painted for, & if we succeed in our intentions the prints to this work will be very profitable to me & not only profitable, but honourable at any rate. The Project pleases Lord Cowper's family, & I am now labouring in my thoughts Designs for this & other works equally creditable. These are works to be boasted of, & therefore I cannot feel depress'd, tho' I know that as far as Designing & Poetry are concern'd I am Envied in many Quarters, but I will cram the dogs, for I know that the Public are my friends & love my works & will embrace them whenever they see them. My only Difficulty is to produce fast enough.

I go on Merrily with my Greek & Latin; am very sorry that I did not begin to learn languages early in life as I find it very Easy; am now learning my Hebrew אבג. I read Greek as fluently as an Oxford scholar & the Testament is my chief master: astonishing indeed is the English Translation, it is almost word for word, & if the Hebrew Bible is as well translated, which I do not doubt it is, we need not doubt of its having been translated as well as written by the Holy Ghost.

my wife joins me in Love to you both.

I am, Sincerely yours,

W. Blake

87 The Life and Posthumous Writings of William Cowper Esqr, by William Hayley
1803–04

Printed book, letterpress, in 3 volumes, open at
The Peasants' Nest and Cowper's Tame Hares,
designed and engraved by Blake, 1802
Engraving printed on a page of letterpress,
$6 \times 4\frac{9}{16}$ (152 × 116)

MOTTO on a *CLOCK,*

With a *Translation by the Editor.*

QUÆ lenta accedit, quam velox præterit hora!
Ut capias, patiens esto, sed esto vigil!

Slow comes the hour : its passing speed how great!
Waiting to seize it—vigilantly wait!

Peace to the Artist whose ingenious thought
Devised the Weather-house, that useful toy!

Fearless of humid air and gathering rains
Forth steps the Man. an emblem of myself.
More delicate his timrous mate retires.

Task. B 1. line 200

THE PEASANTS NEST

Cowper's PUSS TINEY & BESS *tame Hares*

Published Nov.^r 5 1802 by J. Johnson S.^t Pauls Church Yard

88

Lit: Bindman, *Graphic Works*, no. 399; Easson and Essick, *Book Illustrator*, I, no. VII
Yale Center for British Art, Paul Mellon Collection

Blake was employed on a number of engravings after Romney, Flaxman and others for this grand edition of the life of Cowper, published by Joseph Johnson. This plate is Blake's only original design, printed on an ordinary letterpress page of the book. It is more serious than appears at first, for it contrasts the woman in the state of Innocence with Blake's Mental Traveller, stepping forth fearlessly into the world of Experience (compare *The Traveller Hasteth in the Evening* from *The Gates of Paradise*, 1793: Bindman, *Graphic Works*, no. 130).

88 Ballads, by William Hayley 1805

Printed book, letterpress, with 5 plates designed
 and engraved by Blake
Engraved plates approx. $4\frac{1}{4} \times 2\frac{13}{16}$ (108 × 71)
Lit: Bindman, *Graphic Works*, nos. 403–07; Easson
 and Essick, *Book Illustrator*, I, no. VIII
Yale Center for British Art, Paul Mellon Collection

An attempt on the part of Blake and Hayley to recover some of the losses on the 1802 publication of the *Ballads* in parts (No. 85). It is printed more like a children's book, on a smaller scale. The plates were re-engraved, and though they were printed in fairly large numbers it is doubtful if very many were sold.

89 The Horse, from Hayley's *Ballads*, 1805–06?

Tempera with pen on a gesso-primed copper
 engraving plate, $4\frac{3}{16} \times 2\frac{1}{2}$ (106 × 62)
Lit: Butlin, *Paintings*, no. 366
Mr and Mrs Paul Mellon, Upperville, Va.

This little painting is the only one known to have been made from the designs to Hayley's *Ballads*; the subject is a mother defending her child against a fierce runaway Arab horse. It is executed on a piece of copper plate which has some foliage and engraving strokes on the back, not by Blake; they could perhaps have been made by his pupil Tommy Butts, the son of his great patron. The occasion for the painting is not known. The very high quality of the tempera technique may even suggest a date in the 1820s.

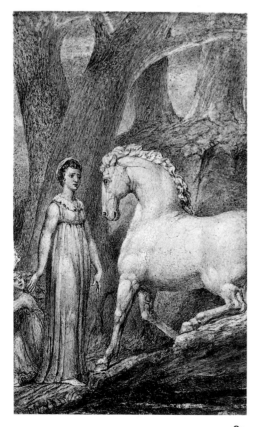

89

Milton: Prophecy and Illustrations, 1801–c. 1820

Despite the limitations of the original work allowed him by Hayley, Blake's mental life at Felpham was one of feverish activity: in January 1802 he claimed to be 'under the direction of Messengers from Heaven, Daily & Nightly'. Felpham was more than once identified by Blake as the 'slumber' from which emerged the great visions of his later years. Hayley inadvertently played a part by embodying the forces in the world hostile to imagination, but the dominating presence in these years was John Milton, whose life Hayley had written and whose works he was editing with Blake's help. Blake's preoccupation with Milton as the poetic redeemer of the English Nation was caught up with the struggles in his own life, especially his relationship with Hayley, and these strands are intertwined in *Milton a Poem*. As early as 1801 he had illustrated *Comus* in watercolour for the Rev. Joseph Thomas, and he returned to Milton in earnest in 1807 and 1808 with two sets of watercolours to *Paradise Lost*. In subsequent years he returned to *Comus* and *Paradise Lost*, and designed other series to *Paradise Regained*, *On the Morning of Christ's Nativity* and *L'Allegro* and *Il Penseroso*.

90 Milton a Poem in [1]2 books 1804–c. 1820

Relief etchings with watercolour, pen and gold, approx. $5\frac{7}{8} \times 4\frac{1}{8}$ (150 × 104)
Lit: Keynes and Wolf, copy D; Bentley, *Blake Books*, pp. 305, 319–20
The Library of Congress, Washington, Rosenwald Collection

Milton a Poem cannot be easily summarized; its central theme is the renewal of Blake's conviction of his own prophetic destiny after years of crisis, culminating in his enslavement to Hayley at Felpham. This renewal is achieved by entering into Milton's own mental struggles, identifying Milton's own errors which led to the unresolved divisions in his life. By absorbing Milton's experience into his own Blake becomes the prophetic saviour necessary for the Apocalypse. *Milton a Poem* is a kind of Preludium to the final vision in *Jerusalem*.

The work has relatively few designs compared to the amount of text, but the full-page images, mostly engraved in white line, are of great power and intensity (ill. p. 9).

The magnificent book exhibited is one of four known copies, and is the only one to have the full complement of 50 plates. The first two copies (British Museum, London, and Huntington Library, San Marino), probably etched about 1807–09, have only 45 plates; the extra 6 (the famous Preface plate having been omitted) were probably

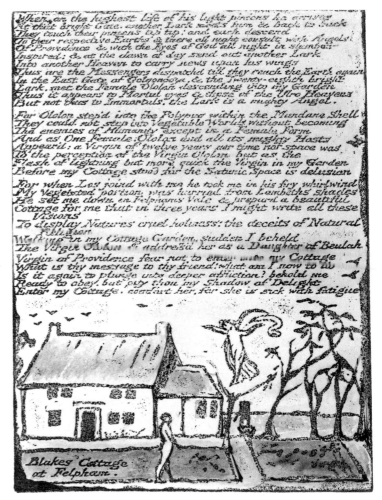

Fig. 33 Blake: plate 36 of *Milton a Poem*, copy A, c. 1807–09, relief etching with watercolour and wash. British Museum, London.

added in 1814–15. The Rosenwald book is also the most elaborately coloured, a fitting companion for the coloured copy of *Jerusalem* in the present exhibition (No. 99). The watermark of 1815 on some of the sheets is significantly later than on any other copy. It might, therefore, have been finished as late as the 1820s. Bentley identified it with the copy comprising 50 plates which Blake offered for sale in a letter of 9 June 1818, but Blake seems there to be offering to print the book specially rather than to sell a copy in stock. The Rosenwald book was owned by James Vine from the Isle of Wight, who bought it from Blake himself or from the notorious poisoner T. G. Wainewright, who was a great admirer of Blake.

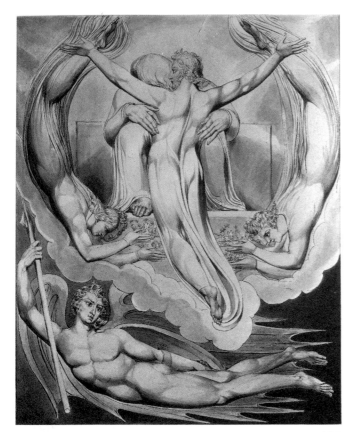

91a

91 Illustrations to Milton's Paradise Lost 1808

These four watercolours are all taken from the second set of 12 illustrations to *Paradise Lost*, dated 1808. The first set, made in 1807 for the Rev. Joseph Thomas (Huntington Library, San Marino), is much smaller in scale. For the third set see No. 114. Of the 1808 series 9 watercolours are in the Boston Museum of Fine Arts, while the other 3 are in the Victoria and Albert Museum, London, the Huntington Library and the Houghton Library at Harvard, having become separated from the main group in the mid-19th century. For *The Creation of Eve* see *Fig. 23*.

Though somewhat faded, the 1808 series is one of Blake's grandest achievements: the monumentality of the images and their theological seriousness give them a special position in his oeuvre. The compositions are related to one another with great care, a strong central axis in each allowing Blake to assert the central role of Christ in man's Redemption, in opposition to Milton's ostensible emphasis on Satan. In Blake's designs Satan appears as merely pathetic when confronted with the grandeur of the Christian Revelation. The central position occupied by Satan in the first design is ultimately assumed by Christ, whose gesture in the illustration to Book 3 (**a**) is a riposte to Satan's pretensions. Blake emphasizes the bleakness of Satan's journey to his ignominious end, making an implicit contrast with Milton's depiction of his magnificent and tragic fate.

a *Christ offers to Redeem Man* (Book 3, ll. 222–352)
Watercolour with pen, $10\frac{1}{8} \times 8\frac{1}{4}$ (257 × 210)
Inscr: 'WBlake 1808'
Lit: Butlin, *Paintings*, no. 529 3
Museum of Fine Arts, Boston

Book 3 of *Paradise Lost* was hardly ever illustrated by other artists. Here Blake has brought out the theological centrality of Christ's sacrifice to redeem man. Christ's ecstatic gesture of renunciation contrasts with the material and therefore despairing perceptions of Jehovah, who cannot understand the nature of his sacrifice. Christ's gesture of affirmation is associated with his sacrifice (see the Introduction, p. 36). In *Milton a Poem* Christ's action is paralleled by Milton's descent to earth to redeem Blake; Milton in plate 11 is bathed in heavenly radiance, for he also renounces his place in Heaven.

b *The Casting of the Rebel Angels into Hell* (Book 6, ll. 835–66)
Watercolour with pen, $10\frac{1}{8} \times 8\frac{3}{16}$ (257 × 208)
Inscr: 'WBlake 1808'
Lit: Butlin, *Paintings*, no. 529 7
Museum of Fine Arts, Boston

The subject is taken from the recapitulation of the events before the Fall, told by the Archangel Raphael to Adam and Eve. Blake's design shows the rout of the rebel angels, and is remarkable for the formality of the composition and the mildness of Christ, who does not appear as the warrior described by Milton.

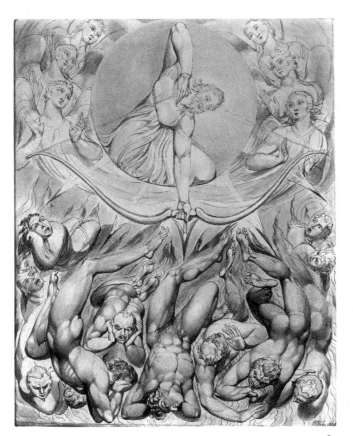

91b

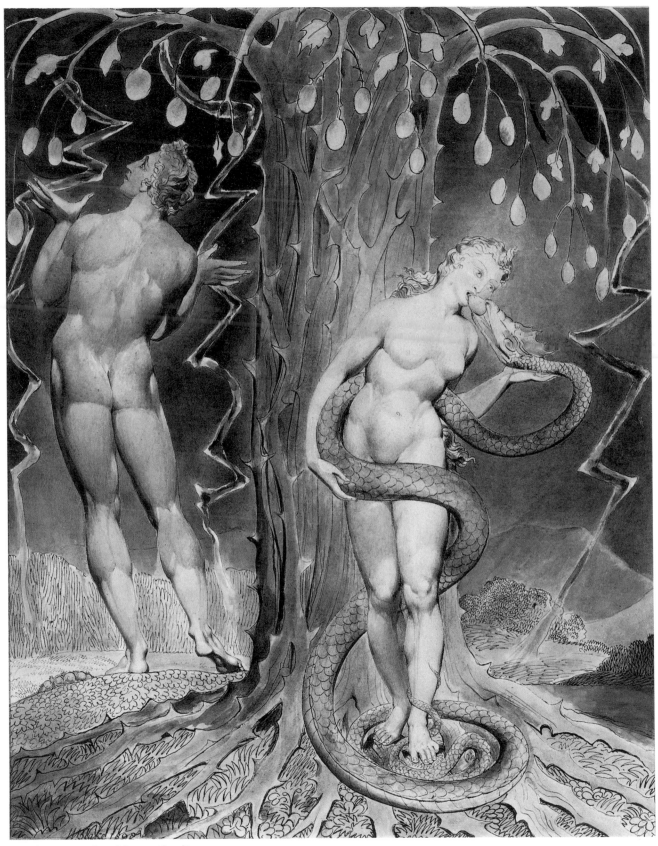

91c (not to scale with 91a, b, d)

91d

c *The Temptation of Eve* (Book 9, ll. 780–84)
Watercolour with pen, 10 × 8¼ (254 × 209)
Inscr: 'WBlake 1808'
Lit: Butlin, *Paintings*, no. 529 9
Museum of Fine Arts, Boston

This astonishing design shows Eve accepting the apple from the Serpent in an openly sexual embrace. The dramatic exposure of the roots and thorns of the tree, and the lightning, are a realization of Milton's lines:

> Earth felt the wound, and nature from her seat
> Sighing through all her works gave signs of woe,
> That all was lost.

Through these convulsions Adam is made aware of the fateful act.

d *The Judgment of Adam and Eve* (Book 10, ll. 163–210)
Watercolour with pen, 9⅞ × 7¹⁵⁄₁₆ (251 × 202)
Inscr: 'WBlake 1808'
Lit: Butlin, *Paintings*, no. 529 10
The Houghton Library, Harvard University

Sin and Death are released upon humanity, but Christ offers Adam and Eve the promise of Redemption, condemning Satan to his serpentine form. The wrath of Jehovah is contrasted with the mercy of Christ, towards whom Adam looks hopefully while Eve buries her face in shame.

92 Illustrations to Milton's Comus *c.* 1815–20

Watercolour with pen, 6¹⁄₁₆ × 4¾ (154 × 120)
Museum of Fine Arts, Boston

The watercolours exhibited are taken from the second set of 8 in the Boston Museum, made for Thomas Butts some time after 1815. The first set, commissioned by the Rev. Joseph Thomas in 1801, is in the Huntington Library, San Marino (*Fig. 34*). The change between the sets reflects the shift in Blake's art from emphatic linearity towards a greater emphasis on colour and atmosphere. This set is close in style to the *L'Allegro and Il Penseroso* series (No. 93), and also to the *Paradise Regained* in the Fitzwilliam Museum, Cambridge.

It is clear in both sets that Blake has given a different emphasis to the story of *Comus* from that of Milton, who intended it as an account of the triumph of Chastity. Blake's interpretation seems to be close in spirit to *The Book of Thel* (No. 40), for the Lady appears to refuse the difficult path to Redemption and to remain perpetually in a state of Innocence. Comus is evidently a Satanic tempter, luring her into a Fall from which she may be Redeemed; the Attendant Spirit, the guardian of the soul, is a type of the artist guiding her towards her Redemption. (For a different interpretation see Irene Taylor, 'Blake's *Comus* Designs', *Blake Studies*, IV, no. 2, 1972, pp. 45–80.)

a *The brothers seen by Comus picking grapes* (ll. 290–303)
Inscr: 'WBlake'
Lit: Butlin, *Paintings*, no. 528 3

Comus comes across the Lady's two brothers picking grapes:

> I saw them under a green mantling vine
> That crawls along the side of yon small hill,
> Plucking ripe clusters from the tender shoots.
> Their port was more than human, as they stood.

b *The Magic Banquet* (ll. 659–813)
Inscr: 'WBlake'
Lit: Butlin, *Paintings*, no. 528 5

Comus (surrounded by his victims, to whom he has given animal heads) tempts the Lady to drink from the magic glass, but she resists:

> Fool do not boast,
> Thou canst not touch the freedom of my mind
> with all thy charms . . .

92a

Fig. 34 Blake: *The Brothers seen by Comus picking Grapes,* from the first set of illustrations to Milton's *Comus, c.* 1801, watercolour with pen. Henry E. Huntington Library and Art Gallery, San Marino

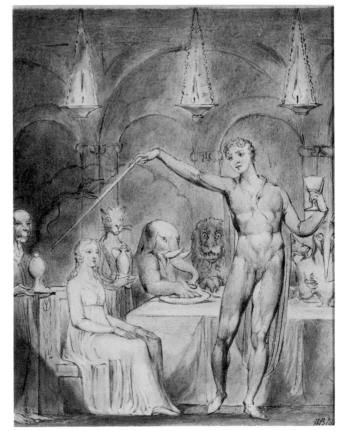

92b

93 Illustrations to Milton's L'Allegro and Il Penseroso, *c.* 1816–20

Watercolour with pen, approx. $6\frac{5}{16} \times 4\frac{13}{16}$
(160 × 122)
Mostly inscr: 'WBlake inv.'
Lit: Butlin, *Paintings*, nos. 543 2, 3, 6, 8, 9, 12
The Pierpont Morgan Library, New York

These 6 watercolours are from the series of 12 (all in the Morgan Library) made for Thomas Butts after 1816, perhaps as late as the early 1820s. Despite contradictory interpretations of certain elements, they are clearly a commentary on Milton's life and art: Milton is identified by Blake as the subject, and the series follows schematically his poetic career, from the early poems like *L'Allegro* and *Il Penseroso* themselves to the late epic *Paradise Lost*. The *L'Allegro* designs must also correspond to the state of Innocence and *Il Penseroso* to Experience. The pattern can be discerned of Milton's development as a poet from youthful lyricism through the scepticism of manhood until he finds a deeper source of inspiration in his old age. Blake remarked to Crabb Robinson that Milton had 'returned back to God whom he had had in his childhood' (Bentley, *Records*, p. 317).

a *The Lark* (no. 2, from *L'Allegro*)
The Lark is depicted as 'an angel on the Wing' casting out 'Dull Night', as dawn awakens the earth beneath. In *Milton a Poem* 'the Lark is Los's Messenger': the beginning of the diurnal cycle is associated with the emergence of Poetic Genius.

b *The Sun at his Eastern Gate* (no. 3, from *L'Allegro*)
According to Blake's commentary, 'The Great Sun [is] represented clothed in Flames Surrounded by the Clouds in their Liveries.' Milton himself is a tiny figure below, 'walking by Elms on Hillocks green'. The sunrise and the advent of Poetic Genius are again drawn together. The poetic spirit descends from Heaven to earth, as the young Milton meditates upon nature in his state of Innocence.

XI **c** *The Youthful Poet's Dream* (no. 6, from *L'Allegro*)
The young poet stretches out on a river bank, while the material sun sinks in the background, indicating that his Innocence is passing from him. He writes at the dictate of 'the more bright Sun of Imagination', containing 'antique pageantry' and a marriage (see p. 40). His youthful imagination is governed by the spirits of learning, in the form of Ben Jonson (left), and nature in the form of Shakespeare, holding panpipes and warbling 'his native woodnotes wild'.

d *The Wandring Moon* (no. 8, from *Il Penseroso*)
Blake's commentary tells us that this depicts 'Milton in his Character of a Student at Cambridge [seeing] the

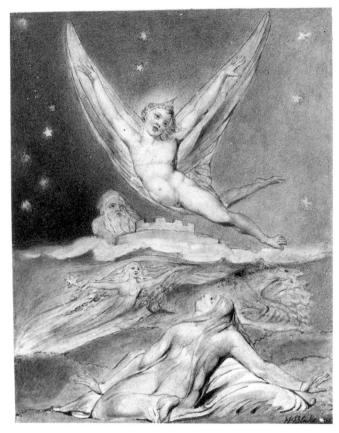

93a

Moon terrified as one led astray'. Learning is associated with Experience and the domination of the moon; by going to Cambridge Milton has entered the Fallen world of abstract speculation.

e *The Spirit of Plato* (no. 9, from *Il Penseroso*)
Milton is enthralled by pagan philosophy under the influence of Plato, who displays his conception of the divisions of the soul, leaving no place for the prophetic imagination.

f *Milton in his old age* (no. 12, from *Il Penseroso*)
'Milton in his Old Age sitting in his Mossy Cell Contemplating the Constellations. Surrounded by the Spirits of the Herbs & Flowers bursts forth into a rapturous Prophetic Strain.' The aged Milton is physically blind but spiritually sighted, exulting in the Divine Vision; he now writes poetry based on experience and the inward spirit. The image is a counterpart to *The Youthful Poet's Dream* (**c**), contrasting artistic creation based on delight in nature with the mature poetry of a man who has learned from experience. This design may represent Milton as the author of *Paradise Lost* or perhaps the redeemed Milton of *Milton a Poem*.

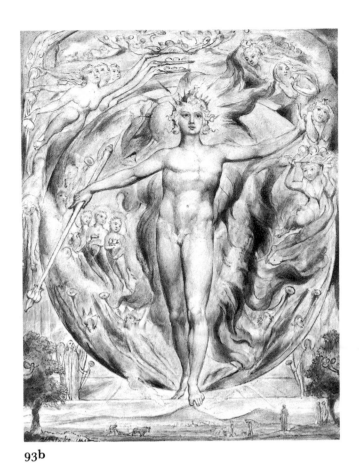

93b

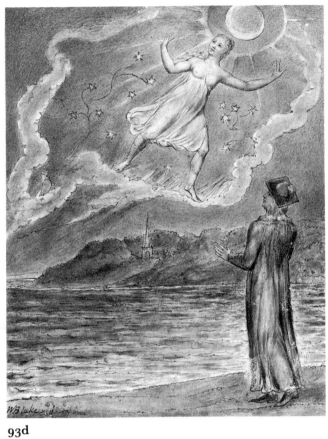

93d

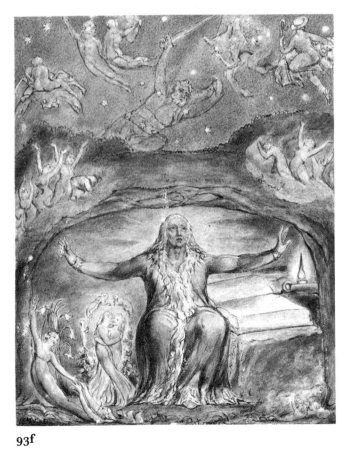

93e

93f

Blake's Exhibition of 1809: the Descent into Obscurity

Blake held an exhibition in his brother James's house in London from May 1809 until the summer of 1810, in an attempt to reverse the misfortunes he had endured since returning from Felpham in 1803. He had failed to recover his foothold as an engraver after his return, and his unhappy relationship with Robert Cromek (see No. 64) only increased his feelings of rejection by his fellow artists.

The stated purpose of the Exhibition was to publicize Blake's method of tempera painting, which he claimed was 'the ancient method of Fresco Painting Restored'. The main exhibits were tempera paintings on a larger scale than those he made in 1799–1800 for Butts (Nos.

69–72). The poor condition of those that have survived disproves Blake's contention that they would outlast oil painting. Four of the temperas have disappeared without trace and the others are too fragile to travel.

The Exhibition was barely noticed, and after a last attempt to produce and publish a large engraving of *The Canterbury Pilgrims* Blake disappears almost completely from view until his rediscovery by John Linnell in 1818. Yet, characteristically, the more his physical circumstances declined the greater became his ambitions; apart from *Jerusalem* and the Milton watercolours he began to work on a large painting of the *Last Judgment*.

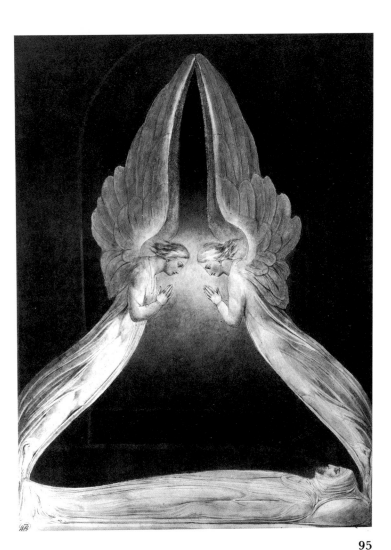

95

94 A Descriptive Catalogue of Pictures, Poetical and Historical Inventions painted by William Blake 1809

Pamphlet, letterpress, unillustrated: 72 pages
Lit: Bentley, *Blake Books*, p. 135, copy J; Bindman, *Artist*, pp. 154–62
Yale Center for British Art, Paul Mellon Collection

The *Descriptive Catalogue*, of which 17 copies are known, is Blake's longest and most considered piece of writing on the subject of his art. Apart from hysterical dismissals of Titian, Rembrandt and Rubens, it asserts strongly the necessity for a clear outline, which can be observed in works of this period, like the *Paradise Lost* series (No. 91).

The catalogue was largely ignored in England, but it provided the basis of an article on Blake written by Henry Crabb Robinson – probably without Blake's knowledge – for the journal *Vaterländisches Museum* of 1811, published in Hamburg by Friedrich Perthes, a friend of Philipp Otto Runge (see *William Blake*, exh. cat., Hamburger Kunsthalle, 1975, p. 75).

95 Christ in the Sepulchre, guarded by Angels
c. 1803–05

Watercolour with pen, $16\frac{1}{2} \times 11\frac{7}{8}$ (420 × 302)
Inscr: 'WB inv' (monogram) and 'Exod. Cxxv.v20'
Lit: Butlin, *Paintings*, no. 500
Victoria and Albert Museum, London

This watercolour was borrowed back from Butts for the 1809 Exhibition, with three others that Blake wished were 'in Fresco on an enlarged scale to ornament the altars of churches . . . to make England, like Italy, respected by respectable men of other countries on account of art' (K.584). It belongs with a group of watercolours within

the Butts series of the Passion and the Resurrection, distinguished by their solemn colour (see No. 76).

The subject does not occur in the New Testament, but the reference to Exodus suggests a typological connection with the building of the Ark and the golden cherubim over the mercy seat: 'And the cherubims shall stretch forth their wings on high, covering the mercy seat with their wings, and their faces shall look one to another.' It has often been noted that the wings of the angels recall tomb figures in Westminster Abbey; it is not coincidental that in this period Blake laid particular emphasis on his youthful experience of the Gothic (see Nos. 6 and 7). For an illuminating discussion of the work, see John Murdoch, *Forty-Two British Watercolours from the Victoria and Albert Museum*, London 1977, no. 24.

96 The Bard, from Gray *c.* 1809

Pen and pencil, $25\frac{5}{8} \times 18\frac{7}{16}$ (650 × 468)
Inscr: 'Grays Bard'
Lit: Butlin, *Paintings*, no. 656
Philadelphia Museum of Art: The Louise and Walter Arensberg Collection

Probably a study for the tempera painting which was no. IV in Blake's Exhibition (now Tate Gallery, London), but also related to a design in the watercolours to Gray's *Poems* (Butlin, no. 335 56).

The Bard tells how the last of the native poets of Wales defies the invading king Edward I and then throws himself from a crag rather than submit to the English. The subject was a very popular one with British painters of the early Romantic period, and there are versions by de Loutherbourg (Lewis Walpole Library, Farmington) and Fuseli among others Blake might have known. In its reference to Welsh bardic mythology it was an appropriate allegory of the indestructibility of poetry. Blake refers in the *Descriptive Catalogue* to Gray's lines, 'Weave the warp, and weave the woof, / The winding sheet of Edward's race', commenting:

Weaving the winding sheet of Edward's race by means of sounds of spiritual music and its accompanying expressions of articulate speech, is a bold, and daring, and most masterly conception, that the public have embraced and approved with avidity. Poetry consists in these conceptions; and shall Painting be confined to the sordid drudgery of fac-simile representations of merely mortal and perishing substances, and not be as poetry and music are, elevated into its own proper sphere of invention and visionary conception?

96

97 The Canterbury Pilgrims engraving
1809–10

The painting of the *Canterbury Pilgrims* (Pollok House, Glasgow) was prominently featured in Blake's 1809 Exhibition and is described in full in the *Descriptive Catalogue*. Blake had high hopes of the success of the engraving from it, which was to be a manifesto on behalf of the artist-engraver – as explained in the *Public Address*, an unpublished draft for another prospectus. The engraving, which is dated 8 October 1810, was probably completed late that year. It attracted little attention.

a Prospectus, dated 15 May 1809
Single leaf
Lit: K.586; Essick, *Printmaker*, p. 190
The Trustees of the British Museum, London

Printed about the same time as the *Descriptive Catalogue* to announce the forthcoming engraving after the painting.

b Copper plate
Lit: Essick, *Separate Plates*, no. XVII; Essick,
Printmaker, p. 188 *passim*
*Yale University Art Gallery, Bequest of Charles J.
Rosenbloom, B.A. 1920*

After Blake's death the plate passed to his widow, and
then to various private collectors. It was extensively
printed from while in possession of the dealers Colnaghi
and Sessler; most impressions are modern. The plate
itself is still in good condition.

c Engraving, $12\frac{1}{4} \times 37\frac{9}{16}$ (310 × 955)
Yale Center for British Art, Paul Mellon Collection

The copper plate and the printing of the *Canterbury
Pilgrims* are discussed exhaustively in Robert Essick's
forthcoming edition of Blake's *Separate Plates*. This im-
pression is from a new third state which Essick has iden-
tified and which he dates 1810–20, before Blake added
various inscriptions in drypoint below the print, which are
similar in thought to those on the *Laocoön* (No. 110). These
were either rubbed out by Blake or wore away; there is no
sign of them on the copper plate itself.

98 The Last Judgment *c.* 1809–10?

Pen and wash over pencil, $17\frac{1}{2} \times 13\frac{5}{16}$ (445 × 338)
Lit: Butlin, *Paintings*, no. 645
*National Gallery of Art, Washington, Rosenwald
Collection, 1945*

This important drawing corresponds more closely than
any other of the *Last Judgment* to the long manuscript
description in the *Notebook* known as *A Vision of the Last
Judgment* (K.604). Blake seems to have intended the

latter to be added to a revised edition of the *Descriptive
Catalogue* in 1810, perhaps to accompany a large tempera
painting on the subject in his Exhibition. Butlin connects
the drawing with this period, but Harvey Stahl (Man-
hattanville, 1974, no. 27) suggests a date of 1820–25
which would perhaps be more compatible with the
fluidity of the design. There is no record of the 1810
painting, but Blake was working on one in 1815, and at
the end of his life he was preparing for exhibition a large
painting which J. T. Smith saw in Mrs Blake's house after
the artist's death. These references may all be to the same
work; there is now no trace of any *Last Judgment* painting.

The *Last Judgment*, like the *Canterbury Pilgrims* and
Jerusalem, is a synoptic work drawing together all the
states of humanity (see the Introduction, pp. 21–22). In
the *Notebook* Blake describes the Last Judgment as twofold
in nature; it begins when 'Imagination, Art & Science &
all Intellectual Gifts . . . are look'd upon as of no use & only
Contention remains to Man'; it is also a state that can be
entered into at any time. Because the Bible is 'Eternal
Vision or Imagination of All that Exists', all the characters
of the Bible, each in their own way, represent human
states: 'It ought to be understood that the Persons, Moses
& Abraham, are not here meant, but the States Signified
by those Names, the Individuals being representatives or
Visions of those States as they were reveal'd to Mortal
Man in the Series of Divine Revelations as they are
written in the Bible.' The Last Judgment is also 'A History
of Art & Science' which are finally purified, like the
Fallen world, so that the wicked will no longer hold
dominion over the mind of man. Finally, it also encom-
passes the national myth of Albion, who is represented as
'our Ancestor, patriarch of the Atlantic Continent, whose
History Preceded that of the Hebrews & in whose Sleep
or Chaos, creation began'.

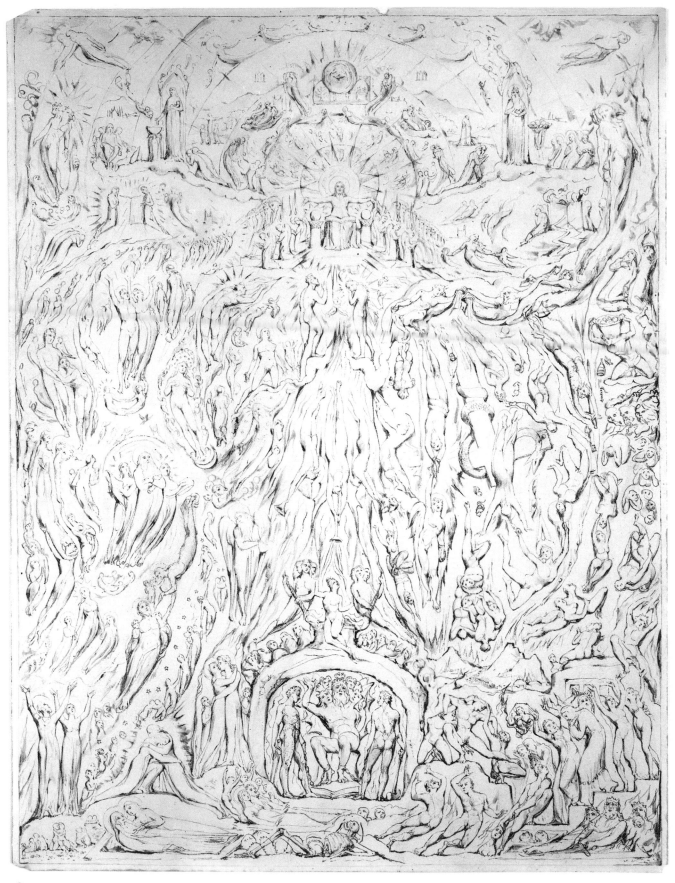

98

Jerusalem, 1804–27

The prophecy *Jerusalem the Emanation of the Giant Albion* is the culminating work of Blake's Prophetic oeuvre, representing a final synthesis which took almost twenty years to complete. As early as July 1803 he announced his aim

> to speak to future generations by a Sublime Allegory, which is now perfectly completed into a Grand Poem. I may praise it, since I dare not pretend to be any other than the Secretary; the Authors are in Eternity. I consider it as the Grandest Poem that this World Contains. Allegory address'd to the Intellectual powers, while it is altogether hidden from the Corporeal Understanding, is My Definition of the Most Sublime Poetry; . . . This Poem shall, by Divine Assistance, be progressively Printed & Ornamented with Prints & given to the Public.

It originated, as Blake notes at the beginning of the book, in his 'three years slumber on the banks of the Ocean', i.e. at Felpham, but references to incidents in his later life and obvious interpolations of plates make it clear that it evolved over many years. None of the complete copies was finished before 1820, and he went on adding to some of them even later.

The work consists of 100 plates, divided into four chapters addressed 'To the Public', 'To the Jews', 'To the Deists' and 'To the Christians'. Each chapter has a full-page frontispiece (all of which are shown in the following selection: **a**, **f**, **k**, and **n**); an address page (**g**) and a pictorial headpiece (**h** and **l**), and ends with a tailpiece (**e**). In addition there are many plates with designs of varying sizes, some of which are also represented in this selection. The chapters correspond to the phases of human history, from the division of Albion, who is 'the Original Man', through the monotheism of the Old Dispensation, then the triumph of Natural Religion, to the final vision of Christian Redemption. For further discussion of *Jerusalem* see the Introduction, pp. 18–21, and for the antiquarian background see the following section.

99 Jerusalem the Emanation of the Giant Albion 1804–27

> Relief etchings with additions in pen, watercolour and gold, now mounted separately, approx. 22 × 16 ($8\frac{5}{8} \times 6\frac{1}{4}$)
> Lit: Keynes and Wolf, copy E; Bindman, *Graphic Works*, nos. 480–579; Trianon Press facsimile, 1953
> *Mr and Mrs Paul Mellon, Upperville, Va.*

One of five known complete copies and the only one to be coloured throughout. Blake managed to sell the four uncoloured copies but not this; it passed through Mrs Blake to Frederick Tatham, who added to it the double portrait (No. 1) and his own manuscript life of the artist. Coloured and finished throughout in Blake's most careful and fully-considered manner, it is the masterpiece of his Illuminated printing.

A selection of 18 key images has been made and these are discussed below.

Chapter 1 : To the Public

a Plate 1 (frontispiece), *Los entering the grave* XII
An early proof of this plate (ill. Bindman, *Graphic Works*, pl. 480a) makes it clear that it represents Los as a night-watchman entering the grave, the secrets of which are in *Jerusalem* itself. The artist with his lamp is a seeker after truth, able to pass beyond the material body to the eternal world. By entering the grave he echoes Christ's sacrifice for mankind, in order to redeem Albion and therefore Blake's countrymen. The artist is not a passive recipient of the Muse, but a fearless mental explorer.

For an uncoloured version see *Fig. 25*.

b Plate 2 (titlepage), *Jerusalem in her desolation* XIII
Jerusalem is represented by a beautiful butterfly, mourned XVIII
by humanized birds and insects. The design is in a 'fairy' mode, expressing the correspondences in nature: the drama of the Fall and Redemption is enacted at all levels of creation throughout the natural cycle. The effect is both beautiful and slightly sinister, redolent of the realm of Beulah.

c Plate 6, *Los at his furnaces*
A classic image of Los at his forge, his creative force vitiated by doubt, in the sinister form of his spectre seeking to lure him away from his 'Great Task'. A spiritual realization of Blake's activity in creating *Jerusalem* in his own workroom. (Illustrated on p. 2.)

d Plate 11, *The swan and the fish*
This beautiful and sinister design has defied convincing explanation in terms of the poem. A swan had been used before by Blake as the 'chariot of Inspiration', but this one appears to be female and dying. The figure below is certainly a fish. They may represent daughters of Albion.

e Plate 25 (tailpiece), *Albion in the agony of self-division* XIV
The final plate to the first chapter of *Jerusalem*. Albion is in agony as three daughters of Albion, in the guise of the three Fates, unwind his mortal coil. The painted emblems on his body refer to ancient Pictish customs (see No. 103, and David Worrall in *Studies in Romanticism*, 1977, XVI, pp. 189–216).

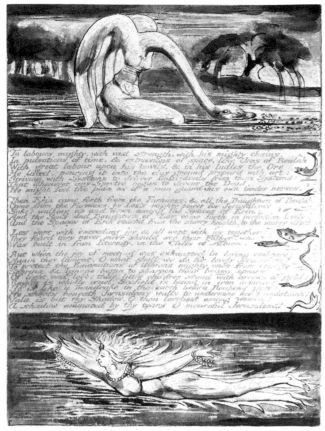

99d

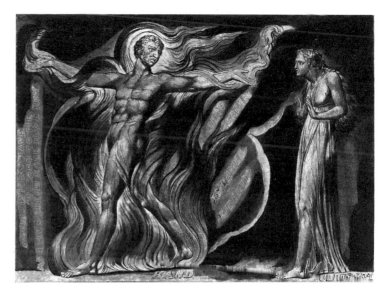

99f (not to scale with 99d, h)

Chapter 2 : To the Jews

f Plate 26 (frontispiece), *Hand and Jerusalem*
Hand, a son of Albion, is shown by his cruciform figure to
be a false prophet or Antichrist. Jerusalem, or Liberty in
this context, looks on him in horror. As Chapter 2 is
addressed 'To the Jews' the scene may be a reference also
to the vengeful monotheism of the Old Testament. Hand
appears to be a spiritual equivalent of the critic Robert
Hunt who woundingly attacked Blake's exhibition.

g Plate 27 (address), *To the Jews*
This address is exhibited as an example of a text page
almost without decoration. By carefully emphasizing the
minimal ornament and applying subtle washes across the
background a luminous effect is achieved, linking the text
pages to the overall design of the book.

h Plate 28 (headpiece), *Couple in a waterlily*
This completes the introductory matter to Chapter 2. In
two earlier states (Pierpont Morgan Library, New York;
Bindman, *Graphic Works*, nos. 507a and b) it can be seen
that Blake has altered the embrace, perhaps to remove the
suggestion of copulation in the first state. The design was
probably intended to be decorative; it might be an image
of Innocence, in contrast to the imposition of Moral Law
by the Fallen Albion in the text which follows, but most
commentators have read the embrace and setting as
sinister. See No. 105 for a comparison with an Indian
design.

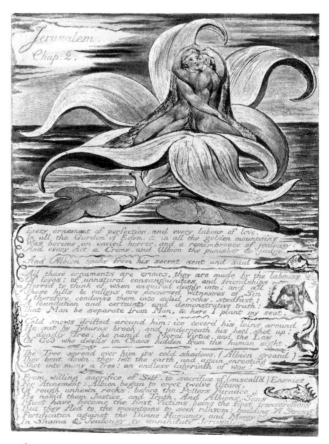

99h

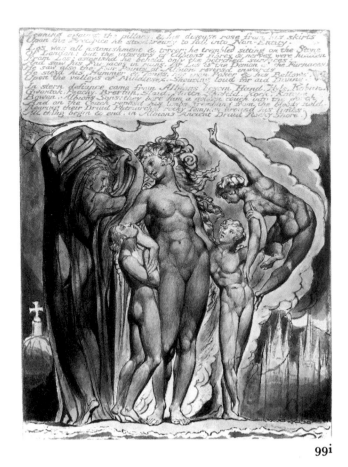

99i

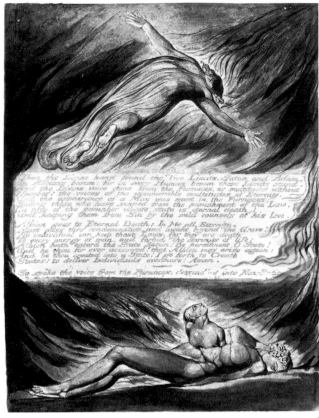

99j

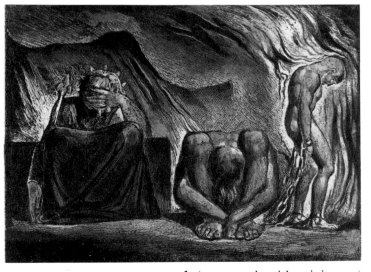

99k (not to scale with 99i, j, m, o)

i Plate 32, *Vala and Jerusalem*
Vala hides her human form while Jerusalem in her nakedness protects the artistic daughters of Albion. Vala is associated with institutional religion by the domed church next to her, Jerusalem being associated with 'true art' in the form of a Gothic church.

j Plate 35, *The descent of Christ*
Christ with the stigmata descends to delimit Albion's Fall, awakening his dormant desire for Redemption, symbolized by the head which emerges from his body as he sleeps. Albion is not yet aware of Christ's sacrifice.

Chapter 3: To the Deists

k Plate 51 (frontispiece), *Vala, Hyle and Skofeld*
The daughter and sons of Albion who represent the presiding gods of Deism: Vala (nature), Hyle (despair and rationality), and Skofeld (war and destruction). Hyle and Skofeld are both based on 'enemies' of Blake – William Hayley and Scolfield, a drunken soldier who had accused him of being a spy.

l Plate 53 (headpiece), *Winged spirit in a sunflower* XVII
A counterpart to the headpiece of the previous chapter (**h**). The spirit's beauty evokes the world of Vala, and perhaps the seduction of Natural Religion. The sinister implications are intensified by the suggestion of a papal tiara on her head.

m Plate 70, *The trilithon*

The trilithon as part of a Druidic temple was associated with the age of human sacrifice in the mythical history of Britain. Its connection with Deism is made more explicit by Blake's suggestion that the three component forms are named Bacon, Locke and Newton. For the importance of Stonehenge see No. 102.

Chapter 4: To the Christians

XV **n** Plate 76 (frontispiece), *Albion adoring Christ*

This majestic design inaugurates the ecstatic vision in the final chapter of *Jerusalem*. Albion awakens to the true meaning of the sacrifice of Christ, shown here on the Tree of the Knowledge of Good and Evil. Albion adopts a stance of ecstatic affirmation as in *The Dance of Albion* (No. 49). The motif recalls the traditional depiction of the *Arbor Vitae*.

o Plate 84, *An old man led by a child*

This touching image illustrates the lines on the same page:

I see London blind & age-bent begging thro the Streets
Of Babylon, led by a child, his tears run down his beard

He is led away to be transformed into the New Jerusalem.

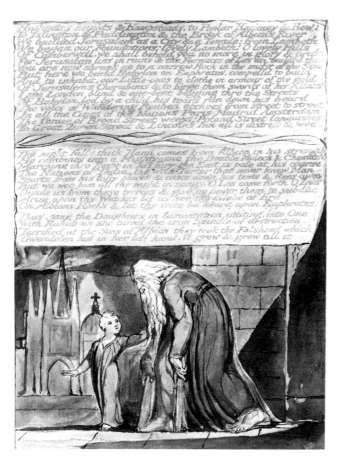

99o

99m

The design derives from that to the poem *London* in *Songs of Experience*, and it can be related to other images of Redemption in Blake's art (e.g. *Death's Door*, No. 64b) where an old man rises as a regenerate youth from the grave.

p Plate 97, *Los with the sun* XVI

A Redemptive transmutation of the frontispiece to Chapter 1 (**a**). Los now appears naked and regenerate, heralding the new dawn and calling Jerusalem to awake:

For lo the Night of Death is past and the Eternal Day
Appears upon our hills.

The effect of colour is particularly splendid, and the radiance of the sun, augmented by gold paint, is unforgettable.

q Plate 99, *The union of contraries*

A visual epitome of the final vision of union and Redemption, in which all contraries are reconciled. The ambiguous identity of the two embracing figures suggests that they encompass all physical and mental contraries in ecstatic union.

Blake appears to have scraped out the surface on the cloak of the bearded figure.

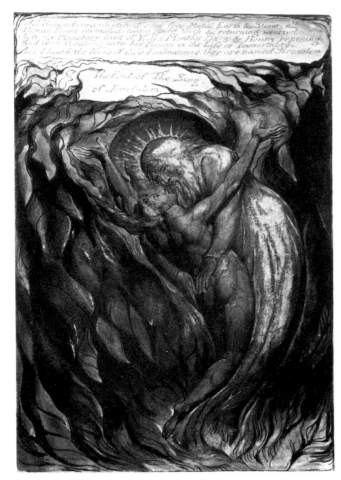

99q

100

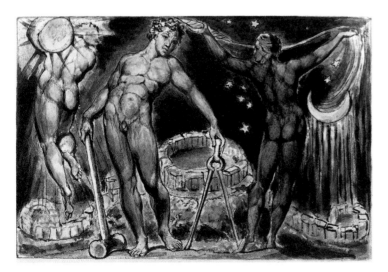

99r (not to scale with 99q)

r Plate 100, *Los before the serpent temple*
Jerusalem ends not on an ecstatic note, but back with the process of creation – the continual building of Jerusalem in a world dominated by false religion, symbolized by the serpent temple overrunning the island of Britain. The three figures are a positive counterpart to those in plate 51 (**k**). In the middle stands Los with his hammer resting from his labours as in the final plate of *The Song of Los* (*Fig. 20*); Enitharmon is to his left winding fibre from a shuttle; and the figure carrying the sun on his shoulder may be 'the spectre of Urthona', as Erdman claims (*Illuminated Blake,* p. 379).

100 Unknown subject: the Sun *c.* 1810

> Pencil, $9\frac{7}{8} \times 12\frac{1}{4}$ (250 × 312)
> Lit: Butlin, *Paintings,* no. 571
> *Yale Center for British Art, Yale University Art Gallery Collection, the Frederick Benjamin Kaye Memorial Collection*

This drawing seems to be a representation of the sun, with flaming locks, holding a bow and an arrow. Cummings (*Romantic Art in Britain,* p. 99) proposed that it is a study for Albion awakening in *Jerusalem,* plate 95, but his interpretation has not won general acceptance, though it is true that in the text of that plate the sun 'takes his Bow, then chooses out / His arrows of flaming gold'. Kostelanetz suggests a connection with the *Night Thoughts* designs (No. 62), which would place the drawing considerably earlier, *c.* 1796–97 (*Blake Newsletter,* II, 1968, pp. 4–6). The later date seems preferable, however, and a connection with *Milton* or *Jerusalem* is not impossible.

Jerusalem: the Antiquarian Background

The text and imagery of *Jerusalem* make reference to a wide range of myth and legend, with a particular emphasis on those of Ancient Britain.

The idea of a return to the city of Jerusalem was central to millenarians, and it is represented here by a book in which Richard Brothers gives an architectural account of the Holy City which he proposed to rebuild.

Ancient Britain was an essential element in Blake's cosmic myth, and *Jerusalem*, he claimed, contained 'the ancient history of Britain, and the world of Satan and of Adam'. In the years after 1800 he read widely in English and Welsh accounts of the prehistory of Britain, with a particular leaning towards 'poetical' rather than methodical accounts of the primitive inhabitants of the island: 'The British Antiquities are now in the Artist's hands; all his visionary contemplations, relating to his own country and its ancient glory, when it was, as it again shall be, the source of learning and inspiration' (*Descriptive Catalogue*, K.578).

Blake also took an interest in the 'Antiquities of every Nation under Heaven', and there are references in his work of this time to non-European art, which he accepted as equal to the great creations of antiquity and the Renaissance:

> Painting and Sculpture as it exists in the remains of Antiquity and in the works of more modern genius, is Inspiration, and cannot be surpassed; it is perfect and eternal. Milton, Shakespeare, Michael Angelo, Rafael, the finest specimens of Ancient Sculpture and Painting and Architecture, Gothic, Grecian, Hindoo and Egyptian, are the extent of the human mind.

101 A Description of Jerusalem, by Richard Brothers 1801

> Printed book, letterpress, open at the 'Plan of the Holy City of the New Jerusalem'
> Lit: M. D. Paley, 'William Blake, The Prince of the Hebrews, and The Woman Clothed with the Sun', in *William Blake: Essays in honour of Sir Geoffrey Keynes*, 1973, pp. 260–94
> *Beinecke Rare Book and Manuscript Library, Yale University*

For the career of Richard Brothers, self-proclaimed Prince of the Hebrews and Nephew of the Almighty, see the Introduction, p. 13, and No. 61. Brothers's conception of the New Jerusalem was a literal one; it was to be built by himself and his followers, who were to include the Jews he

101

was to lead back to the Holy Land (see Gillray's caricature, *Fig. 3*). His plans, as Paley has claimed, were 'a beatific vision of a city as it might have been laid out by a heavenly town-planner of the period'. Everything was based on a square plan and exact measurements. He even designed costumes for the governors of the New Jerusalem. Blake, of course, was not in sympathy with such a Urizenic conception, but they shared a similar eschatology. The fold-out plan of the Holy City was engraved by 'Lowry' – probably Wilson Lowry (see No. 119).

102 Stonehenge, A Temple restor'd to the British Druids, by William Stukeley 1740

> Printed book, letterpress, open at view of reconstructed Stonehenge, 'A peep into the Sanctum Sanctorum'
> Lit: Ruthven Todd, 'William Blake and the Mythologists', in *Tracks in the Snow*, 1946, pp. 29–60
> *Beinecke Rare Book and Manuscript Library, Yale University*

102

103

William Stukeley is of great importance for the mythological background to *Jerusalem*, for he claimed that the Druids were the inheritors of the true patriarchal religion, arriving in England during the lifetime of Abraham:

> they brought along with them the patriarchal religion, which is so extremely like Christianity, that in effect it differed from it only in this; they believed in a Messiah who was to come into the world, as we believe in him that is to come . . . the Druids were of Abraham's religion intirely, at least in the earliest times, and worshipp'd the Supreme Being in the same manner as he did.

Compare this with Blake's claim that

> Adam was a Druid, and Noah; also Abraham was called to succeed the Druidical age, which began to turn allegoric and mental signification into corporeal command, whereby human sacrifice would have depopulated the earth.

For Blake, the Druids perverted the patriarchal religion towards human sacrifice and cruel laws, expressed in the structure of Stonehenge: see *Jerusalem*, plate 70 (No. 99m).

103 Britannia Antiqua Illustrata: or, the Antiquities of Ancient Britain, by Aylett Sammes 1676

Printed book, letterpress, open at illustration of the 'Wicker Image'
Lit: David Worrall, 'Blake's *Jerusalem* and the Visionary History of Britain', *Studies in Romanticism*, XVI, 1977, pp. 189–216; John Beer, *Blake's Humanism*, 1968, p. 255
Beinecke Rare Book and Manuscript Library, Yale University

Sammes's book is an example of the kind of source book Blake used to reconstruct the mythological history of Britain. 'That Holy Fiend / The Wicker Man of Scandinavia' (*Jerusalem*, plate 47, K.677) was an ancient idol, erected originally to cast out the giants who ruled the world, which became an idol in itself, propitiated with human sacrifice. In *Jerusalem* it appears as a manifestation of the Fallen world in Los's lament towards the end of Chapter 2:

> . . . instead of heavenly Chapels built
> By our dear Lord, I see Worlds crusted with snows & ice.
> I see a Wicker Idol woven round Jerusalem's children.

Another source book Blake might have used is John Speed's *History of Great Britain* (1611), which includes the notion that the Picts had cosmographical paintings on their bodies – referred to in the figure of Albion in *Jerusalem*, plate 25 (No. 99e).

XIV

104 The Costume of the Original Inhabitants of the British Islands, by S. R. Meyrick and C. H. Smith 1815

> Printed book with aquatint illustrations, open at plate XI, 'Grand Conventional Festival of the Britons'
> Lit: Worrall, op. cit., p. 209
> *Yale Center for British Art, Paul Mellon Collection*

Worrall suggests that this fanciful depiction of Stonehenge might lie behind the serpent temple in *Jerusalem*, plate 100 (No. 99r). It contains an ark, trilithons and veils, though Blake would have looked upon the Druidic rituals as wholly negative in intent. Worrall argues that in *Jerusalem* 'Blake expected to find correlations between his visions and the learning of others'. For the building of Stonehenge, see *Jerusalem*, plate 66 (K.701–02):

> In awful pomp & gold, in all the precious
> unhewn stones of Eden
> They build a stupendous Building on the Plain of
> Salisbury, with chains
> Of rocks round London Stone, of Reasonings,
> of unhewn Demonstrations
> In labyrinthine arches (Mighty Urizen the
> Architect) thro' which
> The Heavens might revolve & Eternity be
> bound in their chain.

104

105 The Hindu Pantheon, by Edward Moor 1810

> Printed book with engravings after Moses Haughton, open at plate 7
> Lit: Blunt, *The Art of William Blake*, p. 38
> *Beinecke Rare Book and Manuscript Library, Yale University*

Anthony Blunt was the first to point out the possible derivation of plate 53 of *Jerusalem* (No. 99l) from an illustration in Moor's *Hindu Pantheon*. The book was published by Joseph Johnson, and it was well known to artists, including Flaxman. Such borrowing was legitimate in Blake's mind because Hindu antiquities, like those of all other nations, would have reflected archetypes from the prelapsarian world, when 'All had originally one language, and one religion: this was the religion of Jesus, the everlasting Gospel' (*Descriptive Catalogue*, K.579).

VISHNU & LAKSHMI on SESHA or ANANTA contemplating the Creation, with BRAHMA springing on a lotos from his Navel to perform it.

105

The Last Decade, c. 1818–27

From 1818 until his death in 1827 Blake was the object of veneration for a group of young landscape painters, of whom John Linnell and Samuel Palmer were the most prominent members. They brought him out from the obscurity which had followed the failure of the 1809 Exhibition, buying and commissioning original designs. They also encouraged him to make new coloured copies of his Illuminated Books, doing their best to spread his reputation by bringing him into contact with important figures of the day.

Linnell was encouraged to think that Blake could at last find a real public for his designs, and was instrumental in persuading him to make an edition of engravings from the watercolours of the *Book of Job*, done for Butts many years earlier. Thanks to the care with which Linnell and his descendants kept all their relics of Blake, almost everything to do with this commission has survived; it is possible to show in this exhibition a selection of the original watercolours, some of the engravings and a number of documents concerning the contract and sale of the series. This section also includes a number of minor works which reveal Blake's ever clearer sense of his prophetic destiny, after he had completed *Jerusalem*.

106 Illustrations for The Pastorals of Virgil, edited by Dr R. J. Thornton, from the Imitations of the Eclogues by Ambrose Philips 1821

The 17 wood engravings for Thornton's *Virgil* are Blake's only surviving works in that medium. They were made originally to illustrate a cheaply produced school edition of Virgil's *Eclogues* in an 18th-century translation. The commission was obtained for Blake by Linnell from a reluctant Dr Thornton, who after being persuaded not to have them recut added a disclaimer to the printed edition:

The Illustrations of this English Pastoral are by the famous Blake, the illustrator of Young's Night Thoughts,

106b

and Blair's Grave; who designed and engraved them himself. This is mentioned, as they display less of art than of genius, and are much admired by some eminent painters.

They were certainly greatly admired by the Linnell circle, in particular by Samuel Palmer (see No. 122).

Their technique owes less to the wood-engraving manner established by Thomas Bewick (*Fig. 8*) than to Blake's own method of relief etching on copper, and the effects achieved are close to some of the uncoloured plates in *Jerusalem* (see *Fig. 24*). Because of Blake's inexperience in the medium the printing surface tended to be uneven, and they were rarely printed carefully enough, even by Linnell. They appear particularly strongly in a recent printing by Iain Bain and David Chambers (*The Wood Engravings of William Blake for Thornton's Virgil*, British Museum, London, 1977).

106a

a 17 wood engravings, mounted separately, approx. $1\frac{1}{4} \times 2\frac{7}{8}$ (32×73)
Lit: Bindman, *Graphic Works*, nos. 602–18
The Art Museum, Princeton University, given in 1938 by Frank Jewett Mather, Jr.

An unusually well printed set pulled from the wood blocks by Linnell, who owned them. He frequently made sets of impressions for his children and friends. Each wood block originally contained four designs, and a few proofs were taken from them before their separation. In cutting them down for publication some of the image area was lost, particularly at the sides (see Bindman, *Graphic Works*, nos. 603–07).

b *The shepherd chases away the wolf*, study for no. 7
Pencil, pen and grey wash, $1\frac{3}{8} \times 3\frac{3}{4}$ (38×98)
Lit. Butlin, *Paintings*, no. 769 7
Beinecke Rare Book and Manuscript Library, Yale University

One of 20 drawings for the Thornton's *Virgil* wood engravings mounted in a book when in Linnell's collection. The album was broken up in 1924.

107 A 'Visionary Head': Harold killed at the Battle of Hastings *c.* 1819

Pencil, approx. $6\frac{1}{8} \times 8$ (155 × 205)
Inscr: (probably by John Varley) 'Harrold Killd at the Battle of Hastings'
Lit: Butlin, *Paintings*, no. 692 76; M. Butlin, *The Blake-Varley Sketchbook of 1819*, 1969
Collection of Robert N. Essick

From a sketchbook recording a series of evenings, probably in 1819–20, when Blake conjured up historical figures, at the request of the well known landscape watercolourist, Linnell's teacher John Varley (1778–1848). Varley was sometimes coupled with Blake as an eccentric, because of his passion for astrology. He had, it seems, a greater belief in the reality of these images than Blake, who, Linnell claimed, regarded them as a joke. The original 'visions' at the sessions, mainly in Varley's house, were drawn in the small sketchbook from which this drawing comes. The sketchbook was known in the Victorian period, but disappeared until recent years; it was broken up in 1971. There are a great many later versions of the Visionary Heads by Blake himself and also by Linnell, for Varley's projected *Treatise on Zodiacal Physiognomy*, only one part of which was published.

107

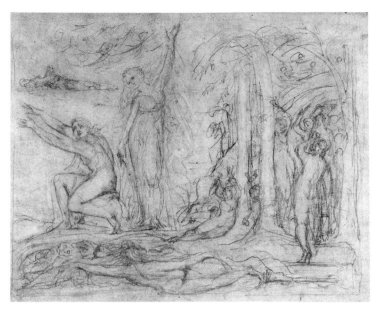

108

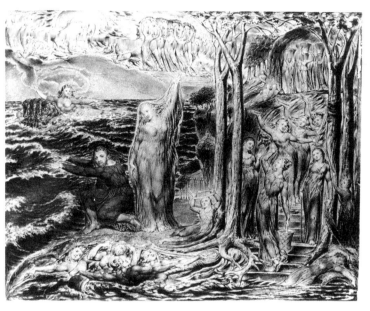

Fig. 35 Blake: '*The Arlington Court Picture*', 1821, pen, watercolour and gouache on gesso-primed paper. National Trust, Arlington Court, Devon

108 'The River of oblivion': study for 'The Arlington Court Picture'

Pencil, $13 \times 16\frac{1}{2}$ (330 × 420)
Inscr: on reverse (not by Blake) 'The River of oblivion'
Lit: Butlin, *Paintings*, no. 804
The Pierpont Morgan Library, New York

This drawing is a study for the mysterious and beautiful watercolour painting at Arlington Court in Devon dated 1821, discovered unexpectedly there in 1947. The only clue to the painting's origin is its frame, by Linnell's

109

The technique of the print is uncertain; it could have been printed with a pewter rather than a copper plate, and the proportion of engraving to etching is not clear. See Essick, op. cit., for a full discussion of the issue.

110 Laocoön *c.* 1820–22

Line engraving, $10\frac{7}{8} \times 8\frac{5}{16}$ (252 × 212)
Inscr: see K.775
Lit: Bindman, *Graphic Works*, no. 623; Essick, *Separate Plates*, no. XIX, B
Mrs Charles J. Rosenbloom, Pittsburgh

One of two known impressions of this extraordinary print, the other being in the Keynes Collection. The occasion for its creation is unknown, but it contains, succinctly expressed, Blake's central artistic beliefs of his last years. The Hellenistic sculpture of *Laocoön*, which Blake, about 1816, had drawn from the cast in the Royal Academy for a reproductive engraving, is interpreted in the light of his claim made in the *Descriptive Catalogue*, that 'all the grand works of ancient art' were copies from 'those wonderful originals called in the Sacred Scriptures the Cherubim' (see the Introduction, p. 20). Hence the *Laocoön*, though a canonical work of antiquity, was merely a copy of a group on the Temple of Solomon, given by the Greek copyists the name of the Trojan High Priest, and made to represent an incident from the 'History of Ilium', though

father; the watercolour is supposed to have been bought from Blake by the owner of Arlington Court, Col. John Palmer Chichester. The painting has been the subject of many interpretations. It seems certain that, as Kathleen Raine first pointed out, it is from the *Odyssey*, the male figure with outstretched arms being Ulysses; the female figure pointing upwards, Athena; and the figure in the left distance, Leucothea receiving her girdle. It appears to be an elaborate commentary on the classical universe, in which Ulysses, by choosing here to return to Greece, ends his allegorical journey where he started, among the classical 'destroyers of all Art' (see No. 110).

This drawing was owned by Flaxman, and it has something in common with his recreation of the *Shield of Achilles*, completed in 1821, the year of the painting. Flaxman's account books in the British Library record a number of payments to Blake, and one of the following may be for this drawing: 11 May 1816, 'A Drawing, Blake £1/–/–'; 2 November 1821, 'Mr Blake £3/–/–'. The title given it by a previous owner, 'The River of oblivion', seems to have no authority.

109 The Man sweeping the Interpreter's Parlour
c. 1820–25

Relief etching, with white-line engraving?,
$3\frac{1}{8} \times 6\frac{1}{4}$ (80 × 160)
Lit: Bindman, *Graphic Works*, no. 619b; Essick, *Separate Plates*, no. XX, copy 2N
Yale Center for British Art, Paul Mellon Collection

An illustration to Bunyan's *Pilgrim's Progress*, possibly commissioned by Linnell, who owned the unique copy of the first state (ill. Bindman, *Graphic Works*, no. 619a). It is an allegory of the Law and the Gospel: the Law, represented by an aged figure, stirs up the dust, but the Gospel sprinkles the floor with water, 'upon which it was cleansed with pleasure . . . so is sin vanquished and subdued, and the soul made clean through the faith of it, and consequently fit for the King of Glory to inhabit'. The room 'is the heart of a Man that was never sanctified by the sweet Grace of the Gospel: The Dust, is his Original Sin, and inward Corruptions that have defiled the whole Man'.

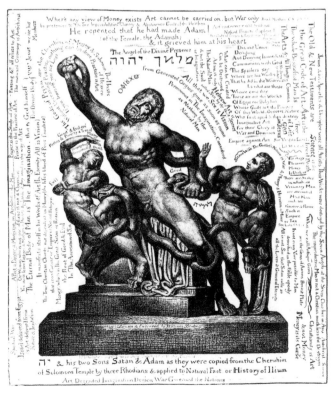

110

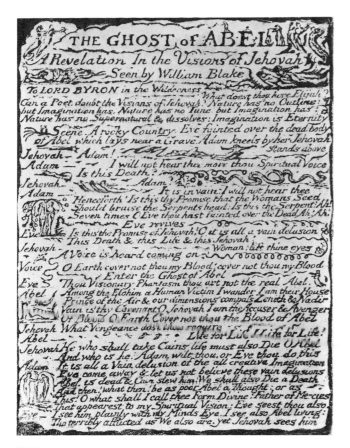

111

the second leaf it is dated 1822, with the information that 'Blake's Original Stereotype was 1788', suggesting that it might have been intended partly as a late demonstration of his relief etching technique. Leslie Tannenbaum argues that the text 'contains an explicit condemnation of the system of retributive justice that underlies conventional ideas about Cain and Abel' (*Blake in his Time*, 'Blake and the Iconography of Cain', p. 29).

112 On Homer's Poetry and On Virgil *c.* 1822

Relief etching, $5\frac{1}{4} \times 4\frac{3}{16}$ (131 × 106)
Lit: Bindman, *Graphic Works*, no. 622; Bentley,
Blake Books, no. 124, copy E
*National Gallery of Art, Washington, Rosenwald
Collection, 1943*

One of six known copies, this leaf is closely tied to *The Ghost of Abel* (No. 111) in technique, and to the *Laocoön* print (No. 110) in sentiment, even referring to the same text in Virgil (*Aeneid*, Book VI, 848). It is probable that all three belong together as occasional reflections on life and art to be given to friends like Linnell and Butts. This text contains Blake's strongest denunciation of the classical world, reiterating the view that the Greek Muses were merely Daughters of Memory and not of Inspiration. This copy may have been given to Thomas Butts.

it was originally a depiction of God the Father with his sons Satan and Adam. Around the figures are extensive inscriptions. These associate true art with prayer and Jesus: 'Prayer is the Study of Art. / Praise is the Practise of Art'. Materialism is linked with destruction: 'Where any view of Money exists Art cannot be carried on, but War only'. Materialism is also specifically associated with the classical world: 'The Gods of Greece & Egypt were Mathematical Diagrams – See Plato's Works'.

In Bindman, *Graphic Works*, p. 486, traces of extra lettering on the Pittsburgh impression are mentioned; in fact they are simply transferred letters from a damp impression of the same print placed on the face of this impression.

111 The Ghost of Abel / A Revelation In the Visions of Jehovah / Seen by William Blake 1822

Relief etching, on 2 leaves, $6\frac{1}{2} \times 4\frac{7}{8}$ (165 × 124)
Lit: Bindman, *Graphic Works*, nos. 620–21; Bentley,
Blake Books, copy A
*The Library of Congress, Washington, Rosenwald
Collection*

One of four known complete copies of this puzzling work, a response to Byron's *Cain a Mystery* (1821). At the end of

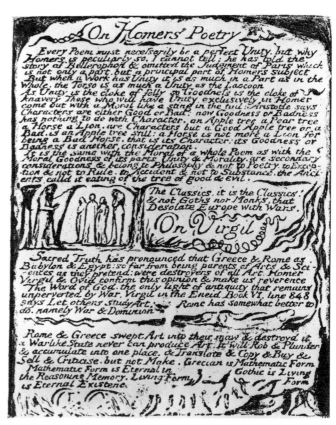

112

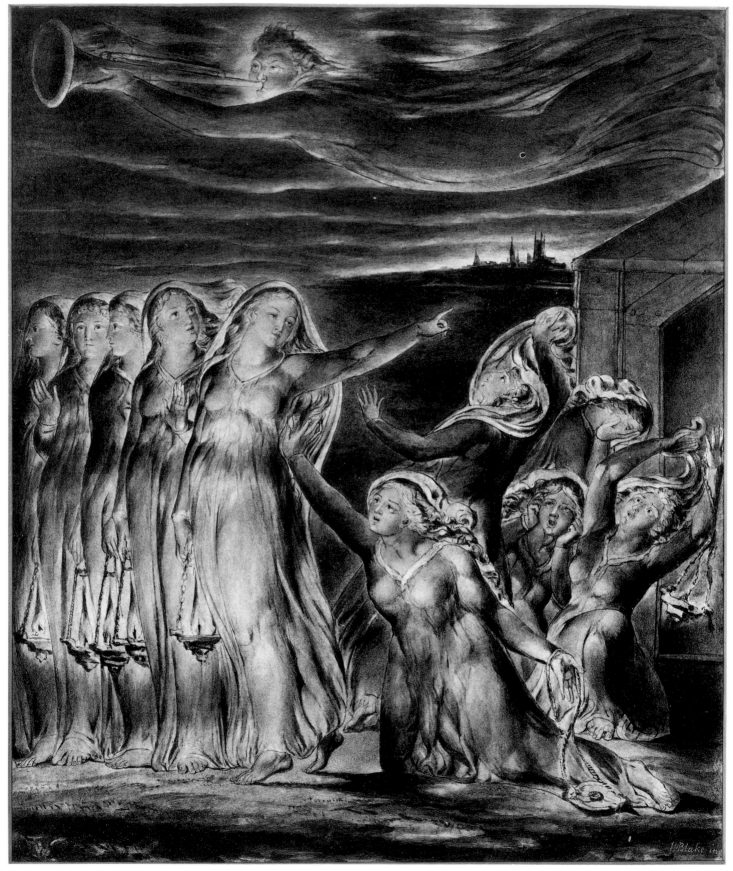

113

113 The Wise and Foolish Virgins *c.* 1825

Watercolour with pen, $16\frac{5}{8} \times 13\frac{7}{8}$ (422 × 353)
Inscr: 'WBlake inv'
Lit: Butlin, *Paintings*, no. 480
Yale Center for British Art, Paul Mellon Collection

One of the four known versions of this composition. The first (Metropolitan Museum, New York) was done for Butts about 1805. The other three, including this one, date from the 1820s – one for Linnell about 1822 (Fitzwilliam Museum, Cambridge), the present example about 1824–25 for the engraver William Haines of Chichester; and the last one probably even later, for Sir Thomas Lawrence (Hofer Collection).

The transformation from the original composition is striking; all the later versions have greater fluidity of line, more elegant gestures, and a greater sensitivity to light. This version, unlike the others, has an English cathedral town in the distance instead of domes and spires. One might expect a reference to the patron's home town, but the cathedral is not Chichester, which Blake knew well (see Bindman, *Graphic Works*, no. 386).

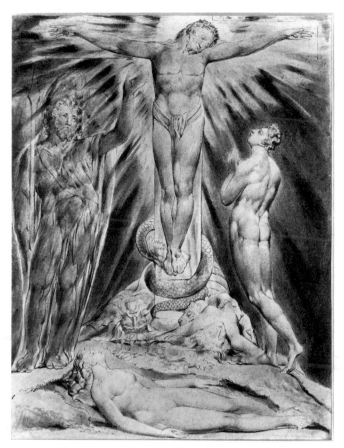

114

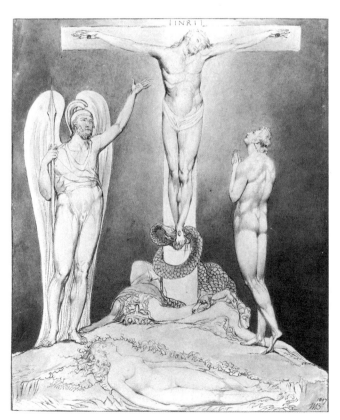

Fig. 36 Blake: *The Archangel Michael foretelling the Crucifixion*, from the first set of illustrations to Milton's *Paradise Lost*, 1807, watercolour with pen. Henry E. Huntington Library and Art Gallery, San Marino

114 The Archangel Michael foretelling the Crucifixion 1822

Watercolour with pen, $19\frac{3}{4} \times 15\frac{1}{8}$ (502 × 385)
Lit: Butlin, *Paintings*, no. 537 3
The Syndics of the Fitzwilliam Museum, Cambridge

One of three watercolours which constitute the third set of *Paradise Lost* illustrations; the two others from this set are in the National Gallery of Art, Melbourne. They were made for Linnell in 1822 from the 1808 series (No. 91), and they show a significant change in handling, though the composition and iconography remain unchanged. By contrast with the 1807 version in the Huntington Library (*Fig. 36*) a radiance streams from the body of Christ, as in plate 76 of *Jerusalem* (No. 99n). XV

This is the penultimate episode in Blake's 1808 scheme of twelve watercolours: Michael, after Adam and Eve are judged, tells them of their salvation through the sacrifice of Christ upon the Cross, which rises from the bodies of Sin and Death. The nail passes through Christ's foot to pin the serpent's head to the Cross, while Eve returns to the earth in the final Redemption.

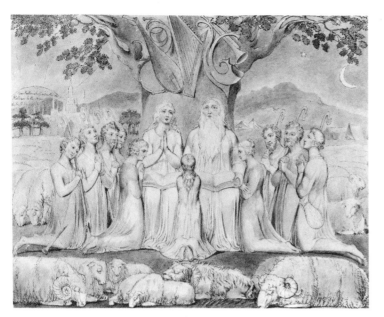

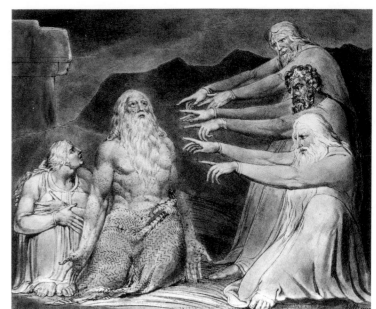

<div style="text-align: right">115a.1</div>

<div style="text-align: right">115a.2</div>

115 The Book of Job illustrations *c.* 1805–25

The *Book of Job* series was thought to have been entirely
a product of Blake's later years, but it is now clear that the
first set of watercolours (Pierpont Morgan Library, New
York: **a**) was, with some later additions, made for Thomas
Butts in the years 1805–10. Linnell had the idea of copying
them, and in 1821 the Butts watercolours were borrowed
back. Blake and Linnell together produced a second set
partly traced from them (most are in the Fogg Museum,
Harvard). When it was agreed in 1823 to engrave the
illustrations, a set of reduced pencil drawings was made
(Fitzwilliam Museum, Cambridge). These contain slight
indications for some of the borders, but essentially Blake
worked them out after the main design was engraved on
the plate. An agreement to produce the 22 engravings was
made between Blake and Linnell on 25 March 1823 (No.
121a). They bear a publication date of 8 March 1825, and
they appeared in early 1826 (**b**).

Some of Blake's early commentators welcomed the
Book of Job engravings as a return to sanity, for they
appeared to employ conventional engraving and to avoid
private mythology. Neither is the case; the story Blake
imposes on the Biblical account of Job is entirely compat-
ible with the larger themes of *Jerusalem*. Job is a type of
Albion, who Falls into spiritual sleep, achieving Redemp-
tion after much travail. Job also enacts in his person the
history of man from Hebraic legalism to future salvation
in Christ. The stages are made manifest in the image of
God, whose patriarchal appearance resembles Job's own,
but who changes according to Job's changing perception
of the world, from the vengeful God of the Old Testament
to Christ in glory. (For a penetrating account of the
meaning of the designs see Lindberg, *Job.*)

Such meanings were rarely observed by Blake's con-
temporaries, and there were complaints of the primitive

'hardness' of his engraving technique which was correctly
noted as influenced by Dürer and the early engravers. It
differs from Blake's earlier technique in entirely dispensing
with preliminary etching. (For a full and subtle account
of Blake's technique in the *Job* engravings and his use of
burnishing see Essick, *Printmaker*, chap. 18.)

a Watercolours from the Butts series, *c.* 1805–10
Watercolour with pen over pencil
The Pierpont Morgan Library, New York

1 *Job in prosperity* (1)
$8\frac{7}{8} \times 10\frac{13}{16}$ (225 × 274)
Lit: Butlin, *Paintings*, no. 550 1

In the first watercolour Job's spiritual complacency is
represented by his adherence to the outward forms of
religion, 'the Letter [which] Killeth [rather than] the
Spirit [which] giveth Life' (see the engraving, **b.**1). His
outward contentment is undermined by the material
nature of his pastoral felicity. The family recite the Lord's
Prayer with conventional expressions of piety; they have
hung up their musical instruments on the tree, a reminder
of the Babylonian Captivity. They inhabit mentally the
Land of Beulah, the pastoral paradise which can precede
the Fall. The books symbolize here the Moral Law which
Job prefers to the active life of artistic expression.

2 *The Just upright man is laughed to scorn* (10)
$9\frac{3}{16} \times 11$ (234 × 280)
Inscr: 'WB inv'
Lit: Butlin, *Paintings*, no. 550 10

A reworking of the earlier composition (No. 15) where
Job with his wife is reproached by his friends. The motif
of the pointing finger appears to derive from Fuseli's *Three
Witches*; but it also, as Lindberg has argued, makes a
typological parallel with the mocking of Christ and, in

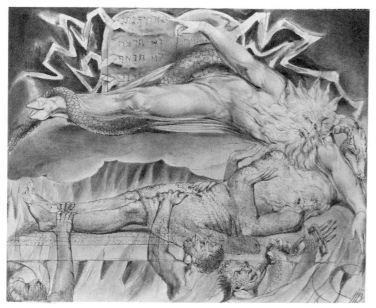

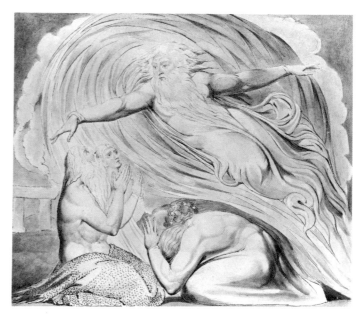

115a.3

115a.4

Jerusalem, plate 93, with the accusing of Socrates by 'Anytus, Melitus and Lycon [who] thought Socrates a very Pernicious Man', to which has been added, 'So Caiaphas thought Jesus'. In this rejection and isolation of Job lie the seeds of his Redemption, which begins with his imminent recognition that the author of his torments is the Satan within him, not the true God.

3 *With Dreams upon my bed* (11)
$9\frac{5}{16} \times 11\frac{5}{16}$ (237 × 288)
Lit: Butlin, *Paintings*, no. 550 11

The turning point in the series is Job's recognition of the true origin of his suffering. Lying on his bed tormented by visions, he perceives for the first time the cloven hoof of Jehovah, who is wrapped round by a serpent and points to the Decalogue, the Moral Law of the Old Testament. He realizes that it is Satan, who 'is transformed into an Angel of Light & his Ministers into Ministers of Righteousness', and that he has worshipped one who exalted himself above the true God.

4 *Then the Lord answered Job out of the whirlwind* (13)
$9\frac{1}{16} \times 10\frac{1}{2}$ (231 × 267)
Lit: Butlin, *Paintings*, no. 550 13

A counterpart to design no. 10 (**a.2**). Job and his wife are vouchsafed a vision of the true God denied to their despairing accusers. In no. 10 Job and his wife pray to a God who offers only vengeance; now in perceiving the merciful God who is Christ, they have passed from the Old to the New Dispensation.

5 *When the Morning Stars sang together* (14)
$11\frac{1}{16} \times 7\frac{1}{4}$ (280 × 184)
Lit: Butlin, *Paintings*, no. 550 14

While Job, his wife and his friends look up in wonder, Christ as God re-enacts the Creation, the 'morning stars' exulting in song and joyous noise. This design reflects

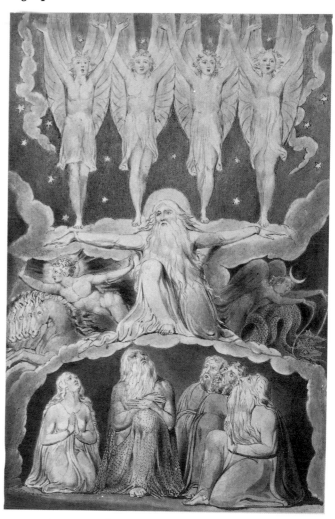

115a.5 (not to scale with 115a.1–4)

nos. 2 and 5 in the series, but with Christ rather than Satan now established in the central position. According to Lindberg (p. 285) it is 'the first of the three visions in which God reveals the creation, organisation and annihilation of the natural world to Job, his wife and his friends'.

6 *So the Lord blessed the latter end of Job* (21)
$9\frac{3}{16} \times 10\frac{7}{8}$ (234 × 276)
Lit: Butlin, *Paintings*, no. 550 21

An antitype of the first design in the series (**a.1**): true prayer now replaces its travesty. The instruments are taken down from the tree, and all the participants are in active attitudes, Job's family praising the Lord through music and song. Job has passed through materialism to an understanding of the Christ within himself.

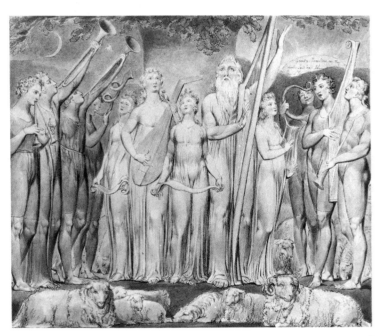

115a.6

b *Illustrations of the Book of Job*, 1825
Line engravings, approx. $7\frac{3}{4} \times 6$ (198 × 152)
Beinecke Rare Book and Manuscript Library, Yale University

1 *Job in prosperity* (1)
Lit: Bindman, *Graphic Works*, no. 626

The technical advance between the first watercolour version and the engravings of 1825 is considerable; this can be appreciated here in the background, in the subtle contrast between the light of the sun and moon. The inscriptions come from the Book of Job and other parts of the Bible.

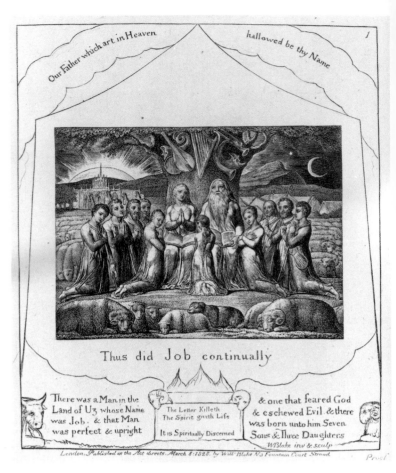

115b.1

2 *The Destruction of Job's Sons* (3)
Lit: Bindman, *Graphic Works*, no. 628

Satan releases the fire of Jehovah's wrath on the children of Job (who reappear nevertheless in the final plate). One of the most sublime of Blake's late designs. Satan's outstretched arms over the scene of revelry show him to be destroying the realm over which he has presided – the Fallen world in its infancy.

3 *The Vision of Eliphaz* (9)
Lit: Bindman, *Graphic Works*, no. 634

Eliphaz seated on the right recounts his fearful dream, of a Spirit who asks rhetorically: 'Shall mortal Man be more Just than God?' The nature of the vision suggests that the Spirit's words are still those of Jehovah, for it is a bleak one, in which man's spiritual longings are reproved as presumption. Job needs to pass through this stage before enlightenment can come. The barren trees in the margin make reference to Job's mental state.

4 *The Just upright man is laughed to scorn* (10)
Lit: Bindman, *Graphic Works*, no. 635

The background of the print is filled with a luminosity absent in the watercolour (**a.2**). Emblems of the Fall surround the image.

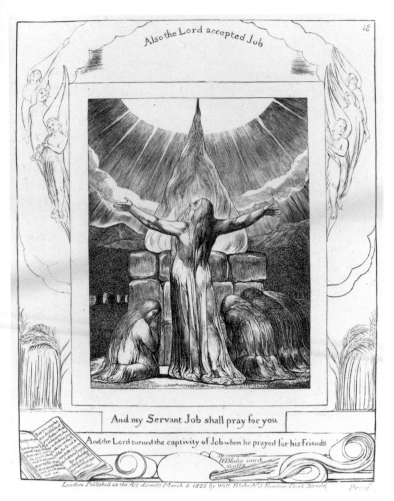

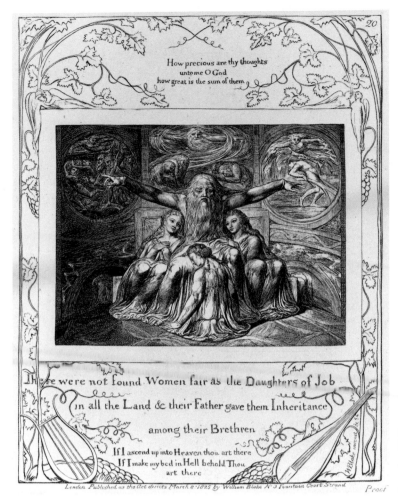

115b.8　　　　　　　　　　　　　　　　　　　**115b.9**

5 *With Dreams upon my bed* (11)
Lit: Bindman, *Graphic Works*, no. 636
The flames in the image are continued into the decorative
borders.

6 *Then the Lord answered Job out of the whirlwind* (13)
Lit: Bindman, *Graphic Works*, no. 638
Note the conspicuous foot of God in the engraving which,
as Lindberg points out (p. 278), is missing from the earlier
watercolour, and the humanized whirlwind made up of
patriarchal figures. In an earlier state (ill. *Graphic Works*,
no. 638b), the whirlwind continues above the top line of
the image, giving a more dramatic effect.

7 *When the Morning Stars sang together* (14)
Lit: Bindman, *Graphic Works*, no. 639
Sequential images of the Creation now fill the margins of
the design.

8 *Also the Lord accepted Job* (18)
Lit: Bindman, *Graphic Works*, no. 643
Job in the act of true prayer. A strong personal meaning is
given by the palette and burin with Blake's signature in
the lower margin, which makes explicit the association
between art and prayer.

9 *Job and his Daughters* (20)
Lit: Bindman, *Graphic Works*, no. 645
Job telling the story of his 'pilgrimage of seventy years',
conversing by means of the images on the wall behind (see
the Introduction, p. 21).

10 *Job and his Wife restored to prosperity* (21)
Lit: Bindman, *Graphic Works*, no. 646
The words of the songs sung by Job's family are now
transferred to the margin, which also contains references
to the first plate (**b.1**).

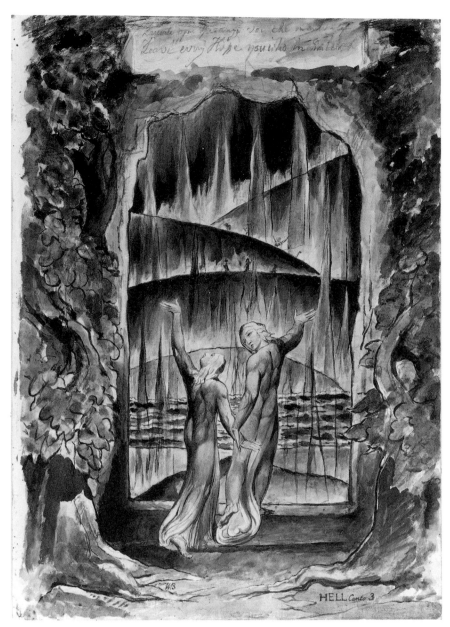

116a

116 The Dante series 1824–27

The 102 unfinished watercolours for Dante's *Divine Comedy* represent a glorious culmination of Blake's career as an artist. Like the *Book of Job* engravings they were commissioned by Linnell, first as watercolours and then as a set of engravings, of which 7 are known in an unfinished state. Blake is first mentioned working on them on 9 October 1824, when Samuel Palmer went to see him.

We found him lame in bed, of a scalded foot (or leg). There not inactive, though sixty-seven years old, but hard-working on a bed covered with books sat he up like one of the Antique patriarchs, or a dying Michael Angelo. Thus and there was he making in the leaves of a great book (folio) the sublimest design from his (not superior) Dante. He said he began them with fear and trembling. I said 'O! I have enough of fear and trembling'. 'Then' said he, 'you'll do.'

Henry Crabb Robinson found him at work on designs on 17 December 1825, and they discussed Dante, whom Blake referred to with a contempt which astonished Robinson:

He [Dante] was an atheist – A mere politician busied abt this world as Milton was till in his old age he returned back to God whom he had had in his childhood.

This remark is ambiguous, for it is not clear whether Blake means Dante or Milton in the second part of the sentence; it does not, therefore, resolve the problem of

whether Dante is finally redeemed at the end of Blake's designs. Blake hated the implied vengefulness of the *Inferno*, and he wrote a number of hostile comments on some of the drawings (see the Introduction, p. 44). Blake makes Dante's Hell an image of the Fallen world, so that Dante's journey parallels the progress of Job in the earlier series: in the third design (Roe, *Blake's Illustrations to the Divine Comedy*, 1953, no. 3) Dante enters Hell through an entrance above which sits the raging figure of Jehovah, inscribed 'The angry god of this world'. Purgatory by the same token can be identified with Beulah; the gorgeousness of the vision of Beatrice is fraught with the temptations of Vala. The designs for the *Paradiso* are, however, filled with ambiguities: some designs could indicate Dante's Redemption, yet the series ends with the unequivocally negative image of the Virgin Mary seated on a large flower, the petals of which imprison writhing human forms.

The Dante watercolours are unprecedentedly free in technique, with washes used with great subtlety, giving each episode its own atmosphere and distinctive light.

The engravings are all from the *Inferno*; they are also remarkable for their technical expansiveness. Some progress proofs are known, but most impressions, including the ones shown, were printed by Linnell in 1838, and there was an edition of 1892. The copper plates are now in the Library of Congress, Rosenwald Collection.

The watercolours and engravings are intermingled here, to follow the sequence of the text.

Inferno

a *The Inscription over Hell-Gate* (4)
Watercolour with pen and pencil, $20\frac{3}{4} \times 14\frac{3}{4}$
(527 × 374)
Inscr: 'WB', 'HELL Canto 3', (above gate) 'Leave every hope you who in Enter'
Lit: Butlin, *Paintings*, no. 812 4
The Trustees of the Tate Gallery, London

Dante, led by Virgil, enters through the dread gate of Hell. Roe (p. 54) argues that they are entering the Fallen world, and that the four mountains ahead represent the four continents. The sinister effect is achieved through broad washes of colour and bold strokes of the pen. The figures by contrast are clearly outlined and move gracefully. Roe argues that Dante and Virgil can be associated with Luvah and Los, or feeling and imagination.

b *Homer and the Ancient Poets* (8)
Watercolour with pen and pencil, $14\frac{9}{16} \times 20\frac{3}{4}$
(371 × 528)
Inscr: 'HELL Canto 4'
Lit: Butlin, *Paintings*, no. 812 8
The Trustees of the Tate Gallery, London

Dante and Virgil observe a group of ancient poets, who

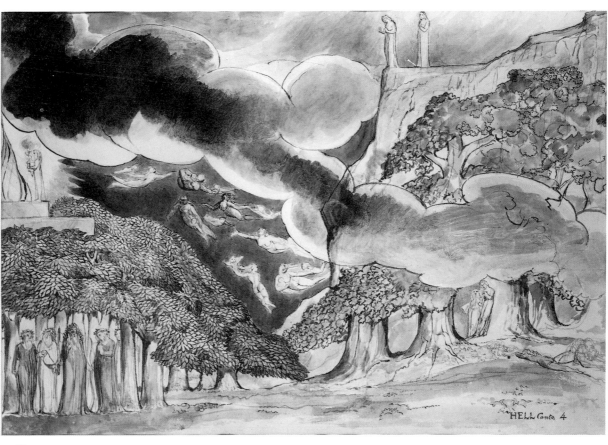

116b

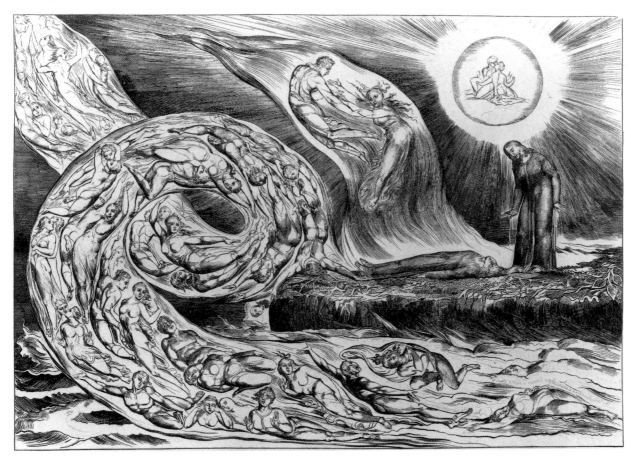

because they 'before / The Gospel lived, they served not God aright'. They are treated with tenderness by Dante, because Virgil is also of that company; for Blake on the other hand they exemplify the essential paganism of Dante's vision. In a long inscription on the previous watercolour in the series he gives a synthesis of Dante's universe, with Homer bearing a sword in the centre: 'Homer is the Center of All I mean the poetry of the Heathen Stolen & Perverted from the Bible not by Chance but by design by the Kings of Persia & their Generals the Greek heroes & lastly by the Romans.' The pagan poets, who include also Horace, Ovid and Lucan, are thus cut off from the light, in what looks like a Druid grove; Blake's imagery serves to emphasize the narrowness of their vision by the dark clouds, which reinforce their distance from the higher reaches of the imagination. Roe suggests that the flying figures are 'creatures of imagination' from which the ancient poets are barred, and that the scene on the right represents the pastoral mode, to Blake the most inspired form of antique poetry.

c *The Circle of the Lustful* (10)
Engraving, $9\frac{9}{16} \times 13\frac{5}{16}$ (243 × 338)
Inscr: in reverse 'The Whirlwind of Lovers From Dantes Inferno Canto V'
Lit: Bindman, *Graphic Works*, no. 647 (1)
Mr and Mrs Paul Mellon, Upperville, Va.

Perhaps the most convincing of all interpretations of this often-painted episode. Blake's design contains both the whirlwind of the carnal sinners and the episode of Paolo and Francesca, represented in a kind of sun, at the moment when Dante, in his compassion for the lovers, 'like a corse fell to the ground'. As images of alienation the lovers in the lower part of the whirlwind of desire look forward to Rodin's *Gates of Hell*, and it is possible that the sculptor knew Blake's design. Dante rests on a thorny promontory which probably stands for Experience; the whirlwind enclosing Paolo and Francesca, by emanating from him, suggests that they represent the divisions of his own soul. In the larger whirlwind the lovers, after swirling round the end of the dangerous promontory, seem to be unified on their upward path.

d *Dante conversing with Farinata degli Uberti* (21)
Watercolour with pen and pencil, $14\frac{7}{16} \times 20\frac{1}{2}$
(367 × 520)
Inscr: 'HELL Canto 10'
Lit: Butlin, *Paintings*, no. 812 21
The Trustees of the British Museum, London

In the City of Dis Dante encounters the Ghibelline leader Farinata degli Uberti, a tormented figure standing in a fiery tomb, who is able, as he tells Dante, to see the future but not the present. The columns, domes and porticoes of Dis identify it as a city of the material world. The figure next to Farinata is Cavalcante Cavalcanti, father of Dante's friend Guido Cavalcanti the poet.

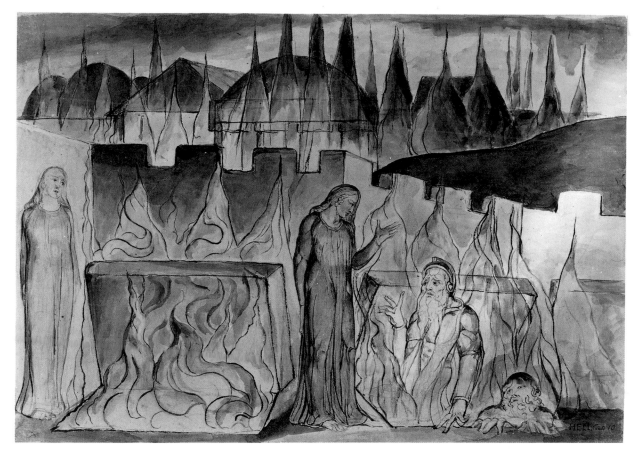

116d

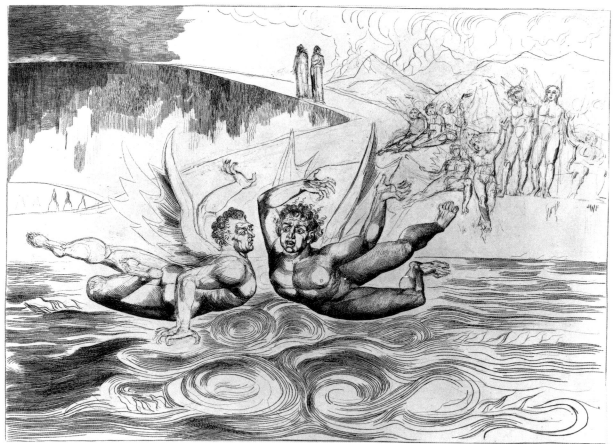

116f

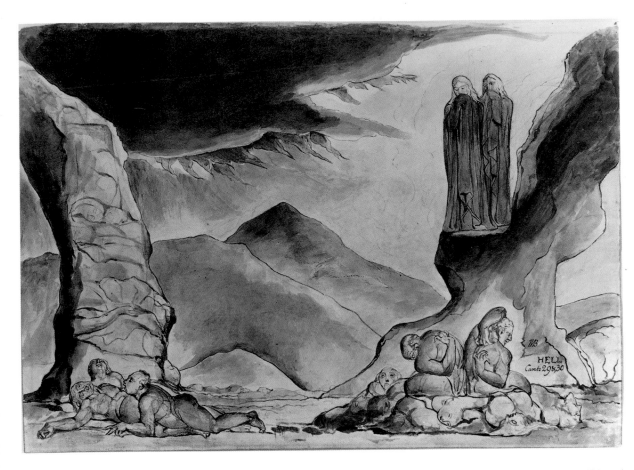

116g

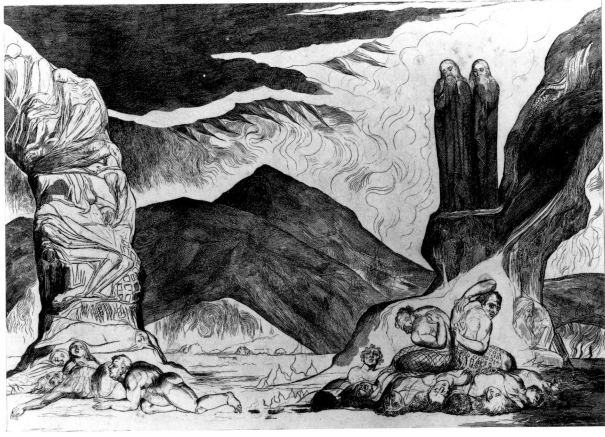

116h

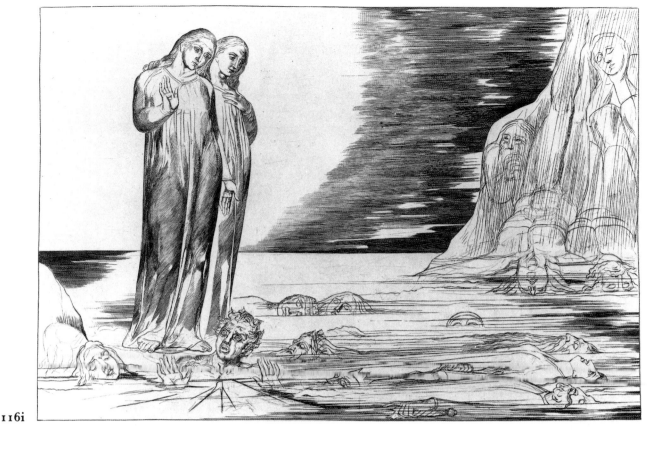

116i

e *The Simoniac Pope* (35)
Watercolour with pen and pencil, $20\frac{3}{4} \times 14\frac{1}{2}$
(527×368)
Inscr: 'WB', 'HELL Canto 19'
Lit: Butlin, *Paintings*, no. 812 35
The Trustees of the Tate Gallery, London

One of the most striking of all the designs for the *Divine Comedy*, and one of the most finished and strongly coloured. It follows the text quite literally: the punishment for the sin of simony (the buying and selling of ecclesiastical preferment) is to be cooked head-down, in wells filled with fire, until the next sinner comes, each in turn being pushed further down in the well to make room for the next. The simoniac here is Pope Nicholas III, who expects one of his successors when he is observed and spoken to by Dante, who is carried to the well by Virgil from the bridge above. The Pope writhes in agony as Dante tells him that he deserves his fate.

f *Baffled Devils fighting* (42)
Engraving, $9\frac{1}{2} \times 13\frac{1}{8}$ (242×333)
Lit: Bindman, *Graphic Works*, no. 649 (3)
Mr and Mrs Paul Mellon, Upperville, Va.

The last to be worked on of all the 7 engraved plates, this was begun in April 1827. It follows the pursuit of Ciampolo, who after being tormented by devils dives back into the lake of pitch (Canto 22). Failing to find him, the devils turn to fighting each other, until they themselves fall in. The foreground is finished but the audience of demons is still in drypoint. Dante and Virgil make their escape in the distance, while the demons are distracted.

g *The Pit of Disease: the Falsifiers* (58)
Watercolour with pen, $14\frac{5}{8} \times 20\frac{3}{4}$ (372×527)
Inscr: 'WB', 'HELL Canto 29 & 30'
Lit: Butlin, *Paintings*, no. 812 58
The Trustees of the Tate Gallery, London

h *The Pit of Disease: the Falsifiers* (58)
Engraving, $9\frac{1}{2} \times 13\frac{5}{16}$ (241×338)
Lit: Bindman, *Graphic Works*, no. 652 (6)
Mr and Mrs Paul Mellon, Upperville, Va.

An opportunity to compare an engraving with a relatively finished watercolour. The falsifiers, afflicted with loathsome diseases, are observed in the tenth ditch of the Eighth Circle by Dante and Virgil, who hold their noses against the stench of rotting bodies. The petrified human forms making up the bridges are one of Blake's most remarkable creations; as Roe points out (p. 116), they are a Blakean symbol of Fallen humanity in a state of mental petrification.

i *The Circle of the Traitors: Dante striking against Bocca degli Abbate* (65) [from Canto 32]
Engraving, $9\frac{1}{4} \times 13\frac{5}{16}$ (235×338)
Lit: Bindman, *Graphic Works*, no. 653 (7)
Mr and Mrs Paul Mellon, Upperville, Va.

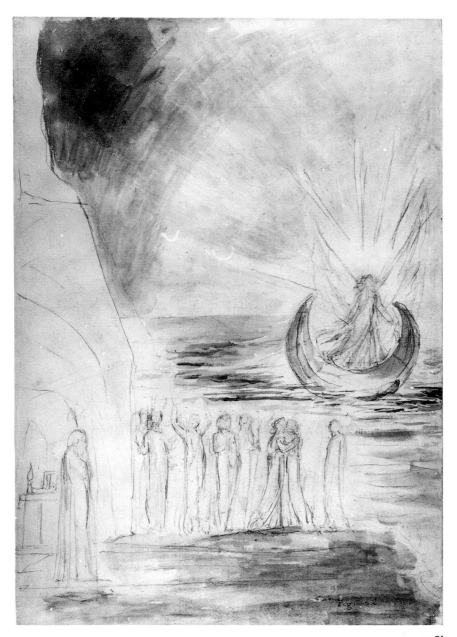

116j

Walking across the ice of the frozen circle of Hell, Dante kicks the face of a traitor, identified by another as the Bocca degli Abbate who caused the Guelfs to be defeated by cutting off the hand of the standard bearer at the Battle of Montaperti. The frozen forms in this astonishing invocation of misty bleakness seem to refer to the powers of the Fallen world, and there is reminiscence of Blake's designs of figures in the tomb in the Blair's *Grave* illustrations (rep. Bindman, *Graphic Works*, no. 468 (4)). The poet with the laurel wreath next to Bocca resembles Homer.

Purgatorio

j *The Angel Boat* (72)
Watercolour with pen and pencil, $20\frac{1}{2} \times 14\frac{1}{2}$
(520×368)
Inscr: 'P—g Canto 2', and 'Cato' over head of figure on left
Lit: Butlin, *Paintings*, no. 812 72
The Trustees of the British Museum, London

We are now in Purgatory. This unfinished watercolour shows how subtly Blake lightens the atmosphere, eliminating the ever-present suggestion of the extremes of heat and cold in the *Inferno* designs. The subordinate position of the figures makes this design evoke contemporary land-

scape watercolour painting, especially that of Turner. The boat in the background, which has brought souls to the shore of Purgatory, is propelled by an angel with beating wings. Among the souls Dante meets his friend Casella and asks him to sing, but they are interrupted by Cato (perhaps, as Roe suggests, a Urizenic figure) who urges them to begin climbing the mountain of Purgatory.

k *The Angel descending at the close of the Circle of the Proud* (82)
Watercolour, pen and pencil, $20\frac{3}{8} \times 14\frac{5}{16}$ (518 × 364)
Inscr: 'P—g Canto 12'
Lit: Butlin, *Paintings*, no. 812 82
The Trustees of the British Museum, London

As Dante and Virgil leave the Circle of the Proud they find the roadway carved in low relief with images of proud men in the history of mankind, including Briareus the Giant, Lucifer, Nimrod and Saul. An angel appears to lead them to the next stage of their journey, against the setting sun.

XX **l** *Beatrice on the Car, Dante and Matilda* (87)
XXI Watercolour, pen and pencil, $14\frac{7}{16} \times 20\frac{1}{2}$ (367 × 520)

Inscr: 'P—g Canto 29'
Lit: Butlin, *Paintings*, no. 812 87
The Trustees of the British Museum, London

For an account of this watercolour see the Introduction, pp. 43–44.

Paradiso

m *St Peter, St James, Dante and Beatrice with St John also* (96)
Watercolour, pen and pencil, $14\frac{3}{8} \times 20\frac{1}{2}$ (365 × 520)
Inscr: 'Canto 25'
Lit: Butlin, *Paintings*, no. 812 96
The Trustees of the British Museum, London

The scene is now Paradise. St John descends to question Dante about love; Dante faces Beatrice with St Peter and St James on either side. Roe claims (pp. 184–85) that St John represents the Poetic Spirit bringing the promise of fourfold unity to Dante, but Dante seems bent on union with Beatrice, the Catholic Church.

One of the most highly finished of the *Paradiso* designs, this makes a striking contrast in its ethereal composition with Flaxman's banal line engraving of the same scene (*Paradiso*, plate 26, *Conference with St John*, in John Flaxman, *Illustrations to Dante*, 1807).

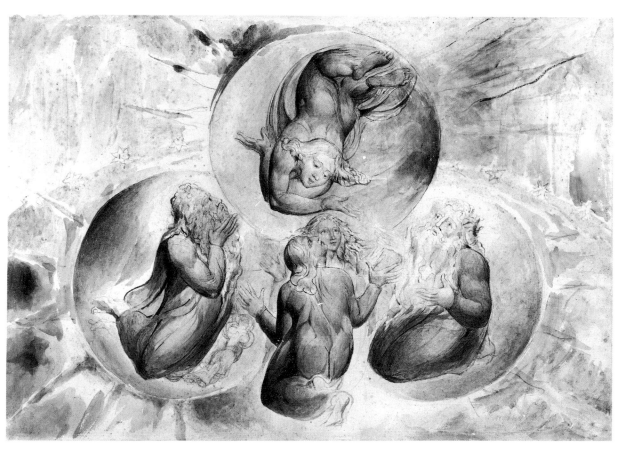

116m

at Hampstead
Drawn by Mr Blake
from the Life 1825.
intended as The Portrait
of J. Linnell

117

The Linnell Circle

In this section the last years of Blake's life are looked at principally through the works of his young friends John Linnell (1792–1882), Samuel Palmer (1805–81) and George Richmond (1809–96). During this period Blake also re-established contact with some of his earlier friends. Although Flaxman seems to have been cool towards him, George Cumberland, who had known him since the early 1780s, kept up the friendship, and was responsible for Blake's last commission – for a modest visiting card or bookplate. Blake's death, on 12 August 1827, was mourned by many who treasured their memories of him for the rest of their long lives; they were all able to give a picture of his productive last years to Blake's biographer Alexander Gilchrist, whose life of the artist was published in 1863.

117 Portrait of John Linnell 1825

Pencil, $6\frac{1}{2} \times 4\frac{3}{4}$ (165 × 120)
Inscr: (by Linnell) 'at Hampstead / Drawn by
 Mr Blake / from the life 1825 / intended as The
 Portrait / of J. Linnell'
Lit: Butlin, *Paintings*, no. 688
*National Gallery of Art, Washington, Rosenwald
 Collection, 1943*

One of the few portrait drawings by Blake, who in general regarded portraiture as a demeaning activity. It is indicative of the relaxed atmosphere of the Linnell circle that he should have consented to draw his host. Linnell moved to Collins Farm in Hampstead in 1824; Blake was a frequent visitor and apparently a great favourite with the Linnell children.

JOHN LINNELL

118 Sheep resting under a Tree 1818

Etching, $5\frac{9}{16} \times 9\frac{1}{16}$ (141 × 231)
Inscr: 'J.Linnell fecit 1818'
Lit: S. Somerville, *John Linnell and his Circle*, exh.
 cat., Colnaghi, London, 1973, no. 48
Collection of Robert N. Essick

An example of the kind of work Linnell was engaged upon when he met Blake in 1818. Linnell has been over-shadowed in reputation by Blake and Samuel Palmer, but he was an artist of considerable distinction in his own right. His early drawings and watercolours have a naturalistic intensity which accounts for his rivalry with John Constable, but he is a very different artist. He showed a strong taste for Dürer and early German prints,

118

and he is closer than any other English painter to German landscape of the period. He led Palmer in the direction of early Northern prints, and Essick has argued that his printmaking technique was important for Blake's later works (*Printmaker*, chap. 16). Linnell became a pupil of John Varley in 1804, and in 1805 entered the Royal Academy. In 1812 he joined the Baptist Church, where he got to know Charles Tatham, the father of Blake's executor Frederick Tatham. He made a living mainly by portrait painting, while also painting landscapes; only at a much later date could he concentrate on landscape.

119

BLAKE and JOHN LINNELL

119 Portrait of Wilson Lowry 1825

Engraving, $5\frac{7}{8} \times 3\frac{15}{16}$ (148 × 100)
Lit: Essick, *Separate Plates*, no. XLIII, 4H
Collection of Robert N. Essick

Blake was paid £20 by Linnell for his work on this plate but it is impossible to tell the extent of his participation.

This shows how close they were in engraving technique in the 1820s, and the willingness of Linnell to pass work on to Blake.

Wilson Lowry (1762–1824) was an engraver, and the inventor of various mechanical aids for architectural drawing. If he did indeed engrave of the plan of the New Jerusalem in Richard Brothers's *Description of Jerusalem* (No. 101), of 1801, one could assume that he then had millenarian connections. He was later a friend of Linnell.

JOHN LINNELL

120 Copy of a version of a wing of the Ghent Altarpiece by Jan van Eyck 1826

Engraving, $19\frac{3}{4} \times 6\frac{5}{6}$ (505 × 177)
Inscr: 'Jⁿᵒ Linnell Sculpᵗ 1826'
Collection of David Bindman

This apparently unpublished print makes an interesting comparison with Blake's *Job* engravings finished in the same year. It is also a record of the collection of the Hamburg merchant Charles Aders, who brought to London a large number of paintings of the early Northern schools. They were gathered together according to the ideas of the Boisserée brothers, and included a great many works of the 15th century. Some of the attributions seem to have been optimistic. One of Aders's greatest treasures was a copy of a wing of the Ghent Altarpiece.

Blake dined with Mr and Mrs Aders frequently, possibly meeting Coleridge there; Henry Crabb Robinson recorded a long conversation with Blake at the Aders house on 18 December 1825 (Bentley, *Records*, pp. 309–14). Blake was certainly impressed with the pictures in the Aders Collection, which were, according to Charles Lamb, arranged to give the house the air of a chapel:

> Whoever enter'st here, no more presume
> To name a Parlour, or a Drawing Room;
> But, bending lowly to each holy Story,
> Make this thy Chapel, and thine Oratory

(quoted in G. Grigson, *Samuel Palmer: The Visionary Years*, 1947, pp. 14–15). The Aders liked Blake's art and saw an affinity between it and what was on their walls. There is a leaning towards early Northern art in Blake's late work, but it is not possible to say that it was directly influenced by anything in the Aders Collection. This was suggested to Blake in connection with the *Canterbury Pilgrims* engraving (No. 97c), but Crabb Robinson reports that he denied it (Bentley, *Records*, p. 310):

One of the figures resembled one in one of Ader's pictures. 'They say I stole it from this picture, but I did it 20 years before I knew of the picture – however in my youth I was always studying this kind of painting. No wonder there is a resemblance.'

120

122 (detail)

121

121 Documents relating to the Book of Job

Beinecke Rare Book and Manuscript Library, Yale University

a Memorandum of Agreement between Linnell and Blake to engrave the *Book of Job*, 25 March 1823
Lit: Bentley, *Records*, p. 227

b Receipt for the sum of £150 for the copyright and plates of *Job*, 14 July 1826
Lit: Bentley, *Records*, p. 582

c Linnell's account book for the *Book of Job*, 1823–34
Lit: Bentley, *Records*, pp. 598–605

SAMUEL PALMER

122 The Crescent Moon *c.* 1824–25

Pen, $7\frac{1}{4} \times 4\frac{9}{16}$ (184 × 116)
Lit: G. Grigson, *Samuel Palmer: The Visionary Years*, 1947, no. 37
Yale Center for British Art, Paul Mellon Collection

A sketchbook page related, according to Grigson, to *Late Twilight* of 1825 in the Ashmolean Museum, Oxford (Grigson, no. 41), which shows the sort of visionary landscape with which Palmer was experimenting when he first knew Blake. There are resemblances between this kind of drawing and some of the designs for Thornton's *Virgil* (No. 106), but in general the influence of Blake on Palmer has been exaggerated. The direction of Palmer's art towards religious landscape was established before he met Blake in 1824; Blake's role was to confirm him in his path. The spirit of Palmer's art is quite different from that of the *Virgil* wood engravings, which express an essentially equivocal view of nature. Palmer's vision by contrast is an ecstatic one, in which nature represents a pathway to Redemption.

GEORGE RICHMOND

123 The Shepherd *c.* 1828

Engraving, $7 \times 4\frac{1}{2}$ (178 × 108)
Lit: L. Binyon, *The Followers of William Blake*, 1925, pl. 16
Yale Center for British Art, Paul Mellon Collection

George Richmond was the youngest of the Linnell circle, and the one whose art is closest to Blake's. Blake helped with some of his early paintings, and his figure style

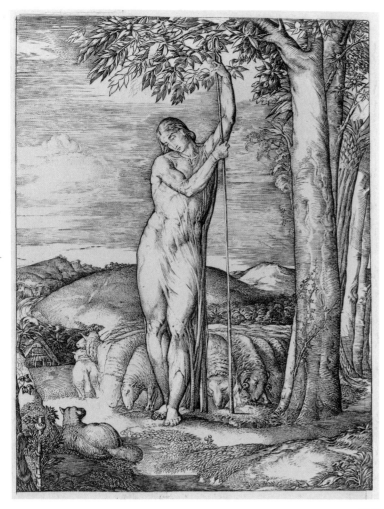

123

particularly is closely modelled on that of the older artist. This can be seen in the way the drapery clings to the body, revealing the form beneath. The sheep recall those in Blake's art from the *Songs of Innocence* onwards. Richmond lived until 1896, and after making a number of Biblical and subject paintings, moved more towards portraiture, achieving eventually a solid reputation in that field (see No. 1).

124 Letter to John Linnell 1827

Single leaf
Lit: Keynes, *Letters*, no. 87
Beinecke Rare Book and Manuscript Library, Yale University

This note is not dated but it clearly belongs to Blake's last few months, when he was largely bedridden, but mentally as clear as ever. In a letter of about the same time (12 April 1827), to George Cumberland, he wrote: 'I have been very near the Gates of Death & have returned very weak & an Old Man feeble & tottering, but not in Spirit & Life, not in The Real Man the Imagination which Liveth for Ever' (Keynes, *Letters*, No. 86).

Dear Sir
 I am still far from recovered & dare not get out in the cold air. Yet I lose nothing by it Dante goes on the better which is all I care about
 Mr Butts is to have a Proof Copy [presumably of the *Book of Job* engravings] for Three Guineas this is his own decision quite in Character he calld on me this Week
 Yours sincerely,
 William Blake

125 George Cumberland's card 1827

Engraving, $1\frac{1}{4} \times 3\frac{3}{16}$ (32×81)
Inscr: 'M�r. Cumberland' and 'W Blake inv. & sc: A AE 70 1827'
Lit: Essick, *Separate Plates*, no. XXI
Beinecke Rare Book and Manuscript Library, Yale University

Begun right at the end of Blake's life, this design (which Cumberland used as a bookplate) was not delivered until after he died. He refers to starting it in the letter of 12 April 1827 to Cumberland, and it was not finally paid for until early 1828. It was never quite finished, and his widow claimed that 'it was the last thing he attempted to engrave'. Blake has put his own age of 70 years under his signature, suggesting an elegiac intention confirmed by the design. Among symbols of Innocence an angel with a sickle descends to cut the thread of mortal life. The wheat growing, beneath the Fate holding the thread, suggests eternal life in death, and the three flying figures rejoice in the imminent ascent of the artist's soul.

125

Index